IMPRESSIONISTS *on the* SEINE

IMPRESSIONISTS *on the* SEINE

A CELEBRATION *of* RENOIR'S *Luncheon of the Boating Party*

Eliza E. Rathbone

Katherine Rothkopf

Richard R. Brettell

Charles S. Moffett

COUNTERPOINT
IN ASSOCIATION WITH THE PHILLIPS COLLECTION, WASHINGTON, D.C.

This exhibition is made possible by Ford Motor Company.

Additional funding has been received from the Janet A. Hooker Charitable Trust, the National Endowment for the Arts, the Christian Humann Foundation, United Airlines, and Artex Inc.

The exhibition is supported by an indemnity from the Federal Council on the Arts and Humanities.

Published on the occasion of the exhibition
Impressionists on the Seine:
A Celebration of Renoir's "Luncheon of the Boating Party"
21 September 1996–9 February 1997
organized by
The Phillips Collection
Washington, D.C.

Library of Congress Cataloging-in-Publication Data
Impressionists on the Seine : a celebration of Renoir's *Luncheon of the boating party* / Eliza E. Rathbone . . . [et al.].
 "In association with the Phillips Collection, Washington, D.C."
 Includes index.
 ISBN 1-887178-30-9 (pb: alk. paper)—ISBN 1-887178-21-X (hc: alk. paper)
 1. Renoir, Auguste, 1841–1919. Luncheon of the boating party. 2. Plein-air painting—France—Seine River Valley. 3. Seine River (France) in art. 4. Impressionism (Art)—France—Seine River Valley.
5. Artistic collaboration—France—Seine River Valley. I. Rathbone, Eliza E., 1948– . II. Phillips Collection.
ND549.S45I4 1996
759.4'34'09034—dc20 96-24291

Title page: Claude Monet, *The Argenteuil Basin* (detail), c. 1872, Musée d'Orsay, Paris, Bequest of Comte Isaac de Camondo, 1911 (pl. 17).
Cover art: Pierre-Auguste Renoir, *Luncheon of the Boating Party* (detail), 1880–81. The Phillips Collection, Washington, D.C. (pl. 60). Photograph: Edward Owen
Cover design: Caroline McEver

Photographic credits and copyrights appear on page 264

First printing
Managing Editor: Carole McCurdy
Editor: Nancy Eickel
Designer: Caroline McEver
Printed in Italy on acid-free paper that meets the American National Institute Z39-48 Standard.

C O U N T E R P O I N T
P.O. Box 65793
Washington, D.C. 20035-5793

Distributed by Publishers Group West

Ford Motor Company is pleased to sponsor this exhibition of French Impressionist masters from collections in ten countries around the world. We recognize that supporting the arts enriches our communities and helps us see the world beyond our own borders. Ford salutes The Phillips Collection on its seventy-fifth anniversary, and for the energy and imagination it took to bring together all the historical and artistic elements of this great exhibition.

Alex Trotman
Chairman, President and Chief Executive Officer
Ford Motor Company

Contents

List of Lenders

The Art Institute of Chicago

Marion & Henry Bloch

Cincinnati Art Museum

Sterling and Francine Clark Art Institute, Williamstown, Massachusetts

The Fine Arts Museums of San Francisco

Fondation Rau pour le Tiers-Monde, Zurich

Kimbell Art Museum, Fort Worth, Texas

Kröller-Müller Museum, Otterlo, The Netherlands

Memphis Brooks Museum of Art, Memphis, Tennessee

The Metropolitan Museum of Art, New York

Musée de l'Orangerie, Paris

Musée des Beaux-Arts de Rennes

Musée d'Orsay, Paris

Museum of Art, Rhode Island School of Design, Providence, Rhode Island

Museum of Fine Arts, Boston

The National Gallery, London

National Gallery of Art, Washington

National Gallery of Canada, Ottawa

Nationalmuseum, Stockholm

Ordrupgaard, Copenhagen

Österreichische Galerie, Belvedere, Vienna

Philadelphia Museum of Art

Portland Art Museum, Oregon

The Saint Louis Art Museum

Santa Barbara Museum of Art

Lucille Ellis Simon

Smith College Museum of Art, Northampton, Massachusetts

Staatsgalerie Stuttgart

The Walters Art Gallery, Baltimore, Maryland

Mrs. John Hay Whitney

Yale University Art Gallery, New Haven

Private collection, U. S. A., courtesy of the Artemis Group

Private collectors

Preface

Impressionists on the Seine: A Celebration of Renoir's "Luncheon of the Boating Party" adds significantly to our understanding and appreciation of French Impressionist painting, especially those river scenes that were executed between the late 1860s and the early 1880s. Moreover, it reveals the complex personal and artistic interactions that existed among a core group of Impressionist painters who were alternatively competitive and collegial, but who were equally committed to portraying the life of leisure along the Seine enjoyed by nineteenth-century Parisians.

The exhibition and its catalogue examine, in part, the relationship between Renoir and Monet and the two artists' diverging developments during the 1870s. Manet, although known primarily as a figure painter, was also drawn to the Seine and produced paintings of remarkable beauty. Morisot's interpretations range from a bold panoramic view of the river sweeping through Paris to a depiction of two lone skiffs moored near a bridge in a small town. Paintings by Sisley and Pissarro from this period not only offer idyllic and peaceful illustrations of popular leisure activities along the Seine but also emphasize the economic importance of the river. Caillebotte, through his artistic contributions and acquisitions of works by his fellow artists, played an essential role in the development of the genre.

By the mid-1860s swimming, boating, and other forms of diversion on the banks of the Seine had become immensely popular. Gathering places and boat-rental facilities appeared from Argenteuil to Bougival, and many were only a twenty minute train ride west of Paris. Croissy, an island located next to Bougival, was the site of the crowded and noisy La Grenouillère. *Impressionists on the Seine* begins there in 1869, when Renoir and Monet sat side by side and depicted La Grenouillère and its patrons on a beautiful summer day. Over the next decade Renoir, Monet, Manet, Morisot, Pissarro, Sisley, and Caillebotte each produced riverscapes that reflected a personal interpretation of the Seine. Our study of these works culminates with Renoir's extraordinary *Luncheon of the Boating Party*, one of the major works of the artist's career and a focal point of The Phillips Collection since Duncan Phillips acquired it in 1923. For the first time, the broader context and developments that led to the creation of Renoir's renowned image are fully revealed. In addition, through such analytical means as x-radiography and infrared reflectography, the exhibition and catalogue bring fascinating new information about Renoir's technique and the evolution of his composition.

The Phillips Collection is immensely grateful to the sponsors of *Impressionists on the Seine*. Without their support this wonderful exhibition might never have happened. The early and exceedingly generous commitment of Ford Motor Company

made it possible for us to proceed with the complex planning for the project. In addition, we greatly appreciate the indemnity provided by the Federal Council on the Arts and Humanities. The exhibition also benefited significantly from a grant received from the Janet Hooker Charitable Trust, as well as the support of the National Endowment for the Arts, the Christian Humann Foundation, United Airlines, and Artex Inc.

We are also deeply indebted to the exceedingly kind and generous private collectors and public institutions (page 7) who have made their paintings available. We would especially like to recognize the Musée d'Orsay, The Art Institute of Chicago, The Metropolitan Museum of Art, and the Sterling and Francine Clark Art Institute for lending so many of their major Impressionist paintings to the exhibition.

Numerous people have contributed to the loan and publication process, and we would like to express our sincerest gratitude to those who assisted in many different ways with the organization of this project: William R. Acquavella, Carol Anderson, Jean Aubert, Colin B. Bailey, Timothy S. Bathurst, William Beadleston, Christoph Becker, Jean-Claude Bellier, Adrian Biddell, Doreen Bolger, Helen Braham, Philippe Brame, Sylvie Brame, Mabel H. Brandon, David S. Brooke, Christopher Brown, John E. Buchanan, Jr., Rainer Budde, Christopher Burge, James D. Burke, Françoise Cachin, Isabelle Cahn, E. A. Carmean, Jr., Görel Cavalli-Björkman, Robert Clémentz, Melanie Clore, Michael P. Conforti, Philip Conisbee, Desmond Corcoran, Anne M. P. Norton Craner, Marianne Delafond, Douglas W. Druick, Suzannah Fabing, Everett Fahy, Michael A. Findlay, Anne Birgitte Fonsmark, Robert H. Frankel, Gerbert Frodl, Barbara K. Gibbs, Sebastian Goetz, Caroline Durand-Ruel Godfroy, Pierre Georgel, Sidney M. Goldstein, Olle Granath, Gloria Groom, Anne d'Harnoncourt, Dare Hartwell, Robert Henning, Jr., Robert Herbert, Waring Hopkins, Christian von Holst, John House, Ay-Whang Hsia, Ellen K. Josefowitz, Paul Z. Josefowitz, Dorothy Kellett, Casey Kesterson, John Leighton, Henri Loyrette, Barbara Burkhart Luton, Neil MacGregor, J. Patrice Marandel, Barbara Mirecki, Robert C. Moeller III, Philippe de Montebello, John Murdoch, Steven A. Nash, Monique Nonne, Harry S. Parker III, Edmund P. Pillsbury, Joachim Pissarro, Earl A. Powell III, G. Rau, Joseph J. Rishel, Kathryn Ritchie, Malcolm Rogers, Daniel Rosenfeld, William Scott, Theodore E. Stebbins, Jr., Evert J. van Straaten, Eileen Sullivan, Martin Summers, Shirley L. Thomson, Gary Tinterow, David Travis, Gérard Troupeau, Paul H. Tucker, Gary Vikan, Susan Vogel, Count and Countess Wilhelm Wachtmeister, Alice M. Whelihan, Daniel Wildenstein, Guy Wildenstein, James N. Wood, Eric M. Zafran, and Marke Zervudachi.

I would also like to express my deepest gratitude to the curatorial team that organized and coordinated *Impressionists on the Seine*, namely, Eliza Rathbone, Chief Curator and Project Director, and Katherine Rothkopf, Assistant Curator, whose unfailing dedication to every detail of this exhibition and publication has been cru-

cial to the project's success. Very special thanks are due to Richard R. Brettell for his outstanding essay, advice, and collegiality. Elizabeth Steele, Associate Conservator, is to be commended for producing the first technical study of Renoir's *Luncheon of the Boating Party*, and Marshall Cohen of Sensors Unlimited is recognized for his generous assistance with infrared reflectography of the painting. The exhibition and the catalogue also benefited from the contribution made by Lisa Portnoy Stein, who provided excellent research and outstanding administrative support. The museum would also like to offer its sincerest thanks to Lina Papandreou, who assisted with early research, and Alexandra Ames, who undertook special research assignments in Paris.

Impressionists on the Seine benefited enormously from the enthusiasm and special assistance of Henri Claudel, former Deputy Mayor of Chatou, who successfully led the effort to restore the Maison Fournaise. Today it is a charming restaurant accompanied by a museum devoted to the history of the Maison Fournaise and its place in the life and culture of nineteenth-century France. Henri Claudel and his colleagues Jean-Guy Bertauld and Benoît Nöel have generously provided assistance with the research for this exhibition.

We are very grateful for the support provided by Counterpoint Press, in particular by Frank H. Pearl, Publisher, and Jack Shoemaker, Editor-in-Chief. A special word of thanks is due to Carole McCurdy, Managing Editor of Counterpoint Press, to our catalogue designer Caroline McEver, and to our editor Nancy Eickel.

In addition, the success of the project is attributable to the many contributions made by the entire staff of The Phillips Collection, especially those of Michael Bernstein, Deanne Collins Ciatto, Anne Dawson, Brion Elliott, Faith Flanagan, Tom Gilleylen, Kelly Gotthardt, Valerie Guffey-Defay, Norman Gugliotta, Joseph Holbach, Oscar Iraheta, William Koberg, Kristin Krathwohl, Robert W. Lovatt, Bruno Mauro, Donna McKee, Marilyn Montgomery, Stephen B. Phillips, Karen Porterfield, Elizabeth S. Redisch, Penelope de B. Saffer, Cindy W. Savery, Karen Schneider, Pamela Steele, Cathy Card Sterling, Kenneth Thompson, Elizabeth Hutton Turner, Leigh Bullard Weisblat, James Whitelaw, Shelly Wischhusen, and Suzanne Wright.

Of course many others, too numerous to mention, have made substantial contributions to the exhibition and catalogue. Indeed, *Impressionists on the Seine* is a tribute to the cooperative spirit of the museum profession and the art world, both in this country and abroad. Our friends and colleagues have assisted at every turn, and we deeply appreciate their support, trust, and willingness to share their information, contacts, and most importantly, outstanding works of art.

Charles S. Moffett
Director

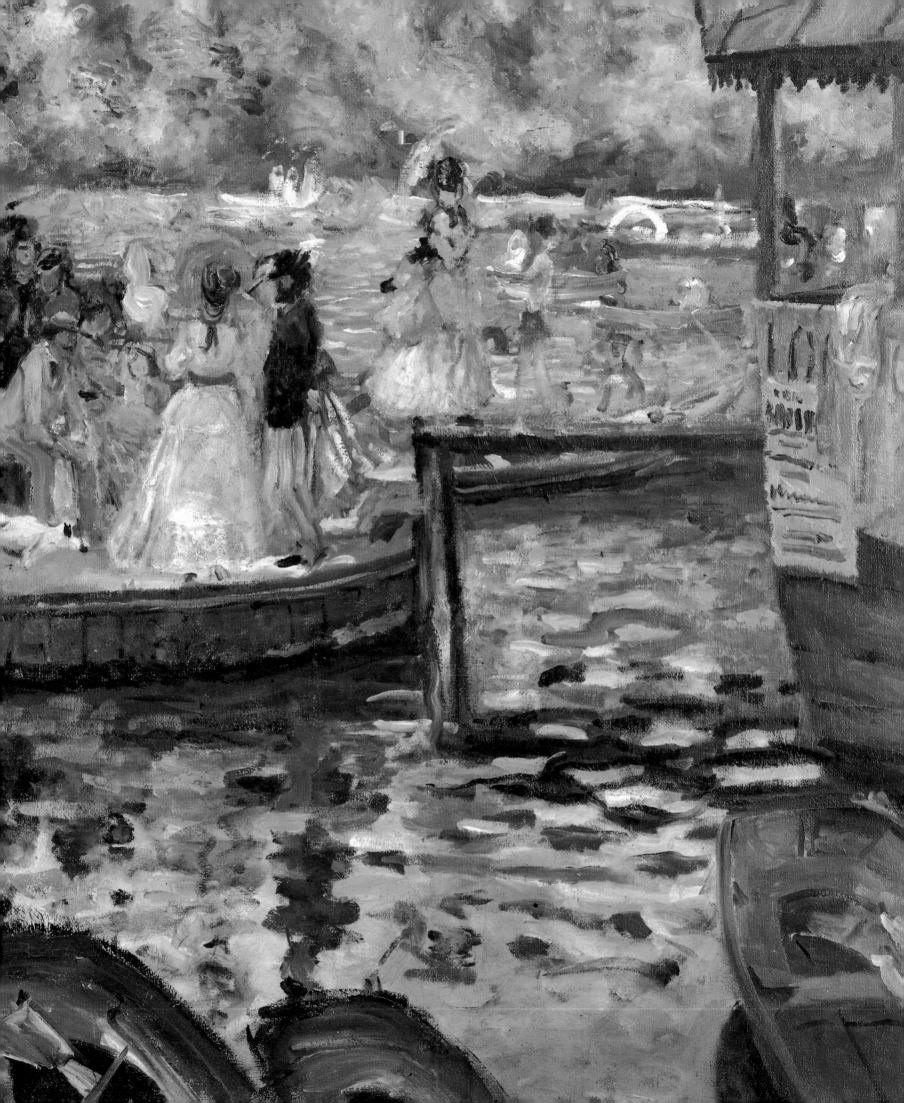

Renoir's *Luncheon of the Boating Party*

Tradition and the New

Eliza E. Rathbone

I am at Chatou. . . . I'm doing a painting of oarsmen which I've been itching to do for a long time. I'm not getting any younger, and I didn't want to defer this little festivity which later on I won't any longer be able to afford—already it's very difficult. . . . Even if the enormous expenses I'm incurring prevent me from finishing my picture, it's still a step forward; one must from time to time attempt things that are beyond one's capacity.

Pierre-Auguste Renoir[1]

Pierre-Auguste Renoir, writing to his friend and patron Paul Bérard, described the struggle and uncertainty he experienced in attempting to complete *Luncheon of the Boating Party* (pl. 60), arguably the greatest painting of his career. The work that the artist had anticipated for so long required all his resources, both financial and creative. Much larger than the average Impressionist painting, the enterprise to which Renoir referred represented a scale of ambition rare in his own work since his early attempts in the 1860s at grand Salon painting and one not rivaled by any of his fellow Impressionists at this time. Edouard Manet, of course, had painted many major compositions and would do so again. Claude Monet, like Renoir, had painted the occasional large figure composition (for example, the monumental *La Japonaise* of 1876 [Museum of Fine Arts, Boston]) but had not yet positioned himself for such a major statement. Some twenty years later, however, Monet would challenge all preexisting assumptions of pictorial composition and propose a new kind of painting with his extraordinary series of water lilies. In 1880 Renoir was uniquely positioned to paint one of the masterpieces of his career. This depiction of young Parisians lingering over an outdoor luncheon on a balcony overlooking the river Seine has come to be one of Impressionism's, not to mention Renoir's, most universally admired paintings.

Pierre-Auguste Renoir,
La Grenouillère, 1869 (detail of pl. 3)

The artist's own testimony is hardly necessary for any viewer of *Luncheon of the Boating Party* to recognize the work as a major undertaking. Assured in its style, complex in its composition, and engaging and compelling in its subject matter, Renoir's painting could only have come about as a culmination of a series

of previous works and experiences. Yet no drawings, oil studies, or any other preparatory exercises specific to this painting are known to exist. The painting represents not only a summation of Renoir's stylistic development of the preceding decade, but also the culmination of one specific thread of the artist's subject matter of the 1870s, a scene from modern life situated on the banks of the Seine. Not long after its completion in 1881, the artist made a radical shift in style and technique that inaugurated a new phase in his life and artistic development. A study of the sources of Renoir's *Luncheon of the Boating Party* sheds light not only on the stylistic development of Renoir's painting of the 1870s but also on that crucial decade of Impressionism when the movement emerged and enjoyed its greatest period of artistic cohesion and identity.

Many of the artists who came to be known as Impressionists in 1874 (when the movement was so named by critics Louis Leroy and Jules Castagnary) had met each other in the early 1860s.[2] Recognizing their shared artistic aspirations, they had hoped as early as 1867 to present themselves as a group by showing their work together in response to the all-too-frequent rejection of their paintings by the juries of the official Salon.[3] Close friendships developed among them. Although specific artists joined or dropped out of the group that showed works at any one of the eight Impressionist exhibitions mounted from 1874 to 1886, the exhibitions themselves served to create a public identity for the artists and for their "new painting."[4] Renoir's particular place in the group is inextricably linked to his success at these exhibitions, the response of the critics to his work, and his own personal experience during this crucial decade.

In charting their course through the decade of the 1870s, we are forced to take into account several overriding aspects of the circumstances that the Impressionists more or less shared over these ten years. During no other period in the history of Impressionism was the group more cohesive in terms of shared style, shared aspirations, and shared financial circumstances, which for many were exceedingly strained. This was a decade of strongly divided opinion on the merits of the "new painting," as it was heralded by the critic Edmond Duranty in 1876. For the Impressionists themselves these were the years in which each found his own voice and marked his path for the future. It was, moreover, a time of varying degrees of success at the Salon and divergent attitudes toward that success. By the late 1870s, Alfred Sisley and Renoir were convinced that they needed Salon recognition to continue their lives as artists. In 1880 Monet joined their ranks, and all three turned their backs on the group exhibitions of the Impressionists, by then referred to as the Independents, in favor of the

Salon. Gustave Caillebotte defended both Monet and Renoir for their action, explaining that their financial situations gave them no choice.[5] During the 1870s, therefore, a key shift took place in Renoir's attitude toward his work and his audience.

By definition, any work that can be described as a summation incorporates a breadth of sources or a richness of prior experience, and Renoir's *Luncheon of the Boating Party* is no exception. In tracing the sources in this case, however, we encounter certain ironies and contradictions on the way to this point in Renoir's oeuvre, contradictions that in themselves make the painting intrinsically a work by Renoir. Two of his greatest living sources of inspiration at that time were Manet and Monet, painters whose personal character and artistic approach were in many ways fundamentally different from his own. Where his own orientation was situated within a largely conservative framework, theirs was more radical. Moreover, his allegiance to past masters from the Renaissance to the eighteenth century never wavered, in spite of his desire to depict subjects from modern life. Yet in aligning himself with the avant-garde and in seeking new techniques and subjects, he challenged his own assumptions of what his art should be. In *Luncheon of the Boating Party*, Renoir integrates his response to all his mentors, creating a work unique in his oeuvre and in all of Impressionism.

When surveying his entire career, we may easily conclude that Renoir's weakness was in being too strongly swayed by his enthusiasm for one mentor or another, as artists from Courbet to Ingres, Watteau to Rubens, entered his constellation of luminaries. Did he question his own instincts too much or not enough? During the 1870s, however, Renoir steered a steady course, folding in influences from past and present with little apparent effort. One reason for this success may be the artist's constant proximity in these years to Monet and Manet.

Born in Limoges in 1841, Renoir was the son of a tailor and a dressmaker. His early apprenticeship, from the ages of thirteen to seventeen, to a decorator of porcelain launched his career as an artisan before his more ambitious aspirations were even formed. Renoir's aptitude and facility made him a willing student. In 1861 he was admitted to the Ecole des Beaux-Arts and entered the studio of Charles Gleyre, where he met Monet, Frédéric Bazille, and Sisley. Unlike Monet, who studied with Gleyre purely to satisfy his parents' demand for a formal education, Renoir, by all accounts, applied himself willingly to the course.[6] Even before he entered the Ecole des Beaux-Arts, however, he had identified a

richer resource for his education as an artist: the Louvre. Every year from 1860 to 1864, with the encouragement and sometimes company of his friend Henri Fantin-Latour, he applied for permission to paint in the Louvre.[7] Works by the old masters that he studied and copied there formed a fundamental source of inspiration for his painting. On occasion his own work declared itself an homage to Watteau or Delacroix. By contrast, Monet resisted the Louvre and had to be dragged there by Renoir. For some years Monet had been going out into the landscape to paint, following the example of Johan Barthold Jongkind and Charles Daubigny, both of whom had encouraged him in this pursuit.

It was Monet's example and friendship that led Renoir to look to the region along the Seine just west of Paris as a site for painting. During the 1860s Monet had devoted the greater part of his energies to landscape painting, and while the seascapes of Eugène Boudin offered him initial encouragement, his subsequent admiration for Daubigny and Jongkind may have inspired him to look to the river for his subjects. Whereas Renoir had grown up in Paris, Monet (who was born in Paris) had spent his childhood by the sea in the harbor town of Le Havre. During the 1860s Renoir showed little interest in maritime subjects or riverscapes. Sporadically he took up the subject of outings in a boat (once in 1862 and once again in 1866), revealing his greater interest in figures

than in the landscape itself. A comparison of Renoir's *Outing in a Rowboat (La Mare aux Fées)* of 1866 (fig. 1) with Monet's *Harbor of Honfleur* of the same year (location unknown) or *Regatta at Sainte-Adresse* of 1867 (fig. 2) proves the absorption of the one artist and the relative lack of interest of the other in observing the effect of light on water and capturing the liveliness of its ever-changing surface. In contrast to Renoir's picturesque scene of boaters, which is probably based on a site near the Forest of Fontainebleau, Monet's painting reflects his own rich experience of the life of the harbor and the coast of France as well as his passion for painting the effects of light on water that would ulti-mately dominate his work.

In 1868 Monet painted one of his earliest views of the river Seine, *On the Bank of the Seine, Bennecourt (Au bord de l'eau, Bennecourt;* pl. 1). Until this time, all

2. Claude Monet, *Regatta at Sainte-Adresse*, 1867, oil on canvas, 29 5/8 × 40 in. The Metropolitan Museum of Art, New York, Bequest of William Church Osborne, 1951 (51.30.4).

of Monet's landscapes with water had been seascapes (with the exception of two winter views of the river).[8] A marked contrast to his paintings of the sea emerges in this work. Where the sea had been conveyed by its vastness, its distant horizon, and its opacity as a body of water, for Monet the river opened up other possibilities, such as a view contained by the opposite bank, and an opportunity to study translucency and reflection. Monet made changes directly on the canvas, which he called a sketch, and used a variety of strokes to create his new composition. Painted further west of Paris than Chatou, near the artist's eventual home in Giverny, this painting was one of Monet's first informal studies of Camille, his wife-to-be, in an outdoor setting.

In the spring of 1869 Monet established himself in the village of Saint-Michel, just fifteen kilometers due west of Paris, above Bougival, on the Seine. By July, Renoir had come out from Paris to spend the rest of the summer with his parents in the nearby village of Voisins-Louveciennes, where they had recently moved. He clearly intended to visit his friend Monet and to share in a few painting excursions. The struggle for survival that was common to both artists at this time is conveyed by Monet's letter of 9 August to his friend Bazille, in which he remarks, "Renoir is bringing us bread from his house so that we don't starve."[9]

Less than two months later, Monet wrote, "The winter is coming, not a very pleasant season for the unfortunate. Then comes the Salon. Alas! I won't be represented there, since I won't have done anything. I do have a dream, a painting, the baths of La Grenouillère, for which I've done a few bad rough sketches, but it is a dream. Renoir, who has just spent two months here, also wants to do this painting."[10]

This frequently quoted segment of Monet's letter of 25 September 1869 is the artist's only mention of the now-famous series of paintings that Monet and Renoir made of the popular café and bathing establishment known as La Grenouillère. Situated on the Ile de Croissy in the Seine between Saint-Michel and Bougival, this gathering place provided an easy destination for the denizens of Paris who were looking for a day's outing in the country. Indeed, by 1869 such was the renown of La Grenouillère that it was frequently illustrated in popular magazines and was even visited that summer by Napoleon III and Empress Eugénie. Throngs of Parisians, lured by magazine ads and popular illustrations of the various diversions afforded by this riverside complex of floating café, changing cabins, and a boat rental, boarded a train at the Gare Saint-Lazare and descended less than thirty minutes later at Croissy (fig. 3).

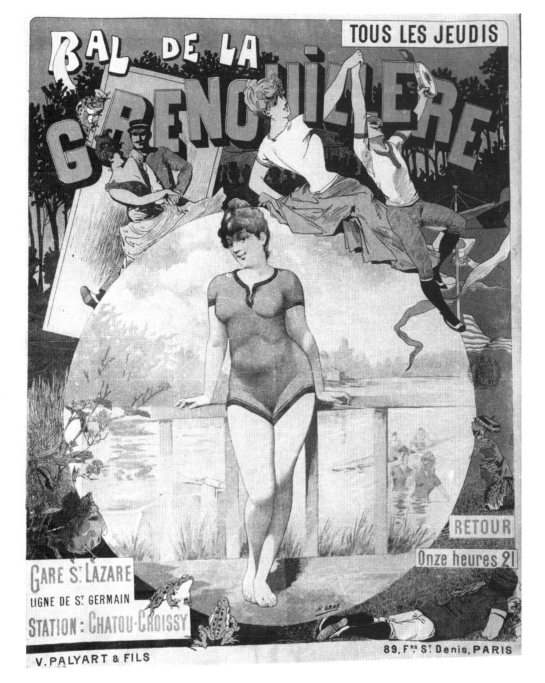

3. H. Gray, *Bal de la Grenouillère*, late nineteenth century, poster for the Chemin de Fer de l'Ouest. Collection Viollet, Paris.

The success of its attractions led to a required code of behavior in an effort to keep the rowdy crowd under control. Posted rules announced, "Bathers must wear a bathing costume covering the body from knee to chest. Undressing, putting on costumes and dressing is forbidden except in the changing huts. It is forbidden to remain in bathing dress on the bank or on the towpath. Indecent or improper cries or gestures are strictly forbidden," etc.[11] In choosing such a subject for their paintings, Renoir and Monet selected a well known and broadly popular image with which a middle-class audience could easily identify.

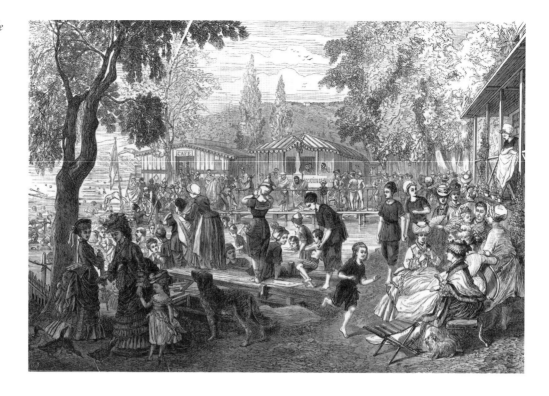

For Monet and Renoir the location provided a seemingly ideal opportunity to create a painting that was neither landscape nor figure painting, but rather a colorful outdoor view of a typical aspect of *la vie moderne*, the same modern life depicted in popular magazines of the period (fig. 4). The paintings, numbering at least three by each artist, that came of their sessions at La Grenouillère are widely thought to mark the beginning of a truly Impressionist style in their apparent spontaneity of brushstroke, their attention to outdoor effects of light, shadow, and reflection, and their brilliant broken touches of color (pls. 2 and 3). This new painting technique conveyed the scene's lively and random activity, with its milling and diverse population of visitors juxtaposed against the boats that bob close to shore or glide across the water farther out. Just as important, however, as the emergence in these paintings of a style later labeled "Impressionist" is the occasion eagerly seized upon by two fundamentally different artists to paint precisely the same subject from nearly the same vantage point in an indisputably similar style. Significantly for both Renoir and Monet, the paintings of La Grenouillère launched both artists in the pursuit of Parisians at leisure on the Seine as a subject matter for painting.

Monet's letter offers further insight into the aspirations and personal circumstances of Renoir and Monet in the late 1860s. A complete reading of the letter clarifies some of the confusion that surrounds these paintings, to which, ironi-

cally, much more attention has been paid in recent years than during the artists' lifetimes. Both men were struggling with little success to make a living from their painting, and their precarious financial situations abated little throughout the 1870s. Both of them wished to exhibit their work at the annual state-sponsored Salon, which they considered essential to their success in finding an audience for their work. Indeed, it provided one of the few opportunities for them to exhibit at that time, and it was by far the most prestigious place to exhibit in Paris, one that was broadly and consistently covered by the press. The fact that Monet mentions the Salon at the same time he describes his dream of doing a painting of "the baths of La Grenouillère" indicates his intention, and Renoir's, of creating a painting based on this subject matter that might be accepted by the Salon. So radical was the change in style from anything either artist had previously submitted to the Salon, and so great was the new informality of the known versions of La Grenouillère, that it seems highly likely that the paintings acclaimed today for heralding the emergence of Impressionism are indeed those to which Monet referred in his letter as "a few bad rough sketches."[12] The pejorative tone in his comment could easily have been exacerbated by his extreme financial straits. In any case, the very fact that the letter to Bazille is dated 25 September precludes any further paintings executed *en plein air* of this subject: the weather in northern France is rarely conducive to bathing in autumn, and Monet is not likely to have found such a scene of outdoor frolic as late as October. Moreover, by late summer it is reported that neither Renoir nor Monet had enough to eat or enough paint supplies with which to work.[13] In all probability neither artist submitted to the Salon the following spring a painting based on the subject of La Grenouillère.[14] Indeed, Renoir seems never to have exhibited any of his Grenouillère paintings, and Monet eventually exhibited only one in the second Impressionist exhibition of 1876.[15]

Little in Renoir's work anticipated his paintings of La Grenouillère. While he had painted an occasional landscape with figures as well as two early paintings dealing with outings in boats (1862 and 1866), these works were pre-Impressionist in technique and somewhat anecdotal in subject matter. Renoir had been mainly preoccupied with the figure, and the only paintings he had shown publicly at the Salon were portraits or large figure paintings, including his recent success at the Salon of 1868 with *Lise with a Parasol* (1867, Museum Folkwang, Essen), a full-scale painting of a young woman holding a parasol, her white dress dappled by sunlight. As if to confirm both Renoir's and Monet's lack of satisfaction with the results of their project at La Grenouillère, which never came to its

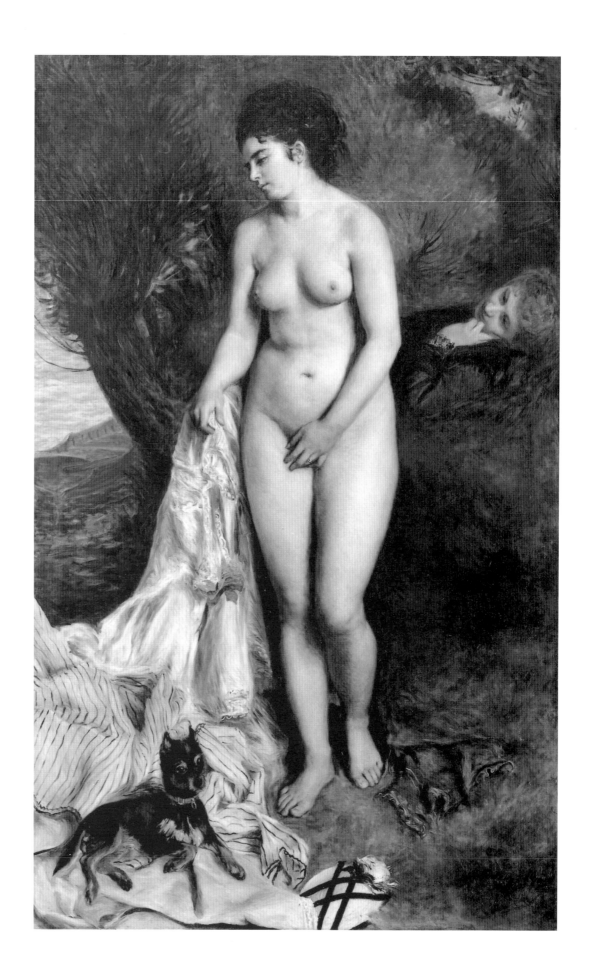

originally projected fruition as a major composition for the Salon, Monet submitted a landscape and a large interior with figures, but they failed to be selected for the Salon of 1870. Renoir's two paintings that were accepted were both large figure paintings following more traditional Salon subjects, *Woman of Algiers* (*Odalisque*, 1870, National Gallery of Art, Washington, D.C.) and *Bather with a Griffon* (*La Baigneuse au Griffon*; fig. 5).

A series of small riverside subjects from the summer of 1869 provided Renoir with the tenuous connection to nature that is seen in *Bather with a Griffon*, a painting created largely in the studio. Strongly reminiscent of work by Courbet, Renoir's painting features a rowboat tied up at the water's edge and two young women on the banks of the Seine—one of them clothed and reclining, the other standing and posed in the manner of a classical nude. The nude covers herself with one hand, while in the other hand she holds a cascade of her finery that falls into a heap on the ground beside her, where her perky pup sits possessively. A far cry from his paintings of La Grenouillère, it was perhaps Renoir's response to his friend Bazille's *Bathers* (Fogg Art Museum, Cambridge, Massachusetts), a large canvas of young men bathing that was also shown in the Salon of 1870.

If we consider Renoir's paintings of La Grenouillère in the context of studies for a larger, more finished work suitable for the Salon, it becomes clear that the artist's dream of a major painting of contemporary life by the river that began in 1869 was only fully realized in his *Luncheon of the Boating Party*. In spite of differences in scale and intent between the works Renoir actually executed, his various versions of *La Grenouillère* provide the clearest and earliest antecedent in form and content to his masterpiece of 1880–81. Painted *en plein air* just a few kilometers from each other, both paintings present typical scenes of idle pleasure by the banks of the Seine. In Renoir's *La Grenouillère* (pl. 3), the artist's evident interest in the figures themselves, their interaction with each other, and the details of their attire foreshadow concerns that he would hone in the 1870s and that would emerge fully developed in *Luncheon of the Boating Party*. By contrast, in his versions of *La Grenouillère* (pl. 2), Monet sums up each figure with mere strokes of the brush. His painting reflects his ability to organize and structure the scene with clarity and uniform brushstrokes, conveying the movement and reflective quality of the water and defining the spatial relationship of the floating café to the opposite bank of the river. Renoir, however, explores the visitor's experience of La Grenouillère by offering a more specific description of their attire and incidental encounters. He makes seductive use of

5. Pierre-Auguste Renoir, *Bather with a Griffon*, 1870, oil on canvas, 72 1/2 × 45 1/4 in. Museu de Arte de São Paulo Assis Chateaubriand.

a palette in which green, white, and blue predominate. During the intervening years of the 1870s, Monet would continue to solidify his identity as a painter of landscape and Renoir, his as a painter of figures.

La Grenouillère was the first of many occasions when Renoir and Monet deliberately painted the same outdoor subject. None of the other Impressionists painted together so frequently. Although in the early 1880s Monet confided to his dealer Durand-Ruel that he now preferred to paint alone, the consistency with which he and Renoir painted together in the early 1870s presents one of those unique partnerships that exist in the history of art and suggests an aspect of mutual support enjoyed by both artists during these pioneering years.[16] Following the panoramic views of Paris that both artists painted in 1868 (figs. 48 and 63) and the series of La Grenouillère, Monet and Renoir painted the same subject on at least four other occasions, three of which involved scenes including water: *The Pont Neuf* in 1872, *Duck Pond* in 1873, where the two artists come very close stylistically, and *The Seine at Argenteuil (La Seine à Argenteuil)* and *Sailboats at Argenteuil (Canotiers à Argenteuil)* in 1874 (pls. 28 and 29).[17] Although they agreed to paint the same site or motif, the differences apparent in their paintings present the clearest evidence in all of Impressionism for the subjective element inherent in the new painting. While each artist painted what he "saw" and described the appearance of nature, Impressionism entailed, by definition, a large degree of subjectivity. These works underscore Emile Zola's description of a painting as a record of an individual sensibility ("A work of art is a bit of nature seen through a temperament").[18] Renoir and Monet were exploring and experimenting, seeking to record their optical experience without any rules for doing so. In the paintings of La Grenouillère, Monet used fifteen separate pigments, many of them only recently available to artists at this time.[19] The conviction that this new work offered rich potential for future development seems to have been a guiding as well as a binding principle for both artists, for whom an extreme stylistic affinity would be a short-lived phenomenon. Reminiscent of other such partnerships that exist in the history of art, we might find parallels in the work of Pablo Picasso and Georges Braque in 1911–12, André Derain and Maurice de Vlaminck in 1904, or even Mark Rothko and Adolph Gottlieb in 1942–43 when, as Gottlieb would later describe it, "we were in an unknown territory."[20] In the case of Renoir and Monet, as much as for Picasso and Braque, each artist was fundamentally different in his temperament, his handling of paint, and his artistic goals. In spite of having come so close, it was inevitable that their work would evolve in different directions.

The summer of 1874 was a turning point for Renoir. Not only was it the last time that he and Monet painted together, but that summer was also the first time Manet joined Monet and Renoir in Argenteuil. While Manet stayed at his parents' house in Gennevilliers, just across the river from Argenteuil, Monet was still living in the house in Argenteuil that Manet reputedly helped him find and which Monet had rented since 1871. Although Manet had done little previous painting outdoors, he certainly had done studies *en plein air* long before his visit to Argenteuil in 1874. Landscape sketches from 1858, including drawings of the river Seine specifically at Bougival, anticipate some later works by Sisley and Monet. His work outdoors is reconfirmed by Antonin Proust, who recalled, "He would go to the Tuileries almost daily from two to four o'clock, doing studies *en plein air*, under the trees, of children playing and groups of nursemaids relaxing on the chairs. Baudelaire was his usual companion. People watched with curiosity as this fashionably dressed artist set up his canvas, took up brush and palette and painted away."[21] In spite of Proust's account, to what extent Manet actually painted outdoors at this time is not known. That he limited himself to sketches and watercolor studies seems most likely, as he reserved for the studio the major undertaking of painting the canvas.

In 1870 Manet decided to experiment with oil and canvas outdoors, which he continued in 1872 and 1873. Two paintings in particular, *Gare Saint-Lazare* (1873; fig. 25) and *On the Beach* (1873, Musée d'Orsay, Paris), painted on the beach at Berck-sur-Mer, reflect Monet's example. The latter painting even includes tangible proof of *plein-air* execution in the form of sand particles embedded in the paint, much like those that have also been found in Monet's *Beach at Trouville* (1870, National Gallery, London). Thus to some extent Manet was primed for painting out of doors during the summer of 1874.

The first Impressionist exhibition had taken place that spring, and Manet's name had figured prominently not only in critical reviews of the Salon but also in articles written about the newly presented group of rebels. Although Manet never showed his work in the Impressionists' independent exhibitions, he was their acknowledged leader. Lambasted by all but a few critics, Manet's courage in confronting the academic criteria of excellence and in following Baudelaire's exhortation to paint *la vie moderne* in an unquestionably bold and original style made him an example to them all, in principle if not altogether in practice.

By Monet's own account, it was he who first introduced Renoir to Manet.[22] Monet and Manet, who had been aware of each other's work since at least 1866,

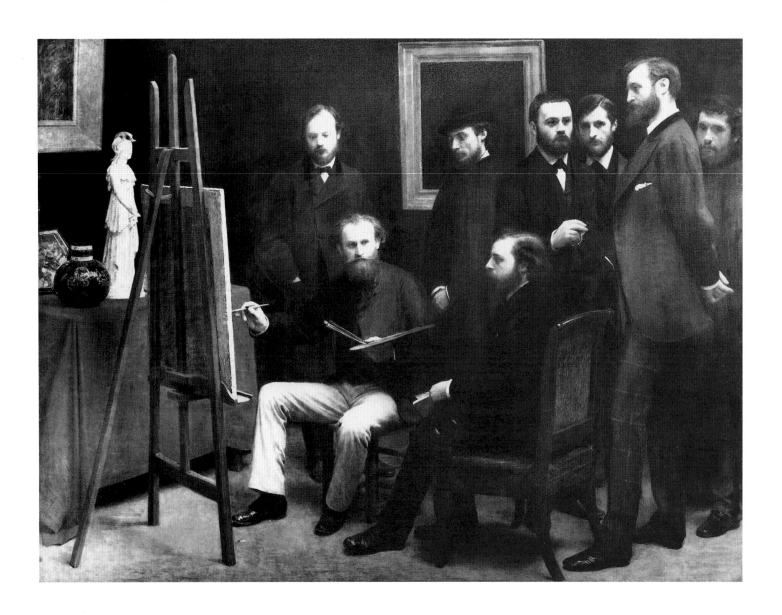

6. Henri Fantin-Latour, *A Studio in the Batignolles Quarter*, 1870, oil on canvas, 68 ½ × 82 in. Musée d'Orsay, Paris. From left to right: Scholderer, Manet, Renoir, Astruc (seated), Zola, Maître, Bazille, and Monet.

became friends in 1869, and Manet invited Monet to join him and his circle that typically met at the end of the day at the Café Guerbois in the Batignolles section of Paris. Monet, who had known Renoir, Sisley, and Bazille since they were students together in the studio of Gleyre, brought them all along. For his part, Renoir had admired Manet's work for some years, and a warm friendship subsequently developed between the two. When in 1870 Fantin-Latour painted *A Studio in the Batignolles Quarter* (fig. 6), his famous tribute to Manet's leadership, Manet requested that Renoir be positioned near him.[23] In the painting itself, Renoir, his head emphasized by the picture frame on the wall behind him, assumes a pose of obvious veneration for the master. Indeed, Manet and Renoir occupy the center of the composition, where they are most immediately joined by Zacharie Astruc, who, as writer and critic, was Manet's earliest

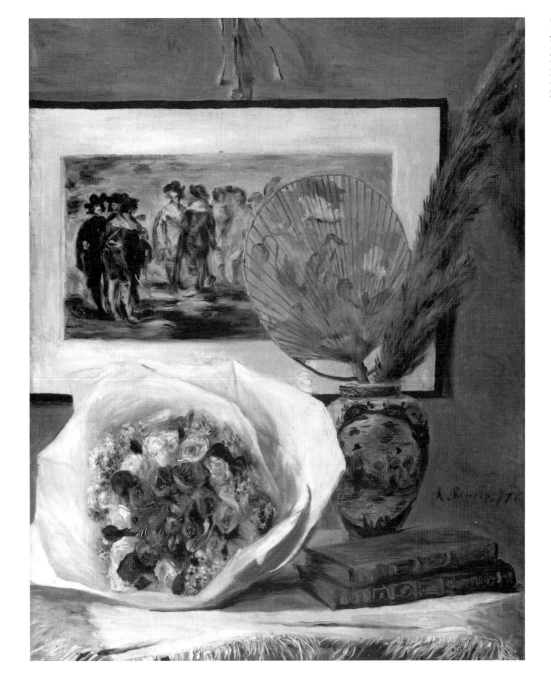

7. Pierre-Auguste Renoir, *Still Life with Bouquet*, 1871, oil on canvas, 28 13/16 × 23 3/16 in. The Museum of Fine Arts, Houston; The Robert Lee Blaffer Memorial Collection, gift of Sarah Campbell Blaffer.

champion and was also a close friend of Fantin-Latour. Farthest to the right, and almost out of the picture, stands Monet, the independent. In a most extraordinary way, Fantin's painting foretells the artistic relationships that remained constant throughout the 1870s.

Only one year later, in 1871, Renoir painted *Still Life with Bouquet* (fig. 7). As Lane Faison has pointed out, the painting is clearly a tribute to Manet as it includes references to him throughout: a print of *The Little Cavaliers* (after

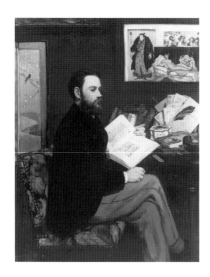

8. Edouard Manet, *Portrait of Emile Zola*, 1868, oil on canvas, 57 ¼ × 43 ¼ in. Musée d'Orsay, Paris.

Velásquez) hangs on the wall; the books, vase, and Japanese fan echo Manet's *Portrait of Emile Zola* of 1868 (fig. 8); and the brilliant bouquet wrapped in white paper is strikingly reminiscent of the bouquet presented to Olympia in Manet's by-then notorious painting of 1863.[24] Renoir's painting not only makes plain his admiration for Manet but also suggests his desire to merge the example of past masters with contemporary innovations. By couching his reference to Manet in a deliberate reach back to Velásquez, Renoir affirms the importance to him of Manet's painting and his sources in the art of the past. Renoir's own particular delight in texture is accentuated in a marriage of disparate elements, from the feathery plumes of the wild grasses and the taut paper-thin fan to the smooth solidity of the Oriental vase in which they rest. Moreover, his inclusion of a Japanese fan signals his desire, like Manet's, to prove himself *au courant* and modern in his interest in Japanese art.[25] Most striking, however, in Renoir's homage to Manet is the difference in palette between Manet's *Portrait of Emile Zola* and Renoir's *Still Life with Bouquet*. Whereas Manet's painting describes a dark interior and is a study in tones of black, gray, and brown that are lightened by a few elements in yellow or gold, Renoir's still life makes full use of the "new" palette in which yellow roses and a golden silk tablecloth are set off against a salmon-colored wall and thus seem to generate light themselves. On his own terms Renoir compresses into one image the example of the past and the vitality of the present. This duality is the foundation of Renoir's best work and is nowhere more eloquently and successfully expressed than in *Luncheon of the Boating Party*.

In coming to Argenteuil in 1874 to paint, and in embracing the subject matter that interested Monet and Renoir, Manet then carried these motifs to a new level of artistic dialogue, bringing to the site and subject his own interest in contemporary society. He produced two major, large-scale figure paintings, *Argenteuil* (fig. 9) and *Boating (En bateau;* pl. 27). To arrive at this point, however, he met his younger colleagues part way, and we can only assume a real spirit of collegiality existed in Monet's garden when Manet, Renoir, and possibly Monet set up their easels to paint together *en plein air.*[26] Significantly, it was Renoir who took up the challenge of painting the same subject as Manet, that of Madame Monet and her son Jean reclining on the grass under a tree. By bringing his example so close to Renoir's own artistic goals, Manet now offered Renoir a strong incentive to follow his original bent in the realm of figure painting and portraiture, even out of doors. Where

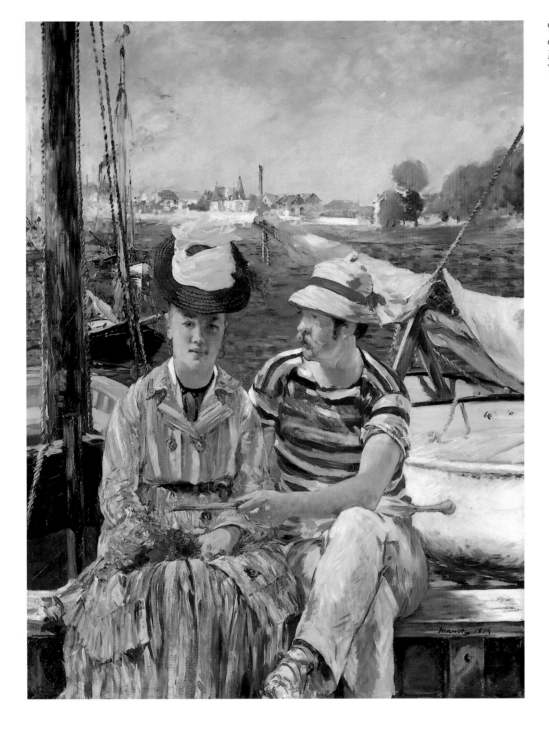

9. Edouard Manet, *Argenteuil*, 1874, oil on canvas, 59 ¾ × 45¼ in. Musée des Beaux-Arts de Tournai, Van Cutsem Bequest.

Monet was a critical force in the development of Renoir's work in the early 1870s, Manet's established role as an example to Renoir increased as the decade wore on.

In characteristic fashion, Manet singled out from the subject of riverside leisure the element that most interested him and isolated it in each of his two major paintings from the summer of 1874, *Argenteuil* and *Boating*. These two works made a more concise study of contemporary Parisians on the banks of the

Seine at Argenteuil than had ever been done before. They are, moreover, a study in opposites.[27] The recreation on the river enjoyed by a broad mix of society at this time afforded both men and women a notable degree of freedom, whether in the form of a bucolic amorous tryst, a casual encounter at an outdoor café, or an outing on a boat. In *Argenteuil* a young man, who, though dressed in the red-and-white striped shirt and red-ribboned straw hat of a boater, does not demonstrate any ability to sail, makes advances to the woman seated beside him. She is rather garishly overdressed in a manner that appears impractical for an outing on the water. Surely her hat would fly off in the first gust of wind. Clearly, serious sportsmanship did not bring either one to this locale. Behind the couple and beyond the helter-skelter of moored boats and their rigging lies the distinctly unromantic industrial side of Argenteuil, possibly to suggest the common background this couple shares.

By contrast, *Boating* features a couple of a superior social station, and everything in the painting conspires to convey the relative restraint, elegance, and higher education of this pair. He, with both hands turned away from his companion (a position that must have appeared more logical in terms of sailing when his right hand held the main, as scientific analysis shows it once did in an earlier state of the painting), demonstrates his knowledge of the sport.[28] Dressed in the traditional garb of the Cercle nautique sailing club of Asnières, he appears in white from head to toe and sports a flat straw hat with a blue ribbon, which also signifies membership in the club. His elegantly dressed lady companion is both demure and suitably prepared for her outing, with her veil and hat neatly tied by a ribbon so as not to lose it on the water. Beyond them no sign of another human being disturbs the expanse of blue. The fact that the next boat or land itself are at an unspecified distance leaves the couple, for our purposes, quite alone and endows the scene with the suppressed possibility of a romantic exchange. It is both the enigmatic quality of the couple's relationship, reminiscent of so many of Manet's works, and the striking newness and austerity of the composition that makes this painting one of Manet's great outdoor compositions. Quite understandably Renoir in 1877 (fig. 12), then Caillebotte in 1877–78 (fig. 17), and finally Mary Cassatt in 1893–94 (*The Boating Party*, National Gallery of Art, Washington, D.C.) derived inspiration from this work for their own interpretations of boating. This may explain why the artist resisted submitting the painting to the Salon until five years later (in 1879), by which time some aspects of Impressionism, including the sometimes startling influence of the Japanese aesthetic, were more fully accepted. Both works by Manet offer insight into a read-

ing of the social station of the individuals gathered on the Fournaise terrace in Renoir's *Luncheon of the Boating Party.*

In a desperate effort to derive some income from their paintings, a group of the Impressionists organized an auction of their own work at the Hôtel Drouot in March of 1875. The sale included paintings by Monet, Sisley, Berthe Morisot, and Renoir. After the Franco-Prussian War of 1870–71, the purchase of art and other luxuries dwindled, and by 1874 the bare essentials of rent and food had increased in price to such a degree that the art market had virtually dried up.[29] In 1876 Boudin described them as "these times of neglect and indifference," and even though Zola had declared in a Salon review as early as 1870 that one day paintings by Renoir and Monet would hang in the Musée du Luxembourg, both artists were far from financial success. Of all the artists who participated in the sale, Renoir fared the worst, with his paintings commanding the lowest prices and some not selling at all.[30] At this sale, however, three works by Renoir were purchased by Georges Charpentier (who would become an increasingly important patron), and before the year was out Victor Choquet commissioned Renoir to paint a portrait of his wife (dated 1875) and probably a portrait of himself.[31] The following year Renoir painted a portrait of Charpentier's daughter, and by the spring of 1877 he had completed a portrait of Madame Charpentier; both were included in the third Impressionist exhibition, the last in the 1870s to engage Renoir's participation.

At the same time, Renoir had received good notices at the hands of the critics, particularly for his portraits. Thus it was not only Manet who must have encouraged Renoir in his pursuit of portraiture and figure painting during the late 1870s. In both the Impressionist exhibitions and the Salon, Renoir typically showed few landscapes, with the most numbering four out of the twenty-one paintings that were included in the third Impressionist show in 1877.[32] Already in 1876 Zola praised Renoir's portrait of Monet: "Renoir is a painter who specializes in human faces. A range of light tones dominates his work, the transitions between them arranged with superb harmony. His work is like Rubens, illuminated by the brilliant sunlight of Velasquez. He exhibits a very successful portrait of Monet."[33] In the exhibition of 1877 Renoir's *Portrait of Sisley* (1874, The Art Institute of Chicago) received similar accolades from Georges Rivière, who noted, "The series of portraits ends with one of Sisley. This portrait achieves an extraordinary likeness and possesses great value as a work."[34]

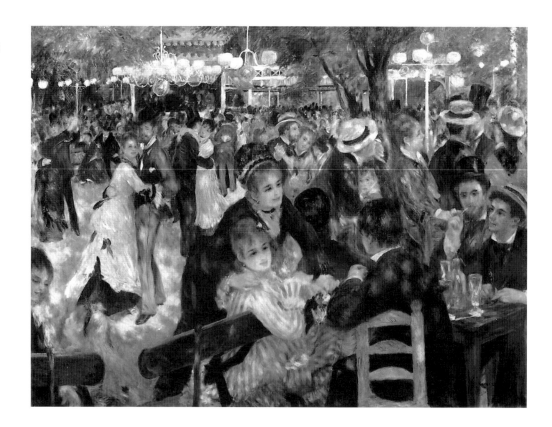

10. Pierre-Auguste Renoir, *Ball at the Moulin de la Galette*, 1876, oil on canvas, 51 ½ × 69 in. Musée d'Orsay, Paris, Bequest of Gustave Caillebotte, 1894.

In 1878 Théodore Duret added his voice to theirs, proclaiming, "Renoir excels at portraits. Not only does he catch the external features, but through them he pinpoints the model's character and inner self. I doubt whether any painter has ever interpreted woman in a more seductive manner."[35] J.-K. Huysmans (who, like Zola, was both a critic and a novelist) joined others in responding with particular enthusiasm to Renoir's portrait of the actress Jeanne Samary and *Madame Charpentier and Her Children* (fig. 73), which were included in the Salon of 1879.[36]

While he pursued portrait commissions, Renoir continued to paint landscapes. He began to build a familiarity with the landscape around Chatou by returning to visit there in the mid-1870s. It is known that he was there in 1875 by the signature and date on his portrait of Père Fournaise (*L'homme à la pipe*; pl. 42), proprietor of the Restaurant Fournaise, and by the portrait of his daughter Alphonsine Fournaise, which was also painted that year. Indeed, he is thought to have had an extended sojourn there that summer.[37] Presumably to the same summer of 1875 belong *The Rowers' Lunch* (*Le déjeuner au bord de la rivière*; pl. 40) as well as *Boating on the Seine* (formerly known as *La Seine à Asnières*; pl. 41), both of which employ the soft feathery brushstroke and blurring of contours typical of Renoir's work of this period. His evident absorption

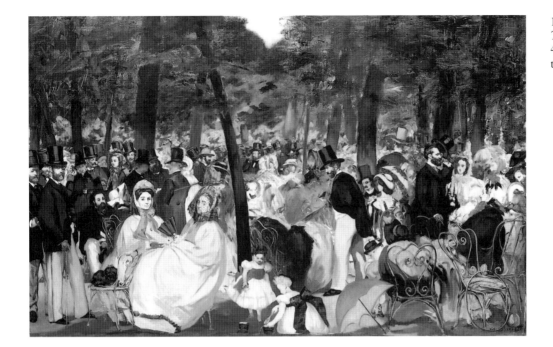

in the effects of brilliant light was further developed the following summer, as seen in *The Swing (La Balançoire)* of 1876 (Musée d'Orsay, Paris).

Specific evidence of extended visits to Chatou made by Renoir during the later 1870s has not come to light. Unlike Monet, Renoir remained a resident of Paris, and his painting of country landscapes was confined to occasional excursions rather than continuing as a year-round pursuit. In fact, during the summer of 1876, Renoir used a studio in the rue Cortot in Montmartre, and he occupied himself with ambitious outdoor subjects situated in the immediate neighborhood, including *The Swing* and *Ball at the Moulin de la Galette* (fig. 10). The latter, virtually the same size as *Luncheon of the Boating Party*, is a painting that anticipates the later work in many respects. Key differences are nevertheless found in both conception and execution. For *Ball at the Moulin de la Galette*, Renoir made two smaller oil studies: the first, a small sketch, and the second, a larger study complete with details of pose and attire, and including all the major figures of the finished painting.[38] No such preparatory studies for *Luncheon of the Boating Party* are known or are believed to exist. Moreover, in *Ball at the Moulin de la Galette*, despite the number of Renoir's friends who have been identified as models for the painting, the subject of the work is a numberless crowd engaged in a popular diversion on a summer afternoon in Paris. Its entire concept and composition, with its band of trees and lights across the background into which fade the throng of distant heads, suggest Renoir's response,

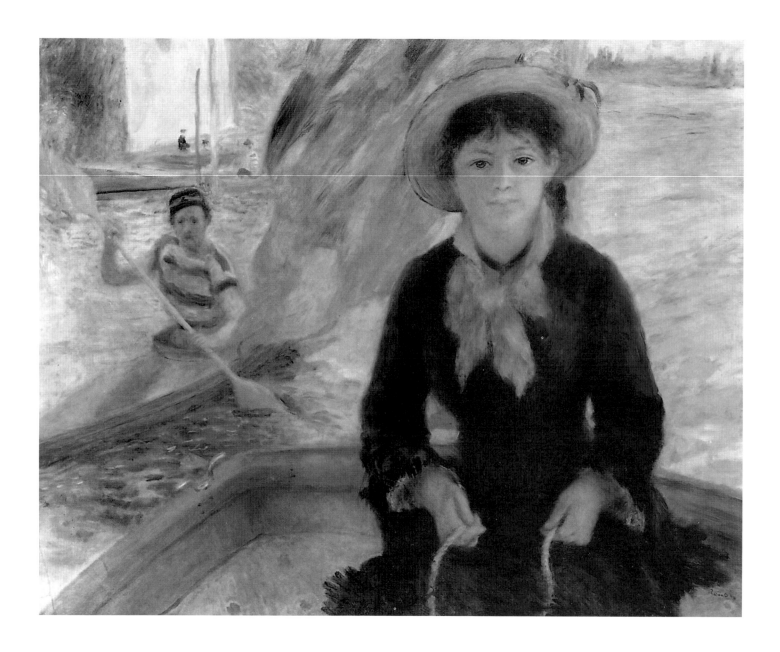

12. Pierre-Auguste Renoir, *Girl in a Boat*, 1877, oil on canvas, 28 3/4 × 36 3/8 in. Private collection. Courtesy of Alex Reid & Lefevre, Ltd., London.

though in a more populist vein, to Manet's *Music in the Tuileries* (fig. 11).

In the summer of 1877 Renoir presumably returned to the Seine, probably in the vicinity of Chatou and the Maison Fournaise, to paint *Girl in a Boat*, dated 1877 (fig. 12), a composition clearly inspired by Manet's *Boating* (pl. 27), but in place of the psychological tension between the two figures in Manet's work, Renoir suggests the young man's pursuit as he paddles swiftly behind the girl in an effort to overtake her. Like the woman in Manet's *Argenteuil*, however, Renoir's principal figure looks directly at the viewer. Additional undated riverside paintings may belong to the summers of 1877 or 1879. Two paintings by Renoir that anticipate *Luncheon of the Boating Party*—*By the Water* (pl. 50) and *Oarsmen at Chatou* (pl. 56)—reflect the artist's special

interest in social interaction and attest to his continuing return visits to Chatou in the late 1870s. Renoir, however, had become increasingly preoccupied with portrait commissions and probably made only brief visits to paint in Chatou until the summer of 1880, when he readied himself to begin *Luncheon of the Boating Party.*

One couple in particular changed Renoir's fortunes in the late 1870s: Georges and Marguerite Charpentier. Their enthusiasm for his work boosted not only his finances but also the audience for his paintings. The famous salon they created, where Renoir was frequently in attendance, attracted Parisian artists and intelligentsia, from politicians to writers, actors, and composers, as well as other painters, including Manet. After painting a portrait of the Charpentiers' daughter Georgette in 1876, Renoir produced individual full-length portraits of Monsieur and Madame Charpentier standing on the elegant stairway of their house on the rue de Grenelle. Georges, whose father Gervais had established the family publishing house, brought into print the work of Gustave Flaubert, Edmond de Goncourt, and Emile Zola. Among the theater personalities who gathered at the Charpentiers' was Jeanne Samary, the famous actress of the Comédie-Française whose portrait Renoir painted many times.

In 1878, Renoir painted the portrait of *Madame Charpentier and Her Children* (fig. 73). He submitted it, along with a full-length portrait of Jeanne Samary, to the Salon of 1879, where, thanks to the intercession of Madame Charpentier herself, the paintings were well displayed and largely well received by the critics. In reviewing the "Salon de 1879," the critic F.-C. de Syène remarked, "Talent attracts talent; and so it is for the portraitist who paints Mademoiselle Jeanne Samary: she appears to us for a second time emerging from the iridescent palette of Monsieur Renoir. In another painting where the ex-intransigent but indefatigable Impressionist plays upon the most shimmering gradations of a prism, he shows us Madame G.C. and her children: the family of an editor who is known around the world and loved by all men of letters."[39]

On countless occasions Renoir requested the Charpentiers' permission to bring friends and potential patrons to their house to see the portrait.[40] Among them were Madame Charles Ephrussi, wife of a distinguished critic who had recently emerged as a champion of Impressionism. An art historian from a well-to-do family of bankers, Ephrussi became the editor of the *Gazette des Beaux-*

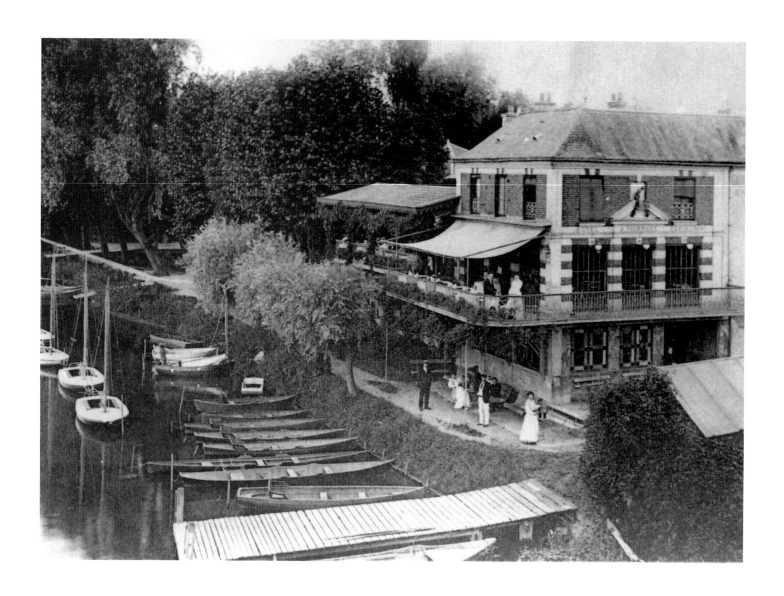

13. *The Restaurant Fournaise and the Seine, Chatou,* late nineteenth century, postcard. Courtesy of the Musée Fournaise, Chatou.

Arts and, in 1885, one of its owners.[41] Renoir also brought Monsieur Charles Deudon, the Ephrussi's friend who became a valuable patron and helped the artist with his expenses while he was working on *Luncheon of the Boating Party.*[42] It was also through the Charpentiers that Renoir met Paul Bérard and his family, with whom he developed a warm personal relationship. Like the Charpentiers, the Bérards asked Renoir to paint numerous family portraits, as well as decorative panels for many rooms in their grand summer house at Wargemont in Normandy. There Renoir spent most of the summer of 1879, and he returned for a month or two almost every summer for the next six years.[43]

Renoir wrote to Paul Bérard the only two known letters that describe in some detail his work on *Luncheon of the Boating Party.*[44] After visiting the Bérards in Wargemont in the early summer, Renoir returned to Paris in July to undertake yet another portrait commission, this time from Madame Cahen d'Anvers, the

wife of a banker, to whom he had been introduced by Ephrussi. Presumably by August he had arrived in Chatou, where he installed himself at least until the end of September to work on *Luncheon of the Boating Party*.

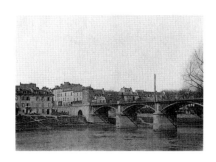

14. *The Bridge, Chatou,* late nineteenth century, photograph. Musée de l'Ile de France, Sceaux.

Several changed circumstances must have prompted Renoir finally to begin work on the painting he had envisioned for perhaps more than a decade. Certainly he at last had the assurance of the financial support he needed. Presumably he now felt confident of the audience he would require for the successful exhibition and sale of a work of such magnitude. To a large degree, his readiness to attempt this major group composition must also have stemmed from the considerable energy he had recently devoted to portraiture. Indeed, *Luncheon of the Boating Party* is distinguished by the fact that the group gathered on the terrace of the Restaurant Fournaise appears to consist of fourteen specific individuals.

Unlike La Grenouillère, the Maison Fournaise was a restaurant with a few rooms for overnight guests. The popularity of boating, which had first come into vogue in the 1850s, had led Alphonse Fournaise to purchase a building and some property by the Seine at Chatou in 1857. His purpose was to create a restaurant and a boat rental business, and over time he added on to the initial building to form an establishment sufficient for his business. By 1869 he augmented the attraction of his boats, restaurant, and rooms for rent with *fêtes nautiques,* and thereafter the Fournaise became a well-known destination for Parisians seeking an outing in the country (fig. 13). Such was the success of the Fournaise by 1877 that the balcony was enlarged, a key development for the eventual setting of Renoir's *Luncheon of the Boating Party.* In the late 1870s Renoir may have made brief visits to his mother in Louveciennes, affording him an occasional opportunity to undertake smaller landscapes around Chatou. It is equally likely that he took periodic breaks from his work on *Luncheon of the Boating Party* to paint a landscape, especially since his first conception of the painting probably included a view of the bridge and the town of Chatou (fig. 14). (See Elizabeth Steele's technical study of the painting, pages 221–29.)

To create such a complex composition, Renoir required models who were willing to come out to Chatou. In his letter to the Bérards he stated, possibly in reference to his models, "Je suis entouré de gens" (I am surrounded by people).[45] Although all his models could not stay at Chatou for the duration of the project, like a cast returning daily to the set, it is easy to imagine that early on Renoir gathered most of them there to structure his composition. Manet, after all, recorded on site the general disposition of the figures and the overall composi-

tion of his *Music in the Tuileries*, for which all the details of the painting itself were accomplished in the studio. The most ambitious precedent for a large figure painting out of doors had been provided by Monet, who dug a trench in the ground to paint his *Déjeuner sur l'herbe*, a response to Manet's painting by the same title. Although Renoir presumably painted one if not both of his preparatory studies for *Ball at the Moulin de la Galette* on the site itself, for *Luncheon of the Boating Party* he went straight to the full-size canvas. The numerous changes and compositional alterations he made on the canvas confirm this approach. Although Renoir may have completed the painting in his studio in Paris, most of the work must have been done in Chatou. The artist's two letters from Chatou to Paul Bérard describe the tremendous effort and time he was investing in the work at the site itself. He suggests a date of 1 October when he "hopes" to see the Bérards in Paris. He begins the second letter by saying that he is still working on his "wretched painting," and he goes on to express his exasperation with his models. "I'm obliged to go on working on this wretched painting because of a high-class cocotte who had the impudence to come to Chatou wanting to pose; that put me a fortnight behind schedule and, in a word, today I've wiped her out and . . . I no longer know where I am with it, except that it is annoying me more and more. Deudon who was meant to come has not showed up. . . . I do not know if Ephrussi is back, I am sacrificing this week too since I have done all I can and I will return to my portraits. . . . When I will be able to leave, I have no idea and I dare not fix a date. I believe I will continue to be delayed and in that case you will be back [in Paris] before me. I would nevertheless have enjoyed a trip to the sea again before winter. Well, all is not lost and I will write to you next week. I hope that finally I will have finished."[46]

Although Renoir did not approach his subject with the aid of quick sketches or small studies, he had not yet envisioned the entire final composition when he began his painting. Rather, he made many adjustments and additions that are visible both in pentimenti and through technical examination of the work. During the several weeks that Renoir was working on the painting, his models came and went, further complicating an already complex task. A difficult model or anyone who did not appear in Chatou as planned cost him precious time. Renoir's letter suggests that one such model was Ephrussi. In 1880 Ephrussi published in the *Gazette des Beaux-Arts* an important article on the Impressionists. Already a collector of Japanese lacquerware, he had recently started to buy Impressionist works.[47] Renoir's desire to include him in his painting may reflect his sense of debt to Ephrussi for his critical support. The

figure of Ephrussi, in a top hat, underwent significant changes as the painting evolved; his placement in the composition was lowered and his face was turned away from the viewer and toward the young man beside him.

Two other writers have been associated with figures in the painting: Jules Laforgue, as the young man talking with Ephrussi, and a journalist called Maggiolo, who stands leaning forward in a striped jacket on the right side of the composition. Laforgue, a poet and critic ten years younger than Ephrussi, met him in 1880 and became his part-time personal secretary. He contributed reviews to the *Gazette des Beaux-Arts* and some years later became known as a Symbolist critic. A lover of art, Laforgue too became a champion of Impressionist painting until his untimely death at the age of twenty-seven in 1887.[48] Renoir's significant inclusion of the world of letters in his painting finds a precedent in Manet's *Music in the Tuileries*, in which the artist depicts notable writers and critics of the time, including Charles Baudelaire, the journalist Aurélien Scholl ("a living incarnation of the boulevard"), and Zacharie Astruc, writer, critic, and champion of Manet's art. In both artists' work the presence of journalists and writers conveyed not only their welcome support but also *la vie moderne* in a city that circulated no less than forty daily newspapers.[49]

Tremendous interest has traditionally been shown in identifying all the individuals who posed for *Luncheon of the Boating Party*. While the identity of the models sheds light on Renoir's world of acquaintances and friends, the painting cannot be considered a group portrait in any formal sense. Only one of the many critics who responded to the work when it was first shown in 1882 noted the resemblance of a figure to a known individual, Charles Ephrussi.[50] Unlike Manet's *Music in the Tuileries*, a painting of elegant Second Empire society, in which a number of well-known personalities are portrayed, only two of those in Renoir's painting might have been considered publicly recognized figures (Charles Ephrussi and Jeanne Samary). Indeed, a comparison of Renoir's painting with contemporaneous photographs of some of the known models demonstrates the degree to which the artist idealized his sitters, softening their features and inviting viewers of the painting to identify with the artist's depiction of perfect youth. Nevertheless, the specific identities of the models underscores the meaning of the painting as a whole. A number of authors have attempted to identify each of the young men and women in the painting, and many of their identifications are sufficiently consistent with each other or with the facts of the models' lives to be persuasive. The earliest source is *Renoir*, a monograph by Julius Meier-Graefe published in 1912 dur-

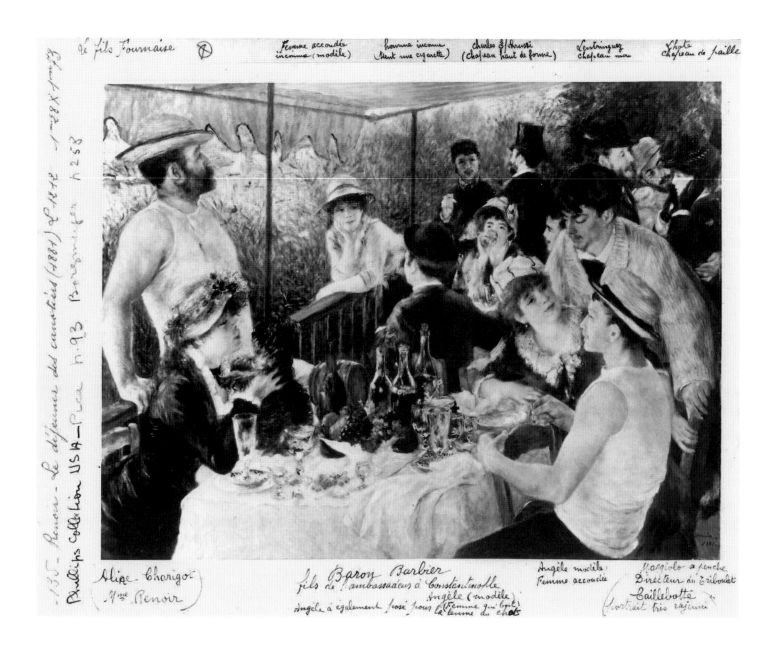

15. Pierre-Auguste Renoir's *Luncheon of the Boating Party*, annotated by an unidentified hand, photograph. Archives Durand-Ruel, Paris.

ing the artist's lifetime. A photograph, annotated in an unidentified hand and now in the Durand-Ruel archives, corresponds in most cases with the identities proposed by Meier-Graefe (fig. 15).

The more we know about the specific individuals depicted in the painting, the more the work appears to be a true reflection of an event that could have taken place in the relaxed ambience of the Restaurant Fournaise. Moreover, knowledge of the specific circumstances of their lives allows us to see their true and actual identities reflected in Renoir's painting. It is the very specificity of these details that makes Renoir's work so convincing.

Regardless of their identities, Renoir wished his painting to represent a gathering of individuals from different walks of life. The man wearing a top hat and a

dark suit (Ephrussi) is talking to a young man dressed casually in a brown jacket and a cap (Laforgue). The gentleman in a bowler seems delighted to converse with a young woman who has the air of a country girl. On the other side of the composition, a well-dressed woman from the city, her gloved hands covering her ears, appears to be approached in a familiar way by a young man in an ordinary boater's costume of a red-striped shirt and a matching straw hat. Even had the man on the left not been identified as Alphonse Fournaise, the son of the restaurant's proprietor, he can be recognized by his attire as a rower of boats. His boating hat is echoed by the one worn by the girl leaning on the balustrade (she is sometimes identified as his sister Alphonsine), suggesting her similar identity as a local. Renoir positions both of them on the Seine side of the composition, associating them visually with the sailboats gliding on the river in the distance. Unlike the restaurant's clientele, they are not seated at a table but nonetheless appear welcome to the group.

On the right side of the table in the foreground sits another young man casually astride his turned chair. He wears a rower's sleeveless shirt but also sports the flat-topped straw hat with a blue band of the Cercle nautique or, in this case perhaps, of the Cercle de la Voile de Paris. Without creating a more obvious contrast by dressing the model in the prescribed white flannel trousers and short-sleeved shirt of the sailor in Manet's *Boating*, Renoir nevertheless signals by the hat alone a superior knowledge of boats. This figure has been consistently identified as the artist Gustave Caillebotte, a passionate sailor of considerable accomplishment (fig. 16). In the painting he is ideally positioned to shift his glance from the young woman with a dog to the view beyond the balcony, which includes his own great love, the boats on the Seine. Around 1880 Caillebotte bought a house overlooking the Seine in Petit-Gennevilliers, an ideal base for his sailing interests, located just across the river from Argenteuil and not far from Chatou. Renoir had met Caillebotte by 1876: he was one of two artists who invited Caillebotte to show his works with the Impressionists in their second group exhibition, which was held in the spring of that year. That their friendship developed rapidly is verified by the fact that Caillebotte named Renoir in his will as executor of his estate in November 1876. (Several years later Renoir asked Caillebotte to become godfather of his first son.) Caillebotte, millionaire son of a successful businessman, was able to offer his artist friends invaluable support both by contributing funds for the Impressionist exhibition of 1877 and by purchasing a large number of their paintings, which he later left to the nation, including Renoir's *Ball at the Moulin de la Galette*.[51]

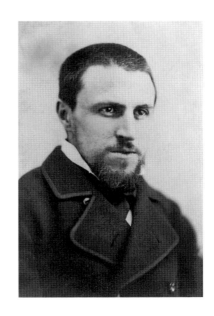

16. *Gustave Caillebotte*, c. 1878, photograph. Private collection. Courtesy of Galerie Brame et Lorenceau, Paris.

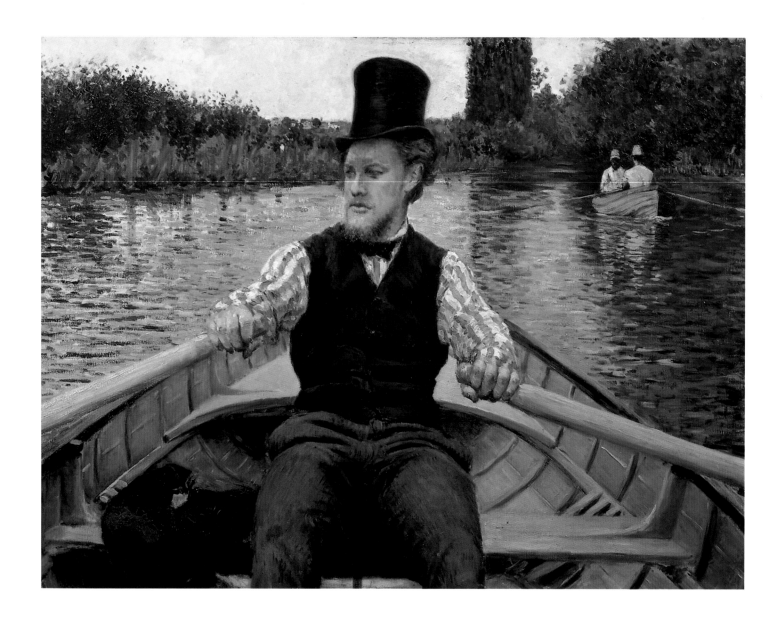

17. Gustave Caillebotte, *Oarsman in a Top Hat*, 1877–78, oil on canvas, 31 7/8 × 45 5/8 in. Private collection.

18. (Right) Pierre-Auguste Renoir, *The End of the Lunch*, 1879, oil on canvas, 39 × 32 1/4 in. Städtische Galerie im Städelschen Kunstinstitut, Frankfurt.

It is tempting to speculate that Renoir and Caillebotte may have been in regular contact with each other in 1877 when Renoir painted *Girl in a Boat* (fig. 12) and Caillebotte painted *Oarsmen (Canotiers ramant sur l'Yerres*; pl. 48). Their close friendship from 1877 to 1880 also suggests the possibility that Caillebotte's frequent use of dramatic foreshortening may have encouraged Renoir to employ similarly daring pictorial means as a way to include fourteen people in the confined space of his *Luncheon of the Boating Party.* Interestingly enough, Caillebotte seems to have engaged in a similar type of social observation to Manet's in his pair of paintings of boating on the Seine. Viewed from inside the boat itself, *Oarsmen* shows the men who know their sport thoroughly engaged, while *Oarsman in a Top Hat* of 1877–78 (fig. 17) presents a rower in his city attire who does not exert himself unduly. He has merely removed his

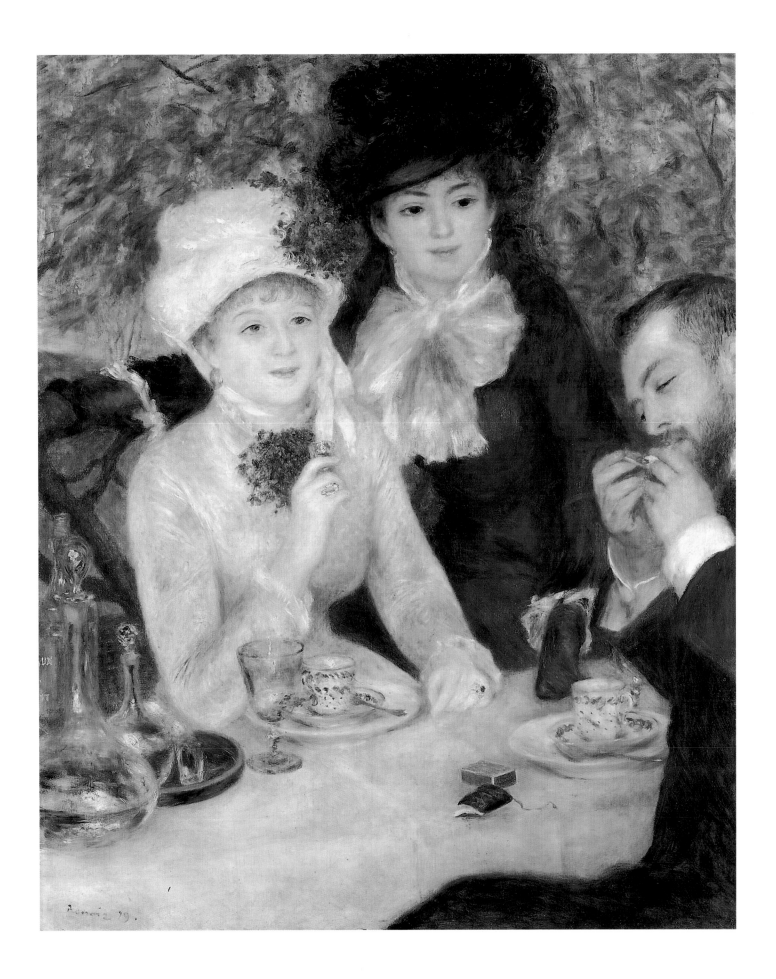

19. Félix Nadar, *Ellen Andrée, Comédienne* (detail), 1879, silver print. Caisse Nationale des Monuments Historiques et des Sites, Paris.

jacket to reveal his natty cuffed shirt and vest. Unlike Manet or Caillebotte, Renoir chose to mingle his social types in *Luncheon of the Boating Party*, perhaps reflecting his recent experience of the Charpentiers' salon, a gathering place for people of diverse talents and social backgrounds.

Renoir's friends, even among artists, came from a gamut of personal circumstances. While Monet grew up in a more established bourgeois family than Renoir, Manet, like Caillebotte, had a more socially prominent background than either of them. More than Caillebotte, Manet enjoyed a show of wealth and was something of a dandy. Renoir, by contrast, was raised in humble circumstances. One of five surviving children, he moved with his family to Paris when he was only three years old.[52] After twelve years of struggle to make a living in the city, the family's situation had not improved greatly. As his younger brother Edmond described it, "[We lived] in a flat scarcely large enough to hold all seven of us. When Auguste reached the age of fifteen, it was necessary for him to learn some profitable trade because we were very poor."[53] Unlike Monet, who had met Camille in 1866, produced a son in 1867, and married in 1870, Renoir maintained his independence throughout his years of greatest financial difficulty and did not meet the woman who would eventually become his wife until his fortieth year, the year of *Luncheon of the Boating Party*.

Many of the models seen in *Luncheon of the Boating Party* had been painted by Renoir before. The man in the bowler, identified by Meier-Graefe as the Baron Barbier, was a great friend of the artist whom he had first met at the Maison Fournaise in about 1876. The next year, 1877, Renoir painted two small studies of Barbier looking down and wearing the same hat and attire as in *Luncheon of the Boating Party*, where, however, his back is turned to the viewer. A cavalry officer, Barbier served as mayor of Saigon during the first years of French occupation. Upon his return to France in 1876, he frequented La Grenouillère and the Maison Fournaise and was reputed to be principally interested in women, horses, and boats.[54] Some of the smaller portraits that Renoir did at about this time, such as those of Baron Barbier or Alphonsine Fournaise, might have served as preparatory studies for his painting.[55] Other models had already figured prominently in Renoir's work in more ambitious paintings, especially Ellen Andrée and Jeanne Samary.

Ellen Andrée was a favorite model of many artists of the time, including Manet, Edgar Degas, and Renoir. In addition to posing for Degas's *Absinthe*

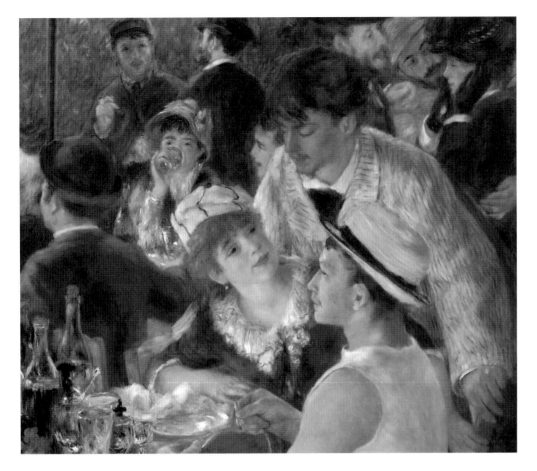

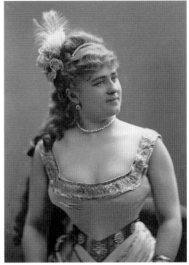

20. Renoir, *Luncheon of the Boating Party* (detail), 1880–81. The Phillips Collection, Washington, D.C. (pl. 60).

21. Félix Nadar, *Mademoiselle Angèle*, c. 1878, silver print. Caisse Nationale des Monuments Historiques et des Sites, Paris.

(1876, Musée d'Orsay, Paris; fig. 68), and Manet's *At the Café* (1878, Oskar Reinhart Collection, Winterthur, Switzerland), she is said to be the seated model for Renoir's *The End of the Lunch* (1879; fig. 18), a painting that more than any other in Renoir's work seems to anticipate directly *Luncheon of the Boating Party*. Although most sources identify the woman looking at Caillebotte as Andrée, and the woman in the center of the composition as another model called Angèle, photographs of both Andrée and Angèle made in the studio of Félix Nadar (figs. 19 and 21) suggest that the opposite is true.[56] Ellen Andrée is more likely to be the young woman with dark, curled bangs and her glass to her lips, while Angèle, a more fair-haired and statuesque type, may be the woman in the foreground. This identification is further supported by other paintings in which Andrée holds or contemplates a glass. Mademoiselle Angèle, a beauty with an hourglass figure, posed for Nadar in her costume for the role of Venus in *Orphée aux Enfers* at the Théâtre de la Gaité. Her pose in Renoir's painting (fig. 20) has been considerably reworked, and she turns her head in a manner not unlike her portrait photograph by Nadar.

Jeanne Samary, a famous and beautiful actress with the Comédie-Française

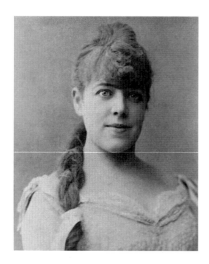

22. *Jeanne Samary*, late 1870s, photograph. Bibliothèque-Musée de la Comédie-Française, Paris.

23. Pierre-Auguste Renoir, *A Girl with a Fan*, c. 1881. Sterling and Francine Clark Art Institute, Williamstown, Massachusetts (pl. 59).

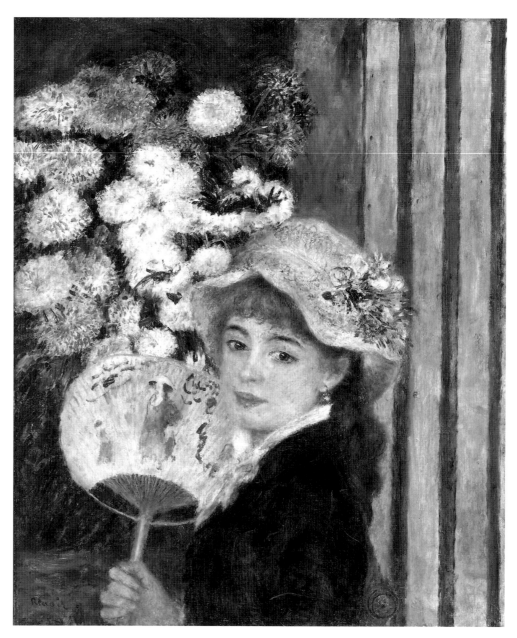

who had all of Paris and even London at her feet, has been identified with the fashionable woman in the top right corner of Renoir's composition (fig. 22). Although she died of typhoid fever at the age of thirty-three in 1890, she was at the peak of her career in 1880 and in the midst of a heated controversy over her impending marriage to Marie-Joseph Paul Lagarde, which had been announced in July of that year.[57] Her fiancé's parents did not approve of the engagement. The story was reported in *Le Figaro, Le Voltaire,* and *Le Temps.* Their eventual marriage in November of 1880 must have put an end to much of the speculation surrounding the couple and dashed the hopes of many young men. It may be with

specific reference to the current controversy that she appears as the only female in the painting to be the sole attention of two men. She claps her hands over her ears as if to block out their flirtatious remarks or enquiries over the status of her engagement. The hand that holds her at the waist, however, may be that of yet another man, her fiancé. Slivers of a top hat and a collar are visible along the upper right edge of the painting. This group of figures was probably added late in the painting's evolution and therefore had to be accommodated in a small space. Without them, the arrangement of the figures creates a more traditional pyramidal composition, in which the balustrade on the left is matched by the line of Maggiolo's arm and shoulder on the right. Both compositional elements originally met at the top of Ephrussi's hat before Renoir lowered its contour. It is unclear whether Renoir's inclusion of Samary's fiancé in such a minimal fashion was to reflect the uncertainty of her future or was purely a matter of space. The two men with her who were fully included in the painting were modeled by Paul Lhote in a striped shirt and Eugène Pierre Lestringuez, both of whom had posed with Samary for Renoir's *Ball at the Moulin de la Galette.*

Samary, who had been staying in Bougival since the spring of 1880, lived not far from Renoir's studio in Paris and probably first met the artist at the Charpentier's salon, where she was a regular guest. Between 1877 and 1881 Renoir painted two small sketches and five portraits of her, including a full-length one shown at the Salon of 1880. One of his portraits of her, *A Girl with a Fan* (fig. 23 and pl. 59), not only reflects Renoir's interest in the Japanese aesthetic but also presents the up-to-date decor of Samary's dressing room at the Comédie-Française, which was decorated from floor to ceiling with fans (fig. 24). His inclusion of the striped motif of her dressing room walls and a large, colorful bouquet evokes the glamorous behind-the-scenes surroundings of this successful actress.

In spite of Samary's great beauty, she takes none of the pictorial emphasis away from the unquestionable focus of feminine beauty and charm, the young woman with a dog. Modeled by Renoir's future wife Aline Charigot, she appears here in the artist's work for the first time. This figure underwent the most dramatic change in the course of the painting's evolution. While pentimenti visible in the painting's surface suggest the alteration of the contours of her hat, x-radiography reveals an astonishingly different initial conception of this figure (fig. 88). In the earlier state of the painting the woman seated in the left foreground looks directly out at the viewer. Her right arm is bent, with her hand up close to her face, and her three-quarter length sleeve ends in a flouncy ruffle. This

24. Félix Fournery, *Jeanne Samary's Dressing Room at the Comédie-Française*, c. 1880, wood engraving. Bibliothèque-Musée de la Comédie-Française, Paris.

strikingly differs from the final figure in profile, with her distinctive attire and long fitted sleeves to the wrist. Having grown up exposed to sartorial concerns, Renoir came naturally by his interest in costume and fashion. His appreciation of style and contrasts of pattern and texture, as well as his keen sense of the potential inherent in a ruffle or a hat to show off a woman to her best advantage, may reflect his exposure to his parents' professions. He even had recently proposed to Madame Charpentier that a page, dedicated to the latest fashion and drawn by Renoir, be added to their publication *La Vie Moderne*.[58] In his depiction of Charigot, who was a seamstress, he gives special attention to the details of her apparel, perhaps refining them at her behest.

In his second letter to the Bérards, Renoir referred to a "high-class cocotte" who insisted on posing for the painting and then had to be wiped out completely, causing him to lose precious time. Although other figures underwent changes, it seems most likely that this is the figure he described. It may well be that Aline Charigot only entered the painting upon the departure of the previous model, when Renoir repainted this figure.

More dramatic than Renoir's changes in her attire is his radical shift in her position, which had a far greater consequence for the painting as a whole. The effect of this figure looking straight out at the viewer, as it once did, isolating her from any interaction with the other figures, is immediately reminiscent of Manet's depictions of Victorine Meurent, who almost always looks out at the viewer, half-challenging, half-beckoning. Many works by Manet include a model that looks directly at the viewer, interrupting the time frame of the work itself and the continuity of the event presented to engage the viewer in a single moment in time and to endow the figure with an enigmatic relationship to the event depicted. Renoir's decision to involve the figure modeled by Charigot in the joyful atmosphere of the scene might not only reflect his personal relationship with her but also his desire to unify the composition by a close interaction of the figures. Because most of them look at someone who in turn looks at someone else (a device used in the Renaissance to unify a multifigured work), the eye travels easily through the group of figures assembled in Renoir's painting.

Nevertheless, Renoir's initial approach to the composition of *Luncheon of the Boating Party* could well reflect his continued admiration for Manet. In the late 1870s, some of those artists who had gathered routinely at the Café Guerbois began to frequent instead the Café de la Nouvelle Athènes on the Place Pigalle. Manet and Degas attended regularly, as did their friends Marcellin Desboutin and George Moore. Indeed, Degas's *Absinthe* (fig. 68), for which Ellen Andrée

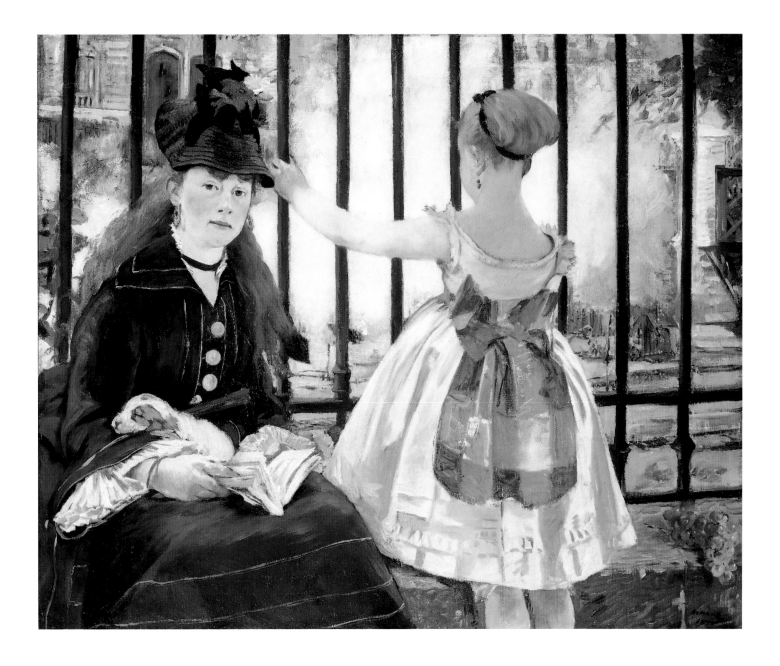

25. Edouard Manet, *Gare Saint-Lazare*, 1873, oil on canvas, 44 ½ × 52 ¼ in. National Gallery of Art, Washington, D.C., Gift of Horace Havemeyer in memory of his mother, Louisine W. Havemeyer.

served as a model, was situated at the Nouvelle Athènes. While Monet, Sisley, and Cézanne almost never stopped in, Renoir appeared regularly.[59] Not only was Renoir living in Paris, where he would have been aware of new developments in the painting of Degas and Manet, but he was also obviously interested in what they were doing and had to say. Manet's decisive approach to structure and composition, with which he frequently constructed a shallow pictorial space, is echoed in Renoir's *Two Sisters (On the Terrace) (Sur la terrasse;* pl. 58), where they are seated in front of the balcony railing, just as the woman and child are situated between the iron fence and the viewer in Manet's *Gare Saint-Lazare* (fig. 25). Similarly, in *Luncheon of the Boating Party,* Renoir put the existing architectural

26. Antoine Watteau, *Pilgrimage to Cythera* (detail), 1717, oil on canvas, 51 × 76 ½ in. Musée du Louvre, Paris.

elements to use in creating a compositional structure for the compressed pictorial space of his painting.

The beckoning glance of Manet's models echoes paintings by the Dutch artist Johannes Vermeer, who was rediscovered and championed in the mid-nineteenth century by the critic Théophile Thoré (W. Burger). Renoir's clearest allegiance, however, was to French art of the eighteenth century, especially the example of Antoine Watteau. Despite the possible influence of Veronese's *Marriage Feast at Cana* (Musée du Louvre, Paris) on Renoir's palette as much as his composition, it is above all the tradition of Watteau that Renoir evokes in *Luncheon of the Boating Party*. Watteau's oeuvre abounds in subjects later adopted by Renoir, from the swing to the *bal champêtre* and *amusements champêtre*, all of which celebrate the

essential theme of love, or the *fête d'amour*. The entire organization of the composition of *Luncheon of the Boating Party*, first titled *Déjeuner champêtre*, lies in the relationships among the figures. Where else but in Watteau's paintings and countless studies of heads could Renoir have found such an exhaustive and applicable study of the expressive potential in the tilt of a head, the direction of a gaze, the inclination of a body (even the back of a head, and certainly a *profil perdu)*, all to the end of conveying the theme of courtship. It may be no mere coincidence that in 1875 Edmond de Goncourt, a close friend of Georges Charpentier, published a catalogue raisonné of the work of Watteau, "the great poet of the eighteenth century."[60] Watteau's *Pilgrimage to Cythera*, which incidently was also a favorite of Claude Monet, hung in the Louvre and had been acclaimed by the Goncourt brothers, Jules and Edmond, as "that masterpiece of masterpieces" (fig. 26).[61] Here, as in Renoir's painting of courtship in a country setting, a look, a gesture, or the placement of a hand conveys the content of the scene.

And what of the dog that appears to be the sole object of Charigot's affection? A common attribute in eighteenth-century portraits, a dog traditionally symbolized fidelity. Yet in other French eighteenth-century depictions of women, the dog has clear connotations of sensuality and availability or, as Richard Thomson describes in his study of the subject, which includes paintings by Watteau, the dog is often depicted as "the intimate, even the playmate, of its coquettish mistress."[62] Here Renoir depicts the object of his own affections with a deliberate implication of the faithful mistress. That the artist had long considered such potential overtones in his work can be seen in his *Bather with a Griffon* of 1870 (fig. 5), where the dog—a griffon, the favorite of prostitutes—sits on his mistress's discarded clothing, offering more than an innuendo of potential promiscuity. In *Luncheon of the Boating Party*, the dog does not gaze hopefully or longingly at his mistress. Instead Aline, the artist's love, buries her hands in her terrier's fur and purses her lips to indicate a kiss about to be or just given, conveying the pleasures of the senses that constitute the overriding theme of the painting itself (fig. 27). In contrast to the privileged rich society, dressed in an abundance of silk, satin, and taffeta that is depicted in Watteau's paintings, Renoir's figures reflect a new society. Yet at this moment in time they lead the same charmed existence.

Renoir brings more than a contemporary view of society to his painting. After having labored over the work, adjusting and refining myriad elements of his masterpiece, for over two months, he nevertheless succeeded in conveying a glorious but fleeting moment by using lively brushstrokes that belie the true history of the painting's execution. White impasto enlivens the painting, from the glass

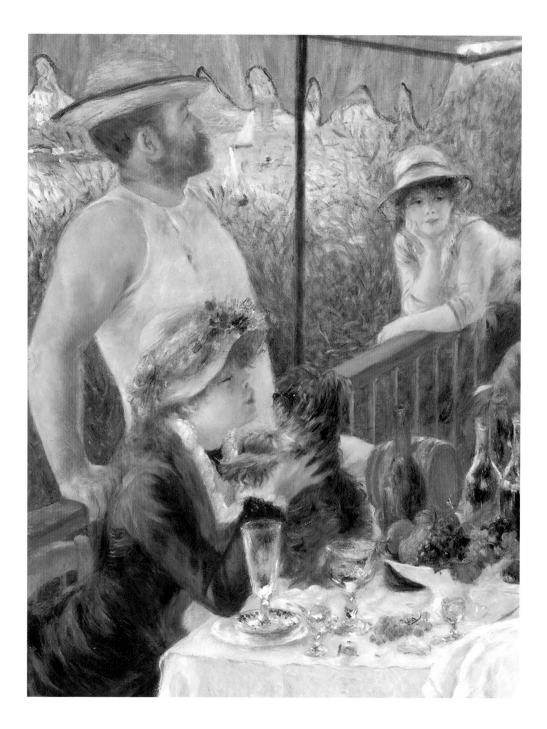

27. Pierre-Auguste Renoir, *Luncheon of the Boating Party* (detail), 1880–81. The Phillips Collection, Washington, D.C. (pl. 60).

flute in front of Aline Charigot and the still life on the first table, to the bottle and glass on the second table and the glass raised to the lips of Ellen Andrée. This sequence of white highlights snakes through the very center of the composition and leads the eye back through the highly foreshortened space. The still life, sufficiently developed to be a painting in its own right, is assembled on the white tablecloth, which, with its folds still visible from pressing, is alive with the blues and greens of reflected light. Indeed, Renoir's whites are among the most master-

ful passages in the painting and contribute to the effect of filtered light on a brilliant day. The awning, which allowed Renoir to bathe his figures in an even, overall light, was given a scalloped edging late in the painting's evolution, thus closing off the space from the distracting view of the bridge and town of Chatou. The energy and immediacy of the artist's undulating brushstroke that defines the edge of the awning by its very movement seems to suggest the breeze that makes the awning flutter, the same breeze that also ripples the water and refreshes the joyous crowd that lingers at their tables on the terrace long after the meal is done. Here, Renoir treats this detail of his scene as casually as Manet did the awning of Monet's studio boat in 1874 (fig. 43). Likewise, the artist's touches of vermilion and red lake, set off by the flowers in Charigot's hat, pick out salient elements of the composition and articulate the distinguishing stylish details of the ladies' attire. These intense finishing touches, which contribute a vibrancy to the painting as a whole, may have been added in Renoir's studio in Paris after the turn of the year, leading the artist to give the painting a completion date of 1881.

Within weeks of its completion, the painting had been sold to Paul Durand-Ruel. Renoir had achieved his goal, and the painting was greeted with considerable critical acclaim the following year. In composition, subject, and technique, Renoir brought traditions of the past to bear on a work that fully utilized the new language and subjects of Impressionism. Within the next few years the artist began to develop his art along new lines and to look for more timeless subjects in order to create an art worthy of museums. To do so he virtually eschewed *la vie moderne*, often favoring instead subjects from Greek mythology to the Renaissance. Emulating great masters of line, such as Ingres, he developed in his painting a crispness and hardness of form it had not known before. Occasional evocations of eighteenth-century subjects reemerged in his art later in the 1880s. Ironically, he had already created his most timeless work. In a unique marriage of the tradition and example of the past with the people and mores of the world he knew, Renoir created the masterpiece that still today symbolizes for many the essence of Impressionist figure painting.

1. Pierre-Auguste Renoir, letter from Chatou to Paul Bérard, 1880, as translated in John House et al., *Renoir*, exh. cat. (London, 1985), quoted in entry by John House on *Luncheon of the Boating Party*, 222, from Maurice Bérard, "Lettres de Renoir à Paul Bérard," *La Revue de Paris*, December 1968.
2. Louis Leroy, *Le Charivari*, 25 April 1874; Jules Castagnary, *Le Siècle*, 29 April 1874. See

Stephen F. Eisenman, "The Intransigent Artist or How the Impressionists Got Their Name," in Charles S. Moffett et al., *The New Painting, Impressionism 1874–1886*, exh. cat. (San Francisco, 1986), 51.
3. Paul Tucker, "The First Impressionist Exhibition in Context," in ibid., 93.
4. Edmond Duranty, reviewing the exhibition of Impressionist painting in 1876, wrote "The

New Painting: Concerning the Group of Artists Exhibiting at the Durand-Ruel Galleries," reproduced in ibid., 37–47.

5. Joel Isaacson, *The Crisis of Impressionism, 1878–1882*, exh. cat. (Ann Arbor, 1980), 6.

6. John Rewald, *The History of Impressionism*, 4th rev. ed. (New York, 1973), 70–72.

7. *Renoir*, Chronology, 295.

8. Daniel Wildenstein, *Claude Monet: Biographie et catalogue raisonné*, vol. 3 (Lausanne and Paris, 1974), cat. 105 and 106.

9. Rewald, *Impressionism*, 226.

10. Monet, letter of 25 September 1869 from Saint-Michel to Bazille, quoted from Gaston Poulain, *Bazille et ses amis* (Paris, 1932) in H. W. Janson, ed., *Sources and Documents in the History of Art* series; Linda Nochlin, *Impressionism and Post-Impressionism, 1874–1904* (New Jersey, 1966), 33.

11. Quoted in Jacques and Monique Laÿ, "Rediscovering La Grenouillère: Ars longa, vita brevis," *Apollo* 807, no. 375 (May 1993), 283.

12. Scholars disagree as to whether or not Monet refers to all his Grenouillère paintings in this letter. For some of the differing views see Kermit Swiler Champa, "Monet and Renoir at La Grenouillère," *Studies in Early Impressionism* (New Haven and London, 1973), 63; Gary Tinterow, in Gary Tinterow and Henri Loyrette, *Origins of Impressionism*, exh. cat. (New York and Paris, 1994), 440; Joel Isaacson, *Observation and Reflection* (Oxford and New York, 1978), 17; and Robert L. Herbert, *Impressionism: Art, Leisure, and Parisian Society*, (New Haven and London, 1988), 213–19.

13. Rewald, *Impressionism*, 226.

14. Some scholars believe that the largest version that Monet painted of La Grenouillère, once in the Arnhold collection (and since destroyed), was submitted to the Salon along with his painting *Le Déjeuner*; and both were rejected. Jean Ravenel and Zacharie Astruc, the only reviewers to mention Monet's rejected works, do not, however, identify the painting as *La Grenouillère*. Ravenel calls it a "paysage" and Astruc, a "marine." Since Monet submitted *Le Déjeuner*, a painting of 1868–69, to the Salon of 1870, there is no reason to believe that he might not have submitted a landscape from the year before. It seems far more likely that Monet had originally intended to paint a large figure composition based on his sketches of La Grenouillère for the Salon, more along the lines and the scale of his *Women in the Garden* (1866–67) or his *Déjeuner sur l'herbe* (1865), both of which exceed 80 by 100 inches in dimension. (Regarding the accounts of Ravenel and Astruc, I am grateful to Anne Norton Craner, former research associate, department of European paintings, The Metropolitan Museum of Art, New York, for sharing her research with me.)

15. Moffett et al., "The Second Exhibition 1876," *New Painting*, Monet, no. 164, *Les Bains de la Grenouillère*, 163. It is not clear which of Monet's paintings on the subject this was.

16. Monet, letter to Durand-Ruel, 12 January 1884, in Lionello Venturi, *Les Archives de L'Impressionnisme*, Durand-Ruel edit. (Paris and New York, 1939), 268: "Nice as it has been to make a pleasure trip with Renoir, just so would it be upsetting for me to travel with him to work. I have always worked better alone and from my own impressions."

17. The two paintings are juxtaposed in Rewald, *Impressionism*, 280–81. In this case, although the artists painted the same view, their paintings were not done at exactly the same time, since Renoir's depicts sunny skies and Monet's shows rain.

18. Emile Zola, quoted in Moffett et al., *New Painting*, 74.

19. David Bomford et al., *Art in the Making: Impressionism*, exh. cat. (London, 1991), 51, 125.

20. Adolph Gottlieb, in an interview with Andrew Hudson, May 1968, verbatim transcript, 5, quoted by Sanford Hirsch, "Adolph Gottlieb and Art in New York in the 1930's," in *The Pictographs of Adolph Gottlieb* (New York, 1995), 20. In this connection, it was brought to my attention that Joel Isaacson compares the relationship between Monet and Renoir to that of Picasso and Braque in his dissertation "The Early Paintings of Claude Monet," Ph.D. diss., University of California, Berkeley, 1967.

21. Antonin Proust, quoted in *Manet: 1832–1883*, exh. cat. (New York, 1983), 122.

22. Claude Monet, in François Thiébault-Sisson, "Claude Monet, An Interview," *Le Temps*, 27 November 1900, translated and reprinted by Durand-Ruel, republished as "Claude Monet: The Artist as a Young Man," *Art News Annual* 1957, part 2 (November 1956), 127–28, 196–99. In fact, Monet and Manet may have met each other as early as 1865. See Poulain, *Bazille*, 48.

23. Rewald, *Impressionism*, 205.

24. S. Lane Faison, Jr., "Renoir's Hommage à Manet," *Intuition und Kunstwissenschaft, Festschrift für Hanns Swarzenski* (Berlin, 1973).

25. *Manet: 1832–1883*, 284.

26. Ibid., 362.

27. See Herbert, *Impressionism*, 236–38, for discussion of both works by Manet.

28. Ibid., 236. For discussion of pentimenti and x-radiography of *Boating* see Charles S. Moffett, entry no. 140, *Manet: 1832–1883*, 359.

29. Rewald, *Impressionism*, 286–87.

30. Théodore Duret, *Renoir*, trans. Madeleine Boyd (New York, 1937), 35–36.

31. Rewald, *Impressionism*, 355. A portrait of Choquet, dated c. 1875, is in the Fogg Art Museum.

32. Moffett et al., *New Painting*, 206.

33. Emile Zola, "Le Messager de l'Europe" [Saint Petersburg], June 1876, quoted in ibid., 185.

34. Georges Rivière, *L'Impressioniste*, 6 April 1877, quoted in ibid., 237.

35. Duret, quoted in *Renoir; A Retrospective*, ed. Nicholas Wadley (New York, 1987), 120.

36. J.-K. Huysmans, "The Salon of 1879," *L'Art Moderne* (Paris, 1883), quoted in ibid.

37. Richard Brettell, *French Impressionists* (Chicago, 1987), 68.

38. François Daulte, *Auguste Renoir: catalogue raisonné de l'oeuvre peint*, vol. 1, *Figures, 1860–1890*, (Lausanne, 1971), 207, 208.

39. F.-C. de Syène, "Salon de 1879," *L'Artiste*, 1 July 1879, 11. "Le talent attire le talent; et c'est a qui, parmi les portraitistes, peindra Mlle. Jeanne Samary: elle nous apparait une seconde fois emergeant de la palette irisée de M. Renoir. Une autre toile ou l'ex-intransigeant mais infatigable impressioniste fait jouer les nuances les plus chatoyantes du prisme, nous montre Mme. G.C. et ses enfants: la famille d'un editeur connu du monde entier et aime de tous les gens de lettres."

40. Michel Florisoone, "Lettres Inédites: Renoir et

la Famille Charpentier," *L'Amour de l'Art* (Paris), no. 1 (February 1938), 35.

41. Anne Distel, *Impressionism: The First Collectors, 1874–1886*, trans. Barbara Perroud-Benson (New York, 1989), 160–62.

42. M. Bérard, "'Lettres à Un Ami' (Lettres de Renoir a Paul Bérard)," *La Revue de Paris* (December 1968), 54.

43. House et al., *Renoir*, Chronology, 299–300.

44. Bérard, "Lettres à Un Ami," 54. In addition to the two letters to Bérard is a brief letter to Georges de Bellio, a collector of Impressionist works, from Renoir, "chez Madame Fournaise dans l'île de Chatou." In it Renoir makes a passing reference to his painting, which has detained him from coming to Paris. This undated document is in the collection of the Institut Néerlandais, Paris.

45. Ibid.

46. Ibid. "Je suis obligé de travailler encore à ce maudit tableau à cause d'une cocote de la haute, qui a eu l'imprudence de venir à Chatou et de vouloir poser, ca m'a coûté quinze jours de retard et bref, aujourd'hui je l'ai effacé et . . . je ne sais plus ou j'en suis, sinon de plus en plus agacé. Deudon qui devait venir me voir n'a pas montre son nez et je n'ai vu personne depuis votre voyage. Je ne sais pas si Effrussy [sic] est de retour, je sacrifie encore cette semaine puisque j'ai tout fait et je reprendrai mes portraits. . . . Quand je pourrai partir je n'en sais rien et je n'ose vous fixer d'époque. Je pense d'être encore obligé de retarder et si je continue vous serez revenus avant moi. J'aurais cependant aimé aller revoir la mer avant l'hiver. Enfin tout n'est pas perdu et je vous ecrirai la semaine prochaine. J'espère enfin que j'aurais terminé."

47. Distel, *First Collectors*, 160–62.

48. "A French Poet in Imperial Berlin," *Apollo* 106, no. 186 (August 1977), 88–97.

49. Ruth Berson, "1874: Un Parcours Critique" (unpublished manuscript), 1.

50. Moffett et al., "The Seventh Exhibition 1882," *New Painting*, 413. Alexandre Hepp, in *Le Voltaire* (3 March 1882), seems to misidentify Ephrussi, writing, "We see the hero of the feast, who looks like M. Ephrussi."

51. Distel, *First Collectors*, 245, 249.

52. House et al., *Renoir*, 294.

53. John Rewald, "Auguste Renoir and His Brother," *Studies in Impressionism* (New York, 1985), 10.

54. Jean Renoir, *Renoir, My Father*, trans. Randolph and Dorothy Weaver (Boston, 1962), 208.

55. Daulte, *Renoir, Figures*, vol. 1, cat. 242, 243, 278, 301, 327, 331, and 332.

56. In fact, John Rewald (*Impressionism*, 356), who identifies only a few of the models in the painting, writes that Angèle is the woman in the lower right section of the painting, talking to Caillebotte, but both Daulte (*Renoir, Figures*, 379) and Meier-Graefe believe that the figure drinking is Angèle, and both Daulte and Jean Renoir (*Renoir, My Father*, 211) state that the woman in the lower right is Ellen Andrée. It is possible that Renoir used photographs while he worked on the painting, but there is no clear evidence that he did.

57. *Le Temps*, 30 July 1880. On 19 September 1880 an article in *Le Temps* announced the opposition of M. and Mme. Lagarde to their son's marriage to Samary (Archives, La Comédie-Française, Paris). (I am especially grateful to Alexandra Ames, who, during the summer of 1995, conducted research on this project in numerous archives in and around Paris, including the Comédie-Française, the Bibliothèque Nationale, the Caisse nationale des monuments historiques, the Musée de l'Ile de France, Sceaux, and elsewhere.)

58. Florisoone, "Lettres Inédites," 35.

59. Rewald, *Impressionism*, 327.

60. Edmond de Goncourt, *Antoine Watteau, Vie et Oeuvre* (Paris, 1875).

61. Edmond and Jules de Goncourt, *French XVIII Century Painters*, reprint (New York, 1948), 51, 52. That Manet was equally familiar with Watteau's work seems inevitable, and Watteau's *Déjeuner en plein air* (Museum of Berlin) seems to be a direct antecedent to Manet's *Déjeuner sur l'herbe*. Regarding Monet's favorite painting, Watteau's *Pilgrimage to Cythera*, see Paul Hayes Tucker, *Monet in the '90s* (Boston, 1989), 136–37.

62. Richard Thomson, "Les Quat' Pattes, The Image of the Dog in Late Nineteenth Century French Art," *Art History* 5, no. 3 (September 1982), 328–29.

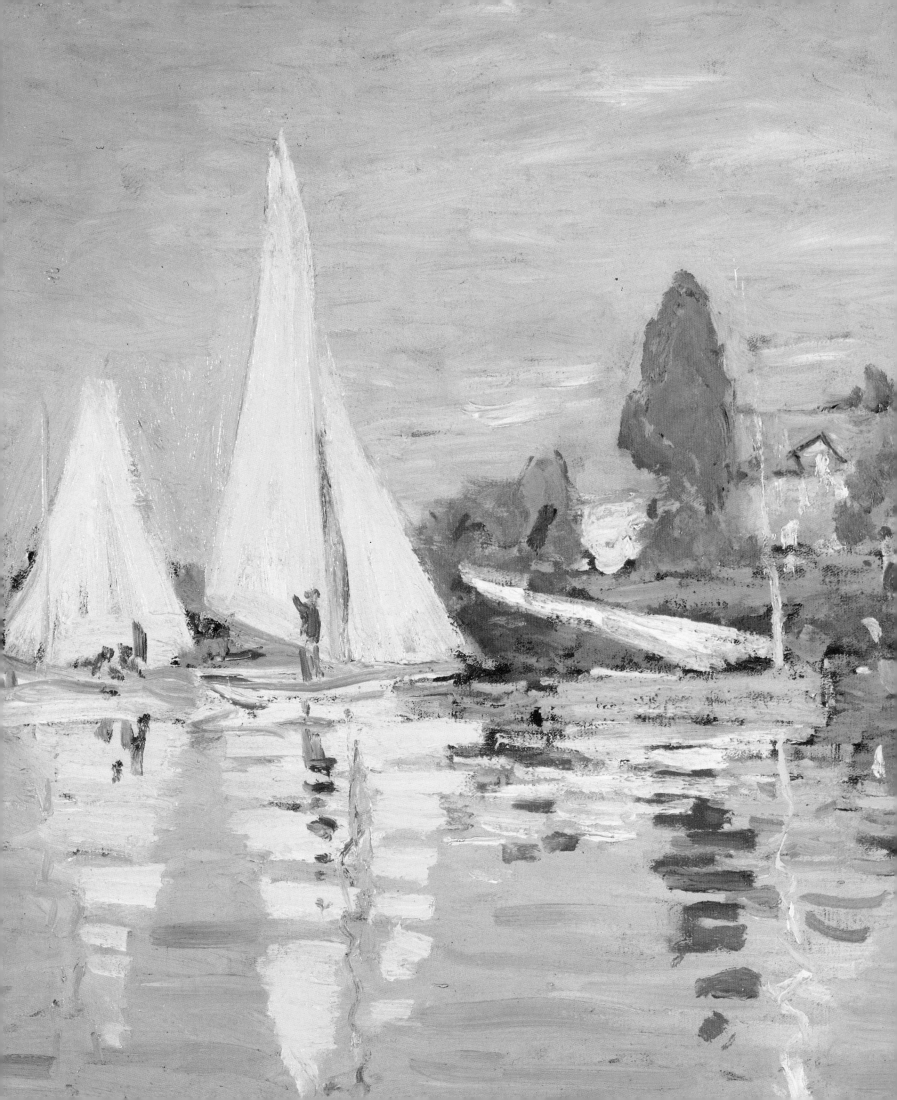

From Argenteuil to Bougival

Life and Leisure on the Seine, 1868–1882

Katherine Rothkopf

[The Seine] *is the great street of a capital with Rouen and Le Havre as its suburbs, the swift passageway that begins at the Arc de Triomphe de l'Etoile and ends at the ocean.*[1]

When one thinks of the quintessential Impressionist landscape paintings from the 1870s, images of blue skies, puffy clouds, river views, and figures in the landscape inevitably appear. Although the artists featured here were distinctly varied in their background, style, technique, and success, their common interest, at one time or another, was depicting the Seine in the western suburbs of Paris. Two important questions immediately come to mind: Why were the Seine and boating a popular subject for the Impressionists? And how did each artist incorporate these themes into his or her paintings of the period?

From 1868 to 1882 Claude Monet, Pierre-Auguste Renoir, Berthe Morisot, Alfred Sisley, Camille Pissarro, Gustave Caillebotte, and Edouard Manet were all inspired to paint along the banks of the Seine west of Paris. For some of these artists, such as Morisot or Manet, working along the banks of the river was a temporary break in their oeuvres that focused primarily on urban leisure and figure painting. For others, such as Monet, Pissarro, and Sisley, whose careers were devoted to landscape painting, the Seine provided innumerable subjects.

Despite the negative criticism their paintings often received in the Salons of those years, as well as in the eight Impressionist exhibitions, their depictions of leisure were not completely revolutionary. Landscape painting had a long and distinguished history in France, and by the 1860s the Salons were dominated by landscape paintings.[2] The Impressionists were tremendously influenced by their predecessors, particularly the Barbizon painters, and they wanted to produce art that would appeal to a middle-class audience. Their contribution to the history of art as a whole came from their revolutionary brushwork, their dependence on painting *en plein air*, their bold use of color, and their interest in depicting contemporary life. They searched for a new type of painting that would reflect their

Claude Monet, *The Regatta at Argenteuil*, c. 1872 (detail of pl. 12)

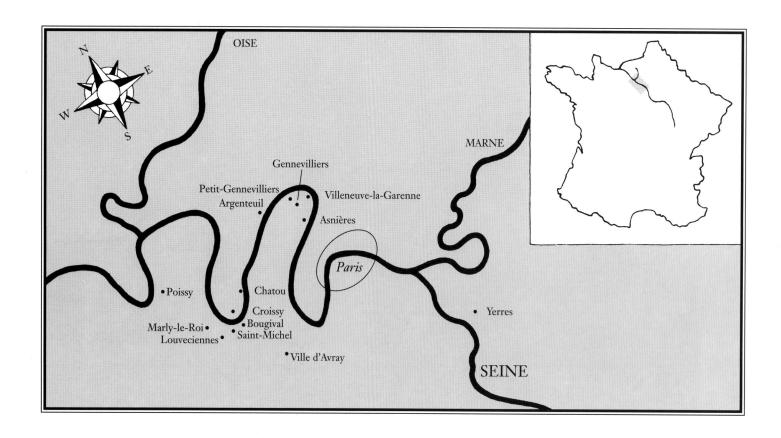

Map of France highlighting the Seine from Poissy to Yerres.

time and would provide them with greater knowledge of the world in which they lived. Drawn to the Seine for different reasons, each found the river, as a focus of contemporary life and sport, compelling in individual ways.

The sport of boating in France was first introduced by the British in the 1830s. Soon thereafter, rowing and sailing clubs began to appear along the banks of the Seine, and the French quickly became enthusiastic competitors. Boating was initially considered a privileged pastime, with only the very wealthy being able to join boating clubs and to purchase boats. By the 1870s, however, it became much easier to become a member of one of these formerly "exclusive" boating clubs, and taking a weekend trip to the suburbs to rent a boat on the Seine became an increasingly popular activity. Thus, by documenting the new and exciting sport of boating, the Impressionists painted hundreds of works that illustrated a new chapter in the social history of France.[3]

Towns along the Seine west of Paris appealed to these artists for several reasons. The Seine itself had long been a major source of inspiration to artists, and the effect of the river that neatly divides Paris in half was not lost on the Impressionists. Monet and Renoir both painted cityscapes of the quays and bridges spanning the Seine in the late 1860s and early 1870s (fig. 28; see also Monet, *The Quai du Louvre*, 1867 [fig. 48] and Renoir, *The Pont des Arts*

[c. 1867–68; fig. 63]), and Morisot followed suit with her sweeping panorama of Paris seen from the Trocadero of circa 1871–72 (pl. 7). Monet's inspiration may have come from his friend Johann Barthold Jongkind, who had been painting traditional views of Paris for more than twenty years.[4] The influence of Camille Corot's city views of Rome and Paris on Monet's paintings from 1867 has also been noted.[5] Once Monet and Renoir moved west to Saint-Michel and Louveciennes in 1869, their interest in painting the great river continued in a more suburban environment.

The development of an artist colony in the towns to the south and west of Paris was hardly unprecedented. Corot had worked in Ville d'Avray and Sèvres,

28. Pierre-Auguste Renoir, *The Pont Neuf*, 1872, oil on linen, 29 5/8 × 36 7/8 in. National Gallery of Art, Washington, D.C., Ailsa Mellon Bruce Collection.

29. *Bal des Canotiers*, c. 1890, poster. Courtesy of the Musée Fournaise, Chatou.

and Charles Daubigny had painted at Auvers-sur-Oise. Unlike Corot and Daubigny, who were in search of quiet and idyllic locations in which to commune with the natural world, the Impressionists chose to live and work in locations where industry was becoming a part of the landscape.[6] The suburban towns of Bougival, Argenteuil, and Chatou attracted these struggling artists because of their low cost and convenience: these towns were much less expensive than living in Paris, and they were easily accessible by train. One could board a train at Gare Saint-Lazare and arrive in Bougival in twenty minutes. Trains ran at frequent intervals from early in the morning until late in the evening. This proximity to the city provided an inexpensive alternative for Monet, Renoir, Sisley, and Pissarro, all of whom had financial difficulties in those years. By living in the Parisian suburbs, they could easily rent studio space in Paris and remain in contact with patrons and dealers in the city.

As Robert Herbert has discussed, the suburbs west of Paris developed quickly during the 1850s and 1860s.[7] The expansion of the railroads allowed the suburban towns of Asnières, Argenteuil, Bougival, and Chatou to grow substantially.[8] Industry, tourism, and leisure activities expanded into the countryside and became an important part of the landscape, later providing interesting motifs for the Impressionists. Parisians began to travel to the nearby suburbs for weekend entertainment, and soon cafés, *guingettes* (taverns), and establishments for boating and swimming appeared on the banks of riverside towns.[9] During these weekend trips, city dwellers found numerous forms of entertainment available, including sailing, rowing, dancing, swimming, and music. All of these attractions were publicized in journals and newspapers, and these towns were soon crowded with pleasure-seekers every weekend (fig. 29).

Travel guidebooks appeared on the market as tourism became increasingly popular. Adolphe Joanne's *Les Environs de Paris illustrés*, initially published in 1856, was the first major guide of the period. Organized by railroad lines, it featured systematic tours of the region.[10] *Paris Guide par les principaux écrivains et artistes de la France*, published in 1867 in conjunction with the Exposition Universelle, featured this description of the pleasures of the Seine in the Ile de France. "Are you an intrepid hiker? . . . Does the bright sunshine invite you into the fields? And do you want to get to know the most picturesque and the richest region in all the environs of Paris, one [that is] justly praised? If so, get up early in the morning and go to Bougival, and after a big lunch on the banks of the river, proceed to Marly-le-Roi by the road through Louveciennes, the route of schoolboys."[11]

The widespread interest in pleasure boating in France began in the 1850s

and first appeared in the town of Asnières.[12] The town competed with its neighbors for tourists by holding festivals and providing entertainment similar to that available in Paris, namely, dancing, eating, drinking, and flirting. Asnières began to grow exponentially, and by the late 1860s it had become too large and urban to be considered part of the countryside.[13] While Asnières began to lose its popularity, other towns in the Ile de France soon became preferable to Parisians, most particularly Bougival, Chatou, and Argenteuil.

From the start Bougival was generally preferred to Asnières because, despite its rapid growth, it was able to maintain its rich historical past and rural flavor. As it grew in popularity and size, the new buildings that were constructed retained some of the elegance of Bougival's past (fig. 30 and pl. 4).[14] The town was best known as the home of La Grenouillère, the restaurant, dance hall, and boat rental establishment that was painted several times by Monet and Renoir during the summer of 1869. La Grenouillère was actually located on Croissy Island, across a

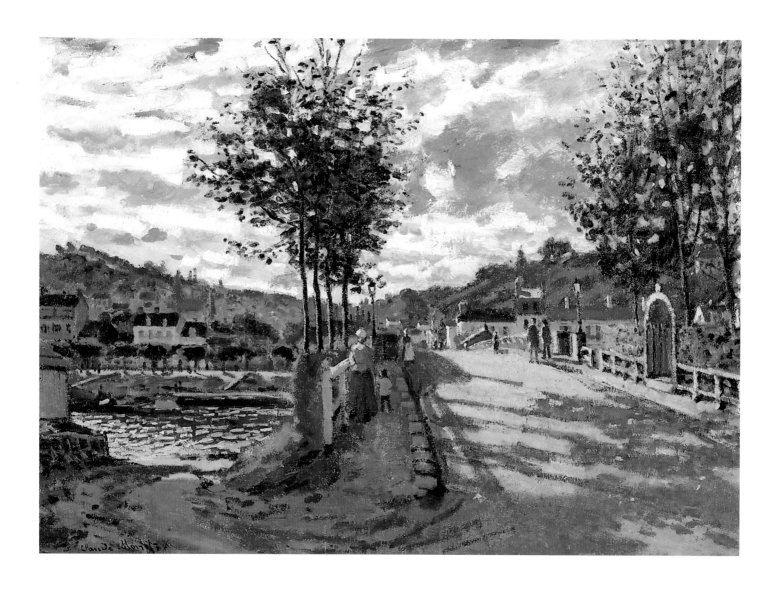

31. Claude Monet, *The Seine at Bougival*, 1869, oil on canvas, 25 3/4 × 36 3/8 in. The Currier Gallery of Art, Manchester, New Hampshire, Currier Funds, 1949.1.

small bridge from Bougival (fig. 31), and it was regarded as the most popular, noisiest, and wildest bathing house in the region. Even Emperor Louis-Napoleon and his wife Eugénie visited during the summer of 1869. Its owner, M. Seurin, ingeniously provided his guests with everything they desired—food, drink, bathing costumes, changing rooms, and boats and cabins to rent.[15] A contemporary engraving by Dominique Yon provides an accurate depiction of the activities available at La Grenouillère, including swimming, sunbathing, and boating (fig. 32). An account published on 20 June 1868 in *L'Evènement illustré* describes it in great detail. "La Grenouillère is Trouville on the banks of the Seine, a meeting place for the noisy, well-dressed crowds that emigrate from Paris and set up camp in Croissy, Chatou, or Bougival for the summer. . . . Boats are moored all around the island, and the boaters, men and women alike, lie asleep in the shade of the great trees. . . . Each group, elegant, select, artistic, or

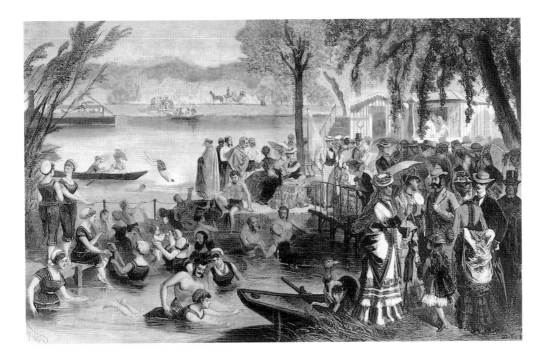

32. (Left) Dominique Yon, engraved by Miranda, *La Grenouillère*, 1873, wood engraving from *L'Illustration*, 16 August 1873, 112–13. Courtesy of the Musée Fournaise, Chatou.

33. M. Grenier, *Course du championnat de France dans le bassin d'Argenteuil*, 1886, wood engraving. Bibliothèque Nationale, Paris.

aristocratic, is made up of people who live or own property in the vicinity."[16]

Argenteuil was also a popular weekend destination. Its main attraction for tourists—sailing—was more specific to it than to Bougival. Due to the width of the river in Argenteuil, thousands of Parisians took the train there to see or to participate in the numerous regattas that were held during the warm months. By the late 1850s Argenteuil housed the headquarters of the Cercle de la Voile de Paris on the banks of its basin.[17] In 1867 the Exposition Universelle held its international sailing competition at Argenteuil, which secured the site's reputation as a center for regattas.[18] Its appeal as a weekend destination can be seen in an engraving from 1886 entitled *Course du championnat de France dans le bassin d'Argenteuil*, which shows all the delights Argenteuil had to offer visitors—rowing, sailing, and promenading (fig. 33).

In the same way that Argenteuil was known for its sailing, Chatou was respected for its rowing, and it soon replaced Asnières as the center for pleasure boating along the river. Parisians flocked to the shores of the Seine in Chatou to indulge in the pastime of paddling. As the railway lines extended into the countryside, the small village increased in size to accommodate the new bourgeoisie who wanted to live in the country and work in the city.[19] Renoir himself provides the most telling descriptions of life in Chatou, where he began to visit in the mid-1870s and produced numerous figure paintings and riverscapes that have been identified as Chatou. While there, he frequented the Restaurant Fournaise and

came to know the owner and his family. Renoir painted their portraits and often traded paintings for lodging and food. The Restaurant Fournaise, best known as the setting for Renoir's *Luncheon of the Boating Party*, was also the site of other figure paintings by Renoir, including *Two Sisters (On the Terrace), (Sur la terrasse;* pl. 58) and *Alphonsine Fournaise* (Musée d'Orsay, Paris).

Perhaps most important, the Impressionists found these riverside towns appealing because they provided interesting subjects. The middle-class patrons of the boat rental houses, restaurants, dance halls, and cafés provided fascinating images of contemporary life in the nineteenth century. In addition, these towns contained compelling landscapes, from a quiet idyllic meadow to the busy, congested river traffic on the Seine.

Significantly, the Impressionists did not merely document the landscape around them. Many of them included signs of industrial growth and integrated factories and smokestacks into their river scenes. These sites, however, were not idyllic villages but modern towns with all of the problems of contemporary life. In fact, the sewage system of Paris emptied into the Seine near Argenteuil and Petit-Gennevilliers and must have been quite offensive.[20] Nevertheless, the thrill of escaping the city for a weekend jaunt on the river seems to have outweighed any unpleasantness caused by the sewage.

By the 1870s the Impressionists started to frequent the towns where the bourgeoisie took their vacations. They often spent their summers in riverside villages in the environs of Paris. Manet's family owned a house in Gennevilliers, Caillebotte and his brother bought property in Petit-Gennevilliers in 1881, Renoir's family lived in Louveciennes and he spent a considerable amount of time in Chatou, Morisot and her family rented a house in Bougival during the early 1880s, and Monet consistently lived in Argenteuil from 1872 to 1877.[21]

Monet is the Impressionist who is most closely identified with the Seine. He spent much of his childhood in Le Havre, where the Seine meets the Atlantic Ocean, and he seemed to gravitate toward the water for the rest of his life. Always interested in landscape painting, the Seine provided Monet with infinite possibilities, and he produced more paintings of the Seine than any of his fellow Impressionists.

His first major painting that depicts the river is *On the Bank of the Seine, Bennecourt (Au bord de l'eau, Bennecourt;* pl. 1). In this work Monet places Camille, his future wife and the mother of his son Jean, in the landscape on the banks of the river. The idyllic scene obscures the true circumstances of their visit to the

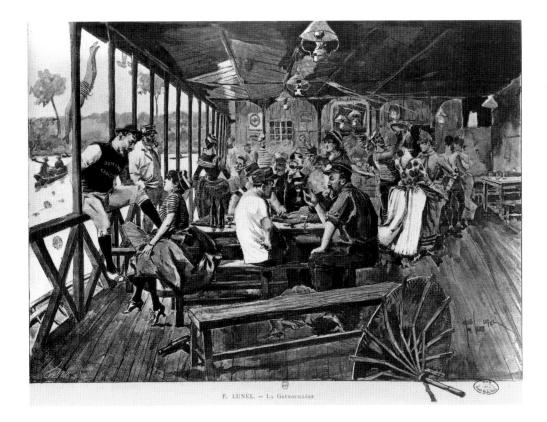

F. LUNEL. — La Grenouillère

34. Ferdinand Lunel, engraved by Eugène Louis Gillot, *Interior of the Pontoon at La Grenouillère*, 1885, wood engraving. Courtesy of the Musée Fournaise, Chatou.

area. After having conducted a secret liaison with Camille for two years, Monet had recently told his parents of his true relationship with her. Much to their disappointment, in May of 1868 Monet moved with his new family to an inn at Bonnières-sur-Seine that had been recommended by Emile Zola. By 20 June, Monet, Camille, and Jean had been evicted from the inn due to lack of payment, and they temporarily moved to Le Havre.[22]

Monet returned to the Ile de France during the summer of 1869, where he was lived in the village of Saint-Michel, not far from Bougival. Renoir was living nearby, and he and Monet often visited La Grenouillère (fig. 34). Monet wrote to his friend and fellow artist Frédéric Bazille on 25 September 1869 about his work in Bougival: "I do have a dream, a painting, the baths of La Grenouillère for which I've done a few bad rough sketches, but it is a dream. Renoir, who has just spent two months here, also wants to do this painting."[23]

The works that were produced that summer are celebrated today as marking a decisive stage in the history of Impressionism, as Monet and Renoir experimented for the first time with a very bright palette and rapid, broken brushstrokes. Monet originally intended to paint a Salon picture of a contemporary place and time, and La Grenouillère, which was well known in 1869, was the perfect location for him to fulfill his "dream."

35. *The Highway Bridge at Argenteuil*, late nineteenth century, photograph. Bibliothèque Nationale, Paris.

Six known pictures of La Grenouillère, with three by Monet and three by Renoir,[24] have been the subject of much discussion. It is uncertain whether the remaining works by Monet are all the "sketches" to which he refers in his letter to Bazille, or whether one of them is actually the finished Salon painting that he wanted to produce.[25] It has also been proposed, however, that Monet submitted to the Salon of 1870 the painting of La Grenouillère that was formerly in the Arnhold collection, but it was then rejected by the jury.[26] Despite these varied interpretations, it seems evident from the revolutionary technique and lack of finish—a characteristic of Impressionist painting deplored by many critics—that Monet could not have considered these works appropriate for the Salon. In the end, perhaps due to financial constraints, Renoir and Monet abandoned their interest in producing a "Salon" version of La Grenouillère.

Monet left the region in the winter of 1869 and did not return until after his trip to London and Holland during the Franco-Prussian War. When he returned to Paris in the fall of 1871, he was most certainly dismayed to see the incredible destruction that had been inflicted upon the city. Many of the great landmarks of Paris had been demolished during the war and the Commune, including the Hôtel de Ville, the Palais Royale, and the Palais de Justice.[27] By December of 1871 Monet and his family had relocated to Argenteuil, where the artist spent seven very productive years. It seems likely that Manet, whose family lived across the river in Gennevilliers, recommended Argenteuil to Monet and may have helped him find his first house.[28]

Upon his arrival in Argenteuil, Monet was immediately inspired to paint. He had produced little while abroad, and during his brief period in Paris during the fall of 1871 he had only painted one picture, *The Pont Neuf* (Dallas Museum of Art). In fact, he produced almost as many works during his first year in Argenteuil as he had in the three years while he and his family were in Saint-Michel, London, and Holland.[29]

Argenteuil had been seriously damaged during the war; its factories were closed and the highway bridge and the railway bridge were both destroyed.[30] Monet was clearly inspired by the process of recovery in Argenteuil. One of the most important examples of his fascination with the rebuilding of the town is *The Highway Bridge under Repair, Argenteuil (Le pont de bois;* pl. 14). Covered in wooden scaffolding, the bridge is perfectly reflected in the still river. Although the bridge is not yet completely reconstructed, it is already being used by tourists and locals alike. Here, Monet first addressed one of the major themes of life in Argenteuil that occupied his art for the next seven years: the relationship between

Le Pont du Chemin de Fer *Argenteuil, le*

leisure and industry in the suburban countryside. In this painting he also added the drama of the bridge as a symbol of the healing of France after the end of the Franco-Prussian War.

Monet's interest in the bridges of Argenteuil grew during the 1870s, and he included both the railway bridge and the highway bridge in numerous compositions from this period. The bridges appealed to him in part because they symbolized the town's progress and modernization (fig. 35). When compared to other images of bridges by Pissarro or Corot, Monet's works are notable for the respect he gave to the design of the bridge itself and for the pictorial structure that the motif provided in these compositions. In *The Railroad Bridge at Argenteuil (Le pont du chemin de fer à Argenteuil;* fig. 37 and pl. 23), Monet includes all the details of its very modern design as it cuts across the painting, emphasizing the importance of progress and industry in Argenteuil.[31] In this very positive image of the town, the smoke from the moving train merges with the clouds above.

Nowhere is Monet's intention to celebrate the progress of modern France more evident than in *Railroad Bridge, Argenteuil* of 1874 *(Le pont du chemin de fer, Argenteuil;* pl. 34). He combines the deep dramatic perspective of the train in motion as it speeds through the landscape with the single sailboat moving at full force in the river. When compared to a vintage postcard of the same bridge (fig. 36), it is obvious that Monet carefully chose his view of the bridge. He does not include the smokestacks or the factory smoke that are apparent in the photo-

36. *The Railroad Bridge at Argenteuil,* late nineteenth century, postcard. Collection Viollet, Paris.

37. Claude Monet, *The Railroad Bridge at Argenteuil,* 1873. Private collection (pl. 23).

38. Theodore Weber, *Environs de Paris—Argenteuil*, 1869, wood engraving. Bibliothèque Nationale, Paris.

graph; instead he limits the industrial images to the bridge, the train, and its smoke. Again, Monet edits the landscape and provides his own image of Argenteuil.

Unfortunately, the townspeople of Argenteuil did not share his enthusiasm for the railway bridge. When the bridge was opened in 1863, an event that gradually changed the town from a rural to an industrial area, the public was dismayed at the simplicity of its design. "Instead of an elegant construction of grandiose or bold forms, there is only a heavy and primitive work which is not at the level of the progress of science. Instead of those gracious constructions on which wagons and machines slide onward to discovery, they made a wall of iron that is impenetrable to the eye. . . . It is a tunnel without a roof."[32]

Monet found Argenteuil to be a pleasant place to live for several reasons. In a letter to Pissarro dated after his move, Monet wrote that he intended to commute to and from his studio in Paris each day at 10 A.M. and 4 P.M.[33] Argenteuil was quickly changing from country town to suburb, and both its rural sections and its heavily industrial areas appealed to Monet. Within a short walk he could see the commercial river traffic and the railroad bridge as well as a peaceful and idyllic meadow. He seemed most fascinated with scenes that provided interesting juxtapositions and contrasts of rustic village and growing suburb, work and leisure, modernity and an eternal past. Along the banks of the Seine in Argenteuil, Monet found a wealth of motifs with these themes which he investigated enthusiastically for seven years.[34]

Approximately 175 known paintings by Monet are of Argenteuil, and 75 of them depict the boat basin next to the highway bridge and the area downstream.[35] His boating paintings can be divided into three categories: views of the Petit Bras, the boat rental area, and the basin. The Petit Bras, a small "arm" of the river, was approximately one and a half kilometers from the highway bridge and surrounded a tree-lined island called the Ile Marante. This area was often used as a mooring place for boats that were too large to keep at the boat rental area, and Monet seemed to regard it as a refuge from the hustle and bustle of the river (pl. 20). The boat rental area, located along the south bank of the river facing Argenteuil, could hold as many as two hundred sailboats and rowboats at any given time (pls. 25 and 39). Most of the sailing competitions took place there due to the depth and width of the river in the basin. Promenades on both banks of the river afforded spectators a wonderful view of the races (pls. 15 and 17).[36] These three areas in Argenteuil allowed Monet to explore completely different views of one theme—leisure and boating on the river.

39. Claude Monet, *Argenteuil Basin*, 1874, ink sketch on paper. Musée Marmottan, Paris.

One of the most curious aspects of Monet's images of boats and the Seine is his apparent lack of interest in depicting the sport of boating itself. Although he chose to live in a town that was renowned for its regattas and sailing, Monet depicted few boating races. In fact, according to Paul Tucker, regattas were held in the Argenteuil basin at least twice a month from late spring to fall, but Monet painted them infrequently (fig. 38; pls. 12 and 30).[37] He did undertake views of one or two boats under sail, but unlike Caillebotte or even Manet, he paid little attention to rigging or the actual workings of a sailboat (pl. 22). For Monet, the sailboat was simply a part of the landscape at Argenteuil.

Monet's interest in boating as subject matter may also have been affected by his acquisition of a floating studio in 1872, a purchase that may have been inspired by the studio boat of Charles Daubigny.[38] He depicted his studio in several paintings (pl. 35), and even Manet chose to paint a portrait of Monet aboard his beloved boat (fig. 43). With greater access to his subjects, Monet could complete a painting out of doors under the shaded protective canopy of the studio (fig. 39; pl. 25).[39] Another work that was most certainly painted from his studio boat is *Sailboat at Petit-Gennevilliers* from 1874 (*Voilier au Petit-Gennevilliers*; pl. 32). Monet was probably moored near the boat rental house when he painted this beautiful work, which delicately juxtaposes the leisurely

pleasure of boating against the industrial smokestacks in the far distance.[40]

Throughout his stay in Argenteuil, Monet often returned to the same locations for inspiration. Even when looking at a small selection of his paintings from this period, certain landmarks and buildings become recognizable parts of his personal landscape. From 1872 to 1875 the Château Michelet (fig. 40), located next to several factory smokestacks on the river's edge, appears in many of his works (fig. 41 and pl. 15; see also pls. 14, 25, 33, and 44). The Michelets apparently were a relatively wealthy family in Argenteuil. Emile Michelet served as a vice-president of the Cercle de la Voile de Paris and often competed against Caillebotte in regattas.[41] Another familiar motif in Monet's paintings of this period is a group of small red houses with a tall tree in Petit-Gennevilliers, located on the banks of the Argenteuil basin (pls. 12, 24, 30, 32, and 39). One painting featured here includes both the Château Michelet and the red houses in a view of the boat rental area and the Argenteuil basin (pl. 25). It has been stated that Caillebotte and his brother bought one of these red houses in 1881.[42] This suggestion becomes even more interesting when one considers that well before he moved there, Caillebotte already owned a Monet painting of Petit-Gennevilliers that prominently features the red houses (pl. 12).

After the first Impressionist exhibition was held in the spring of 1874, Monet

continued to paint images of Argenteuil. Unlike his previous works that harmoniously juxtaposed scenes of industry and leisure, his later paintings seem more concerned with depicting the town as a modern utopia. For example, the careful composition of *The Bridge at Argenteuil (Le pont routier, Argenteuil;* pl. 31) balances the deep perspective of the bridge with the foliage at right. The factory smokestacks evident in a contemporary postcard (fig. 61) do not appear in Monet's painting. Here, he is more interested in his role as creator, as the unexpected appearance of the mast in the foreground reasserts his role as the composer of the painting.[43]

During the summer of 1874 Renoir frequently visited Monet at his home in Argenteuil. As they had done four years earlier at La Grenouillère, Monet and Renoir worked side by side and painted views of the river. A pair of paintings from that summer—Monet's *Sailboats at Argenteuil (Canotiers à Argenteuil;* pl. 29)

41. Claude Monet, *The Promenade along the Seine*, 1872. Private collection (pl. 15).

and Renoir's *The Seine at Argenteuil (La Seine à Argenteuil*; pl. 28)—seems at first glance to be even more similar than their earlier collaborative works at La Grenouillère. Both paintings have comparable compositions, broken brushstrokes, and brilliantly contrasting palettes. On closer examination, however, their inherent differences become clear. Monet's version includes two boats under sail and, in one of his rare views of a boating competition in the Argenteuil basin, two skiffs in the midst of a close race. Renoir depicts a calmer and more leisurely view of the river, with more attention directed to the contrasting colors and atmospheric effects. The summer of 1874 was the last time Monet and Renoir worked together, and afterward they independently developed their individual styles.

After 1875 Monet's views of Argenteuil became more bucolic and tranquil. His earlier paintings, although never strict documentary accounts of the Seine, provide a relatively realistic view of life in Argenteuil. The artist's later works eliminated all signs of encroaching modernization and concentrated instead on the town's pleasurable activities. *Red Boats, Argenteuil (Les bateaux rouges, Argenteuil*; pl. 44), for example, is a virtual advertisement for the attractions available to tourists visiting the town. Monet creates a spectacular view of Argenteuil on a sparkling day, with sailboats and rowboats floating on the brilliant blue river.

After moving to Vétheuil in 1878, Monet never again included references to the progress and industrial advances of the nineteenth century. His work from that point on focused on beautiful and pristine landscapes as he moved farther from Paris.

From the very beginning Renoir was uncertain about which direction to take as an artist, whether to be a landscape or a figure painter. The late 1860s and early 1870s were his most experimental years, and he freely tried all types of painting, including still lifes, landscapes, and large figure painting. He was particularly influenced by Monet, with whom he worked in 1869 at La Grenouillère on his first serious attempt at landscape painting in the Ile de France. Even in those early paintings Renoir's successful future as a figure painter is anticipated.

Although Renoir's family lived in Louveciennes, he only sporadically traveled to the region to work. When Monet moved to Saint-Michel and Argenteuil in the late 1860s and early 1870s, Renoir was inspired to come to the area to paint with him. During the summers of 1869, 1873, and 1874, Renoir and Monet worked together, and their collaborations were a source of inspiration to them both.

After 1875 Renoir became a friend of the Fournaise family in Chatou, where he traveled to paint figures, landscapes, boating scenes, and portraits. His great interest in the subject matter of rowing, sailing, and leisure can be seen in numerous paintings from the 1870s, in which he reviews the experiences that constituted a visit to Chatou, including the train ride from Paris *(The Railroad Bridge at Chatou [Le pont du chemin de fer à Chatou]*; pl. 53), renting a boat for leisurely rowing *(Oarsmen at Chatou [Les canotiers à Chatou]*; pl. 56), boating on the river *(Boating on the Seine [La Seine à Asnières*, called *La Yole]*; pl. 41), and eating and socializing *(The Rowers' Lunch [Le déjeuner au bord de la rivière]*; pl. 40) and *Luncheon of the Boating Party [Le déjeuner des canotiers]*; pl. 60).

Alfred Sisley was equally inspired by the Seine during the 1870s. He and his family lived in Louveciennes until 1874 and then in Marly-le-Roi until the fall of 1877.[44] In the winter of 1872,[45] Sisley often painted with Monet in Argenteuil, where he produced a group of paintings that document his observations of the town and its riverbanks. Despite the general similarity in subject matter and style, his views of the Seine differ from those of Monet. Sisley's serene and subtle compositions place greater emphasis on the sky and the water than on any overriding theme of modernity or progress (pl. 13).[46] He was interested in depicting riverside towns that were centers of both industry and recreation, but he primarily focused on the effects of nature itself. From the beginning of his career Sisley concentrated solely on landscape painting.

While living and working in the Ile de France, Sisley devoted himself primarily to depicting scenes of ordinary life, such as images of local townspeople at work (pl. 9). Sisley, however, did not depict new, modern business in Argenteuil, but rather premodern industries that potential patrons would consider picturesque. On occasion he presented images of pure leisure (pls. 8 and 18), but unlike Monet he did not routinely juxtapose progress and pleasure in his paintings of the Seine.[47] Sisley's interest in boating was almost exclusively focused on the economic life of the Seine, and he often included barges, ferries, and tugboats in his paintings.[48]

Bridges were an important subject for the Impressionist painters, both for their aesthetic and architectural qualities within a composition and for their significance as symbols of economic growth and progress in these small towns. In his painting *The Bridge at Villeneuve-la-Garenne (Le pont de Villeneuve-la-Garenne)*; pl. 16), Sisley focuses on the bridge itself, introducing a dramatic viewpoint that

Bougival (S.-et-O.) — Les Machines de Marly

42. *The Machine at Marly*, 1905, photograph. Bibliothèque Nationale, Paris.

shoots into the composition. As Robert Herbert points out, the small figures in the landscape suggest the town's local economy, from the tourists in the rowboat who are being guided by a boatsman to the villagers standing on the riverbank.[49]

In 1875 Sisley turned his attention to the towns of Port-Marly and Marly-le-Roi on the left bank of the Seine near Bougival. Boating was an essential part of his fascination with the river, and throughout the 1870s Sisley investigated all aspects of river life. One of the most unusual works from this period is *The Seine at Port-Marly, Piles of Sand (La Seine à Port-Marly—tas de sable*; pl. 45), in which Sisley concentrates on sand dredging, a process that removed sand from the bottom of the river to keep commercial traffic flowing freely from Paris to Le Havre. The dredged sand was then sold for use in construction and gardening. The rather documentary subject matter of this painting is offset by its brilliant combination of colors.[50] *The Seine at Port-Marly (Bords de la Seine à Port-Marly*; pl. 37) depicts the same activity in a calm rural landscape. Much like Monet's works painted from his studio boat, Sisley seemingly places the viewer in the water of an almost deserted

river (which, by all contemporary accounts, was an extremely rare occurrence), across from a tranquil and beautiful farm on the opposite bank.[51]

Sisley often chose motifs that included symbols of the past and the encroachment of modernity on the remants of the *ancien régime*. Similar to La Grenouillère, the park of the ruined Château de Marly at Marly-le-Roi was a popular tourist spot that was discussed in detail in contemporary guidebooks. Originally a country retreat of Louis XIV, the chateau had been destroyed during the French Revolution, and its deserted grounds attracted tourists in the nineteenth century. Sisley painted several paintings of the pools at the chateau during the late 1870s.[52]

The nearby water pumping station in Marly also fascinated Sisley as a motif in the 1870s (pl. 46). Renovated by Napoleon III in the late 1850s,[53] the station was able to pump over 12,000 cubic meters of water each day, and it was considered a technological marvel of its time (fig. 42).[54] Although it was another popular tourist attraction at the time, Sisley focuses his attention on the beauty of the architecture and the surrounding landscape, only occasionally including figures. In these works Sisley gives equal importance to the natural and manmade aspects of the French countryside.

Camille Pissarro was a founding member of the Impressionists and the only artist to participate in all eight of the Impressionist exhibitions. Like his fellow artists, he painted riverscapes of the Seine while he lived in Louveciennes for two short periods, from the spring of 1869 to September 1870, and from late 1871 to the summer of 1872. These two stays in the environs of Paris allowed Pissarro to depict suburban life for the first time.[55]

Upon his return from London after the Franco-Prussian War, Pissarro discovered that his home had been ransacked, and only 40 out of 1,500 paintings that he had stored during the war had been saved.[56] Thus, his surviving riverscapes from this period are almost exclusively limited to his stay in Louveciennes after the war. Because of the brevity of his stay there, this period in his oeuvre has been largely ignored in the literature.

From the beginning of his career in the 1850s, Pissarro dedicated himself to painting landscapes and rural scenes. This type of painting was popular with the urban bourgeoisie, who found that images of the countryside provided a sense of relief from the stress of urban life.[57] Even though the suburbs of Paris were quickly developing into larger industrial towns, Pissarro often ignored the mod-

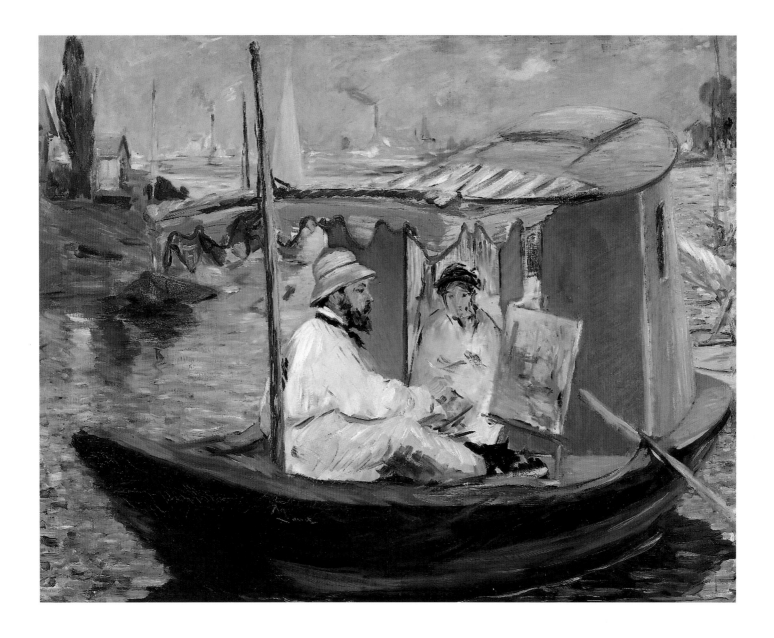

43. Edouard Manet, *Monet Painting on his Studio Boat*, 1874, oil on canvas, 31 ½ × 38 ½ in. Bayerische Staatsgemäldesammlungen, Neue Pinakothek, Munich.

ern aspects of Louveciennes and instead portrayed it as a picturesque rural town. Nevertheless, his emphasis on even the most mundane aspects of country life can still be considered part of the Impressionist idiom because they truly depict contemporary life in France.[58]

Upon his return to Louveciennes in 1871, Pissarro produced several canvases of the Seine. Unlike Monet's fascination with modernity, Pissarro's later paintings of this country town contain more subtle views of progress and industrialization in rural France. In *The Wash House, Bougival* (formerly called *Le lavoir, Pontoise*; pl. 10), Pissarro depicts the same town that Renoir and Monet featured in their paintings of La Grenouillère, yet he selected a dramatically different viewpoint. In fact, the popular and noisy bathing establishment was located only

one hunded yards from this calm and peaceful scene. Pissarro chose the traditional theme of washing clothes on the banks of the river and returned to his roots in French landscape painting with the Corot-like female figure who leans against a tree as she awaits her turn in the wash house. Three years later Sisley depicted the same location in his painting *The Seine at Port Marly, Piles of Sand* (pl. 45), but he omitted the smokestack from his view of the river. In his effort to concentrate fully on the many uses of the river, Pissarro includes the smokestack in the background as he contrasts the traditional, nonmechanized work of washing laundry by hand with the machines in the factory.[59]

Pissarro also explored the tensions that arose between leisure and labor in his works from Marly. In *The Seine at Port-Marly (La Seine à Port-Marly;* pl. 11) he presents various commercial uses of the river, with steamboats moored along the promenade. He depicts the tools on board and contrasts the men working on the ships with the middle-class figures who enjoy the river. In the background he has included the Machine de Marly, the pumping station that Sisley also depicted in several paintings (pl. 46).[60] After this short period in Louveciennes, Pissarro moved to Pontoise in 1872, where, like Monet in Argenteuil, he developed a special relationship with the town and its river, the Oise.

Although his family owned a house in Gennevilliers for many years, Edouard Manet seems to have painted on the Seine only during the summer of 1874. During this, one of the most important periods in the history of Impressionism, Monet, Manet, and Renoir painted side by side and succeeded in further developing their personal styles. Manet, who was not completely oblivious to the works of his younger colleagues Monet and Renoir, produced his first *plein-air* painting as early as 1870.[61] Upon his arrival in Gennevilliers, Manet was soon further convinced of the benefits of painting out of doors, and although the majority of his known works from that summer are figure paintings, Manet was tremendously influenced by the lighter palette and technique of his two colleagues. Manet's portrait of Monet working on his studio boat (fig. 43) offers the most vivid description of Monet's *plein-air* painting technique in action. In this breathtaking view of the artist and his wife on the floating studio, Monet is shown as both a painter and a sportsman, wearing a boater's straw hat while working on a landscape of the river and its banks. This Monet-inspired composition includes a panoramic view of the basin with the familiar red houses of Petit-Gennevilliers that appear in numerous Monet compositions from the period

44. Edouard Manet, *Claude Monet*, c. 1874, brush and India ink, 6 ¾ × 5 ⅜ in. Musée Marmottan, Paris.

(pls. 24, 25, and 32). An ink drawing by Manet from the Musée Marmottan also features Monet in a similar straw boater (fig. 44).

The summer of 1874 provided Monet, Manet, and Renoir with a unique opportunity to learn from one another. Manet produced several paintings that summer, and three of them have particular significance to the theme of boating and leisure on the Seine. Of course, Manet was primarily an urban painter who enjoyed depicting the mores and fashions of modern Paris. Since relaxation on the banks of the Seine had become a fashionable pastime, it was only

fitting that Manet would travel to Argenteuil to observe the chic crowd enjoying itself.

In both *Boating (En bateau;* pl. 27) and *Argenteuil* (fig. 9), Manet explored different aspects of the boating life in Argenteuil. In *Boating* he documented the actual act of sailing, with his brother-in-law Rodolphe Leenhoff posing as a sailor and wearing the costume of a member of the Cercle nautique boating club, which was located in Asnières.[62] In *Argenteuil,* Manet positioned a boatman and his female companion on the shore, before a backdrop of buildings and factories that identifies the location as Argenteuil. Visible just above the hat of the female figure is the Château Michelet, with a factory smokestack working at full capacity to its right. This chateau can also be seen in many of Monet's paintings from Argenteuil (pls. 15, 25, 33).

Monet's influence on Manet seems the most evident in *Banks of the Seine at Argenteuil (Bords de la Seine à Argenteuil;* pl. 26). The brushstrokes, color scheme, and subject matter clearly mark this as a Monet-inspired painting. Its style and subject are similar to Monet's *Promenade with the Railroad Bridge, Argenteuil (Au pont d'Argenteuil;* pl. 21), in which a woman and a child also stand at the water's edge with their backs to the viewer.

Berthe Morisot was only tangentially involved with boating on the Seine, but her participation in the group of artists known as the Impressionists merits special mention. Like her great friend and mentor Edouard Manet, Morisot was a true figure painter. As she wrote to her sister Edma in 1869, "landscapes bore me."[63] She was the only woman included in the first Impressionist exhibition, and she participated in all but one of the exhibitions held from 1874 to 1886.

Because Morisot, as a woman, was constrained by decorum, her subjects were more limited than those of her male counterparts. She came from a well-respected bourgeois family, and it was not considered appropriate for her to appear in certain public places, particularly when she was alone, much less pursue a career as a professional painter. One of Morisot's early art teachers wrote to her mother regarding this interest in painting, acknowledging that "they will become painters. Do you realize what this means? In the upper class milieu to which you belong, this will be revolutionary, I must say almost catastrophic."[64]

Best known for her depictions of women, particularly her female family members, in interior and outdoor settings, Morisot also investigated the Seine in several paintings from the 1870s and early 1880s. Her *View of Paris from the*

Trocadero (Vue de Paris des hauteurs du Trocadéro; pl. 7) shows a beautiful, silvery view of the capital as seen from Passy, the outlying section of Paris where Morisot and her family had lived since the early 1850s.[65] This wonderful cityscape can be compared to Manet's *World's Fair of 1867* (Nasjonalgalleriet, Oslo) in its similar motif and palette. In addition, her delicate technique was influenced by Corot, who served as her teacher during the 1860s.[66]

Although Morisot was quite interested in boats and leisure scenes, one of her most important boating images was painted away from the Seine. *Summer's Day* of 1879 (fig. 45), a dramatic view of boating on the lake in the Bois de Boulogne, appears to have been inspired by Manet's *Boating* of 1874. Both works place the viewer inside the vessel, and both offer a close-up view of weekend leisure on the water. Unlike Manet's painting, however, Morisot does not show the two women in the act of rowing, but instead places them on the ferry that transported visitors to the small islands in the lake.

Of course, Morisot painted views of boating on the Seine as well, with *Boats on the Seine (Bateaux sur la Seine;* pl. 51) being a delicate and sensitive sketch of life on the river. Like many of Monet's paintings from his period in Argenteuil, Morisot features only moored sailboats in this idyllic view of a riverside town. Although its date and location are undocumented, Robert Herbert has identified the site as the bridge at Villeneuve-la-Garenne, which Sisley had also painted in 1872 (pl. 16). Herbert assigned it a date of 1875, stating that Morisot visited the Manet family in Gennevilliers during that summer.[67] Even though it appears that Morisot and her family actually spent the summer of 1875 on the Isle of Wight,[68] the identification of Villeneuve-la-Garenne as the location is quite believable. When compared with Sisley's interpretation of the town and bridge, similarities appear in the architecture on the shoreline, most particularly in the building adjacent to the bridge. One of the main buildings in Morisot's painting contains the same patch of green as in Sisley's work, and although the building has been expanded on the left side in the Sisley work, it seems likely that this Morisot painting is a view of Villeneuve-la-Garenne.

Gustave Caillebotte is remembered today as a collector and supporter of the Impressionists and as an important painter in his own right. The wealthy young man used his resources to further the Impressionists' cause after he participated in the second Impressionist exhibition in 1876. As for his interest in boating as a subject matter for his paintings, sailing was a major part of Caillebotte's life, both

45. Berthe Morisot, *Summer's Day*, 1879, oil on canvas, 18 × 29 5/8 in. Courtesy of the Trustees of the National Gallery, London, Lane Bequest, 1917.

as a sportsman and an artist, for he was a serious competitor who designed, built, and raced his own boats in the 1880s.[69]

Caillebotte first painted views of the river that flowed past his family's house in Yerres, located southeast of Paris.[70] His boat paintings of the Yerres River are distinguished by their dramatic perspective, much like his contemporaneous urban views of Parisian streets and bridges. In *Oarsmen (Canotiers ramant sur l'Yerres*, 1877; pl. 48), a marvelous example of his boat paintings from this period, Caillebotte presents a close-up image of two figures actively rowing. By deemphasizing their faces, Caillebotte focuses attention on the physical exertion of the two men. Unlike Monet's works from Argenteuil, in which boats are generally shown at a great distance, Caillebotte's fascination with the physical act of boating is illustrated in his close observations.

After his mother died in 1878, Caillebotte and his brother Martial sold the house in Yerres, and by 1881 they had bought property in Petit-Gennevilliers, across the river from Argenteuil.[71] They were particularly attracted to this part of the Seine because it provided a wonderful area in which to sail, with the river

46. *Cercle de la Voile de Paris Regatta, 30 May 1880*, poster. Musée d'Argenteuil.

GRANDES RÉGATES INTERNATIONALES
A VOILES ET A VAPEUR
DONNÉES LE DIMANCHE 30 MAI 1880
Avec le concours de la Ville de Paris et de la Ville d'Argenteuil

BASSIN D'ARGENTEUIL (COMMUNE DE GENNEVILLIERS)

COURSES DE BATEAUX DE PLAISANCE A VOILES
DÉPART A 1 HEURE 1/2

1re SÉRIE. — Bateaux n'excédant pas 2 tx (guidon rouge).
1er prix : 100 fr. offerts par la ville de Paris et médaille d'argent. — 2e prix : 50 fr. offerts par la ville de Paris et médaille de bronze. — 3e mention : médaille de bronze.

Nos	NOMS DES BATEAUX	TONNAGE	PROPRIÉTAIRES
1	Galathée	1 9	MM. Taskin.
2	Écureuil	1 9	Schlatter.
3	Rubis	1 9	Michelet.
4	Jeune-André	1 8	Chalier.
5	Aquilon	1 8	Anquetin.
6	Seine II	2	Pinel.
7	Courlis	2	Thierry.
8	Fugitive	2	Ozanne.
9			
10			

2e SÉRIE. — Bateaux au-dessus de 2 tx et n'excédant pas 4 tx (guidon bleu).
1er prix : 100 fr. offerts par la ville de Paris et médaille d'argent. 2e prix : 50 fr. offerts par la ville de Paris et médaille de bronze. 3e mention : médaille de bronze.

Nos	NOMS DES BATEAUX	TONNAGE	PROPRIÉTAIRES
1	La Mouette	2 1	MM. Foulquier.
2	Condor	4	M. Caillebotte.
3	Hourrah	3 7	E. Albert.
4	Franc-Tireur	3 1	Paillart.
5	Iris	2 9	Camus.
6	Argus	3 4	Hébert.
7	Pierrot	3 2	G. Verbrugghe.
8			

3e SÉRIE. — Bateaux au-dessus de 4 tx et n'excédant pas 6 tx (guidon jaune).
1er prix : 100 fr. offerts par la ville de Paris et médaille d'argent. 2e prix : 50 fr. offerts par la ville de Paris et médaille de bronze.

Nos	NOMS DES BATEAUX	TONNAGE	PROPRIÉTAIRES
1	Albatros	5 9	MM. Leseure.
2	Le Dragon	4 8	Keittinger.
3	Lison	4 7	David.
4	Quille-en-Fonte	5 9	Giudicelli.

4e SÉRIE. — Yachts au-dessus de 6 tx (guidon vert).
1er prix : 100 fr. offerts par la ville de Paris et médaille d'argent. 2e prix : 50 fr. offerts par la ville de Paris et médaille de bronze.

Nos	NOMS DES BATEAUX	TONNAGE	PROPRIÉTAIRES
1	Rouge-et-Noir	50	MM. L. Verbrugghe.
2	Inès	8	G. Caillebotte.
3	Jupiter	10 3	Fraimbault.
4			

5e SÉRIE. — Yachts de mer à quille fixe (guidon blanc).
1er prix : 100 fr. offerts par la ville d'Argenteuil et médaille d'argent. 2e prix : 50 fr. offerts par le Cercle de la Voile et médaille de bronze.

Nos	NOMS DES BATEAUX	TONNAGE	PROPRIÉTAIRES
1	Etoupille	4 9	MM. de Saimville.
2	Miss Helen	4 2	P. Le Roy d'Etiolles.
3	Miss Jane	6	Lamy.
4	Cormoran	4	Guilleminot.

PRIX D'HONNEUR (toutes séries réunies)
1er Prix : Un objet d'art, d'une valeur de 500 fr., offert par le Cercle de la Voile de Paris. — 2e Prix : Un objet d'art, d'une valeur de 200 fr., offert par M. le Président de la Société. — 3e Prix : Une montre à remontoir gravée aux armes du Cercle, offerte par M. GABRIEL. (Ces prix ne pourront pas être décernés à deux yachts de même série.)

COURSES DE BATEAUX DE PLAISANCE A VAPEUR
Parcours au chronomètre, avec rendement de temps calculé suivant le règlement du Cercle de la Voile de Paris.

1re SÉRIE. — Bateaux de 10 mètres et au-dessus à la flottaison (guidon bleu).
Départ à midi 1/2. — Parcours, 24 kilomètres environ.
1er prix : 250 fr. offerts par la ville de Paris et médaille de vermeil. 2e prix : 100 fr. offerts par la ville d'Argenteuil et médaille de bronze.

Nos	NOMS DES BATEAUX	LONGUEUR	FORCE des machines	PROPRIÉTAIRES
1	Courlis	11m75	6 ch.	MM. Schweighaëuser.
2	Trois-Etoiles	12	14 »	Jourdan.

2e SÉRIE. — Bateaux au-dessous de 10 mètres à la flottaison (guidon rouge).
Départ à 2 h. 1/2. — Parcours, 12 kilomètres environ.
1er prix : 150 fr. offerts par la ville de Paris et médaille d'argent. 2e prix : 75 fr. offerts par la ville de Paris et médaille de bronze.

Nos	NOMS DES BATEAUX	LONGUEUR	FORCE des machines	PROPRIÉTAIRES
1	Javotte	»m»	» ch.	MM. Genevois.
2	Gallia	8 50	4 »	Imbart Latour.

Paris. — Imprimerie Malabouche et Cie, 70 et 72, rue Taitbout.

more than two hundred yards wide for a distance of seven miles. Caillebotte apparently first visited the area in 1878, and he began competing in regattas the next year. By 1880 he was a vice-president of the Cercle de la Voile de Paris sailing club and was a frequent participant in numerous regattas. In a poster advertising the Cercle de la Voile de Paris regatta on 30 May 1880, Caillebotte is listed with his boat *Inès* (fig. 46).[72] His boat *Iris* figures prominently in an engraving of the Argenteuil basin from 1879, which also features the Château Michelet on the opposite bank (fig. 47). Well aware of Monet's paintings of Argenteuil—Caillebotte owned *The Regatta at Argenteuil* (pl. 12)—he may have chosen to live

in Petit-Gennevilliers because of Monet's close relationship with the area.[73] As sailing grew increasingly important in his life, Caillebotte continued to depict boats and the river in his paintings, attempting subjects that Monet and the other Impressionist painters had produced earlier in the decade. *The Argenteuil Basin (Le bassin d'Argenteuil*; pl. 55) and *The Argenteuil Bridge and the Seine (Le pont d'Argenteuil et la Seine*; pl. 54) are both "typical" Monet subjects, but Caillebotte personalized them with a dramatic perspective and his own bold sense of color.

Caillebotte was notable for his support and financial contribution to his friends who were struggling to survive as avant-garde artists. In 1876 he began to buy works by Monet and sent the artist many advances to cover future purchases. He also rented an apartment for Monet in Paris on rue Moncey from January 1877 to July 1878, and another on rue Vintimille from October 1878 until the fall of 1881 or spring of 1882.[74] He purchased works by Monet, Pissarro, Renoir, and Manet, and in the process formed a remarkably rich collection of Impressionist paintings, which he bequeathed to the French government upon his death in 1894. His original offer of "a collection of about sixty works by Messieurs Degas, Césanne *[sic]*, Manet, Monet, Renoir, Pissarro, Sisley"[75] was eventually reduced to forty works, and its acceptance forced the French government to admit works by the Impressionists into the Musée du Luxembourg, the French museum of con-

temporary art.[76] His legacy can be seen in the works that were part of the Caillebotte bequest and are now in the collection of the Musée d'Orsay (pls. 10, 12, 53, and fig. 10).

In the late nineteenth century the Ile de France was filled with important sites that were easily recognizable to French viewers, yet from the late 1860s and beyond, the Impressionists avoided depicting monuments and other reminders of their nation's historic past.[77] Familiar churches and traditional institutions are absent from their paintings; recognizable monuments are masked by nature. Their insistence on investigating the "new France" stems from their general rejection of the subject matter and technique of traditional landscape painting. Instead of searching for sublime or dramatic views of nature, they painted the world around them. The Seine, a perfect model, provided varying moods and diverse landscapes. Through their paintings, the Impressionists promoted the progress of the railroad, the advance of tourism, the evolution of agrarian and rural life, and the poignant, enduring beauty of modern France.

1. *Guide de voyageur sur les bateaux à vapeur de Paris au Havre* (n.p., c. 1865), 1, cited in Richard R. Brettell et al., *A Day in the Country: Impressionism and the French Landscape* (Los Angeles, 1984), 20.
2. Ibid., 27.
3. Robert L. Herbert, *Impressionism: Art, Leisure, and Parisian Society* (New Haven and London, 1988), 234–35.
4. Gary Tinterow and Henri Loyrette, *Origins of Impressionism*, exh. cat. (New York and Paris, 1994), 432.
5. Joel Isaacson, "The Early Paintings of Claude Monet," Ph.D. diss., University of California, Berkeley, 1967, 176.
6. MaryAnne Stevens, ed., *Alfred Sisley*, exh. cat. (New Haven and London, 1992), 17.
7. See chapter 6 of Herbert, *Impressionism*, 195–263.
8. Ibid., 196.
9. Ibid., 195.
10. Adolphe Joanne, *Les Environs de Paris illustrés* (Paris, 1856), cited in Brettell et al., *Day in the Country*, 44–45.
11. *Paris Guide par les principaux écrivains et artistes de la France*, edited by La Croix, 1867, vol. 11, 1455, cited in Brettell et al., *Day in the Country*, 81.
12. Herbert, *Impressionism*, 198–99.
13. Ibid., 202.
14. Ibid.
15. Ibid., 211–12.
16. Quoted in John House et al., *Renoir*, exh. cat. (London, 1985), 191.
17. Herbert, *Impressionism*, 234.
18. Paul Hayes Tucker, *Claude Monet: His Life and Art* (New Haven and London, 1995), 62.

19. Herbert, *Impressionism*, 246–47.
20. Anne Distel et al., *Gustave Caillebotte, Urban Impressionist*, exh. cat. (Paris, 1994), 268.
21. Herbert, *Impressionism*, 219.
22. Tinterow and Loyrette, *Origins of Impressionism*, 436.
23. Monet to Bazille, 25 September 1869, cited in Daniel Wildenstein, *Claude Monet: Biographie et catalogue raisonné*, vol. 1 (Lausanne and Paris, 1974), letter 53, 427.
24. The three paintings by Monet are in The Metropolitan Museum of Art (pl. 2) and The National Gallery, London; one formerly in the Arnhold collection in Berlin was probably destroyed in World War II. The three paintings by Renoir are from the Pushkin State Museum of Fine Arts in Moscow, the Nationalmuseum in Stockholm (pl. 3), and the Oscar Reinhart Collection, Winterthur, Switzerland.
25. See Tinterow and Loyrette, *Origins of Impressionism*, 440, where Gary Tinterow argues that the Arnhold painting, due to its large size, is probably the final painting that Monet originally intended for the Salon. John House, in *Monet: Nature into Art* (New Haven and London, 1986), also suggests that the Arnhold painting was the landscape rejected from the 1870 Salon. Herbert, in *Impressionism*, 213–19, feels they are just sketches for a composition that was never realized. In addition, in David Bomford et al., *Art in the Making: Impressionism* (London, 1991), 120, the authors disagree that the Monet painting was submitted to the Salon of 1870, citing a review of the Salon by Zacharie Astruc that mentions Monet had a "marine" painting rejected.

26. Wildenstein, *Monet*, vol. 1, no. 136, 178, and Tucker, *Monet: His Life and Art*, 43.
27. Ibid., 48–49.
28. Paul Hayes Tucker, *Monet at Argenteuil* (New Haven and London, 1982), 18–19.
29. Ibid., 10.
30. Douglas Skeggs, *River of Light: Monet's Impressions of the Seine* (New York, 1987), 74.
31. Herbert, *Impressionism*, 222–23.
32. F. Lebeuf, "Ouverture de la nouvelle gare d'Argenteuil," *La Journal d'Argenteuil*, 7 June 1863, 2, quoted in Tucker, *Monet: His Life and Art*, 72.
33. Wildenstein, *Monet*, vol. 1, letter 61, cited in Charles S. Stuckey, *Claude Monet: 1840–1926*, exh. cat. (Chicago, 1995), 196.
34. John House, *Claude Monet: Painter of Light* (Auckland, New Zealand, 1985), 12.
35. Herbert, *Impressionism*, 229–30.
36. Tucker, *Monet at Argenteuil*, 92–101.
37. Ibid., 101.
38. Wildenstein, *Monet*, vol. 1, 62, cited in Stuckey, *Monet*, 196.
39. Joel Isaacson, *Observation and Reflection* (Oxford and New York, 1978), 19.
40. Brettell et al., *Day in the Country*, 154.
41. As seen in a poster (fig. 46) from the Cercle de la Voile de Paris, Grandes Régates Internationales, 30 May 1880, M. Michelet's boat *Rubis* competed against Caillebotte's boat *Inès*. See also Distel et al., *Caillebotte, Urban Impressionist*, 269.
42. Pascal Bonafoux et al., *De Manet à Caillebotte: les impressionistes à Gennevilliers* (Paris, 1993), 87, 134.
43. Tucker, *Monet at Argenteuil*, 76–79.
44. Herbert, *Impressionism*, 205.
45. Hôtel Drouot, lot 183, cited in Stuckey, *Monet*, 197.
46. Stevens, *Sisley*, 104.
47. Herbert, *Impressionism*, 226.
48. Brettell et al., *Day in the Country*, 102.
49. Herbert, *Impressionism*, 226–29.
50. Brettell et al., *Day in the Country*, 102.
51. Ibid., 102–104.
52. Ibid., 84–85 and 98.
53. Stevens, *Sisley*, 19, and in Marly entry, no. 20, 122.
54. Richard Thomson, *Camille Pissarro, Impressionism, Landscape, and Rural Labour* (Birmingham, England, 1990), 26.
55. Ibid., 19.
56. *Pissarro*, exh. cat. (London, 1980), 60.
57. Thomson, *Pissarro*, 11.
58. See Brettell et al., *Day in the Country*, 35–36.
59. Ibid., 94.
60. Thomson, *Pissarro*, 25–26.
61. *Manet: 1832–1883*, exh. cat. (New York, 1983), 319; see also *In the Garden* of 1870, Shelburne Museum, Shelburne, Vermont.
62. See Emile de LaBédollière, *Histoire des environs du nouveau Paris*, 1861, 135, cited in Herbert, *Impressionism*, 236.
63. Denis Rouart, ed., *Berthe Morisot: The Correspondence with her family and friends* (London, 1987), 18.
64. Ibid., 19.
65. Ibid., 18.
66. Brettell et al., *Day in the Country*, 118.
67. Herbert, *Impressionism*, 227.
68. Charles S. Stuckey and William P. Scott, *Berthe Morisot: Impressionist*, exh. cat. (New York, 1987), 65.
69. See Sailing Chronology, in Distel et al., *Caillebotte, Urban Impressionist*, 341–43.
70. Ibid., 311.
71. See note 41 regarding Caillebotte's house in Petit-Gennevilliers.
72. Distel et al., *Caillebotte, Urban Impressionist*, 341.
73. Ibid., 268.
74. Ibid., 312–14.
75. Archives de Louvre, Paris, P8 1896, cited in ibid., 23.
76. For a detailed account on the negotiations over the bequest see Pierre Vaisse and Marie Berhaut, "Dossier on the Caillebotte Bequest," *Bulletin de la Société de l'art francais* [1985], cited in ibid, 24.
77. Brettell et al., *Day in the Country*, 34–35.

The River Seine

Subject and Symbol in Nineteenth-Century French Art and Literature

Richard R. Brettell

My one absorbing passion for ten years was the Seine. That lovely, calm, ever-changing, stinking river, full of glamour and filth! I loved it so, I think, because it gave me a sense of life.

Guy de Maupassant[1]

For the great French emperor/administrator Napoleon I, "Paris, Rouen, and Havre are all the same city, and the Seine is their main street."[2] As a partial result of this statement of Imperial policy, the Seine became during the nineteenth century the central aquatic boulevard of a national system of rivers and canals that was the largest and most comprehensive in Europe. The Seine is not itself the largest river in France, nor is it the most heavily traveled (that honor goes to the Rhône), but it is—and was—the most important because it is the river of the French capital, Paris. Even Louis XIV and his iconographers gave the allegorical sculpture of the Seine pride of place among the sculpture of rivers in the gardens of Versailles, which were, in turn, both befountained and watered by an elaborate system of pumps, aqueducts, pools, and pipes that originated in the Seine at nearby Port-Marly. Arguably, if there is a natural symbol of the French nation, of "la belle France," it is the Seine.[3] The Seine is as symbolically potent as any mountain, cliff, or valley in France, and its image in French visual arts and literature is more ubiquitous than that of any work of architecture, including Chartres Cathedral, Nôtre Dame de Paris, the Arc de Triomphe, the Palace at Versailles, or the Louvre.

Paris, like Rome, London, and Berlin, is a landlocked capital, and its connection to the sea is the Seine. And like those cities, it was organized around the river, whose well-watered basin was gradually filled with an urban structure of city, suburbs, towns, villages, hamlets, and farms. All maps and plans of Paris are oriented so that the river flows through the center of the pages on which they are drawn or printed, and the river within the city is straight enough and narrow enough to pull its city together rather than separate it into two cities as does the

Alfred Sisley, *The Seine at Bougival*, 1872 (detail of pl. 8)

Thames in London, the Neva in St. Petersburg, or the Danube between Buda and Pest. There are, of course, the left and right banks in Paris, but even in medieval times Parisians crossed from one side of the Seine to the other, often several times in one day. In recognition of its generative and connective role in Paris, a good deal of the urban history of Europe's greatest modern city involves the Seine. Generations of Parisians joined together across time to regularize its contours, to calculate the height of its quays, to conjoin its scattered islands, to allocate space for its harbors, and to construct bridges across it. The river is as feminine as Paris itself, and it is symbolized most often as a garlanded woman, a goddess, not a god.[4]

Paris, like all great cosmopolitan capitals, is worshipped as fervently by foreign visitors as by its own inhabitants. Indeed, since the Middle Ages the population of Paris has swelled with regular influxes of people not only from the French provinces but also from the entire world. More than Rome, Paris has become the cultural destination of modern man, and books, novels, guides, articles, and journals about the city abound in every major world language.[5] Paintings, drawings, prints, and photographs of it are so numerous that even to imagine their quantity is beyond comprehension. No urban iconography approaches that of Paris, and at its center are uncountable images of its river, "la Seine."

Not surprisingly, the Seine resides at the very heart of the historical image of Paris. From the Middle Ages until its last important remaking during the Second Empire, the seal of Paris featured a large, three-masted ship.[6] How odd, we might think, having never seen or imagined such a vessel in the Paris we know today. The image is surely more suitable for truly maritime cities such as Amsterdam, Venice, Genoa, St. Petersburg, Marseilles, or Bordeaux. Yet the Paris city seal originally represented the most powerful independent company within the city, the Company of Water Merchants, whose shipbuilders, traders, warehousemen, and ship owners won from the crown the right of self-government for the municipality. The ship—and its "main street," the Seine—were absolutely central to the freedom and prosperity of Paris.

Just as the Seine is the symbol of Paris, and in turn, of France, the single most pervasive style of painting—Impressionism—is also of French, and indeed Parisian, origins.[7] Whether created by the group of diverse men and women who joined together in the 1870s in the loose alliance that gave the Impressionist movement its name, or made by the tens of thousands of French and foreign artists who were inspired enough by those artists to mimic their style and imagery, freely painted and brilliantly colored transcriptions of Paris and the Ile

48. Claude Monet, *The Quai du Louvre*, 1867, oil on canvas, 25 ¾ × 36 ⅝ in. Haags Gemeentemuseum, The Hague.

de France can be found on every continent. At least one Impressionist painting of Paris or its river appears in museums from Cairo, Cape Town, and Caracas, to Buenos Aires, Hong Kong, Manchester, Sydney, and Kansas City. Interestingly, until now a carefully selected group of Impressionist "Seinescapes" has not been gathered for delectation and analysis.[8] Whether by Monet, Sisley, Pissarro, Caillebotte, Renoir, or Morisot, these paintings describe a landscape centered on a waterway whose surface is often covered with boats, whose breadth is measured by bridges, and whose banks are lined with fields, forests, houses, factories, restaurants, boathouses, quays, suburbs, or urban structures (fig. 48).

Their works concentrate on the relatively short section of the Seine that originates in Paris itself and winds in long, meandering loops until it reaches the great inland port city of the Seine's tidal basin, Rouen. This is not, however, the extent of the Seine actually painted by the Impressionists. In fact, Sisley special-

ized from 1880 onward on a beautiful portion of the Seine and its tributary, the Loing, up the river from Paris. Caillebotte painted many of his most persuasive boating paintings of the late 1870s not on the Seine but on another tributary, the Yerres, and Monet made numerous landscapes of the Seine's immense tidal basin at Honfleur and Le Havre, where he spent his boyhood.[9] In focusing on the seductively curving section of the Seine just west of the capital, our attention is brought squarely to the portion of the river that was most frequently represented not only by the Impressionists but also by two overlapping generations of French writers, whose novels and stories use the same suburban and rural setting for many of the most memorable scenes in all of French literature. Surely, it is no coincidence that the Seine of Flaubert, Zola, and Maupassant corresponds to the Seine of Monet, Renoir, Sisley, and Caillebotte, four painters whose repeated transcriptions of its banks are better known internationally than are the wonderful passages of prose by any of their contemporaries in French letters.

The Seine Itself

Before turning to literary and pictorial representations of the great river of France, let us talk about the river itself, first as a natural system, and then as it was altered to suit the needs of a newly industrialized capitalist economy in the nineteenth century. At five hundred miles in length, the Seine is the third longest river in France, after the Rhône and the Moselle. It drains a gently shaped basin or valley, much of which has long been called the Ile de France and which is fed by no fewer than eight tributaries that enter the Seine in its long route toward the sea. All writers about the Seine stress the peaceful and gentle quality of the river. A recent geographic study of France puts it most succinctly: "Cette impressionism de calme . . . la Seine."[10] Like the Mississippi River, few rapids disturb its flow, and the curving descent toward la Manche (the French word for the English Channel) is so gradual that for centuries the river was easily navigable by small boats. In fact, the difference in elevation between the river in Paris and 230 miles later, when it empties into the sea, is only 76 feet, a descent of 6 ¾ inches per mile.[11]

Yet, tranquil and regular as the river then tended to be, it had, like all natural forms, its disadvantages. The first, and most serious, problem was its tendency to flood, sometimes calamitously, a problem exacerbated by its banks, which were often not much higher than the river itself. The earliest recorded flood in the

region of Paris occurred in 1176, when the river submerged virtually the entire medieval city of Paris. And even after massive improvements to its banks, the floods of 1740 and 1751 raged through Paris, often for days, with the latter one flooding even the relatively high ground of the Champs Elysées.[12] Another disadvantage had to do with the river's relative shallowness, with the descent in certain areas proving too rapid for easy navigation. These obstacles were particularly important in the nineteenth century, when the population of Paris reached truly epic proportions and the resulting need for raw materials and goods put the inland city at a disadvantage when compared to London, its major economic and cultural competitor in modern Europe.

During the nineteenth century France changed even more dramatically than Britain, Germany, and the United States, and its national river was altered as much as was its capital city. Paris itself was redesigned, reconstructed, and systematized in those decades, and the river shared the fate of its medieval neighborhoods and small-scale streets. Both within the city and between Paris and the sea, the Seine was straightened, dredged, and otherwise modified for two basic reasons: to suppress its natural, relatively regular, and devastating tendency to flood, and to increase the river's depth and regularize its gradual descent from Paris to Le Havre so it could be navigated throughout the year by increasingly bigger boats. Both the construction of quays and rural flood planes and the dredging of the river were large-scale processes of national importance that were most concertedly and successfully undertaken following the 1845 plans of the great engineer Poirée and the more comprehensive plan of 1874 by the engineer de Lagrène. The Seine's minimum depth between Le Havre and Paris was set first at five feet, increased in 1866 to six and a half feet, and finally reached its apogee of ten and a half feet in 1886. In each case, the river was made accessible to larger and larger barges between the seaports of Le Havre and Rouen and the freshwater harbors of Paris.[13]

This feat was accomplished both by dredging the river in certain shallow areas and by creating canals to parallel it in an effort to add depth and build locks and weirs. The process effectively prepared the river for industrialization, bringing it from a natural state into man's control, linking it to the vast system of canals that fanned out across northern France, and connecting the industrial areas of northeast France and Belgium with consumers in Paris and its surrounding suburbs.

This process of modernization and industrialization reached its peak in the 1870s and 1880s, precisely when the Impressionists were exploring the river for

49. *Chatou, Perspective of the Bridge,* nineteenth century, photograph. Bibliothèque Nationale, Paris.

subject matter. Coincidentally, the emerging technological revolution that forever changed the river and its traffic took place at the same time that France was creating an entirely new transportation network based on rail travel. Like the systems of rivers and canals that focused on the city of Paris, the railroads linked the capital city with destinations throughout France and Europe by means of considerably straighter and more efficient routes, most often without serious interruptions (fig. 49). Indeed, the distance between Paris and Le Havre is only 112 miles as the crow flies, but 230 miles on the river.[14]

The greatest nineteenth-century study of Paris is indisputably Maxime du Camp's four-volume monograph entitled *Paris, ses organes, ses fonctions, et sa vie dans la seconde moitié du XIXeme siècle,* completed in 1868 and reissued many times during the Third Republic. Du Camp, a brilliant amateur photographer, writer, and a close friend of the great novelist Gustave Flaubert, ingeniously dissects Paris as if it were a human body, with various arterial systems bringing fluids, power, and information to its far-flung neighborhoods. We learn about the dis-

posal of the dead, the functioning of the markets, the systems of education—indeed, *all* the systems that together created the city of Paris. Interestingly, France's great river, la Seine, plays only a minor role in du Camp's immensely detailed study. He makes it clear that by mid-century the river had already been surpassed by the railroad as *the* national system of transport. Before the railroad networks had been built, du Camp explains, the Seine was the key to the prosperity—or famine—of Parisians: the Seine *was* Paris. Since the introduction of the railroad, however, Parisians had less and less contact with the river, which led to their indifference to the Seine. Quays constructed far above the river and linked by bridges caused Parisians literally to "look down" on the Seine and thus lose forever their sense of its connection to daily life in the city.[15]

In fact, du Camp was among the few important French writers of the nineteenth century to notice that the Seine had been transformed from *the* vital component of the freedom and identity of Paris to merely one element in the national transport system. He praises the system of bridges over the Seine, but because of it the experience of the river for du Camp's Parisians had become aesthetic rather than actual. Their eyes surveyed the water from above as they scuttled along the quays and crossed the bridges on their way about their daily affairs. Like so many other writers, the American Henry James gives clear evidence that the Seine had become a visual element in Paris. "I walked over to Notre Dame along the quays, and was more than ever struck with the brilliant picturesqueness of Paris as, from any point opposite the Louvre, you look up and down the Seine."[16]

What is remarkable about du Camp's descriptions of the river's diverse functions, the untranslatable names of its boats,[17] and the "professions" the Seine had spawned is less its wonderfully accurate passages than its assertion of the marginal importance the river played in the consciousness of Parisians. Hundreds of other sources verify that this was *not* the case. Indeed, in images and texts Parisians continued to rhapsodize about their river throughout the nineteenth century. Yet du Camp was surely correct in pointing out that their praise had more to do with its symbolic potency than with its actual role either in their daily lives or in the French economy. The river was a decreasingly important presence as the century continued, to be replaced in our century by railroads and super-highways.

What du Camp failed to recognize in his treatment of the great struggle between rail and water for dominance in France is that the railroad actually brought growing numbers of Parisians into contact with the river—but not in

50. Honoré Daumier, *Laundress on the Quai d'Anjou*, c. 1860, oil on wood panel, cradled, 11 ¼ × 7 ¾ in. Albright-Knox Art Gallery, Buffalo, New York, George B. and Jenny R. Mathews Fund, 1964.

Paris. Indeed, the links between Parisians and the river suburbs and leisure towns, most of which lie to the west of the city, were multiplied by the railroad, which made it possible to spend time in the country by boarding one of the many trains that went daily (and with greater frequency on Sunday) from the Gare

Saint-Lazare to the river towns painted so lovingly by the Impressionists. An urbanite could walk mindlessly over the Seine several times a day, doing little more than admiring it as a sort of urban tourist. Yet, because of the train the same person could bathe or boat *in* the Seine on weekends or, if a commuter, on warm summer evenings.

Later in his great tome on Paris, du Camp treats the systems of fresh water distribution and sewage, both of which were considerably improved at mid-century. With widespread fresh water distribution (by 1868, Parisians on the left bank drank water from the Marne, while those on the right bank enjoyed the waters of the Seine),[18] the need for bathing and laundry establishments *in* the river decreased every year. Consequently, it becomes clear why the washerwomen of Daumier (fig. 50), who trudged toward the Seine with huge bundles of clothes and linens, were replaced in the 1870s by Degas's laundresses (fig. 51), who worked indoors in establishments that were fed by piped water and thus could be built anywhere in the city. Again, the direct experience of the Seine by Parisians decreased in virtually every way during the nineteenth century. The working river, the lifeblood of the great capital city, was transformed into a natural amenity for most citizens.

51. Edgar Degas, *The Laundress*, 1873, oil on canvas, 9 7/8 × 7 5/8 in. Norton Simon Art Foundation, Pasadena, California.

A Cluster of Images: The Seine Before Impressionism

In the first half of the nineteenth century, representations of the Seine in popular art and guidebook literature were more numerous and widely recognized than those in painting. Indeed, the relative prejudice against the French landscape on the part of the Académie des Beaux-Arts cannot be underestimated, and even contemporary proponents of the Barbizon School stressed the difficulties their heroes encountered in the Salon. Of the French landscapes that were included in the Salons, the majority represented nature as the antithesis of cities and suburbs. The Salons of the first half of the century exhibited many images of Italy and Switzerland or, if of France, of the wilder landscapes of the Forest of Fontainebleau, the French Alps, the Pyrenees, or the Franche-Comté. Not until the Second Empire did representations of the Seine by Corot, Daubigny, Français, Pissarro, and others make a measurable impact at the Salon or in the newly established private exhibitions in Paris.

For images of the Seine before mid-century we must turn to travel artists interested in historical monuments and to foreigners such as Pugin and

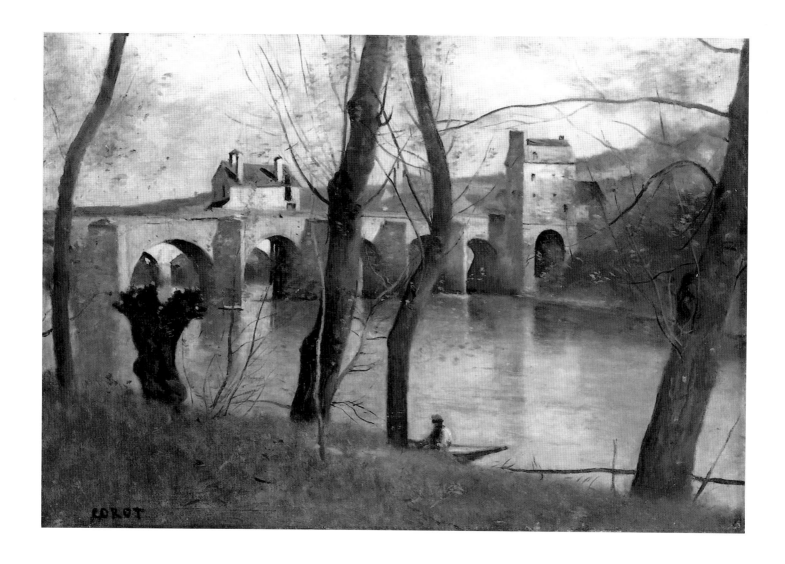

52. Jean-Baptiste-Camille Corot, *Pont de Mantes*, c. 1868–70, oil on canvas, 15 ⅛ × 21 ⅞ in. Musée du Louvre, Paris.

Turner.[19] For all these artists, the Seine was Napoleonic in character, a watery highway linking Paris with the sea. For artist/voyagers traveling by boat, a journey down the Seine was punctuated by stops at cities and small towns, each of which attracted their attention and was subsequently rated by the quality of its site, its size, and most importantly, its historical monuments. Whether the great ruins of La Roche Guyon or the "living" history of Rouen or St. Germain-en-Laye, the architecture along the Seine was more important than the river itself.

When traveling the Seine, the well-heeled visitor could easily consult an illustrated guidebook that would describe the richness and complexity of French history arranged not chronologically but geographically. "L'Histoire," noted the great French historian Michelet in his *Tableau de France* of 1833, "est d'abord toute géographie" (history is at first geography), and he might well have reversed the order of his words.

The canonical images of the historical Seine are paintings by Camille Corot, as exemplified by his depiction of the Pont de Mantes from the late 1860s (fig. 52). Although the subject of Corot's landscape is *not* the Seine itself, most viewers would have immediately recognized the river. Corot includes only one small boat in the landscape, the location and color of which are important in establishing scale. We would never know from this tranquil landscape painting that the Seine was then the principal waterway of northern France, filled with barges, motor-powered tugs, ferries, and other specialized crafts. While no practical boats travel on Corot's Seine, no carts, carriages, or stagecoaches rumble across the bridge, which in reality was in ruin and already had been replaced by a newer, functioning bridge. A river that was actually noisy and active becomes for Corot a silent, timeless surface reflecting a cloudy sky, the grayed atmosphere of which seems to fill the painting like Monet's later "enveloppe de lumière." For Corot, the atmosphere is the humid penumbra of a timeless past, evoked less by the actual bridge at Mantes than by our silent meditation upon the arresting of time.

This idea of a landscape animated by actual figures living in real time is central to the enterprise of French positivism as well as to its artistic parallel, realism, and its offshoot, Impressionism. The visual expression of that world view is first found not so much in painting as it is in printmaking and photography. Because lithography in particular was associated with the written word throughout the century, the graphic arts tend to "illustrate" the descriptive texts created for the newly burgeoning press that was devoted to travel and leisure. Whether the caricatures of Daumier and Gavarni, in which the Seine plays a fascinating, if minor role, or the travel images of artists such as Daubigny, these images represent the actual rather than the historical Seine.

The Bible for historians of French popular imagery in the mid-nineteenth century is the famous book *Les Français peints par eux-mêmes* of 1861. With its delightfully satirical texts and modish lithographic illustrations, it attempted to be an encyclopedic portrait of urban types as depicted by several generations of popular artists in the eighteenth and early nineteenth centuries. Most of these urban types could be found in the boulevards, streets, and arcades of Paris or in the semipublic realms of cafés, beer gardens, nightclubs, street circuses, and other areas of so-called popular entertainment. One among the numerous types—the fisherman—relates directly to the Seine and thus to Parisian perceptions of their river and its free use. The fisherman along the banks of the Seine purports to be a universal Parisian male type, presumably down-and-out, unemployed, or retired, and, in the words of the text's author Brisset, absolutely ubiq-

53. *Bridge at Argenteuil (with fisherman)*, late nineteenth century, photograph. Musée de l'Ile de France, Sceaux.

uitous. "The banks of the Seine are covered from morning until evening with fishermen of all ages, sizes, and habits" (fig. 53).[20] Other sources tell us that these men *never* caught fish, but rather involved themselves in the isolated activity of fishing for what might be called aesthetic reasons.[21]

Indeed, many writers insist that, for the French along the Seine, the point of fishing is *not* to catch fish. "There is not even a legend," Arthur Bartlett Maurice explains in his delightfully literate book *The Paris of the Novelists*, "that within memory of man anyone ever saw a fish being caught, or heard of one being caught."[22] The act of fishing itself is the fisherman's goal. As he manipulates the rod and line in the tranquil, reflective surface of the Seine, he tries neither to be seen nor to emit any sound that will frighten the fish he will never catch. The fisherman is rather like the landscape painter, who, even when working on the same view with a group of colleagues, is engaged in his own individual and personal quest for something ultimately elusive.

This type of activity is utterly opposed to the collective and social use of the

54. (Left) Jules Desprès, *Le Dimanche aux environs de Paris*, 1879, wood engraving. Collection Viollet, Paris.

55. Antony Morlon, *A la belle tête (plongeon à La Grenouillère)*, c. 1875, lithograph. Courtesy of the Musée Fournaise, Chatou.

LE DIMANCHE AUX ENVIRONS DE PARIS

Seine by the boaters and swimmers who dominate the "other half" of the popular image of the river in French caricature (fig. 54). This is made clear in *Le Diable à Paris; Paris et les Parisiens*, a collection of texts and caricatural illustrations published in 1845. Here, we learn that "Parisians love the Seine like the Venetians love the Adriatic"[23] and that, aside from the fishermen who long for a certain isolation to ply their craft, the Seine is really dominated by two rowdier and noisier types of activities, swimming and leisure boating. Gavarni illustrated a delightful essay by Eugène Briffault on "Swimming Schools along the Seine," and the accompanying drawings abound in skinny old men with hairy legs, immense women covered in yards of cloth, and numerous river-rat children. Thus, the image of the Seine in Parisian popular imagery is a thoroughly human image dominated by lower- and middle-class leisure. Absent are the dock workers, the laundresses, the ferryboat operators, the tugs, and the river taxis that depended on its waters. Even at mid-century the idea of Paris as a leisure city, which used its river for recreation rather than commerce, transportation, and shipping, dominated popular imagery (fig. 55).

Unlike the isolated fisherman, these men, women, and children used the freedom that the collective ownership of the Seine provided for altogether different purposes. Perhaps the right to be alone belonged to the fisherman, who escaped the noisy prison of the city for the reflective calm of the river. Yet, an

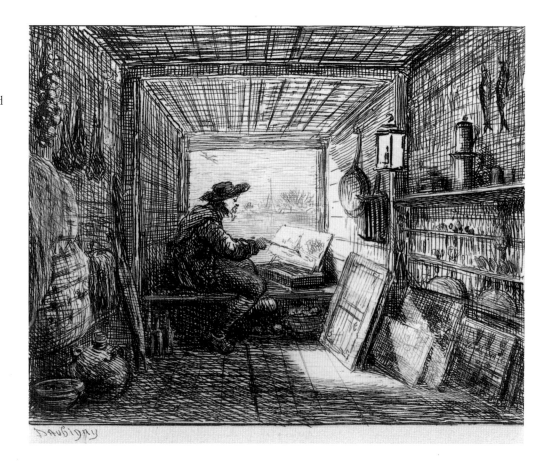

56. Charles-François Daubigny, *The Artist in his Studio Boat*, 1861, etching, 9 3/8 × 10 3/4 in. (sheet), 5 1/8 × 7 in. (plate). The George A. Lucas Collection of The Maryland Institute, College of Art, on extended loan to The Baltimore Museum of Art, L.1933.53.4198.

opposite kind of freedom—the right to say anything, be with anyone, and do anything without the social constraints of the city—was celebrated by boaters and swimmers in caricatures by Daumier, Gavarni, and Cham, among many others. This right to cavort or carouse was rooted in the post-Revolutionary mentality of urban France, as was the loftier right to be alone, and both were forms of release from the social conventions of urban life, whether the constraints of family, social class, religion, or the workplace. For boaters and swimmers, the Seine was a place to use—and, within certain limits, expose—their bodies, free from the class-bound and profession-bound "uniforms" they wore in the city. Without these common costumes, social origins and jobs were not clearly projected, and a kind of social anarchy prevailed on the river.

The most enchanting, and important, series of popular images of the Seine created in the decade before Impressionism was Charles Daubigny's entertaining sequence of etchings entitled *Voyage en bateau*. Published in 1862 by Cadart, the main character of this river narrative was the artist himself, who, in his tiny *botin*, or studio boat, navigates the waters of the Seine from Paris (or rather, from the nearby suburb of Asnières) to la Manche for the sole purpose of documenting his voyage. Because Daubigny's medium was the hand-printed, small edition etch-

ing, the audience for these prints was both small and relatively wealthy, and he chose to amuse and divert these urban connoisseurs with an artist's adventure. Filled with dancing fish, inky black nights, drunken meals, and adventures offshore, Daubigny's voyage was a nineteenth-century male-bonding trip on the Seine, which became a common expedition for young French and British artists and amateurs to undertake well into the twentieth century. The French tended to start in Paris and proceed down river, while the English, who imagined themselves hardier, started in Le Havre because it was nearer England.

Perhaps the most charming record of these English voyages is Sir Edward Thorpe's *The Seine from Havre to Paris*, published in 1913, in which he recounts his journey in a small boat (with an unrelated female artist/companion!) and details each stop with lengthy descriptions. Although it fits completely into the English Romantic tradition of trips down the Seine in its interest in history, architecture, and landscapes, Thorpe's description of the river itself is worthy of extended quotation. "This noble river winds through a beautiful champaign, doubling, twisting, curving, and recurving upon itself, playing along rush-lined banks, gliding beneath the shade of overarching willows and the shadow of tall poplars, and lingering by innumerable islands; as if loath to leave the land of its birth."[24]

This image of a boater's river, more delightful than useful or commercial, has its origins in Daubigny's voyage. Yet, as is often the case in the history of representation, the prototype is both more complex and more powerful than its progeny. For Daubigny, the Seine had to be shared not only with the fish who inhabited it but also with the motor tugs and the barges that traveled its waters. Indeed, as an ending to a truly "modern" journey, the artist returns home on the train! His visual narrative appeared in fifteen etchings, carefully chosen from more than forty drawings that he made in 1857 on the first of many painting trips on his *botin*, and it helped Daubigny to create a professional image as a free-floating painter of northern France. This slow-moving and thoroughly traditional view of the countryside was at odds with that of the modern urban tourist, whose sense of the landscape was dominated by fleeting views from the train. Daubigny's waterscapes have often been considered a prototype for the later Impressionist Seinescapes of Monet, but there is a world of difference in each artist's motifs. In painting from his *botin*, Daubigny preferred traditional small villages and, on occasion, historically important sites—several times he painted the Château Gaillard at Les Andylis, famous in French and foreign guidebooks—casting a spell of rural simplicity and timelessness (what French historians have

called *la longue durée*) (fig. 56) that is almost completely at odds with Monet's aggressively modern and industrial views of the Seine.

Daubigny was perhaps the most important of the many artists who worked for the burgeoning industry of illustrated guide and travel books during the Second Empire, but the group of images these artists created tells us that virtually every aspect of the river painted by the Impressionists in the 1870s and 1880s had already been explored in the graphic arts. Whether the rowdy pleasures of the outdoor café La Grenouillère at Bougival, the informal dining at the famous Restaurant Fournaise at Chatou, or the regattas at Argenteuil, the visual festival of leisure on—and along—the Seine was amply studied in the graphic arts of the Second Empire. Most of these illustrations were made for large-circulation books such as Jules Janin's *Guide de voyageur de Paris à la mer* of 1862 (with illustrations by Daubigny, among others), Emile de La Bedollière's *Histoire des environs de nouveau Paris* of the early 1860s, or the immense compilation created for visitors to the International Exhibition of 1867, *Paris, Guide par les principaux écrivains et artistes de la France* by Adolphe La Croix. Although some of these glory in the absurdities of urbanites strolling, picnicking, and boating in a landscape filled with rushing trains, immense iron railway bridges, and factories belching smoke, most of them could serve as respectful advertisements for the accessible pleasures of the Parisian countryside. Virtually all of them are filled with people, as if going to the country was ultimately the social act of urbanites afraid of or unused to being alone or left behind. And all but a few represent the countryside in good weather, as if it never rained or was windy there. Due in large part to the scale of the images, the human figures are small and unspecific, which allows the viewer the luxury of responding to the illustrated places at a discreet distance. In virtually every case the captions of the illustrations describe an exact location. There is no mistaking the view from the terrace at St. Germain-en-Laye for that from the hillside in nearby Louveciennes, nor can one fail to discern the difference between the Ile de Croissy near Bougival and the Ile de la Grande Jatte between Neuilly and Asnières. Each place had its own image, which was widely known among Parisians of all classes. Even the ever-sedate Henry James "indulged in a cheap idyll the other day by taking a penny steamer down the Seine to Auteuil . . . and dining at what in Parisian parlance is called a 'gringuette' on the banks of the stream [fig. 57]. It was a very humble style of entertainment, but the most frantic pursuit of pleasure can do no more than succeed, and this was a success."[25] If Henry James indulged in such pursuits in the winter of 1876, they must have been widespread indeed!

Photography, as the most thoroughly urban and industrial medium of the nineteenth century, had been extensively practiced in France from the 1840s onward. By the 1860s, France was literally inundated with photographs, which provided an alternative form of representation to the graphic arts. A good many of the literally thousands of French photographers at mid-century were amateurs who created photographs for private use. A rapid review of the literally millions of surviving French landscape photographs taken before 1870 reveals a preponderance of exotic travel landscapes. Photographers seem to have concentrated on the medium's ability to provide visual documentation of distant and inaccessible realms, rather than the way it could record the nearby and familiar area of the Ile de France. However, found in the boxes and boxes of landscape photographs in the Bibliothèque Nationale, the world's largest collection of French nineteenth-century photographs, are countless representations of the Seine made in virtually every photographic medium, from prints on salted paper or albumen-coated paper made from paper or glass-plate negatives, to the infrequent landscape daguerreotypes made on silvered metal surfaces. The names of the makers of these photographs most often remain unknown.

Most of these images represent monuments that lined the river's banks, some of which are historical, while others, such as railway bridges and newly built docks and quays, are of modern origin. The reasons for this prejudice in favor of structures rather than the river itself are twofold. In describing architecture, pho-

58. Henri Bevan, *Photographies—Louveciennes et Bougival*, 1870, album cover. Private collection, Paris.

tographers worked in a well-established tradition in which the river itself was less interesting than the products of man's work, whether historical or modern. The second reason has to do with the technical limitations of the medium. Due to the lengthy photographic exposure times that were required well into the late nineteenth century, light-filled aspects of the visual world (the sky and the reflective surfaces of water) "burned" the negative in the long time needed to record the denser surfaces of buildings and foliage, resulting in completely featureless or "white" areas on the print. Although disturbing in the sky, this was particularly troublesome in depicting water, which lost virtually every trace of its visual character. No waves, ripples, or eddies were slow enough to appear, and only the darkest of reflected forms are seen in the final print. For this reason, photographers tended to avoid water, just as they crowded the sky into the upper portions of their landscapes and cityscapes.

This formal constraint of the medium gives the many surviving photographs of the Seine an eerie silence, a kind of timelessness much different than that achieved by Corot and Daubigny. Because motion is absent from these photographs, even contemporary reality takes on a temporal durability, and the great river of France becomes a pure white surface as spaceless as the sky. Among the most successful early attempts to compensate for this problem is Victor Regnault's calotype *Sèvres, The Seine at Meudon*, of circa 1853. In this superbly contrived view, a group of three small river boats, artfully arranged in the foreground of the river, make the entire space of the photograph legible, even though the river itself appears essentially spaceless.[26] Among the reasonably successful attempts to deal photographically with the life of the Seine is the important series of photographs made by Charles Nègre in 1851 of the quays near the Hôtel de Ville. These represent small-scale merchants who sailed their boats from their farms into the city and sold their produce informally on the quays. In each image, the river itself is absent, as are the boats. Instead, Nègre filled his frame with architecture and instructed his human subjects to stand as still as possible. The results contain inevitable blurs, but these grainy, salted paper prints possess an undeniable sense of human presence along the banks of the great national river.[27]

By the 1860s and 1870s, many landscape photographers joined painters and printmakers in enriching the visual representation of the Seine basin. Of these, perhaps the most underrated is the commercial photographer Achille Quinet, whose views of the vegetation along the river are of enormous visual refinement and subtlety. Eschewing human presence (perhaps because it was still so difficult to control), he concentrated on unpopulated reaches of the Seine, particularly

59. Henri Bevan, *The Ruined Bridge at Saint-Cloud*, 1870, albumen print from a glass-plate negative. Private collection, Paris.

along the many uninhabited islands between Paris and St. Germain-en-Laye. He treated the river as a reflective surface virtually filled with mirrored vegetation. Neither the sky nor its reflection in the water below occupy much space in Quinet's photographs, which become subtle studies of middle value tones. The most interesting aspect of Quinet's riverscapes is that they most often have no clear sense of place. None of the river photographs in the Bibliothèque Nationale has titles, and very few contain architectural forms that make it possible to locate them along the Seine, the Oise, the Viosne, or one of the smaller rivers that abound in the region of Paris. For this reason, they have a curious abstractness because the viewer has no ability to place them, and yet they capture an isolating realm in which nature itself predominates. For Quinet, the river was neither historical nor commercial, but rather a place of escape and quiet contemplation.[28]

An album of photographs by the amateur photographer Henri Bevan documents a particular stretch of the Seine just west of Paris. Grouped, mounted, and bound in an album in 1870 (fig. 58), these images concentrate on the section of the Seine between Saint-Cloud and Marly-le-Roi, precisely the same region favored both by the Impressionist painters and by the greatest French writers associated with the Seine.[29] For Bevan, the Seine was alive with motion, change, and modernity. Even though his views along the river contain very few figures, human pres-

ence is felt—through a study of the bridge at Saint-Cloud destroyed by the advancing Prussian troops in the siege of Paris (fig. 59), or through a clearly labeled landscape featuring the well-known pleasure garden La Grenouillère near Bougival. His photographs remain emblems of progress, of leisure, of industry, and, more poignantly, of war, and they deal clearly and forcefully with virtually every motif that was to become central to Impressionist landscape painters in the 1800s (fig. 62). This album makes it abundantly clear that Bevan was well attuned to the progressive, aesthetic aspects of the landscape. In nearly every case, his images can be paired with paintings by the Impressionists, artists whom he may never have known, much more powerfully than can photographs by professionals, paintings by their teachers, or any particular type of popular imagery.

A Cluster of Words: Literary Representations of the Seine, 1860–1890

When eighteen-year-old Frederick Moreau, Flaubert's antihero in his great novel of 1869, *L'Education Sentimentale*, boards a boat on the Quai Saint-Bernard in Paris to go home to his native Nogent-sur-Seine, he is somewhat old-fashioned. Train service already went from the Gare Saint-Lazare to Nogent, but Frederick elected the slower, less direct, and in most respects, thoroughly traditional route of traveling on the river from Paris to the sea. Admittedly, the boat he took was a motor-powered vessel with two paddles. Flaubert gloried in its rattles, vibrations, and belching black smoke, which contrasted with the utterly calm and tranquil world around it. Even the city of Paris is transformed from Frederick's vantage point on the boat. It begins as a noisy human realm, "crowded with warehouses, timber-yards, and manufacturers," yet as the boat moves on, it "opened out like two huge ribbons unrolled. . . . Penetrating the haze, he could see steeples, buildings of which he did not know the names; then, with a farewell glance, he observed the Ile St. Louis and Notre Dame. As Paris faded from view, he heaved a deep sigh."[30]

Frederick's journey home is, like so many such journeys in European literature, a failure, and he soon returns to the capital to pursue his career and his love. Yet, Flaubert sets the stage for Frederick's tumultuous emotional journey on this boat as it moves gradually down the Seine. "Then the drifting haze cleared; the sun appeared; the hill which had been visible on the right of the Seine subsided by degrees, and another rose nearer on the opposite bank."[31] As the landscape of the Ile de France unfolds for the floating passengers, Frederick walks along the boat's decks, motion upon motion, making plans for the future, observing his fellow pas-

sengers, and reciting memorized verses. Socially, the immense urban realm of the Paris quays is condensed into the passengers who will share the landscape with Frederick until he reaches his family home. He is alone, knows no one on board, and young—and this state of utter openness and potential is highly attractive to Flaubert. Like other literary heroes, of which he is something of a parody, Frederick immediately focuses his attention on a beautiful woman, who, during the course of the voyage, becomes known to him and who, we trust, will dominate his emotional life over the next five hundred pages. His free access to this woman is blocked because she is married and is accompanied by her husband. In a brilliant passage Flaubert uses the landscape alongside the moving boat as a metaphor for her inaccessibility. "On the right, a plain was visible. On the left, a strip of pasture-land rose gently to meet a hillock where one could see vineyards, groups of walnut trees, a mill embedded in the grassy slopes, and, beyond that, little zig-zag paths over a white mass of rocks that reached up toward the clouds. What bliss it would have been to ascend side by side with her, his arm around her waist, as her gown swept the yellow leaves, listening to her voice and gazing into her glowing eyes! The steamboat might stop, and all they would have to do would be to step right out; and, yet, this thing, simple as it seemed, was not less difficult than it would have been to alter the course of the sun."[32]

This passage is a quintessentially modern representation of landscape. It combines machine-powered motion with a psychic frustration common in bourgeois fiction. The landscape is "consumed" by Frederick, who populates it in his imagination. No rural workers or local people are allowed into his realm, which becomes, however temporarily, a pastoral paradise no less contrived than Fragonard's overgrown gardens or Marie Antoinette's hamlet in Versailles.

It is clear from Flaubert's novel that a journey down the Seine contained all the elements of myth he needed for his modern "quest romance" about sensual education. It also served to render this tale accessible to a modern readership, many of whom had taken precisely the journey described by Flaubert. Obviously the same effect could not have been achieved had Flaubert set the scene in a railway car hurtling through the landscape. Frederick could never have met his love, Madame Arnouil, so discreetly or fantasized about her so intently had he been trapped with her—and her husband—in a crowded railway cabin. Where could they have strolled? How could he have observed her from a distance while appearing to talk with another? No, Flaubert needed the slowness of river travel, with its meanderings and fresh air, as a setting for the foreplay of his modern romance.[33]

If Flaubert, whose life had revolved around the Seine since his boyhood in

60. *Guy de Maupassant with Jeanine Dumas d'Hauterive and Geneviève Strauss*, c. 1885, photograph. Courtesy of the Musée Fournaise, Chatou.

Rouen, made the river central to the fictive enterprise of his longest realist novel, two of his younger writer friends surpassed him in their devotion to France's most famous river. One can scarcely imagine two more different sensibilities than those of the Norman, Guy de Maupassant, and the Provençal, Emile Zola. Yet each man described, evoked, and consumed the landscape of Paris and its countryside in lit-

erally thousands of passages in their novels and stories. "Every turn of the winding Seine for twenty miles below Paris," we learn from the literary historian Arthur Bartlett Maurice, "is associated with the tales of Guy de Maupassant, who loved the river only a little less than he loved the shores of the Mediterranean and the Norman Coast."[34] An analogous statement could be made for novels by Emile Zola. Indeed, Zola's first great novel, *Thérèse Raquin*, published in 1867, is set in Paris and its countryside, and the central dramatic action—the murder of Thérèse's husband by her lover Laurent—occurs in the Seine itself. Zola's taut and powerful prose sets the scene for the disaster. "As soon as they arrived in Saint-Ouen, they began to look for a clump of trees with a carpet of shady green grass. They crossed on to an island and plunged into a thicket. A reddish layer of fallen leaves covered the ground, rustling and crackling underfoot. The innumerable tree trunks were straight up like clusters of gothic columns, and the branches came down to head-height, so that the strollers' horizon was hemmed in by a copper coloured vault of dying leaves. . . . In this wild, cut-off place they found a small deserted clearing, a melancholy retreat where everything was cool and quiet. All around them they could hear the rumbling of the Seine."[35]

The suspense grew. Thérèse "played dead" as her lover caressed her foot. Her husband fell asleep, and the temptation to murder him proved almost irresistible, but Laurent went "down to the water's edge and watched the river flowing by with a vacant expression on his face. Then, suddenly, he plunged back into the copse; at last he had hit on a plan, a convenient murder that would not put him in any danger."[36] The plan is executed along and in the Seine, which is the setting for their stroll, their drunken supper, and at last, their final boating trip at dusk. In all of this, the river is at once the ominous setting and, eventually, the weapon. If Flaubert's river banks provide an imaginary Eden for lovers, Zola's Seine teems with images of violence, jealousy, and death.

In *Thérèse Raquin*, Zola conceived of the Seine as a love-death symbol that he used repeatedly throughout his masterpiece, the group of novels called the Rougon-Macquart series and subtitled *Histoire naturelle et sociale d'une famille sous le Second Empire*. This in turn became the predominant literary trope for the Seine in the novels and tales of Guy de Maupassant. Even Flaubert, in writing to their mutual friend Zola, refers to "a most entertaining epistle from our young friend Maupassant, full of details about his lewdness with a fat woman on the Seine."[37] In fact, Francis Steegmuller's wonderful biography of Maupassant makes it clear that the writer spent a good deal of time shuttling between small apartments in the city and rented rooms in houses situated directly on the Seine.

Maupassant practiced river life with all the stamina of an athletic youth, learning well its extremes as sources for vitality and debauchery (fig. 60). In many instances in Maupassant's fiction, the Seine has a character that is at once healing and ominous, and its banks and waters are the setting for many of his most violent murders. At a small riverside restaurant in Saint-Cloud, Maupassant's Monsieur Parent carried out a terrible act of revenge for which he had waited twenty years. The most sinister scenes in "La Femme de Paul" occur along the Seine at Bougival, and the terrible murder in "L'Affair Lerouge" takes place in a cottage on the banks of the Seine between Malmaison and Bougival.[38]

The main character in Maupassant's most Poe-like story, "The Horta, or Modern Ghosts" gradually goes mad in a beautiful house on the banks of the Seine in Rouen. One of Maupassant's most powerful passages about the effect of landscape upon the human psyche is found at the beginning of that disturbing story. "I go down by the side of the water and suddenly, after walking a short distance, I return home wretched, as if some misfortune were awaiting me there. Why? . . . Is it the form of the clouds or the color of the sky or the color of the surrounding objects which is so changeable, which have troubled my thoughts as they passed before my eyes? Who can tell? Everything that surrounds us, everything that we see without looking at it, everything that we touch without realizing it, everything that we handle without feeling it, all that we meet without clearly distinguishing it, has a rapid, surprising, and inexplicable effect upon us and upon our organs, and, through them, on our ideas and on our heart itself."[39] The growing madness of Maupassant's character, recorded in a fictional diary, is manifested in both his gradual detachment from society and his sense of being isolated even from the nature that surrounds him. Ever present is the river: "It is splendid weather, and I spend my days watching the Seine flow past."[40]

The double-edged notion of the Seine as a wonderful natural river disturbed by the great city through which it flows plays a major role in Maupassant's story "Mouche." "How simple and good and hard it was to live as I liked then, between my office in Paris and the river in Argenteuil. My one absorbing passion for ten years was the Seine. That lovely, calm, ever-changing, stinking river, full of glamour and filth! I loved it so, I think, because it gave me a sense of life . . . and all those things I saw either on or beside the stream that carried seaward all the refuse of Paris" (fig. 61).[41] This sinister character was established by Maupassant in his earliest fiction, including a story of 1876 first called "En Canot" and later known as "Sur l'Eau." The sophistication of this

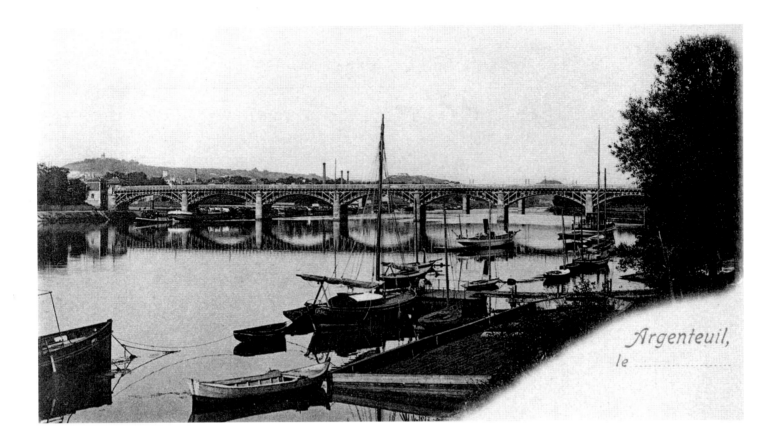

Argenteuil,
le

story led to Flaubert's recognition of Maupassant's powers as a writer. It describes a night spent in the middle of the Seine by a lone boater who has been unable to pull up his anchor. Between the effects of rum and fog, the night becomes a phantasm, complete with a series of brilliantly described hallucinations. The next morning Maupassant's hero is rescued by a local fisherman who helps him to pull up the anchor, only to realize that it had become entangled in the bloated corpse of a murdered woman. Again, the Seine is anything but benign in many of Maupassant's most powerful stories.

There is, however, a counterbalance to these images of death, depravity, and guilt that crowd the early works of Zola and nearly all the writings of Maupassant. Indeed, in writing such wonderful stories as "The Sunday Outings of a Bourgeois," Maupassant seems to have been fascinated with caricatures by Daumier, Gavarni, and others. In this delightfully savage portrait, an unmarried, middle-aged man who has worked in Paris from 1854 to 1880 without once leaving the city outfits himself for his first adventure: a fishing excursion to Bezons. With his comfortable income he buys ridiculously expensive clothing and fishing gear. "He left by the first train. The station was full of people equipped with fishing lines. . . . Everyone got off in Courbevoie and rushed to the stage for Bezons.

61. *The Highway Bridge, Argenteuil,* late nineteenth century, postcard. Musée de l'Ile de France, Sceaux.

. . . All along the road, men were traveling in the same direction as if on a pilgrimage to an unknown Jerusalem."[42] The gentleman's next outing is in the company of a friend, who takes him to pay visits to Meissonier in Poissy and Zola in Medan. For Maupassant, both trips of his good bourgeois were "fishing" expeditions, and in neither case was anything caught.

Most often for Maupassant and for Zola, the Seine is a place of seduction, which leads to an act filled with pleasure but one ultimately tainted with guilt. In one of Maupassant's most moving stories, "The Father," the main character meets an attractive young woman in Paris, asks her to accompany him on an outing to the country, and, as a result of her entreaties before they depart on the train, promises to respect her virtue. After lunch on the river, "the air, the heat, the weak white wine, and the sensation of being so close together made them silent . . . but after coffee, they regained their spirits, and, having crossed the Seine, set off along the banks toward the village of La Frette"—all of this before he even asks her name![43] Finally, in a field of flowers they make love, after which she deserts him at the station. Years later he visits her widowed husband to see for one time the son he sired in the field of flowers. The passionate kisses that he gives the young boy are both desired and unwanted, as were the kisses that Maupassant's hero gave the mother before the moment of conception on a drunken Sunday afternoon along the banks of the Seine.

Two of the Seine's most widely recognized spots during the Third Republic—the bathing establishment at La Grenouillère in Bougival and the Restaurant Fournaise in Chatou—play major roles in Maupassant's lengthy and morally complex seduction of a courtesan's daughter by an attractive young aristocrat in the novella *Yvette*. The narrative begins, like *L'Education Sentimentale*, in Paris, but with an extended ramble on the city's boulevards. This is followed by a splendid party at the home of the Marquise d'Obardi, Maupassant's exotic but clearly concocted name for the courtesan. The action then moves to "Villa Printemps," a house in Bougival that the courtesan rents for summer weekend parties. The house "stood halfway up the hillside, just where the Seine made a turn, running round in front of the garden wall and down toward Marly. Opposite the house, the island of Croissy formed a background of trees, a mass of foliage. A long reach of the river was clearly visible as far as the floating café, la Grenouillère, half hidden in the branches. . . . No gust of wind disturbed the smooth, translucent surface of the Seine."[44]

As the virtuous daughter begins to fall in love with the aristocrat, they visit

the distant Grenouillère. "They reached the gate facing the Seine. A flood of light fell on the quiet, gleaming river. A light heat-mist was also lifting, the steam of evaporated water leaving a glittering vapour on the surface of the stream. From time to time a boat went by, a light skiff or a heavy barge, and distant sounds could be heard, the short notes of the whistles on the Sunday trains that flooded the country with Parisians and the long warning notes of the steamboats passing the weirs at Marly." [45] In this scene set for tragedy, man and landscape, leisure and labor coexist in a balance more forced than natural, a balance analogous to that between virtue and vice, man and woman, aristocrat and commoner. The Seine forms the backdrop for these tensions, these competing emotions that Maupassant knew all too well by the late 1880s, when, with his health rapidly deteriorating, he began to conceive of his fiction in terms of decline, disease, and death. Not even the healthfulness of the boaters, the laughs of the *promeneurs*, the naïveté of the bourgeoisie on its first outings—none of the innocence of the Seine—could cheer him.

Perhaps the ultimate literary passages about the Seine as a symbol of life—and death—in France are found in Zola's masterful novel about a modern artist, *L'Oeuvre*, which is often badly translated into English as *The Masterpiece*. In fact, Zola was assiduous in *not* saying *chef d'oeuvre*, or masterpiece, and endeavored not to work against his prototype, Balzac's *Le Chef-d'oeuvre inconnu*. In writing *L'Oeuvre*, Zola returned once again to the territory of his first novel, *Thérèse Raquin*, creating a character that has been much discussed in twentieth-century criticism as a sort of collective portrait of the modern painter, combining the qualities of Cézanne, Manet, Renoir, and their colleagues to deal fictionally with creative failure. Throughout the novel, the Seine winds along, through city and suburb, day and night, tranquilly or actively. The river is, in the end, the constant force in the novel, a constant of change that Lantier, its tragic hero, tries again and again to entrap in his paintings. Whether depicting nudes or suburban landscapes, his painted works include the Seine, and "the work" of the novel's title is a huge canvas in which the nude, the city, and the Seine are inextricably linked to create a modern classic.

For Zola, such a work forever eludes his antihero/artist. It is not, as has often been naively assumed, a castigation of the achievements of Manet or Cézanne, the two painters most important to Zola's conception of the modern visual artist. That would be too simple for a writer of his intelligence. Instead, Zola deals forcefully and frankly with the contrast between vaunting ambitions and actual achievements in a medium that he understood less well than writing. Through-

out this book, choked as it is with the utter financial, critical, and personal failure of its main character, Zola sets the action around the Seine, the river of life.

L'Oeuvre begins in Paris as Claude Lantier walks along the Seine in a pounding rainstorm. Everywhere there is water, and amidst the rain, the reflections, and the lightning he meets a young woman who, as is always the case in such novels, will animate many of the remaining pages. "It was an amazing conglomeration," Zola observes after Lantier meets the girl Christine, "a whole world, in fact, besides the milling of the water—the tall chimney of the laundry boat, the static chain of the dredger, the heaps of sand on the opposite wharf—that filled the enormous trough cut out from one horizon to the other. Then, with the sky blotted out again, the river was once more a stream of darkness amid the rattle of thunder."[46]

If the Seine introduces the novel during a devastating nighttime thunder and lightning storm (no one ever said Zola was subtle), it appears and reappears with all the inevitability of fate itself. In passage after passage Lantier walks along it, across it, above it, and into it. "Claude trailed gloomily along the riverside until noon, his brain throbbing with the persistent thought of his importance, but otherwise so numb that he perceived his favorite stretches of the Seine only through a veil of mist."[47] Later, as Claude and Christine find themselves in the first bloom of love, "The lovely sunsets they watched on those weekly strolls along the Seine, when the sun shone ahead of them all the way through the many lively aspects of embankment life: the Seine itself, the lights and shadows dancing on its face, the amusing little shops, . . . the pots of flowers on the seedman's stalls, the deafening twitter of the bird-shops, and all the joyous confusion of sounds and colors that makes the waterfront the everlasting youth of the city. . . . And twilight would come down as they took leave of each other, their eyes dazzled by the glory of the sky, and felt that Paris in its triumph had its share in the boundless joy that was theirs every time they wandered by the banks of the Seine."[48]

When their love later cools, "The joy they had known in the early days of the country life was over. Their boat had rotted, fallen to pieces and sunk to the bottom of the Seine. . . . They had grown tired of the river and lost all taste for rowing, and although they still repeated the same cries of enthusiasm over certain favorite beauty-spots on the islands, they never had any inclination to go and visit them again. Even their rambles along the river bank had lost their charm; it was too hot down there in the summer, and in winter it was where you caught colds."[49] Following the birth of their child, Claude took Christine on another urban walk. "So they went down as far as the Pont Louis Philippe and

spent a good quarter of an hour on the Quai des Ormes leaning over the para-pet, looking in silence across the Seine to the old Hôtel du Martoy where they first fell in love. . . . They followed the embankment, under the plane trees, see-ing the past rise up at every step as the landscape opened out before them: the bridges, their arches cutting across the satin sheen of the river; the Cité covered with shadow, dominated by the yellowing towers of Notre Dame; . . . and the broad avenues, the buildings on either bank, and between them, the Seine, with all the lively activity of its laundry boats, its baths, its barges. . . . The time-worn stones were cold and the ever-flowing stream beneath the bridges seemed to have carried away something of their selves, the charm of awakening desire, the thrill of hope and expectation."[50] In the end Claude awakens to the Seine itself more than to his wife and son, and a massive representation of the city around the Seine is his sole preoccupation in the last section of the novel. He chooses to paint in the shadow of the Pont des Saints-Pères, a place that becomes "his refuge, his roof, his home,"[51] where he works on a great painting with the Seine itself as its central motif.

As he works, spends money with careless abandon, and fails to create his painting, the novel enters its bleakest phase, and the Seine once again appears. On a wintery night, Christine silently and from a distance watches Claude on what she suspects is the night of his suicide. "Down below, the Seine was ablaze with nocturnal splendor known only to the waters of cities, reflecting every lighted lamp as a comet with a streaming tail. . . . The great flaming tails . . . were never still, but lashed about the water, the quivering of their black and gold scales revealing the ceaseless flowing of the stream. Along the whole of its length, the Seine was ablaze, its depths mysteriously illumined beneath its glassy surface, as if by some brilliant fête or sumptuous transformation scene. Over the conflagration and the embankments bespangled with lights, a red haze hovered in the starless sky; the hot, phosphorescent vapour that nightly rises out of the sleeping city as from a dormant volcano."[52]

After this passage Claude's death is inevitable. Rather than throw himself into the river that glides forever through the novel, Claude hangs himself in front of his unfinished—and unfinishable—work in which the Seine serves as both symbol and setting. For Zola, it was not the Seine that had failed, but Lantier's representation of it. And in sending his hero to a featureless funeral in a new cemetery located in the river suburb of Saint-Ouen, Zola makes it clear that Lantier was not good enough—or perhaps brave enough—to die in the enduring waters of the Seine.

Of the artists who rethought landscape painting in the last third of the nineteenth century, four painted the Seine with a frequency that might be called obsessive. Monet, Sisley, Renoir, and Caillebotte made canonical representations of the national river of France, most of which date from the 1870s and 1880s. When considered as a group, these paintings form the greatest collective portrait of a river in the history of art. No other river—not the Thames, the Tiber, the Danube, or the Rhine—can lay claim to such numerous or potent representations painted within so concentrated a period. In many ways the Impressionists' views of the Seine have transformed the French national river into an international waterway.

We have surveyed the Seine through the eyes and minds of others, both before and during the Impressionist enterprise, and we have learned that the young artists participated in a national discourse about "la Seine." Popular images and certain paintings, particularly those by Corot and Daubigny, were familiar to all of them. Undoubtedly they had read—or at least had heard of—a good deal of the popular literature that was directed toward urban tourists. Virtually every one of the Impressionists read Zola, and Maupassant was known to them initially through Zola and, by the mid-1880s, personally. No literate Frenchman of the late nineteenth century was unaware of Flaubert, who by 1870 was considered to be the greatest living man of letters in France. Certainly their choice of places to paint along the Seine—Bennecourt, Bougival, Port-Marly, Chatou, Croissy, Argenteuil, Vétheuil, la Roche Guyon, and Vernon—was absolutely consistent with the prevailing taste of Parisians during the Third Republic. They undertook their painted representations of the Seine as part of this larger discourse.

Two questions arise at this point. First, just what does a knowledge of this discourse do to our understanding of the paintings? And second, how do the paintings collectively contribute to this literary and visual discourse? Curiously, the short answer to the first question is "very little," while that to the second is "a good deal." Of the four major artists mentioned above, Monet and Sisley were the most faithful and detailed recorders of the river, and each made more than two hundred different paintings of the Seine. Monet represented it from its mouth at Le Havre but concentrated on the locations where he lived and worked for several years: Argenteuil, Poissy, Vétheuil, and Vernon, near Giverny. Sisley was interested in the Seine on both sides of Paris, beginning his investigation of

62. Henri Bevan, *The Seine near Port-Marly*, 1869–70, albumen print from a glass-plate negative. Private collection, Paris.

the river in its curving section near Marly-le-Roi (fig. 62) and, after 1880, transferring his affections to the intersection of the Loing and the Seine east of Paris. He also painted the river and its associated canals in the city of Paris.

Renoir was fascinated by the river for a little less than fifteen years, and his ultimate representation of it is not a landscape but the elaborate figure painting *Luncheon of the Boating Party* (pl. 60). For Caillebotte, the Seine was not his only river. Indeed, many of his most important representations of boating were made in one of its tributaries, the Yerres River, east of Paris. After 1880, when he acquired a large property at Petit-Gennevilliers, directly on the Seine, he concentrated on works that described the landscape of the upper-class boater he had become.

The work of these four artists dominates the larger population of paint-

63. Renoir, *The Pont des Arts,*
c. 1867–68, oil on canvas, 24 ½ ×
40 ½ in. Norton Simon Art
Foundation, Pasadena, California.

ings depicting the Seine, yet Pissarro, Manet, and Morisot also produced
Seinescapes during the 1870s. The vast majority of Pissarro's numerous paint-
ings of rivers represent not the Seine, along which he worked for a brief period
from 1869 to 1872, but one of its tributaries, the Oise River near the town of
Pontoise, where he lived from 1872 to 1883. In the years just before and after
the Franco-Prussian War, Pissarro worked along the Seine with Renoir and
Monet, attempting to capture in paint the kind of metropolitan landscape that
is chiefly associated with Impressionism. Manet rarely painted scenes of the
Seine, but when he did, his work serves to summarize numerous paintings by
his colleagues Monet and Renoir. Indeed, the summer of 1874 is perhaps the
great high point of collaboration between Manet and the Impressionists when
the dean of French realist painters spent several months in Argenteuil, submit-
ting himself both to the landscape and to the technique of his younger col-
leagues just after their first independent exhibition.

In recent years Morisot often has not been included among the Impressionist
landscape painters, yet she made substantial contributions to the movement. Like
many of the other artists associated with the Seine, she and her husband kept a

summer house on the slope of the hill above the river at Bougival for many years, and her immersion in that landscape produced works of subtlety and painterly power. Perhaps because of her status as an *haute-bourgeois* woman, she avoided the banks of the river, preferring to remain in her garden well above the noisy Seine and including only occasional glimpses of the river below.

To these suburban Seinescapes we must surely add the many representations of the Seine in Paris by Monet, Renoir, Guillaumin, Cézanne, Morisot, Sisley, and Pissarro. Their works most often concentrate on that section of the river at the center of the city, between the Ile de la Cité and the Tuileries, which has been celebrated in thousands of passages of French, English, and German prose. Of these, only the Seinescapes of Cézanne and Guillaumin deal forcefully with the ports along the Seine in the eastern section of the city. The port or the quays at Bercy, where both timber and wine were unloaded in bulk, are represented in several paintings by both artists.

The Parisian Seine of the Impressionists centers on the area around the Pont Neuf, which was painted early in 1872 by both Renoir (fig. 28) and Monet. These works also help to verify Maxime du Camp's assertions that Parisians had lost touch with their river. Instead of looking at the Seine itself, each artist painted the view from the comfort of a second-story window above a small café that overlooked the road atop Henri IV's great bridge. To the young Impressionists, the bridge was simply a boulevard, along which the carts, omnibuses, carriages, and pedestrians of Paris moved on their way about the city. Both Renoir and Monet included river traffic (Monet even added a puff of steam from a motor-driven tug), but the action on the Seine is peripheral to their intended subject. Indeed, we must turn to *The Pont des Arts*, an earlier painting by Renoir (fig. 63), for the unique Impressionist representation of the Seine from the level of the river itself. In this wonderfully active work of circa 1867–68, Renoir describes the shadows of pedestrians walking along the bridge above the river. Interestingly, he chose exactly the same point along the Seine at which Flaubert's Frederick caught the ferry that took him from Paris to Nogent-sur-Seine in the opening pages of *L'Education Sentimentale*, published two years later. Yet, if Flaubert immerses the reader into the jostling movements and noises of the crowd, Renoir keeps well back from such activity, preferring to treat the city as a distant spectacle animated by human figures with no threatening proximity to the viewer.

The true painter of the Parisian Seine was Pissarro, who turned to the river in several series of paintings made along its banks around 1900, at the very end of the

64. Georges Seurat, *A Man Leaning on a Parapet*, 1880–81, oil on wood, 6 5/8 × 5 in. Private collection, New York.

Impressionist enterprise. Most of these were painted from rented rooms in a beautiful house at the very end of the Ile de la Cité, from where Pissarro could look north, over the Pont Neuf, or east, where the branches of the Seine conjoin between the Louvre and the Institut de France. For the elderly Pissarro, looking down on the river from his windows, the Seine had become a detached visual element rather than an economic or social force within the city. Although he inserted tugs, barges, and the anachronistic laundresses into virtually every painting, they

are tiny, distant elements from which the painter is separated by a physical and a social gulf. The Seine had become part of the spectacle of tourist Paris for Pissarro, not the economic engine that had driven the city for nearly a millennium.

One small painting crystallizes the detachment from the life of the Seine that had come to link Parisians with the many tourists that thronged their city. In *A Man Leaning on a Parapet*, painted around 1880–81 by Georges Seurat (fig. 64), a lone male figure leans against the parapet of the quay opposite the Church of the Invalides, the gilded dome of which glints in the sunlight. In this telling representation of urban alienation, Seurat's male figure stands completely alone, his back to the viewer. Beyond the height of the parapet and the characteristic shape of the drum and dome of Hardouin-Mansart's famous church, the painting gives little hint that he looks down at the flowing waters of the Seine, which are invisible. Nevertheless, we can almost hear the river's sound as it consoles this melancholic man, who forever supports his heavy head with his hand and arm.

The figures that are oddly absent from the vast majority of Impressionist representations of the Seine in Paris are the fishermen celebrated in countless popu-

65. Georges Seurat, *Fishermen*, 1883, oil on wood, 6 1/4 × 9 7/8 in. Musée d'Art Moderne de Troyes, Gift of Pierre and Denise Lévy.

lar texts of the nineteenth century. For these figures we must turn again to Seurat, whose tiny panel of fishermen probably depicts the Ile de la Grande Jatte (fig. 65). Seurat was able to condense into one small work the sense of shared or mutual isolation that is described in many texts that deal with these archetypical figures. Indeed, Seurat conveys the poignancy—and ultimate frustration—of urban and suburban fishing more convincingly than do any of the delightful caricaturists who included fishermen in their drawings.

The overwhelming majority of Impressionist images of the Seine are suburban and rural, and we are forced to conclude that writers and painters represented the same stretch of the Seine. Bennecourt, Bougival, Chatou, and Argenteuil are mentioned in countless passages of realist fiction, and these same places appear over and over in paintings. Maupassant's wonderful passages about the floating café La Grenouillère were written after Renoir and Monet painted the superb group of works of that same place in the summer of 1869. Yet, only one of those paintings was ever exhibited during the 1870s and 1880s when Maupassant was writing, which suggests that both the painters and the writers were informed less by the work of one another than by the widespread popular discourse on the Seine that was generated in gossip, conversation, and of course, the ephemeral press.

The most startling fact that arises in analyzing the Impressionist contribution to this collective discourse is that, although Monet, Renoir, Sisley, and Caillebotte repeatedly painted scenes of the Seine, they chose to include very few of these works in the eight independent exhibitions that have come to define the Impressionist movement.[53] Only two submissions among 165 to the 1874 Impressionist exhibition, a painting by Stanislas Lépine and one by Sisley, included in their titles the word Seine or the name of any well-known place along its banks. The 1876 exhibition had only four such paintings—two Argenteuil views by Monet, a scene Renoir painted at the Restaurant Fournaise, and Sisley's depiction of the recent floods at Port-Marly—among 248 total works. The landmark 1877 exhibition included two Seinescapes by Alphonse Moreau, one by Renoir, and five representations of the river by Sisley among more than 240 works.

A large number of river pictures by Caillebotte were included in the 1879 exhibition, but these were made not on the Seine but along its tributary, the Yerres. Their titles contain no hint of place, but instead frequently refer to the type of boat being used or to the activity of the male figures who cavort on the river. This series of works was, in fact, the first exhibited by the group that dealt forcefully with the leisure use of the river, even though the subject had

already been featured in the fiction of Flaubert, Zola, and Maupassant. Monet exhibited five paintings of the Seine at Lavacourt and Vétheuil, suggesting that the river came to be central to the Impressionist exhibition strategy only in the fourth of the eight exhibitions. The 1880 exhibition had no Seinescapes by any of the Impressionists themselves (only three such works were shown: one by Jean-François Raffaëli, another by Paul Victor Vignon, and the third by Henri Rouart), while the 1881 exhibition contained a series of studies of the Parisian quays by Cézanne's friend Armand Guillaumin. The 1882 exhibition was the one most thoroughly devoted to representations of the Seine, with five works by Guillaumin, four by Monet, five by Renoir, two by Sisley, and three by Vignon. The eighth and final exhibition of 1886 was dominated by Seurat's *Sunday Afternoon on the Island of La Grande Jatte* (the successor to Renoir's *Luncheon of the Boating Party* and now in the Art Institute of Chicago [fig. 82]), as well as only three other representations of the river, those being two works by Seurat (including *Fishermen* [fig. 65]) and one by his younger friend Paul Signac.

The actual number of these Seinescapes that were shown is startlingly low, especially when one considers that the eight Impressionist exhibitions, while smaller than the official Salons, most often included as many as 250 works. The numbers are also low when compared to the actual production of the artists, at least four of whom painted so many representations of the Seine that the river and its surrounding landscape virtually dominate their production of the 1870s and 1880s. We can scarcely escape the Seine when looking through modern books about Impressionism, but the artists themselves seem to have placed little emphasis on depictions of the river in their own exhibitions. Lacking a definitive explanation, we are left with the vague sense that Monet, Sisley, Caillebotte, and Renoir repeatedly painted the Seine because they felt that works with such popular subject matter would themselves be popular with the modern, bourgeois clients that they evidently wanted to attract.

In interpreting the Impressionists' views of their national river, two major types of images can be identified. The first—and probably the largest—deals with the river of the boaters through depictions of sculls, canoes, sailboats, or less-specialized crafts. This is the Seine of Monet, Renoir, Caillebotte, and Manet, the Seine whose waters are filled with boats and whose banks are lined with onlookers and promeneurs enjoying the river as a site for outdoor athletic leisure. This aspect of the river coincides *almost* completely with the literary Seine of Zola and Maupassant as well as with that of the popular press. We must keep in mind that while popular literature and its "higher" counterparts

dealt with the moral dimensions of suburban leisure, the paintings contain few narrative hints of the depravity, moral decay, and death that fill the pages of contemporary fiction. Renoir paints couples isolated along the banks of the Seine, couples that have undeniable affinities with many of the passages by Zola and Maupassant quoted above. Yet, we must look carefully to find pictorial evidence to suggest that the sunny outing of a young man and woman might turn from a happy occasion into a prelude for tragedy.

That evidence *does* exist, although Renoir was much too complex and subtle in sensibility to accept the banalities of simple sensuality. A wonderful 1867 watercolor of two lovers (Reves Collection, Dallas Museum of Art) shows signs of a struggle between an ardent man and his less than compliant female companion. In *The Promenade*, the great masterpiece of 1870 (fig. 66), a young man conducts an unenthusiastic woman up a steep, overgrown path for a tryst, the moral implications of which are suggested by her very reluctance to follow. In both these works and others by Renoir, the tangled narratives of Zola and Maupassant find their visual equivalents, and we are reminded that at one time Renoir actually attempted to illustrate Zola's *L'Assomoir*.

Not surprisingly, it is in the realm of figure painting that the narratives of French realist writers have their equivalents. Renoir excavates the erotics of the river as a locus for temporarily unencumbered leisure. Manet, in his brilliant canvases of 1874, deals with the modern states of boredom and fatigue as athletic men and complacent women coexist unhappily along the Seine. Caillebotte sublimates the mind to the body in his visual analyses of boaters and bathers in the act of entering and negotiating the river. And Morisot deals with the generational dance of family members in her summer garden above the Seine at Bougival. Yet, the Impressionists' representations of the young men and women who "consume" the Seine during their leisure time are most often landscapes in which the figures play roles dissociated from narrative. Indeed, the humanized, modern landscape is the subject of most Impressionist depictions of the Seine, and the viewer is more fascinated by the delicate taupe of the sails in Monet's *Sailboat at Petit-Gennevilliers* (pl. 32) or the brilliant blue of the water in *The Basin at Argenteuil* (pl. 22) than by any figural narrative. We have no need for Zola or Maupassant in interpreting most Impressionist landscapes that include the Seine, largely because the paintings actually resist narrative interpretations in their enthusiasm for color harmonies and for the active brushstrokes that become in many senses the subject of the painting. The very place names in the titles simply verify that the world represented physically exists, thereby creating a link

66. Pierre-Auguste Renoir, *The Promenade*, 1870, oil on canvas, 31 1/2 × 25 1/4 in. Collection of the J. Paul Getty Museum, Los Angeles, California.

between two types of viewing: the actual experience of the landscape and the virtual experience of a painted representation of that landscape. The very proximity of the leisure landscapes of the Impressionists is part of their meaning. As contemporary French viewers, we could easily have visited Impressionist sites simply by following their titles. Alternatively, as Parisians we could compare the painter's experiences of the leisure landscape with our own weekend outings to the picturesque suburbs.

The second type of Seinescape favored by the Impressionists uses the river as a landscape site but deemphasizes the elements of leisure. Major painters of this everyday Seine are Sisley and, by the late 1870s, Monet, with a minor contribution by Pissarro. If the leisure component of the Impressionist iconography of the Seine stresses boating (and to a lesser extent, swimming), the quotidian Seine of Sisley deals with the river throughout the year and at points along its banks that have no overt association with leisure. This Seine includes locks, barges, pumping stations, steam tugs, washerwomen, factories, farms, dredging sites, and woodworkers. Figures are small and most often indigenous; the weather is occasionally brisk and cool. The river even turns dangerous, as Sisley depicted in his extended analysis of the great floods that occurred in the early spring of 1876.[54] In this ever-present Seine, the river works for France in a thoroughly traditional way, and we are reminded less of the literary Seine of Zola and Maupassant than of the photographic Seine of the amateur Bevan.

There are, of course, exceptions to this binary modernism. Certain paintings, mostly by Monet but occasionally by Renoir and Sisley, address neither suburban leisure nor the industrial river. They are most often unpeopled landscapes in which even architecture is either excluded or rendered so peripheral or so distant that it aids the painter/viewer in feeling a sense of real isolation. Whether Monet was representing the engorged river in the spring of 1879 in his wonderful *Seine at Lavacourt* (Fogg Art Museum, Cambridge, Massachusetts) or floating alone amidst the breaking ice masses of a winter storm, he seems to have sought escape from the city and its uses of the river. Yes, his places are often named and familiar, but Monet endeavored to escape these places in his painting boat and sought out wilder stretches of the river at times of the year unfamiliar to tourists and leisure-oriented urbanites. Also in his painting he either omitted or avoided the barges and their tugs that continually plied the waters of the Seine. Such avoidance has its conclusion in Monet's last paintings of the river, the so-called Mornings on the Seine series in which he guided his own version of Daubigny's *botin* into the narrow subsections of the river near Vernon. In their deserted

equivalents to Monet's empty Seinescapes, Sisley and even Renoir undertook such strategies in their paintings of tall fields of grass that toss in the wind and sweep through the basin of the Seine.

Yet, for Monet, Sisley, and Renoir, all children of the north of France, the Seine was, above all, the element of nature that linked city, suburb, town, country, farm, and sea. It was their symbol for abundant leisure, for the richness of France, for the power of her industry, and in certain cases, for everyone's right to be alone.

The Seine flows through thousands of French landscape paintings and through the pages of even more passages of French prose. As twentieth-century viewers of Impressionist representations of the Seine, we often tend to think only of its surface, plied by boaters and sailors and gazed upon by Parisians at leisure. Whether it is the supremely social world of Renoir's *Luncheon of the Boating Party*, the broad, empty river of Monet's *Ice Floes*, or the industrialized river painted so often by Sisley, the Impressionist landscape is usually down river from Paris, and the Seine appears as a seamless surface that reflects the sky and moves forever seaward. We must remember, however, that these paintings form only part of the national discourse—the Seine also had its depths. Those deep, dark undercurrents—cold in winter, always flowing—contained not only the refuse of Paris but also the victims of the urban crime that contaminated French society. The bourgeois escape from Paris was not into an Eden, but instead into a broad, spacious countryside in which the river itself contained the evidence of urban sin. Many have thought that a prostitute Maupassant met on the banks of Seine gave him the syphilis that first drove him to madness and finally to death. In Zola's earliest masterpiece Monsieur Raquin was murdered and his hideous, bloated body discovered in the Seine.

It is much more difficult to paint these depths than to write about them, yet literary descriptions of the Seine were familiar to every French reader. Indeed, when it was first entitled *A Luncheon at Bougival*, Renoir's painting was immediately linked to the stretch of the Seine down river from Paris that was associated with vice and sin as well as with the healthy and wholesome aspects of leisure. Renoir celebrates the end of a country lunch along the Seine, but after reading excerpts of contemporary French literature, we know that a good deal happened after such lunches.

One can argue that Renoir's painting is a bourgeois fiction in paint—bour-

geois in its imposition of urbanites in the countryside, but its unequal mixing of men and women, its absence of children, and its delightfully tipsy informality must be read much more as an affront to, rather than an embodiment of, bourgeois values. In fact, this survey of diverse representations of the Seine has demonstrated that no summary work, no painted image or written word, can serve as *the* representation of the Seine. Without the prose of Zola, Maupassant, and Flaubert, and paintings by Caillebotte, Sisley, Manet, and Monet, Renoir's *Luncheon of the Boating Party* is merely a charming, attractive, and beautifully painted work. With their words and images in our minds, however, the painting's meanings multiply and its range of inference increases. Renoir's painting is a masterpiece not because it supersedes other representations, but because it is enriched by them.

1. Guy de Maupassant, "La Mouche," English translation quoted in Francis Steegmuller, *Maupassant, A Lion in the Path* (New York, 1949), 48–50.
2. The translation of this famous passage can be found in Blake Ehrlich, *Paris on the Seine* (New York, 1962), 11.
3. "Paris lives with its river, intimately, amorously. . . . The Seine is the symbol of Paris for the Parisians and for all the French." Ibid., 3.
4. See Anthony Glyne, *The Seine* (New York, 1967), 5.
5. The most powerful discussion of Paris as a world capital is, of course, found in the numerous texts about the city by its greatest modern apologist, Victor Hugo. Writing from exile in 1867, in an essay simply entitled "Paris," Hugo called Paris the capital of France, of Europe, and of mankind. See Victor Hugo, "Paris," 1867, 17.
6. There are many discussions of the seal of Paris. The most recent—and accessible in English—is in Ehrlich, *Paris on the Seine*, 4.
7. We know well by now that, although the term "Impressionism" was adopted by the artists in their third exhibition of 1877, it was not invented by them. For a wonderfully piquant discussion of the politics of the name see Stephen F. Eisenman, "The Intransigent Artist or How the Impressionists Got Their Name," in Charles S. Moffett et al., *The New Painting, Impressionism 1874–1886* (San Francisco, 1986), 51–60.
8. What is particularly odd, given the ubiquitous status of Impressionist landscape in global popular taste, is that so few of the existing books on the Seine are illustrated with Impressionist paintings. The "literary" Seine is most often illustrated with photographs, prints from drawings, and topographical views rather than the many thousands of paintings. This is apparent in one of the more recent books on the subject, Jean H. Prat's *Si la Seine m'etait contee: l'Homme et la Riviere, La Seine et la France* (Paris, 1969). Veritably obsessed with the source of the Seine, Prat is much less interested in its actual use by the French. He does, however, reproduce one Impressionist painting, Sisley's *The Seine at Port-Marly* of 1875 (pl. 37).

9. Many authors discuss the Seine in the work of the Impressionists, but these references tend to be scattered. Of all modern scholars, Paul Hayes Tucker has dealt most clearly with the Seine as a subject in paintings by Monet, in such publications as his monograph *Monet at Argenteuil* (New Haven and London, 1982) and his book *Monet in the '90s: The Series Paintings* (London, 1989, particularly 233–52 and related notes). His monograph *Monet: His Life and Art* (New Haven and London, 1995) deals briefly with Monet's representations of the Seine from other phases of his long working life. Tucker's teacher, the great historian of modern iconology Robert L. Herbert, dealt thoroughly with both urban and suburban Seinescapes in and around the capital in *Impressionism: Art, Leisure, and Parisian Society* (New Haven and London, 1988). The work of Richard Shone and Sylvie Patin on Sisley has dealt with that artist's representations of the Seine, but more in the context of the painter's own oeuvre. Several sections of the exhibition catalogue *A Day in the Country: Impressionism and the French Landscape* (Los Angeles, 1984) deal with the Seine and its imagery. And the widely accessible, recent scholarship on Caillebotte, Seurat, Manet, and Renoir has also dealt with these issues. In most of these texts, the iconography of the Seine serves as a foil for discussing larger issues, such as nationalism, capitalist economic developments, leisure, industry, and "modernism."
10. Georges Chabot, *Geographie regionale de la France* (Paris, 1966), 270.
11. Sir Edward Thorpe, *The Seine from Havre to London* (London, 1913), 7–9.
12. Maxime du Camp, *Paris, ses organes, ses fonctions, et sa vie dans la seconde moitie du XIXe siècle* (Paris, 1875), 364–80.
13. Of the many published discussions of this modernization process, the clearest in English is Thorpe, *Seine*, 9–24.
14. Ibid., 7.
15. Du Camp, *Paris*, 359–60.
16. Henry James, *Parisian Sketches, Letters to the New York Tribune, 1875–6* (New York, 1957), 41.
17. Du Camp, *Paris*, 406.

18. Ibid., 364.
19. A particularly splendid example is *Picturesque Tour of the Seine from Paris to the Sea* (London, [1821]).
20. *Les Français peints par eux-mêmes* (Paris, 1861), 241.
21. Arthur Bartlett Maurice, *The Paris of the Novelists* (New York, 1919), 197.
22. Ibid.
23. See "Une journée a l'école de natation" by Eugène Briffault, in *Le Diable a Paris* (Paris, 1945), 123–45.
24. Thorpe, *Seine*, VIII–IX.
25. James, *Parisian Sketches*, 190.
26. This photograph was published in Louis Desire Blanquart-Evrard's collection of photographs entitled *Etudes et Paysages*, published in 1853–54. It appears on the cover of *The Art of the French Calotype* by Andre Jammes and Eugenia Parry Janis (Princeton, NJ, 1983).
27. See James Borcomon, *Charles Nègre, 1820–1880* (Ottawa, 1976), plates 18, 20, and 21, entitled, respectively, *Paris, Scene de Marche au port de l'Hôtel de ville*, *Paris, Marchand de pommes au port de l'Hôtel de ville*, and *Paris, vendeur de cresson sur les quais*.
28. The volumes of photographs by Achille Quinet in the Bibliothèque Nationale were deposited at the library in 1875, but the photographs themselves were made through the previous decade. The river photographs are found in volume III, and plates 73, 127, 129, and 132 are perhaps the best. Some Seinescapes made at St. Cloud are also found in volume I.
29. Bevan's album was partially reproduced and discussed in this author's essay "The Cradle of Impressionism," in Richard R. Brettell et al., *Day in the Country*, 79–87.
30. Gustave Flaubert, *Sentimental Education* (New York, 1957), 1.
31. Ibid., 2.
32. Ibid., 9.
33. The truth of this becomes particularly clear after reading Wolfgang Schivelbusch's brilliant first book *The Railway Journey: Trains and Travel in the 19th Century*, trans. A. Hollo (New York, 1979).
34. Maurice, *Paris of the Novelists*, 199.
35. Emile Zola, *Thérèse Raquin*, trans. Andrew Rockwell (Oxford, England, 1992), 58–59.
36. Ibid., 60.
37. Steegmuller, *Maupassant*, 84.
38. Maurice, *Paris of the Novelists*, 200.
39. See *The Best Short Stories of Guy de Maupassant*, introduction by Arthur Symons (New York, 1944), 87.
40. Ibid., 103.
41. English quotation from Steegmuller, *Maupassant*, 48–50.
42. For this translation see *Guy de Maupassant, Selected Stories*, vol. III, trans. and ed. Dora Knowlton Ranous (New York, 1912), 11.
43. *Best Short Stories of Maupassant*, 113.
44. *Maupassant, Selected Stories*, vol. VIII, 18.
45. Ibid., 30.
46. Emile Zola, *The Masterpiece*, trans. Thomas Walton (Ann Arbor, 1968), 15.
47. Ibid., 63.
48. Ibid., 104–105.
49. Ibid., 168.
50. Ibid., 113–14.
51. Ibid., 235.
52. Ibid., 343.
53. This information comes from the useful "reprints" of the catalogues of the eight exhibitions included in the landmark publication *The New Painting*.
54. Even Henry James experienced this extraordinary flood. In a letter to the *New York Tribune* of 21 May 1876, he observed "the suffering and injury inflicted upon the poor people, who form almost exclusively the population of the flooded quarters" and indicated that "its present condition, like a great many painful and cruel things, was extremely picturesque" (James, *Parisian Sketches*, 112).

An Icon of Modern Art and Life

Renoir's *Luncheon of the Boating Party*

Charles S. Moffett

They say that in painting you must look for nothing and hope for nothing except a good picture and a good talk and a good dinner as the height of happiness, without counting the less brilliant parentheses.

Vincent van Gogh[1]

The enduring popularity and appeal of Pierre-Auguste Renoir's *Luncheon of the Boating Party* (pl. 60) is attributable to several factors, the most salient being its subject matter. Virtually everyone who stands in front of the painting would welcome the opportunity to participate in such a gathering, the scene is so alluring and sympathetically presented. On a beautiful summer day a group of young Parisians has come together to enjoy a meal in a fine restaurant along the river. The painting is about the pleasures of food, friendship, conversation, and good weather. Moreover, within this remarkable composition reside an exceptional group portrait and an outstanding still life.

Although we know that the setting was the Restaurant Fournaise (fig. 13), which still exists on an island in the Seine near the town of Chatou, the site was not identified in the title when the painting was first shown in 1882 in the seventh Impressionist exhibition. In fact, it was misidentified as *Un déjeuner à Bougival.* We do not know whether the title in the catalogue of the seventh Impressionist exhibition was provided by the artist or his dealer, Paul Durand-Ruel, the first owner of the painting.[2] If Renoir supplied the incorrect title, he may not have wanted the image to be read as a group portrait of actual people painted *en plein air* and *sur le motif.* Perhaps he hoped to obviate a discussion of specific individuals, some of whom were well known in the Parisian art world. Possibly he wished to avoid interpretation of the painting as merely a group portrait of the artist's own friends in a popular restaurant along the Seine. Regrettably, we do not know if he intended it to be understood as fiction or nonfiction. Nevertheless, it is inarguably a benign and positive interpretation of a gathering that is the antithesis of the scathing observations offered by Gustave

Pierre-Auguste Renoir, *Luncheon of the Boating Party*, 1880–81 (detail of pl. 60)

Courbet's *Burial at Ornans* of 1849–50 (fig. 67). In contrast to Courbet's pointed realist statement, nothing about *Luncheon of the Boating Party* seems hostile. It is pleasant, inviting, and, at first glance, seemingly devoid of social or political commentary.

After the viewer encounters *Luncheon of the Boating Party* and marvels at its execution, composition, and mood, the painting provides little further indication of its meaning. Indeed, perhaps there is nothing else. If this is the case, the painting is little more than a grandiose Impressionist snapshot. However, as Eliza Rathbone points out, the painting offers much to be seen and discovered.[3] The cast of characters can be identified, and the figures are a fascinating assemblage of individuals, each of whom posed individually for the artist during the summer and fall of 1880.[4] Among the group are Aline Charigot, the artist's future wife, seated at the lower left; Alphonse Fournaise, Jr., and his sister Alphonsine, the son and daughter of the proprietor, leaning on the railing at the left; Charles Ephrussi, the top-hatted figure in the background, who was a successful banker, amateur art historian, and collector of Impressionist paintings; the actress Ellen Andrée, well known as the model for the female figure in Degas's *Absinthe* of 1876 (fig. 68), seated in the middle ground with a glass raised to her mouth; Jeanne Samary, an actress, depicted at the far right speaking to two of Renoir's friends, Eugène Lestringuez and Paul Lhote; and Gustave Caillebotte, the Impressionist painter and collector, who is seated in the lower right foreground engaged in conversation with the journalist Maggiolo (standing) and Angèle, a well-known model. No doubt Renoir made a special effort to give Caillebotte a prominent position in the composition and to portray him sympathetically, because he was both an important collector and an occasional organizer of the Impressionists' exhibitions.

Renoir also painted a particularly flattering portrait of Mademoiselle Charigot, the attractive young woman whose attentions he sought.

It is possible to speculate about the figures depicted and their relationship to each other as well as to the artist, but no evidence suggests the composition reflects either an intentional or an unintentional drama.[5] Ultimately, the painting depicts an experience that was and is common to most French men and women, especially those Parisians who sought relief and distraction from the city. Villages along the Seine to the west of Paris were accessible by train (pls. 23 and 31), and day trips and weekend excursions were easily undertaken. For most people, an outing to La Grenouillère (pls. 2 and 3), the Restaurant Fournaise, or a similar establishment was a common, affordable pleasure. In fact, on 23 August 1879 *La Vie Moderne*, a publication with which Renoir was very familiar, included a poem that describes a raucous luncheon at the Restaurant Fournaise.[6]

In the lives of Europeans of the second half of the nineteenth century, restaurants and cafés were of paramount importance. Throughout Europe they continue to serve a significant role in society, although one that is somewhat mitigated by modern telecommunications and other forms of access to information. People met in cafés and restaurants to eat, drink, talk, observe, be seen, amuse themselves, and interact with others. Monet's description of the conversations and discussions at the Café Guerbois around 1869 suggests what one might have overheard on the second-floor balcony of the Maison Fournaise in the early 1880s. "Manet invited me to join him every evening at a café in the Batignolles quarter [of Montmartre] where he and his friends would gather and talk after leaving their ateliers. There I met Fantin-Latour, Cézanne, and Degas, who joined the group shortly after his return from Italy, the art critic Duranty, Zola, who was then embarking on his literary career, as well as some others. I myself brought along Sisley, Bazille, and Renoir. Nothing was more interesting than our discussions, with their perpetual clash of opinion. They sharpened one's wits, encouraged frank and impartial inquiry, and provided enthusiasm that kept us going for weeks and weeks until our ideas took final shape. One always came away feeling more involved, more determined, and thinking more clearly and distinctly."[7]

Of course, Monet's description is that of a gathering of artists, writers, and critics, but the group in Renoir's painting includes a journalist, a writer, two actresses, and two distinguished collectors, one of whom was also a leading Impressionist painter. In short, it is likely that from time to time the conversation turned to subjects analogous to those described by Monet, but about a dozen years had passed, and the situation was different. The Second Empire had fallen

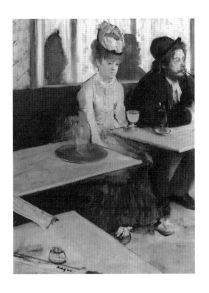

68. Edgar Degas, *Absinthe*, 1876, oil on canvas, 37 × 27 ½ in. Musée d'Orsay, Paris.

133

69. Ernest Meissonier, *Memory of Civil War (The Barricades)*, 1849, oil on canvas, 11 ½ × 8 ½ in. Musée du Louvre, Paris.

70. Ernest Meissonier, *The Ruins of the Tuileries*, 1871, oil on canvas, 53 ½ × 37 ¾ in. Musée National du Château de Compiègne.

(1870); France had suffered a humiliating defeat in the Franco-Prussian War (1871); the violent civil upheaval known as the Commune had racked Paris in 1871; the French economy, burdened by the war reparations demanded by Prussia, had suffered a six-year depression; and Corot, Courbet, Millet, Couture, Carpeaux, Daubigny, and Daumier had died. In short, the old order was passing

quickly. The social and geographical appearance of Paris had also been dramatically affected by the massive replanning and rebuilding of the city as designed and directed by Baron Georges Eugène Haussmann during the Second Empire. Furthermore, with the inception of the Third Republic (1871) the political balance of power had begun to shift meaningfully to the bourgeoisie.

What is not apparent when looking at *Luncheon of the Boating Party* is that the comfort and well-being of those assembled resulted, at least in part, from the social and political upheaval of the Revolution of 1848, the Franco-Prussian War, the Commune, and the new political situation. Meissonier and Manet, among others, recorded the aftermath of the devastating violence that signaled the forces

71. Edouard Manet, *The Rue Mosnier with Flags*, 1878, oil on canvas, 25 ¾ × 31 ¾ in. Collection of the J. Paul Getty Museum, Los Angeles, California.

of change in French society in 1848 and 1870–71 (figs. 69–71). A mere ten years after the Franco-Prussian War and the creation of the First Republic, the French middle class—*la France bourgeoise*—had begun to take control of many aspects of life that had previously been rigidly controlled by the government and/or government-sanctioned institutions. During the 1860s, for example, the Ministry of Culture, directed by Count de Nieuwerkerke, had been the official arbiter of taste in the arts. Not until after the fall of the Second Empire in 1870 did art dealers, collectors, and entrepreneurs begin to exert as much influence as had the government in matters of artistic and aesthetic excellence. To a certain extent, market forces then began to define standards in the arts. Collectors, dealers, and critics sympathetic to the modern movement started to supplant the official system. One's position as a Membre de l'Institut, a professor at the Ecole des Beaux-Arts, a Salon juror, or a winner of the Prix de Rome became considerably less significant than had previously been the case.

One of the principal manifestations of change was the burgeoning influence and importance of the eight Impressionist exhibitions held between 1874 and 1886, organized by the painters of the avant-garde as an alternative to the conservative, officially sanctioned, juried exhibitions known as the Salons.[8] In addition, it became increasingly more meaningful for an artist to be represented by Durand-Ruel, Georges Petit, or Bernheim-Jeune than to win a medal in a Salon. Of course, the official recognition that accompanied a medal from the Salon jury remained significant in certain quarters. Manet, who from the beginning eschewed participation in the Impressionist exhibitions in favor of the Salon, was finally awarded a medal in 1881. Renoir and Sisley exhibited in the Salon of 1878, a year when no Impressionist show was held. After the success of *The Cup of Chocolate* by Renoir (fig. 72) in the Salon of 1878, Cézanne and Monet joined Renoir and Sisley in submitting work to the Salon of 1879. The submissions of Cézanne and Sisley were rejected that year but those of Monet and Renoir were accepted. Among the reasons these artists defected from the independent exhibitions in favor of the Salon were complaints that the group shows had neither generated significant sales nor produced an entirely salutary effect on the reputations of the participants. Furthermore, the late 1870s and early 1880s were a time of complex transition, as individual members of the avant-garde began to achieve varying degrees of critical and financial success. In addition, some artists were exploring stylistic alternatives to the "high" or "classic" Impressionism of the early and mid-1870s.[9]

Renoir was one of the first Impressionist painters to enjoy commercial

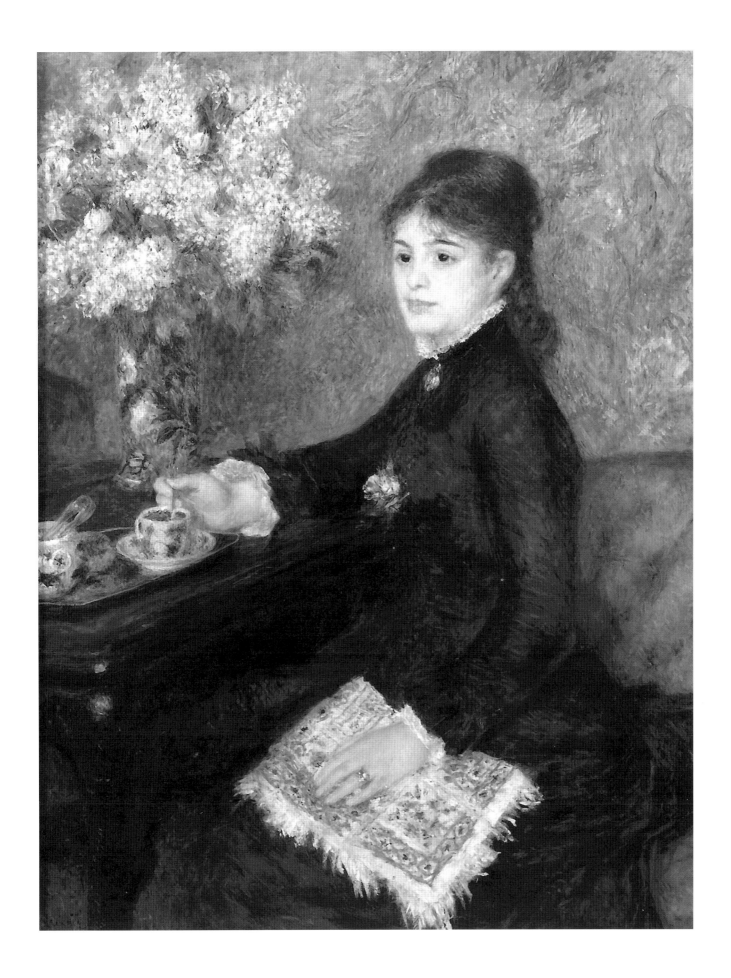

recognition. His success, however, is attributable not to the more daring paintings that he presented in the Impressionist group shows of 1874, 1876, and 1877 but instead to the more conservative figure paintings and portraits that were shown in the Salons. His first submission to the Salon that attracted attention was *The Cup of Chocolate*, but his reputation was assured the following year with *Madame Charpentier and Her Children* (fig. 73), one of the most popular paintings in the Salon of 1879. As John Rewald notes, "The critics unanimously acclaimed the painting; for the first time Renoir could feel that he had almost arrived. Castagnary, still hostile to Manet, whom he accused of making concessions to the bourgeois, highly praised Renoir's 'agile and intellectual brush,' his 'lively and happy grace,' and the enchantment of his color."[10] The portrait depicts the wife and children of Georges Charpentier, the eminently successful publisher of Daudet, Maupassant, Flaubert, the de Goncourt brothers, and Zola, among others. Madame Charpentier, with her daughter and son, are seen in the modish *japoniste* drawing room of the family's elegant house on the rue de Grenelle. As a result of his success in the Salon, Renoir soon became the painter of choice among some of the wealthiest families in Paris. Moreover, he was represented by Durand-Ruel, the most important dealer of Impressionist paintings in Paris and New York. He had become a fashionable painter of fashionable people.

One of the few rules upon which the organizers of the group exhibitions insisted was that if an artist participated in the Salon, he or she would be barred from the independent exhibitions. In short, Renoir had to defect from the Impressionist exhibitions to find fame and create a market for his work. In a letter of 27 May 1879 to the collector/pastry chef/restaurateur Eugène Murer, Pissarro reported sympathetically that "[Renoir] has been a great success at the Salon. I think he has made his mark. So much the better; poverty is so hard."[11]

Renoir's decision to abandon his friends and colleagues was not made without controversy. In 1881, the year Renoir finished *Luncheon of the Boating Party*, his defection from the independent exhibitions was apparently still a matter of discussion. In a letter of March 1881 to Durand-Ruel, Renoir argued rather defensively that his defection was purely a business decision that entailed no stylistic compromises. "I am going to try to explain to you why I submit to the Salon.

"There are in Paris scarcely fifteen art-lovers capable of liking a painting without Salon approval. There are 80,000 who won't buy an inch of canvas if the painter is not in the Salon. This is why each year I am sending two portraits. Furthermore, I don't want to descend to the folly of thinking that anything is good or bad according to the place it is hung. In a word, I don't want to waste my

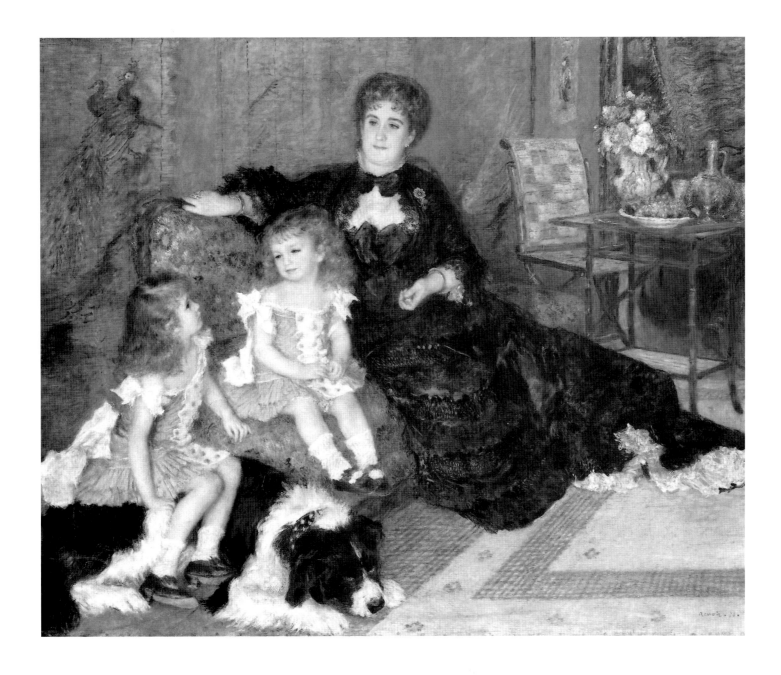

time in resentment against the Salon: I don't even want to give that impression. I believe one must do the best painting possible. That's all. Well, if I were accused of neglecting my art, or of being motivated by idiotic ambition and making sacrifices against my convictions, then I should understand the carpers. But since that doesn't come into question, there is nothing to say against me. . . . A little more patience and shortly I hope to give you some proof that one can submit to the Salon and do good painting.

"I beg you to plead my cause with my friends. My submitting to the Salon is entirely a business matter."[12]

Indisputably, the economic motives for seeking success in the Salon were

73. Pierre-Auguste Renoir, *Madame Charpentier and Her Children*, 1878, oil on canvas, 60 1/2 × 74 7/8 in. The Metropolitan Museum of Art, New York, Wolfe Fund, 1907.

compelling, and in a letter of 24 January 1881 to Pissarro, Caillebotte under-scored the importance of Pissarro's comment to Murer in 1879 that "poverty is so hard." Significantly, Caillebotte's remarks were made in the midst of a discus-sion about defectors from the group exhibitions. "If there is anyone in the world who has the right not to forgive Renoir, Monet, Sisley, and Cézanne, it is you, because you have experienced the same practical demands as they and you have not weakened. . . . You know that there is only one reason for all this, the needs of existence. When one needs money, one tries to pull through as one can. Although Degas denies the validity of such fundamental reasons, I consider them essential."[13]

In a letter of 8 March 1880 to critic Théodore Duret, the author of *Les Peintres Impressionistes* (1878), Monet similarly emphasized the financial motives that led him to submit to the Salon the year before, but he also stressed the fail-ure of the group exhibitions to generate meaningful attention. "Since you are among those who have often advised me to submit again to the official jury, it behooves me to let you know that I am going to try this experiment. . . . It's a big gamble that I am taking, without even counting that I am treated like a turncoat by everyone in the group, but I believe that it is in my best interest to do so as I am rather certain of doing some business, notably with [the dealer] Petit, once I have forced the door of the Salon. But it is not out of pleasure that I do this, and it is very unfortunate that the press and the public have taken little serious inter-est in our exhibitions which are very preferable to the official emporium. But finally, since everyone visits it, so will I."[14] It is easy to imagine that Duret also encouraged his friend Renoir to abandon the independent exhibitions in favor of the Salon, and that the latter, too, believed that the potential gains far out-weighed the risks, including incurring the wrath of the artist's friends and colleagues.

From the painting's inception Renoir very likely intended to exhibit *Luncheon of the Boating Party* at the Salon of 1882. The substantial size and exceedingly ambitious composition suggest that the artist had created a painting meant to compete with those large works known as *machines* that academic artists often sent to the official exhibition. Indeed, not long before the seventh Impressionist exhibition, Renoir told Durand-Ruel that he would continue to submit work to the Salon. As Rewald notes, "[Renoir] wrote several ill-tempered letters to Durand-Ruel, explaining that he was again exhibiting at the Salon and refusing to join in any show of the so-called *Independents*. . . . Yet he definitely authorized Durand-Ruel to show pictures of his, owned by the dealer, on the condition that

they be listed as loaned by Durand-Ruel and not by himself."[15]

As it happened, Durand-Ruel, who represented all of the Impressionists and who took the lead in organizing the seventh group show, included *Luncheon of the Boating Party* in the independent exhibition of 1882. Nevertheless, Renoir had probably conceived and executed the painting as a response to a challenge offered in one of Zola's reviews of the Salon of 1880. John House has observed that Renoir's *Luncheon of the Boating Party*, "undertaken just after Zola's 1880 Salon reviews, reflects both Renoir's own dissatisfaction and the novelist's challenge";[16] moreover, "*Luncheon of the boating party*, with its many figures and complex spatial organization, was a more ambitious project than any [earlier work] except for *Ball at the Moulin de la Galette* [fig. 10]. . . . Renoir had come to see the limitations of an exclusive dedication to open-air effects. Portrait commissions had forced him to individualize his figures more precisely, and in his handling of paint he had experimented with alternatives to the freely brushed, superimposed layers of colour of *Ball at the Moulin de la Galette*."[17]

In the review itself Zola had in fact inveighed against informality and sketchiness. Speaking about Monet, he complained, "Too many informal drafts have left his studio in difficult hours, and that is not good; it pushes an artist on the slope of unworthy and cheap creation. If one is too easily contented, if one sells sketches that are hardly dry, one loses the taste for works based on long and thoughtful preparation. . . ."[18] Later in the essay Zola issued a rhetorical challenge addressed to no one in particular. "The real misfortune is that no artist [among the Impressionists] has achieved powerfully and definitely the new formula which, scattered through their works, they all offer. The formula is there, endlessly diffused; but in no place, among any of them, is it to be found applied by a master. They are all forerunners. The man of genius has not yet arisen. We can see what they intend, and find them right, but we seek in vain the masterpiece that is to lay down the formula. . . . This is why the struggle of the impressionists has not yet reached a goal; they remain inferior to what they undertake, they stammer without being able to find words."[19]

Luncheon of the Boating Party appears to address this issue directly. It is a large, fully realized composition designed to impress, astonish, and delight. Moreover, the painting is clearly the polar opposite of the works that Zola characterized as "informal drafts" and "sketches that are hardly dry," and it answers the critic's wish for "long and thoughtful preparation."[20]

Comments about *Luncheon of the Boating Party* in reviews of the seventh Impressionist exhibition were generally favorable, but those offered by the

prominent and influential critic Armand Silvestre, writing in *La Vie Moderne* on 12 March 1882, suggest that Renoir had indeed replied to the objections raised by Zola two years earlier. "Renoir is unique among this essentially liberal group. His *Déjeuner à Bougival* seems to me one of the best things he has painted; shaded by an arbor *[sic]*, bare-armed boatmen are laughing with some girls. There are bits of drawing that are completely remarkable, drawing—true drawing—that is the result of the juxtaposition of hues and not of line. It is one of the most beautiful pieces that this insurrectionist art has produced. For my part, I found it absolutely superb."[21] Silvestre's observations about the "essentially liberal group," "drawing," and the artist's command of color indicate that he admired *Luncheon of the Boating Party* as a serious work of art, one far different from the "informal drafts," "unworthy and cheap creation[s]," and "sketches that are hardly dry" about which Zola had complained. In short, the size, finish, and ambition of the painting identify it as a candidate for what Zola characterized as "the masterpiece that is to lay down the formula."

Nevertheless, in terms of the range of Renoir's stylistic achievement, and that of his "insurrectionist" colleagues, *Luncheon of the Boating Party* is a relatively conservative work. It is tighter, more anatomically precise, and less virtuoso in its brushwork than many other Impressionist paintings, including numerous examples by Renoir himself. As John House has observed, "In the mid-1870s, [Renoir] had adopted a style which largely replaced drawing and traditional tonal modeling with juxtaposed patches of color; later in the decade, though, he had begun to move in more fashionable circles and to gain portrait commissions. The demands of depiction and the expectations of sitters forced him sometimes to adopt more traditional methods, though he continued at the same time to paint some of his boldest color-patch paintings."[22] The careful rendering of *Luncheon of the Boating Party* is yet another indication that the painting was probably intended to be judged by the Salon jury. That Manet's more stylistically advanced *A Bar at the Folies-Bergère* (fig. 74) appeared in the Salon of 1882, while Renoir's larger and more conservative canvas was seen in the Impressionist exhibition, is not without a degree of irony. Moreover, while Manet took great delight in challenging the visitors to the Salon visually, intellectually, and stylistically, it seems that by 1882 Renoir had begun purposefully to distance himself from revolutionary art or paintings that commented critically on society. In a rough draft of a letter that Renoir dictated to his brother while the artist was in bed with pneumonia in l'Estaque in 1882, he stated his position while explaining his reluctance to participate in the seventh

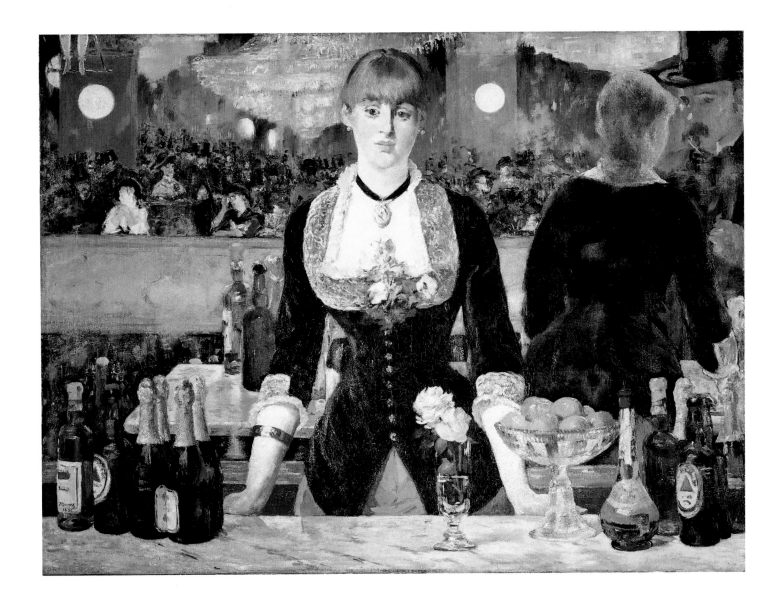

74. Édouard Manet, *A Bar at the Folies-Bergère*, 1881–82, oil on canvas, 37 3/4 × 50 in. Courtauld Institute Galleries, London.

Impressionist exhibition. "To exhibit with Pissarro, Gauguin, and Guillaumin is as if I were to exhibit with some sort of socialist group. A little farther and Pissarro will invite the Russian [anarchist Pierre] Lavrof or some other revolutionary. The public doesn't like what smells of politics and I certainly don't want, at my age, to become a revolutionary."[23]

A few lines later in the same text Renoir tried to justify his position from the vantage point of both style and content. "Get rid of [Pissarro, Gauguin, and Guillaumin] and give me artists like Monet, Sisley, Morisot, etc., and I am with you, for it's not about politics, it's about pure art." One must remember, however, that the comment about "pure art" was made by an artist whose experiments with a more conservative manner had yielded significant benefits. He no longer wanted to be associated with artists whose ideas and work might offend the suc-

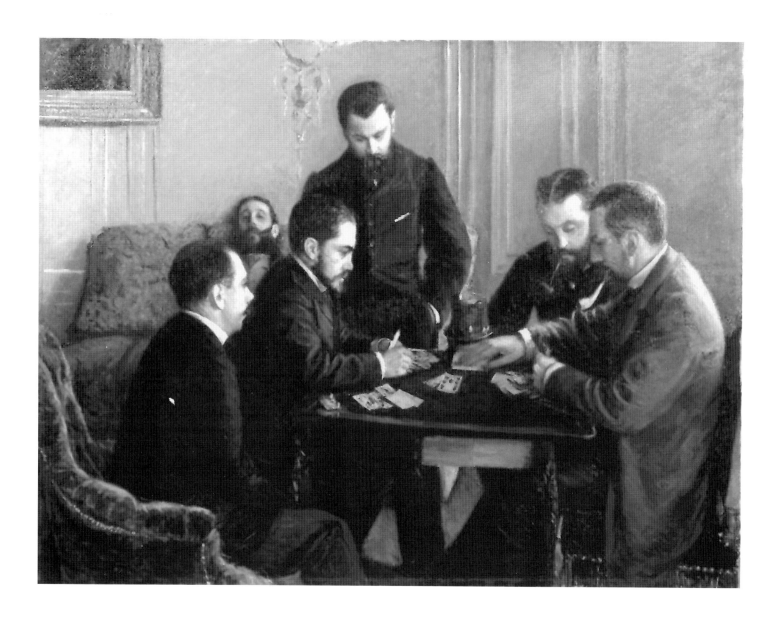

75. Gustave Caillebotte, *The Bezique Game*, 1880, oil on canvas, 49 5/8 × 63 3/8 in. Private collection, Paris. Courtesy of Galerie Brame et Lorenceau, Paris.

cessful bankers and businessmen who collected his work and commissioned portraits of their wives and children. He had grown accustomed to the drawing rooms of Paris, to women who wore designer clothes, such as Madame Charpentier's Worth dress (fig. 73), and to the country house in Wargemont that belonged to his patron Paul Bérard. As Renoir himself noted in the letter he drafted in l'Estaque, "I took a big step forward as a result of showing at the Salon. It is a matter of not losing what I have gained."[24]

While Parisians in 1882 and art historians in the twentieth century might have enjoyed seeing *Luncheon of the Boating Party* and Manet's *A Bar at the Folies-Bergère* in the Salon, the decision to include his painting was not Renoir's to make. Indeed, shortly after he finished the painting, the artist sold it to the Durand-Ruel gallery in February 1881.[25] As Joel Isaacson has noted, "[Renoir] realized, as did

Monet, that he could do nothing to prevent Durand-Ruel from showing [in the 1882 Impressionist exhibition] the paintings he already owned and so resigned himself to his inclusion."[26] A further complication was that Durand-Ruel had emerged as the organizer of the seventh (1882) Impressionist exhibition. In the midst of a situation increasingly dominated by bitterness and fractiousness, the dealer stepped forward to try to unite the group. According to Rewald, "At this moment, apparently, Durand-Ruel took the matter into his own hands. Since he was again the dealer who exclusively handled the pictures of the Impressionists, he was not only annoyed by their disputes but actually interested in the projected exhibition. . . . He himself now wrote to Monet and Renoir, pressing them to join the others. Renoir's answer was that he would follow Durand-Ruel in whatever projects he had, but declined to deal with his colleagues. He was sour because the show had been discussed without him, because he had not been invited to the three previous exhibitions, and because he suspected that he was asked only to fill a gap. . . . Monet's answer was more or less the same. He refused to be associated with artists who did not belong to the real Impressionist group. But upon Durand-Ruel's insistence he, too, felt embarrassed in declining an invitation from the man who had done so much for him and his comrades."[27] In addition, it is worth noting that the dealer was under unanticipated financial pressure, which motivated him to assure the success of the show.

When the seventh Impressionist exhibition opened in March 1882, the distinguished novelist and critic J.-K. Huysmans excoriated the infighting and bickering that had reduced the participating artists to eight. "The circle of Modernism has really become too restricted and one cannot sufficiently deplore this diminution that vile quarrels have brought about in the collective effort of the little group. . . ."[28] Nevertheless, the exhibition attracted meaningful attention and interest. Although Caillebotte's *The Bezique Game*, a conservatively rendered depiction of cardplayers (fig. 75), was favored by most critics, at least three—de Charry, de Nivelle, and Silvestre—praised *Luncheon of the Boating Party* as the best work in the exhibition, perhaps, as Isaacson comments, "because of its rare and successful amalgam of Impressionist richness and delight in the color of the open air with a firm treatment of figural form."[29] Silvestre judged it "absolutely superb," but the equally influential Albert Wolff, the mercurial critic for *Le Figaro*, found fault: "If he had learned to draw, Renoir would have a very pretty picture in his *Repas des canotiers*. . . ."[30]

Regardless of the praise or quips of critics, scholars, and the interested public of the last century and beyond, *Luncheon of the Boating Party* remains one

76. Delivery truck for la Madeleine Bakery & Café, Bethesda, Maryland, 1996, photograph.

of the most popular and appealing images in any museum in the world. It seems not to matter whether Renoir defected from the Impressionist exhibitions, carped about his colleagues, abjured "revolution" and "what smells of politics," compromised his integrity as a painter of advanced tendencies in an effort to satisfy Salon jurors and wealthy patrons, or managed ever again to paint a work as beautiful, complex, or important as *Luncheon of the Boating Party.* He created an image that transcends borders, languages, cultures, and time. As Duncan Phillips wrote the treasurer of his new museum shortly after he purchased the painting from the Durand-Ruel gallery in 1923, "people will travel thousands of miles to our house to see it" (fig. 97).[31] Today, people continue to travel from all over the world to see this painting that they know from reproductions, books, postcards, posters, calendars, sugar packets, advertisements for cheese and wine, illustrations on the sides of bread trucks (fig. 76), and of course, the visual vernacular that has been created by scores of books about Renoir and Impressionism. *Luncheon of the Boating Party* has taken its place as an icon in the lexicon of modern popular culture.

Among the many reasons it continues to fascinate is its cinematic quality. It could be a single frame from a recent movie based on the lives of a group of artists, collectors, and actresses in Paris in the early 1880s. Indeed, its sense of immediacy is equalled by only a few paintings of the 1870s and 1880s, especially

77. Edouard Manet, *The Plum*,
c. 1877, oil on canvas, 29 × 19 ¾ in.
National Gallery of Art,
Washington, D.C., Collection of
Mr. and Mrs. Paul Mellon.

those by Manet and Degas. Photography was not capable of this in 1880–81; such imagery was still in the domain of the painter (figs. 68 and 77). Even though we observe the scene before us as if through the lens of a camera, we have not inter-

78. Pierre-Auguste Renoir, *Luncheon of the Boating Party* (detail), 1880–81. The Phillips Collection, Washington, D.C. (pl. 60).

rupted the group; they continue their conversations oblivious to our presence.

More importantly, *Luncheon of the Boating Party* is the full realization of the kind of art that Edmond Duranty described in his essay of 1876, "The New Painting: Concerning the Group of Artists Exhibiting at the Durand-Ruel Galleries."[32] Early in the essay Duranty quotes the artist Eugène Fromentin, who scornfully wrote, "If one keeps at all current with the new trends . . . he notices that the goal of the new painting is to assail the eyes of the public with striking and literal images, easily recognizable in their truthfulness, stripped of all artifice,

and to recreate exactly the sensation of what is seen in the street. The public is only too ready to celebrate an art that so faithfully depicts its own costumes, faces, customs, tastes, habits, and spirit." Duranty, however, admired such "trends" as advances. Later in the essay he added, "Farewell to the human body treated like a vase, with an eye for the decorative curve. Farewell to the uniform monotony of the bone structure, to the anatomical model beneath the nude. What we need are the special characteristics of the modern individual—in his clothing, in social situations, at home, or on the street. . . . The very first idea was to eliminate the partition separating the artist's studio from everyday life, and to introduce the reality of the street. . . . It was necessary to make the painter come out of his sky-lighted cell, his cloister, where his sole communication was with the sky—and to bring him back among men, out into the real world. . . . Our lives take place in rooms and in streets, and rooms and streets have their own special laws of light and visual language."[33]

Indeed, Renoir's "special visual language" is particularly evident in the variety of gestures, poses, and postures of the figures depicted in *Luncheon of the Boating Party* (fig. 78). Clothing, body language, and demeanor suggest different classes, moods, and interests. "What we need," exhorted Duranty, "are the special characteristics of the modern individual—in his clothing, in social situations, at home, or on the street. . . . A back should reveal temperament, age, and social position, a pair of hands should reveal the magistrate or the merchant, and a gesture should reveal an entire range of feelings. Physiognomy will tell us with certainty that one man is dry, orderly, and meticulous, while another is the epitome of carelessness and disorder. Attitude will reveal to us whether a person is going to a business meeting, or is returning from a tryst."[34] Although it is not possible to "read" the painting as specifically as Duranty suggests, Renoir does in fact seem to have fully embraced the canon of "the new painting." *Luncheon of the Boating Party* is very much a celebration of popular culture, modern life, and the world beyond the studios of dogmatic painting professors at the Ecole des Beaux-Arts. As such, it epitomizes the spirit of Duranty's essay, as well as that of Baudelaire's landmark essay of 1862, "The Painter of Modern Life."[35]

Not only did Renoir find uncommon beauty in a relatively common experience, but he was also able to elevate the subject to a level of dignity and significance that had eluded the many academic realists and illustrators who had depicted similar or related scenes (fig. 34). The artist succeeded in conveying the importance and great pleasure of an aspect of modern life that is central to *la France bourgeoise*. The sense of reverence for the ritual is unstated but unmistakable. Indeed, the meal

79. Edouard Vuillard, *The Luncheon*, 1912, oil on canvas, 72 1/2 × 42 7/8 in. Private collection. Courtesy of Galerie Brame et Lorenceau, Paris.

80. Albert André, *Seaside Restaurant*, 1918, oil on canvas, 21 ¾ × 25 ⅝ in. The Phillips Collection, Washington, D.C.

shared with friends has taken its place in the iconography of modern life, as is evident in images by Vuillard, André, and Cartier-Bresson (figs. 79–81).

Those attending the luncheon at the Restaurant Fournaise have left their workaday lives in the city and escaped to a restaurant on an island in the Seine. All are young, attractive, and apparently well behaved. The scene depicted could serve as a public relations statement for life in modern France. The promise of *liberté, egalité, fraternité* that began with the French Revolution and continued with the Revolutions of 1830 and 1848, the fall of the Second Empire in 1870 and subsequent rise of the Third Republic, and the adoption of a new constitution in 1875 was finally a reality. Indeed, the Third Republic (which lasted until 1940) had recently begun its second decade. The blood that had run in the streets of Paris during the Commune was rapidly becoming a memory (fig. 71). *La France bourgeoise* was thriving economically, politically, and socially. In the opening lines of *France 1848–1945*, Theodore Zeldin notes, "In France, more than anywhere else, because aristocracy and monarchy were defeated in the great Revolution, the bourgeois appeared manifestly supreme for a century and a half after it, to the extent that the two words have been combined into a single idea: *la*

France bourgeoise. It is argued that it was in this period that the bourgeois attained self-confidence, ceased to aspire to enter the old hierarchy, and sought rather to replace it. He developed his own moral and economic doctrine and formed an original class with a spiritual identity."[36]

To a certain extent, one might well interpret *Luncheon of the Boating Party* as portraying an event that reflects the values and ideals of *la France bourgeoise*. Despite Renoir's aversion to canvases with political content, his painting provides an important window into modern French history. And whether he wished to acknowledge it or not, he was a participant in an ongoing process of revolution, not one with the socialist and anarchist aspirations that Pissarro favored, but rather one that challenged the official artistic establishment through the independent exhibitions that permanently changed attitudes toward art in France and beyond. Renoir had been an insurrectionist, although evidently by the late 1870s or early 1880s he preferred not to be regarded as one in such fashionable places

as the evening gatherings that his patron Madame Georges Charpentier hosted in her large, well-appointed house on the rue de Grenelle.[37] Ironically, in 1886 Renoir refused to participate in the eighth Impressionist exhibition, probably because works by the new insurrectionists, Seurat and Signac, were to be included. There, Seurat exhibited *Sunday Afternoon on the Island of La Grande Jatte* (fig. 82), another extraordinary modern painting devoted to a view of Parisians at leisure on the banks of the Seine. In the early stages of the exhibition's organization, which was undertaken by Berthe Morisot and her husband Eugène Manet, Seurat's controversial large painting generated considerable discussion.[38] It is indeed curious that apparently Renoir, Monet, Caillebotte, and Sisley were unable to recognize and appreciate Seurat and Signac as artists whose works built on and advanced the achievements of the Impressionists, especially such canvases as *Luncheon of the Boating Party*.

Today, both *Luncheon of the Boating Party* and *Sunday Afternoon on the Island of*

82. Georges Seurat, *Sunday Afternoon on the Island of La Grande Jatte*, 1884–86, oil on canvas, 81 ¼ × 120 ¼ in. The Art Institute of Chicago, Helen Birch Bartlett Memorial Collection, 1926.224.

La Grande Jatte are revered as pillars of the modern movement and are instantly recognized by millions of people throughout the world. Moreover, both are the most popular images in the collections of the museums in which they reside. They are veritable icons of modern art, modern life, and the popular culture of the twentieth century. As the work that is very likely the masterpiece called for by Zola in 1880, *Luncheon of the Boating Party* is a summation of the "classic" or "high" phase of the Impressionist movement, while Seurat's great painting is more clearly a harbinger of the art of the next century. Considering the profound differences between the two, perhaps we should not be surprised by the reaction of Renoir and some of his colleagues to the bold new ideas and stylistic innovations of the younger artist.

The relatively brief interval between the creation of these two monuments of avant-garde painting underscores the speed with which art had begun to progress and develop in the modern era. Renoir's greatest painting stood squarely at the crossroads of the modern movement, the years of "the crisis of Impressionism."[39] More than a century later it continues to generate a level of interest and excitement that the artist probably never anticipated or imagined. Although Renoir had created most of his best work by the early 1880s, exceptional works such as *Luncheon of Boating Party* provide ample evidence that he had figured significantly in the challenge to the establishment that changed forever the course of art. He had made a lasting contribution to the ongoing realization of what Duranty called "the first idea" of the new painting: "to eliminate the partition separating the artist's studio from everyday life." Art would never be the same again.

Coincidentally, the year that *Luncheon of the Boating Party* was finished, Picasso entered the world, and when it was first exhibited the following year, Braque was born. The visual icons produced by one generation would soon be joined by those of the next, but images such as *Luncheon of the Boating Party* would remain few and far between. It has permeated our collective consciousness and etched itself in our memories. Unlike most images in the history of art that have attained the status of visual icons, Renoir's painting of the gathering at the Restaurant Fournaise asks little beyond our enjoyment. In this respect it is one of the most hedonistic images in modern art, and it seems to anticipate Matisse's comparison of art to a good armchair. "What I dream of is an art of balance, of purity and serenity devoid of troubling or depressing subject matter, an art which might be for every mental worker, be he businessman or writer, like an appeasing influence, like a mental soother, something like a good armchair in which to rest from physical fatigue."[40]

1. Vincent van Gogh, *The Complete Letters of Vincent van Gogh*, vol. 3, 2d ed., letter no. 631, May 1890 (Boston, 1981), 268.
2. John House et al., *Renoir*, exh. cat. (London, 1985), 223: "Durand-Ruel bought the painting for a high price in February 1881, and sold it that December to the banker Balensi, who, apparently, failed to pay for it. Durand-Ruel took it back in April 1882, and it became one of the centerpieces of his private collection, until in 1923 his sons sold it to Duncan Phillips, in order to finance new premises for the Durand-Ruel Gallery."
3. See Eliza Rathbone, above, 13–55.
4. House, *Renoir*, 223: "[Evidently] the picture was painted additively, with Renoir's various sitters posing when they could visit him in Chatou."
5. Ibid. "Renoir . . . was at pains to prevent the picture, or any of its parts, from being legible in narrative terms. The gestures and expressions of the figures are consistently amicable yet consistently inexplicit; we are given no access to the content of these interchanges or the nature of their relationships. . . . Renoir consistently rejected codes of legibility so widely used in genre painting, using his subjects to evoke moods rather than tell a story."
6. Ibid.
7. François Thiébault-Sisson, "Claude Monet: Les Années d'épreuves," in *Le Temps*, 26 November 1900, 3, as cited in Charles S. Moffett, "Manet and Impressionism," in *Manet: 1832–1883* (New York, 1983), 31.
8. For a thorough study of the eight Impressionist exhibitions see Charles S. Moffett et al., *The New Painting: Impressionism 1874–1886*, exh. cat. (San Francisco, 1986).
9. Joel Isaacson, *The Crisis of Impressionism, 1878–1882*, exh. cat. (Ann Arbor, 1980); also see House, *Renoir*, 220.
10. John Rewald, *The History of Impressionism*, 4th rev. ed. (New York, 1973), 424.
11. As quoted in House, *Renoir*, 214; see also Rewald, *Impressionism*, 430; and A. Tabarant, *Pissarro* (Paris, 1924, and New York, 1925), 45.
12. Lionello Venturi, *Les Archives de l'Impressionnisme* (Paris and New York, 1939), 115, letter of March 1881 from Renoir in Algiers to Durand-Ruel; see also Rewald, *Impressionism*, 416, whose translation is used here.
13. As quoted in Rewald, *Impressionism*, 418.
14. Translation by author; for original French text see Daniel Wildenstein, *Claude Monet: Biographie et catalogue raisonné*, vol. 1 (Lausanne and Paris, 1974), 438, letter no. 173.
15. Rewald, *Impressionism*, 467–68; Venturi, *Les Archives*, 119–22.
16. House, *Renoir*, 220.
17. Ibid., 222.
18. As quoted in Rewald, *Impressionism*, 445; for the original French text see Emile Zola, "Le Naturalisme au Salon" (four articles), in *Le Voltaire*, 18–22 June 1880, reprinted in Emile Zola, *Salons* (Geneva, 1959), 233–54.
19. As quoted in Rewald, *Impressionism*, 445; for the original French text see Zola, *Salons*, 233–54.
20. House, *Renoir*, 223, and Rathbone, above, 13–55.
21. Armand Silvestre, *La Vie Moderne*, Paris, 11 March 1882, as quoted in Moffett et al., *New Painting*, 413.
22. House, *Renoir*, 220.
23. Ralph E. Shikes and Paula Harper, *Pissarro: His Life and Work* (New York, 1980), 178.
24. Ibid., 178.
25. See note 1, above.
26. Joel Isaacson, "The Seventh Exhibition 1882: The Painters Called Impressionists," in Moffett et al., *New Painting*, 377.
27. Rewald, *Impressionism*, 467–68.
28. J.-K. Huysmans (from an article of 1882), "Appendice," *L'Art Moderne* (Paris, 1883), 261–77, as cited in Moffett et al., *New Painting*, 373.
29. Isaacson, in Moffett et al., *New Painting*, 379–80.
30. Albert Wolff, in *Le Figaro* (Paris), 2 March 1882, as quoted in Moffett et al., *New Painting*, 413.
31. Letter from Duncan Phillips in Paris to Dwight Clark in Washington, 10 July 1923, The Phillips Collection archives.
32. Edmond Duranty, "The New Painting: Concerning the Group of Artists Exhibiting at the Durand-Ruel Galleries" (1876), in Moffett et al., *New Painting*, 37–47. Duranty's entire essay is reprinted there in translation.
33. Ibid., 38 and 43–44.
34. Ibid., 43–44. This passage pertains more directly to the work of Degas than to any of the other Impressionists. It underscores the principal weakness of Duranty's essay, in which he attempts to characterize the attributes of the modern movement but focuses on the work of individuals with strong stylistic differences.
35. Charles Baudelaire, *The Painter of Modern Life and Other Essays*, trans. and ed. by Jonathan Mayne (London and New York, 1965/1970), 1–40.
36. Theodore Zeldin, *Ambition, Love, and Politics*, vol. 1 of *France 1848–1945* (Oxford, 1973), 11.
37. Rewald, *Impressionism*, 382.
38. Ibid., 521–22, 608. For a wide ranging discussion of the eighth Impressionist exhibition see Martha Ward, "The Rhetoric of Independence and Innovation," in Moffett et al., *New Painting*, 421–27.
39. Isaacson, *Crisis of Impressionism*, passim.
40. Henri Matisse, "Notes of a Painter," 1908, as quoted in Herschel B. Chipp, *Theories of Modern Art* (Berkeley, Los Angeles, and London, 1968), 135.

The
Exhibition

Preceding page: Claude Monet,
Sailboat at Petit-Gennevilliers, 1874
(detail of pl. 32)

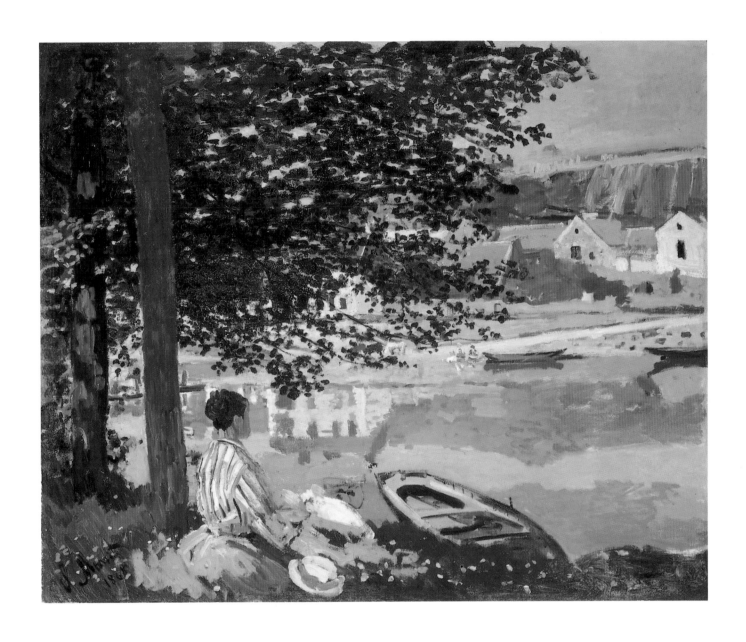

1. Monet, *On the Bank of the Seine, Bennecourt*, 1868, The Art Institute of Chicago, Potter Palmer Collection

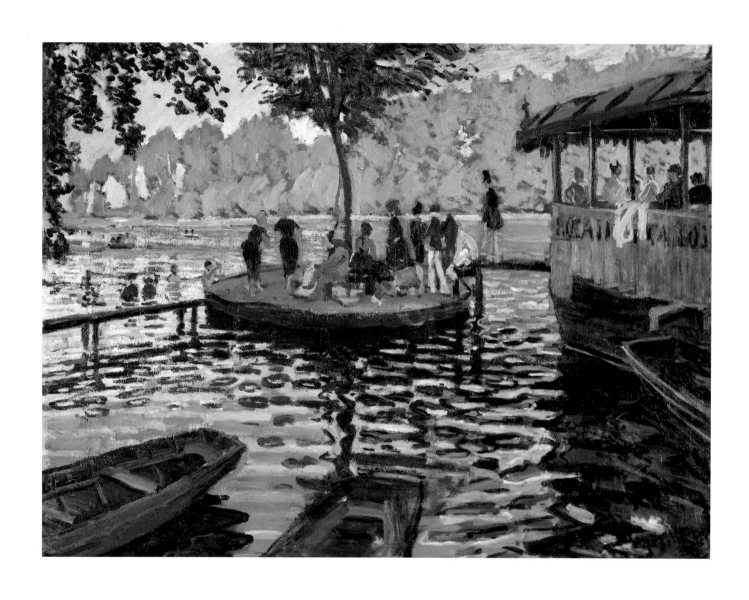

2. Monet, *La Grenouillère*, 1869, The Metropolitan Museum of Art, New York, H. O. Havemeyer Collection, Bequest of Mrs. H. O. Havemeyer, 1929

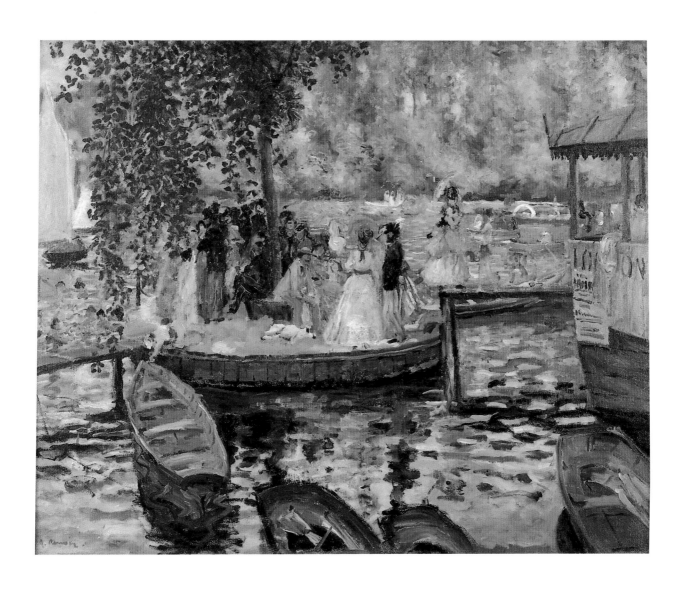

3. Renoir, *La Grenouillère*, 1869, Nationalmuseum, SKM, Stockholm

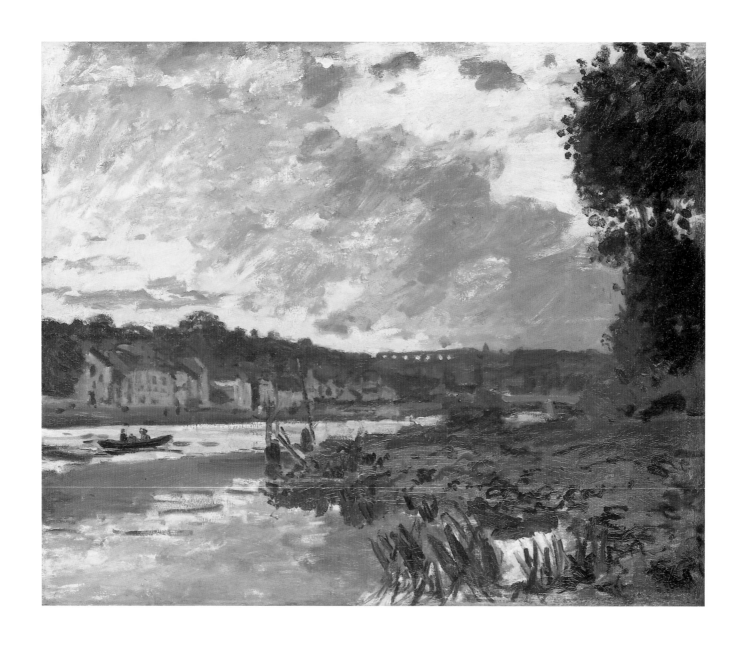

4. Monet, *The Seine at Bougival*, 1869–70, Smith College Museum of Art, Northampton, Massachusetts. Purchased, 1946

5. Pissarro, *The Lock on the Seine at Bougival*, 1871, Marion & Henry Bloch

6. Renoir, *La Grenouillère*, c. 1871–72, private collection, U.S.A., courtesy of the Artemis Group

7. Morisot, *View of Paris from the Trocadero*, c. 1871–72, Santa Barbara Museum of Art, Gift of Mrs. Hugh N. Kirkland

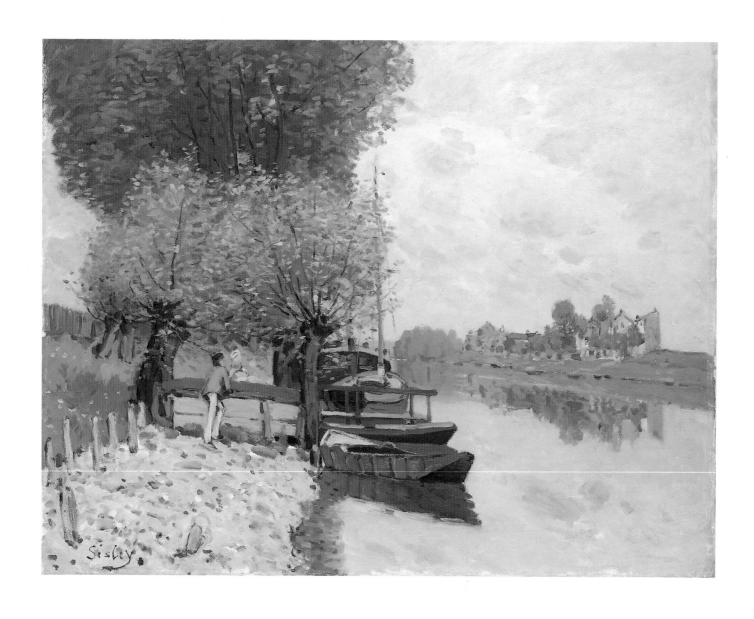

8. Sisley, *The Seine at Bougival*, 1872, Yale University Art Gallery, Gift of Henry Johnson Fisher, B.A. 1896

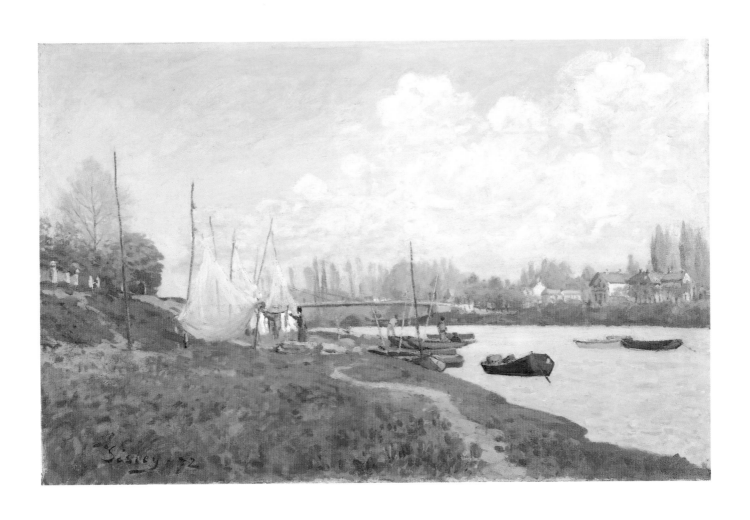

9. Sisley, *Fishermen Drying Their Nets*, 1872, Kimbell Art Museum, Fort Worth, Texas

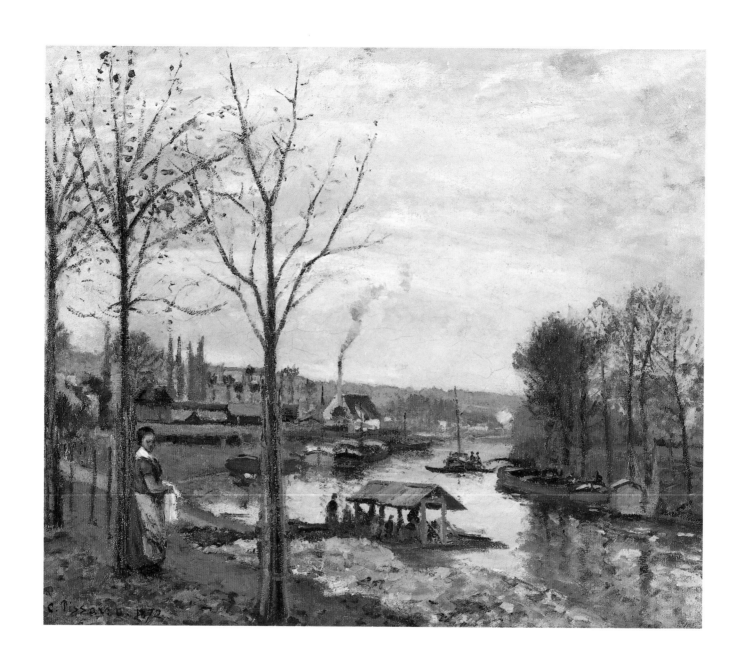

10. Pissarro, *The Wash House, Bougival*, 1872, Musée d'Orsay, Paris, Bequest of Gustave Caillebotte, 1894

11. Pissarro, *The Seine at Port-Marly*, 1872, Staatsgalerie Stuttgart

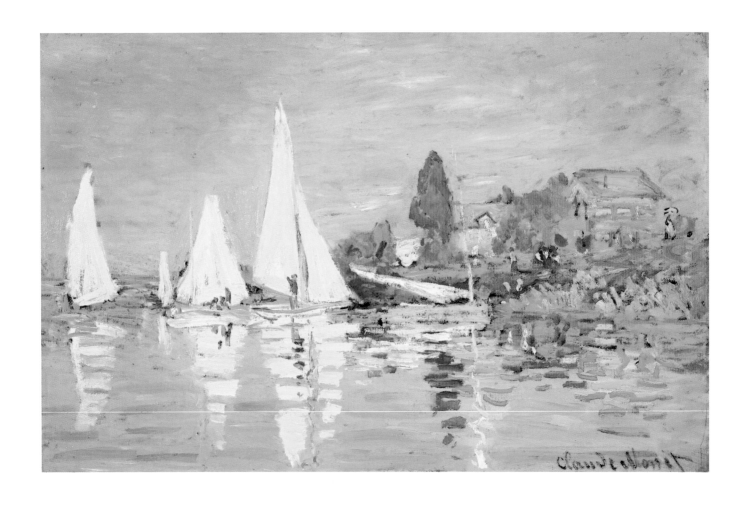

12. Monet, *The Regatta at Argenteuil*, c. 1872, Musée d'Orsay, Paris, Bequest of Gustave Caillebotte, 1894

13. Sisley, *The Bridge at Argenteuil*, 1872, Memphis Brooks Museum of Art, Memphis, Tennessee;
Gift of Mr. and Mrs. Hugo N. Dixon

14. Monet, *The Highway Bridge under Repair, Argenteuil,* 1872, Fondation Rau pour le Tiers-Monde, Zurich

15. Monet, *The Promenade along the Seine*, 1872, private collection

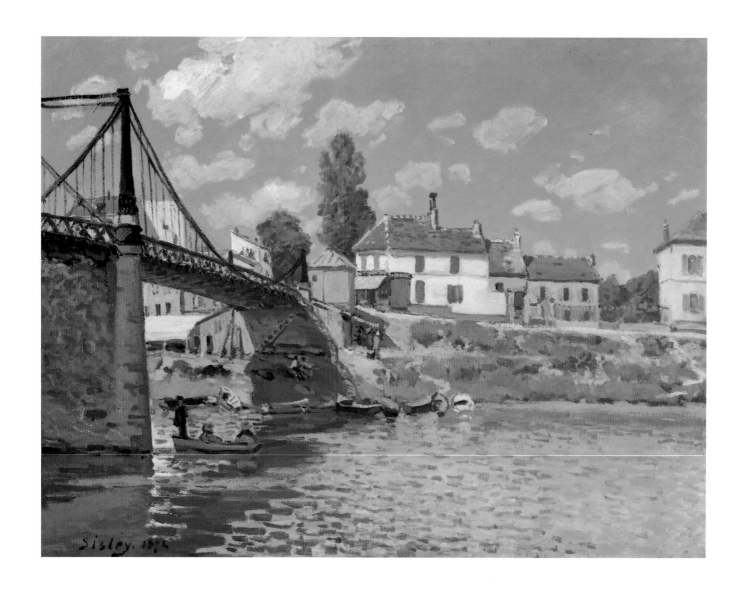

16. Sisley, *The Bridge at Villeneuve-la-Garenne*, 1872, The Metropolitan Museum of Art, New York,
Gift of Mr. and Mrs. Henry Ittleson Jr., 1964

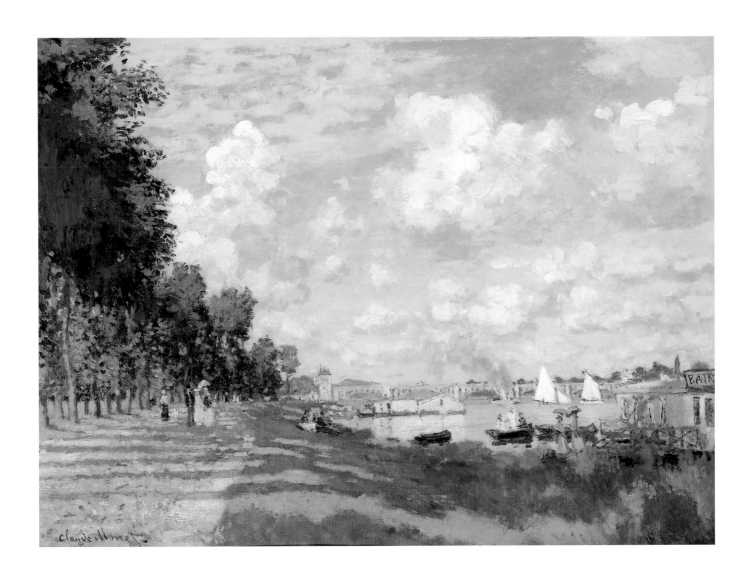

17. Monet, *The Argenteuil Basin*, c. 1872, Musée d'Orsay, Paris, Bequest of Comte Isaac de Camondo, 1911

18. Sisley, *Banks of the Seine at Argenteuil*, 1872, private collection

19. Sisley, *Factory on the Banks of the Seine, Bougival*, 1873, Ordrupgaard, Copenhagen

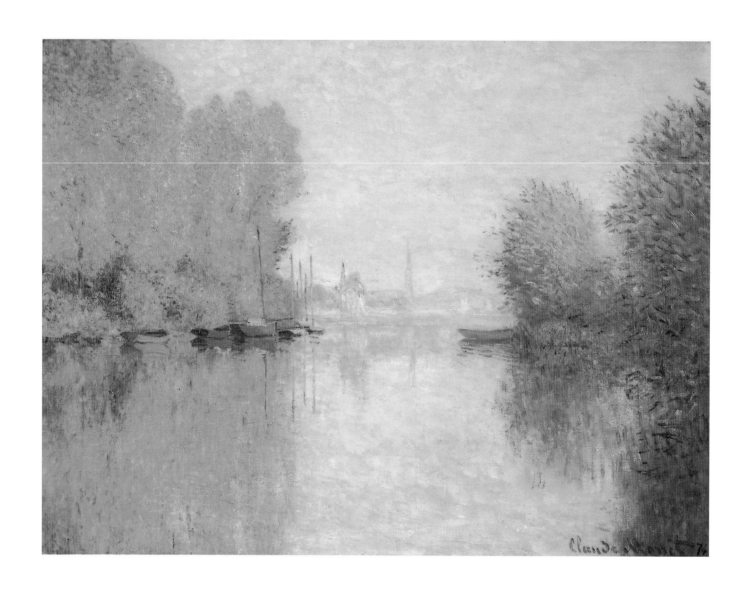

20. Monet, *Autumn on the Seine, Argenteuil*, 1873, Mrs. John Hay Whitney

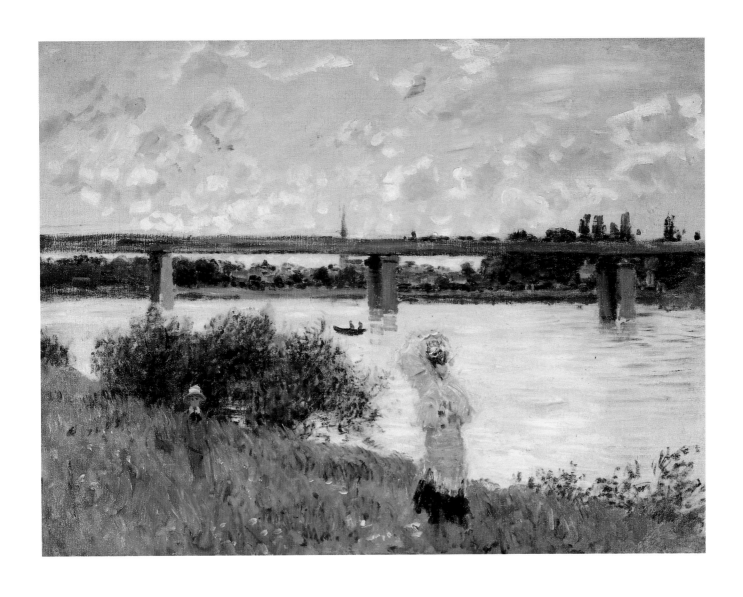

21. Monet, *The Promenade with the Railroad Bridge, Argenteuil*, 1874, The Saint Louis Art Museum, Gift of Sydney M. Shoenberg, Sr.

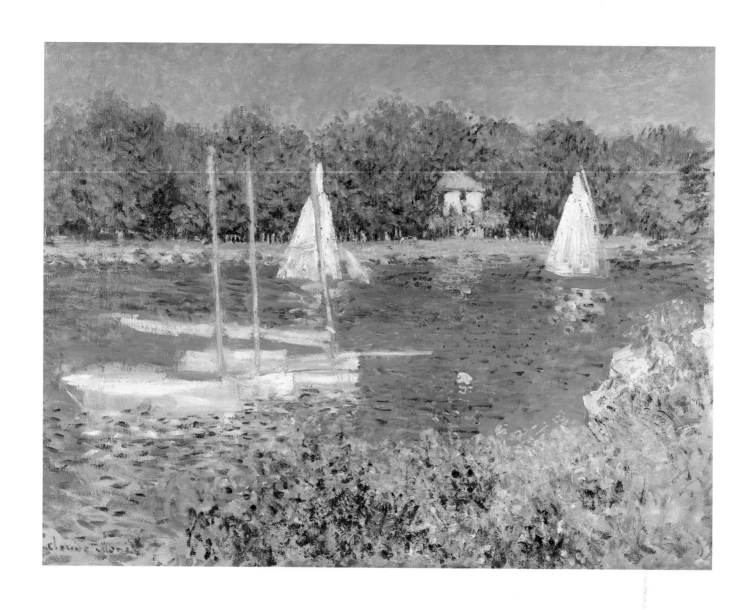

22. Monet, *The Basin at Argenteuil*, 1874, Museum of Art, Rhode Island School of Design, Providence, Rhode Island; Gift of Mrs. Murray S. Danforth

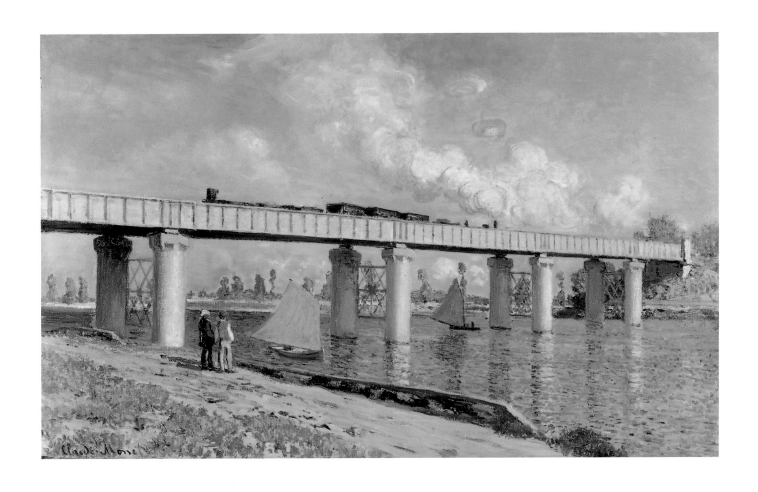

23. Monet, *The Railroad Bridge at Argenteuil*, 1873, private collection

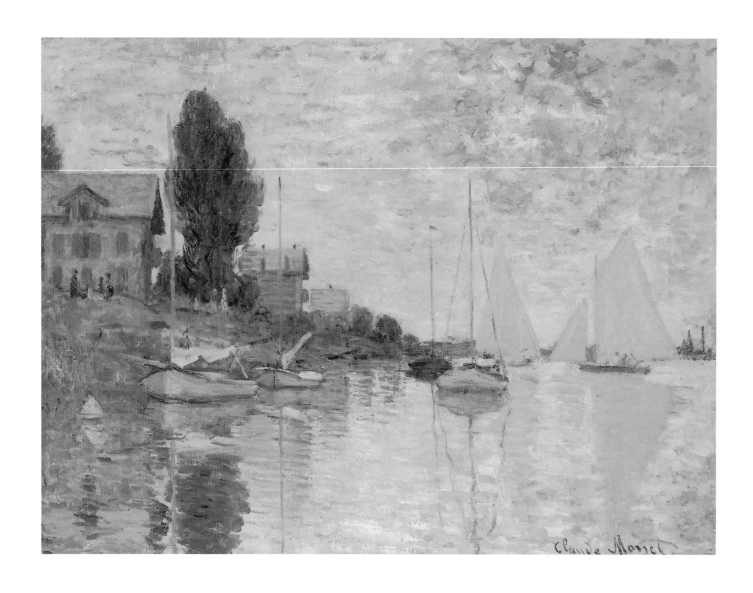

24. Monet, *Petit-Gennevilliers*, 1874, private collection

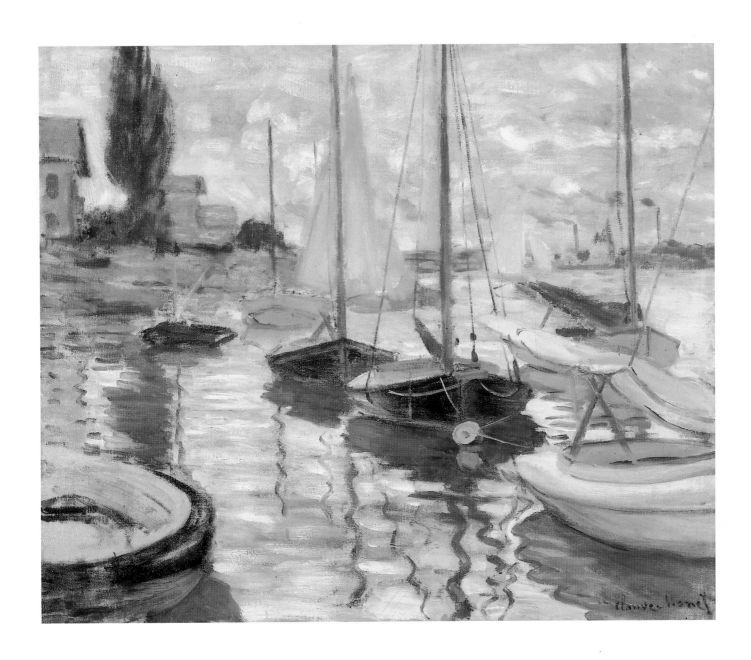

25. Monet, *Sailboats on the Seine*, 1874, The Fine Arts Museums of San Francisco, Gift of Bruno and Sadie Adriani

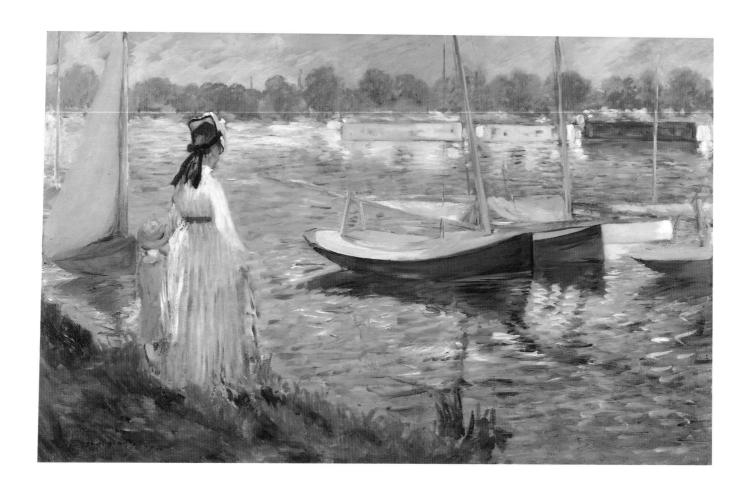

26. Manet, *Banks of the Seine at Argenteuil*, 1874, private collection, on extended loan to the Courtauld Institute Galleries, London

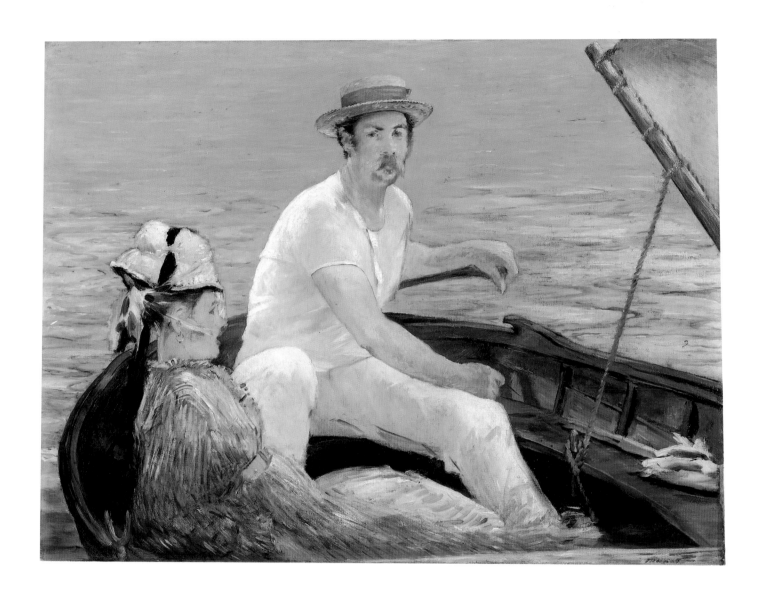

27. Manet, *Boating*, 1874, The Metropolitan Museum of Art, New York, H. O. Havemeyer Collection, Bequest of Mrs. H. O. Havemeyer, 1929

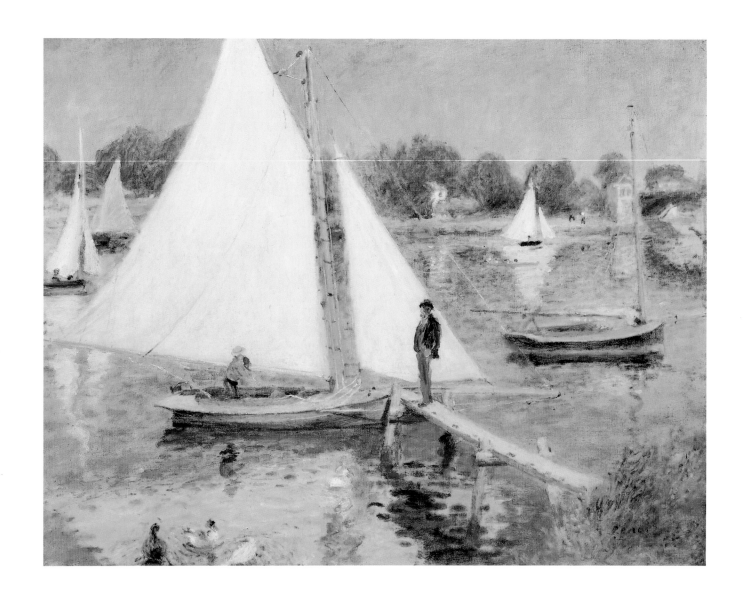

28. Renoir, *The Seine at Argenteuil*, 1874, Portland Art Museum, Oregon; Bequest of Winslow B. Ayer

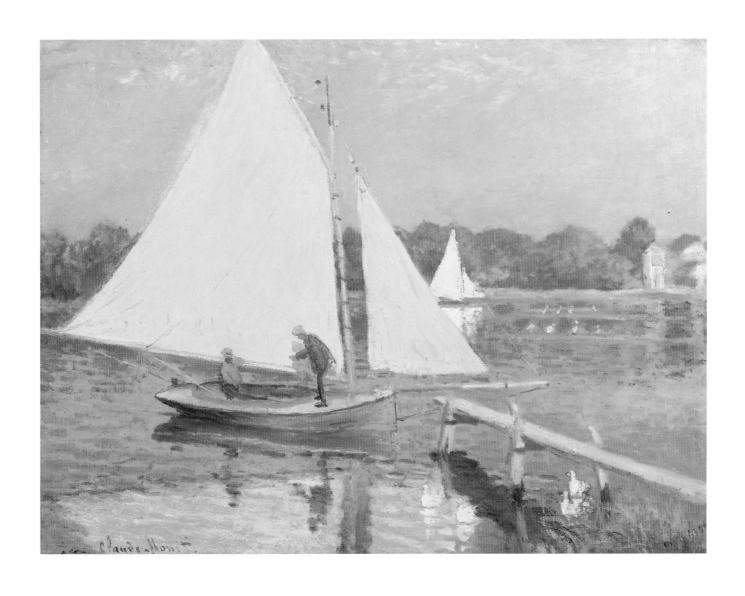

29. Monet, *Sailboats at Argenteuil*, 1874, private collection

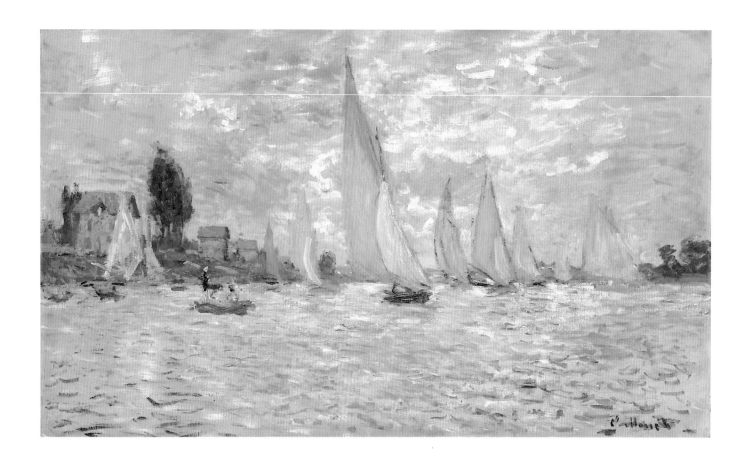

30. Monet, *Boats: Regatta at Argenteuil*, c. 1874, Musée d'Orsay, Paris, Bequest of Comte Isaac de Camondo, 1911

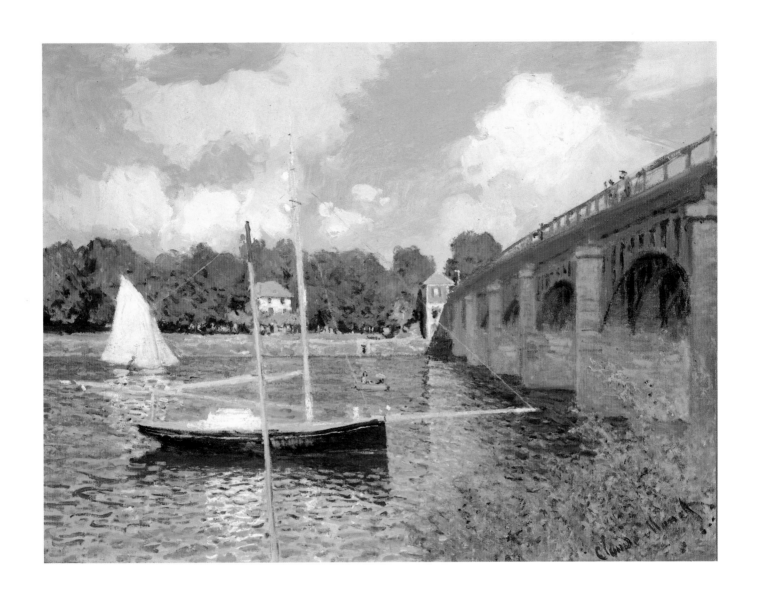

31. Monet, *The Bridge at Argenteuil*, 1874, National Gallery of Art, Washington, D.C., Collection of Mr. and Mrs. Paul Mellon

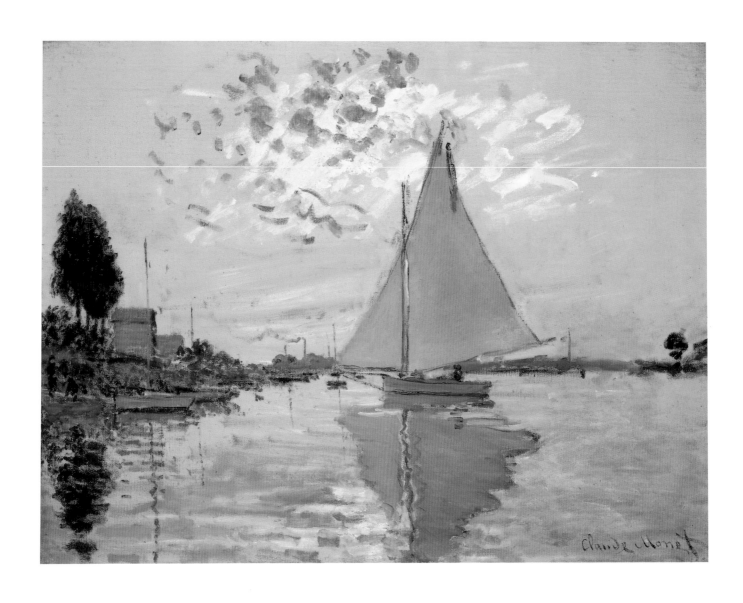

32. Monet, *Sailboat at Petit-Gennevilliers*, 1874, Lucille Ellis Simon

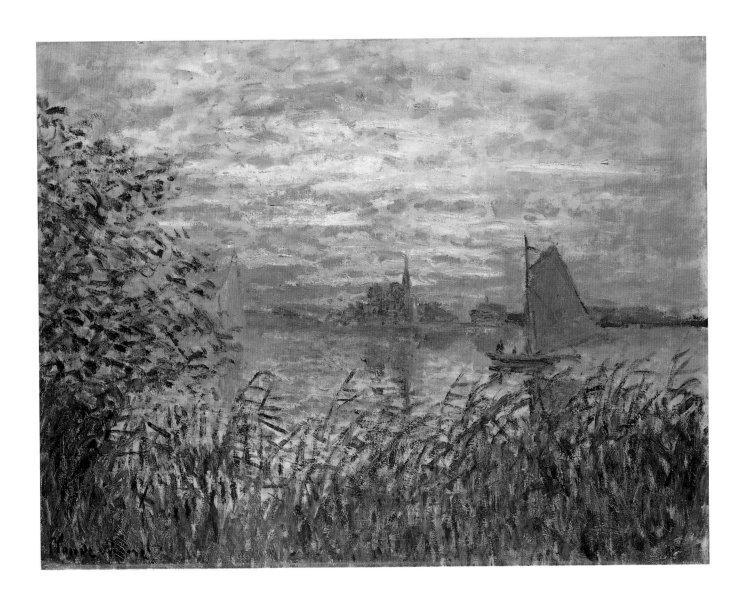

33. Monet, *Argenteuil Basin at Sunset*, 1874, Philadelphia Museum of Art: Purchased with the W. P. Wilstach Fund

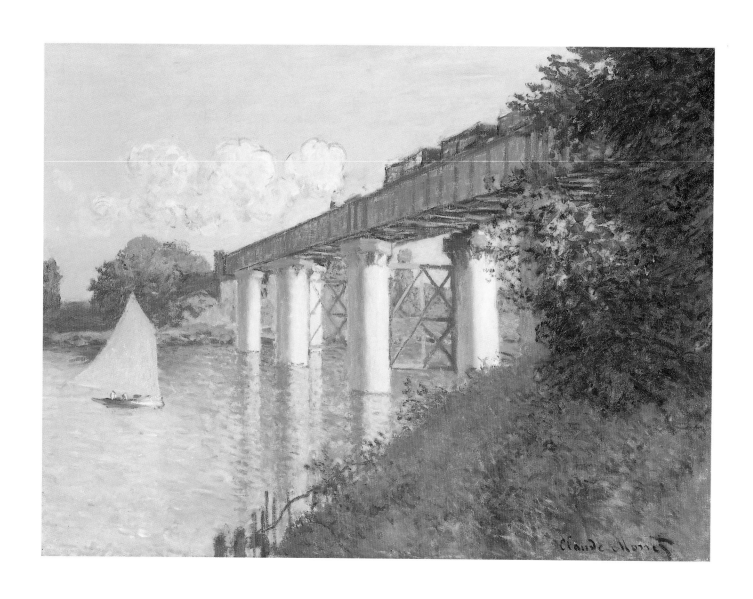

34. Monet, *Railroad Bridge, Argenteuil*, 1874, The John G. Johnson Collection, Philadelphia Museum of Art

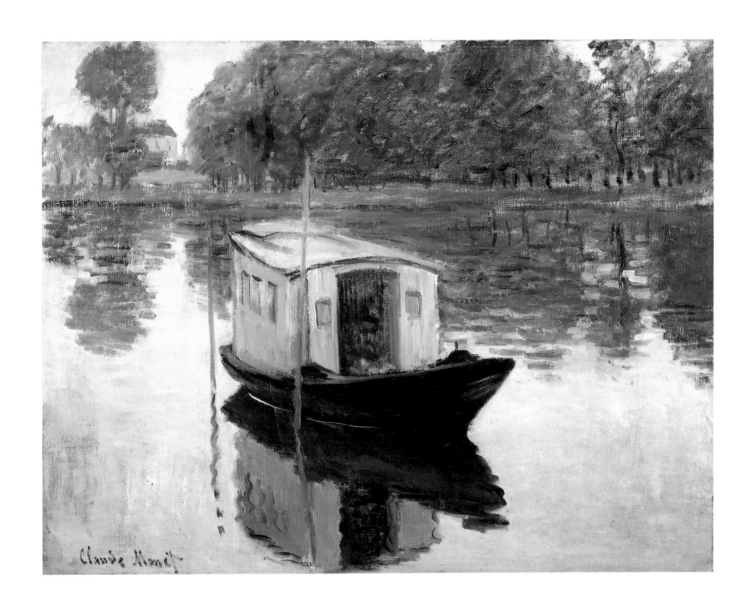

35. Monet, *The Studio Boat*, 1874, Kröller-Müller Museum, Otterlo, The Netherlands

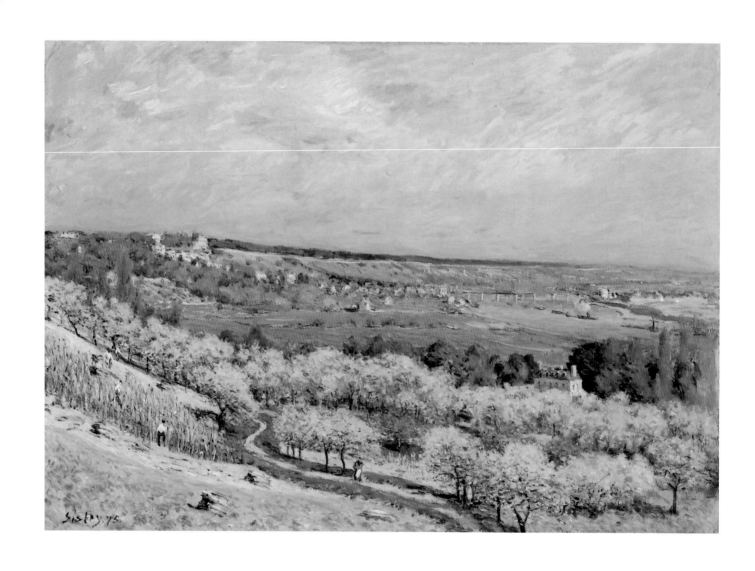

36. Sisley, *The Terrace at Saint-Germain: Spring*, 1875, The Walters Art Gallery, Baltimore, Maryland

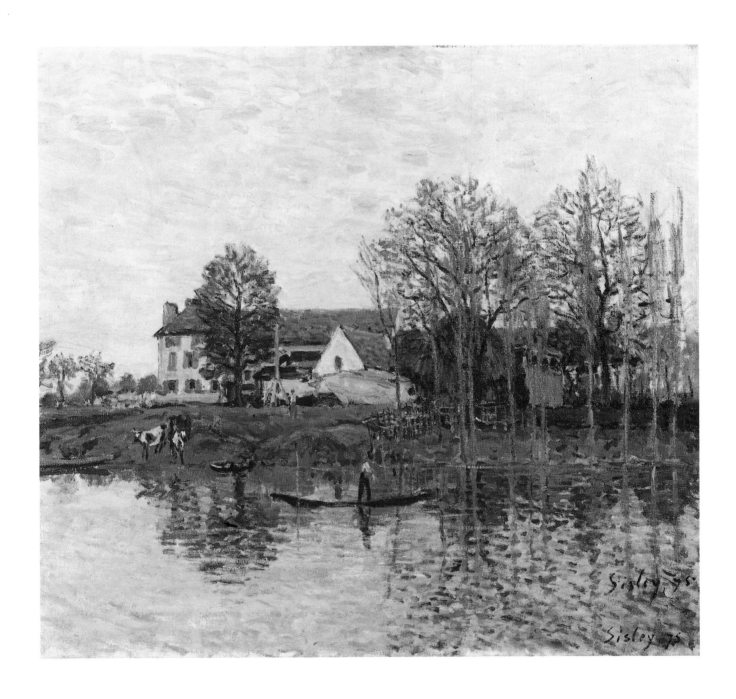

37. Sisley, *The Seine at Port-Marly*, 1875, private collection, Chicago

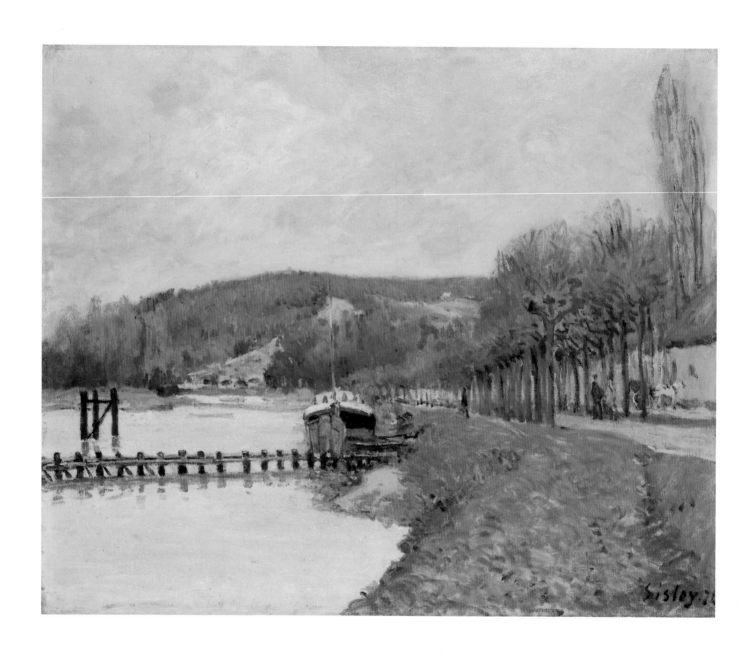

38. Sisley, *The Slopes of Bougival*, 1875, National Gallery of Canada, Ottawa

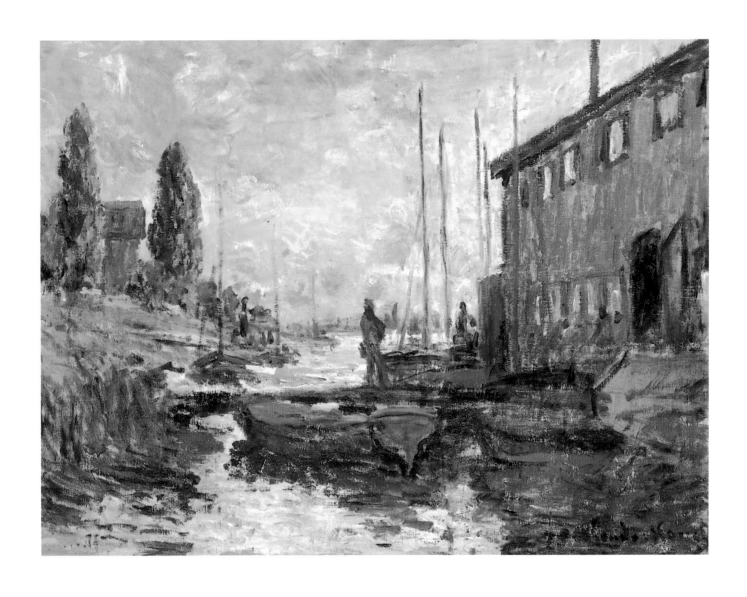

39. Monet, *The Argenteuil Basin*, 1875, private collection, London

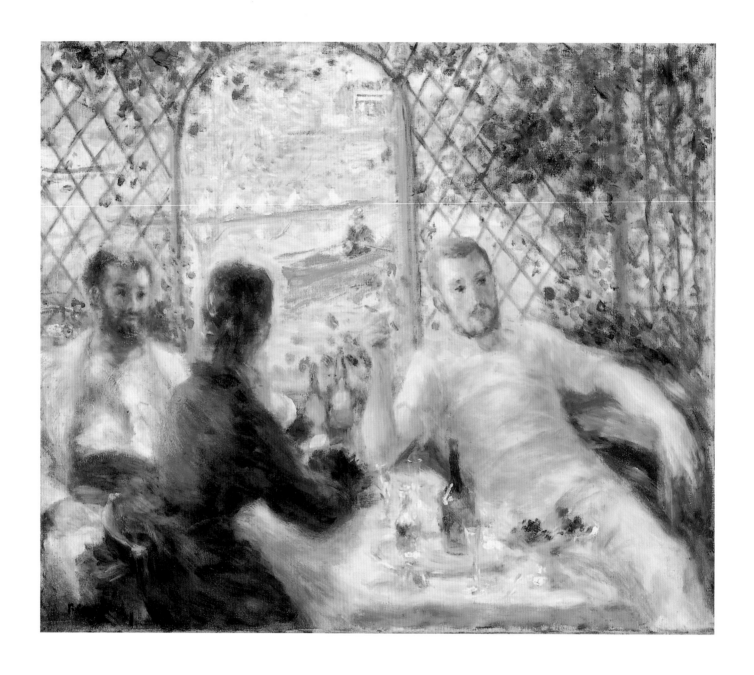

40. Renoir, *The Rowers' Lunch*, c. 1875, The Art Institute of Chicago, Gift of Honore and Potter Palmer. Potter Palmer Collection

41. Renoir, *Boating on the Seine*, c. 1875, The Trustees of the National Gallery, London

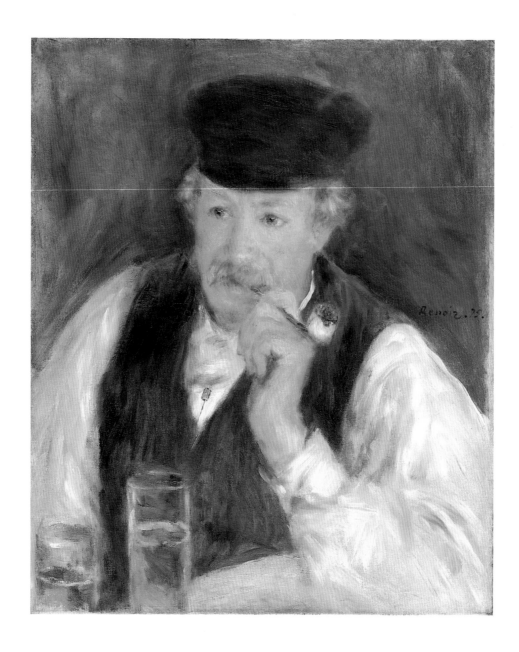

42. Renoir, *Monsieur Fournaise*, 1875, Sterling and Francine Clark Art Institute, Williamstown, Massachusetts

43. Renoir, *Self-portrait*, c. 1875, Sterling and Francine Clark Art Institute, Williamstown, Massachusetts

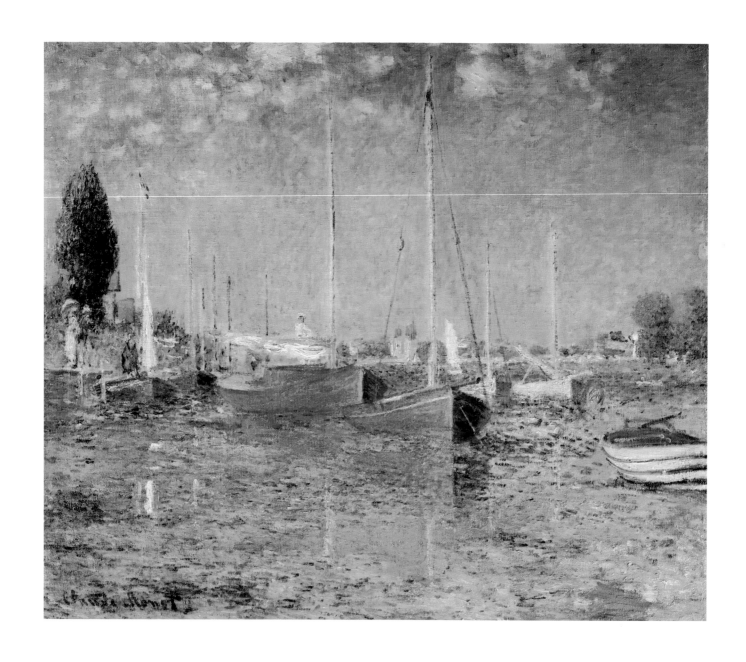

44. Monet, *Red Boats, Argenteuil*, 1875, Musée de l'Orangerie, Paris, Collection of Jean Walter and Paul Guillaume

45. Sisley, *The Seine at Port-Marly, Piles of Sand*, 1875, The Art Institute of Chicago,
Mr. and Mrs. Martin A. Ryerson Collection

46. Sisley, *Waterworks at Marly*, 1876, Museum of Fine Arts, Boston. Gift of Miss Olive Simes

47. Sisley, *Bougival*, 1876, Cincinnati Art Museum: John J. Emery Fund

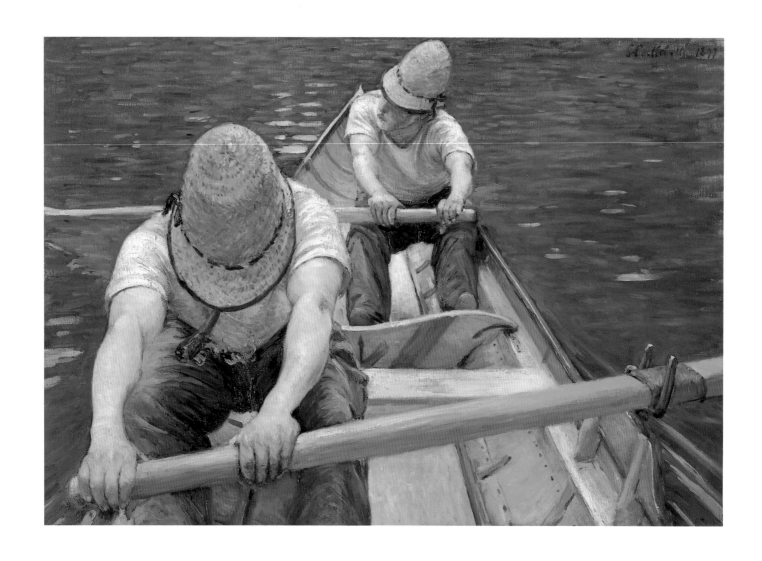

48. Caillebotte, *Oarsmen*, 1877, private collection

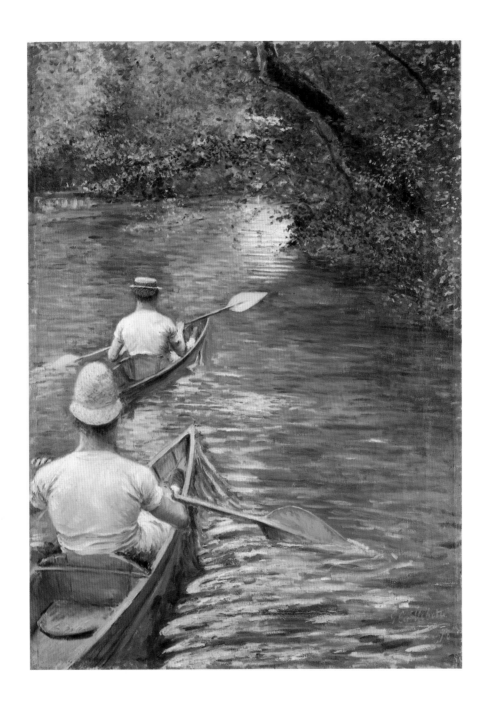

49. Caillebotte, *Périssoires*, 1878, Musée des Beaux-Arts de Rennes

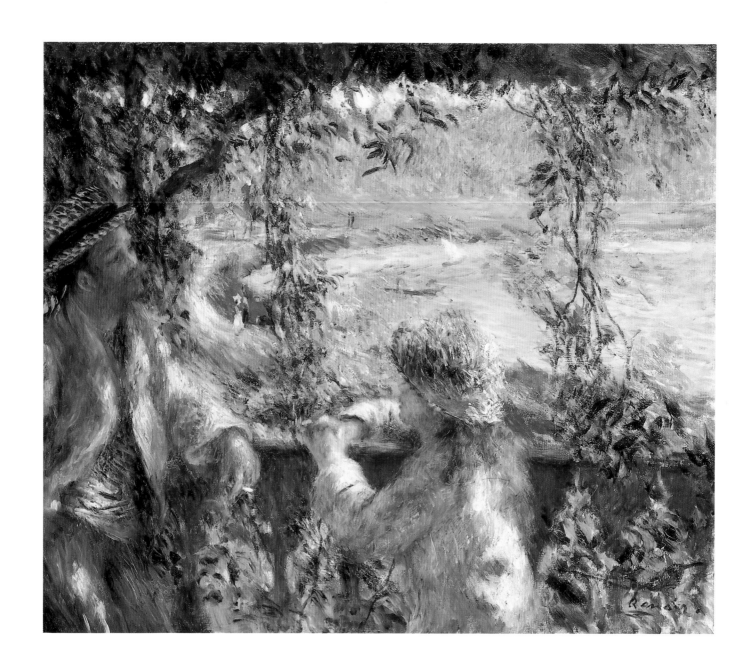

50. Renoir, *By the Water*, c. 1879, The Art Institute of Chicago, Gift of Honore and Potter Palmer. Potter Palmer Collection

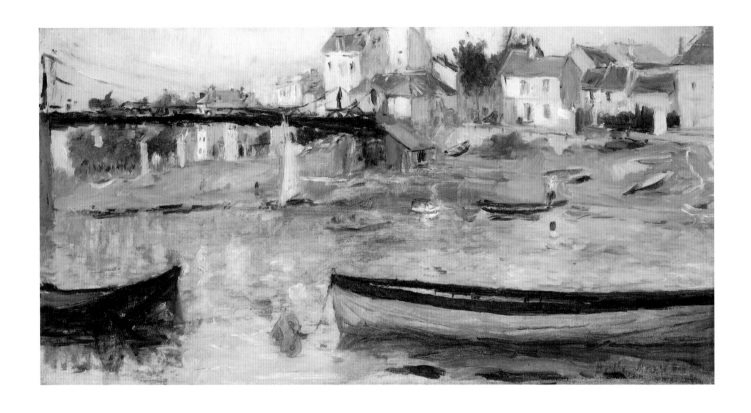

51. Morisot, *Boats on the Seine*, c. 1880, private collection

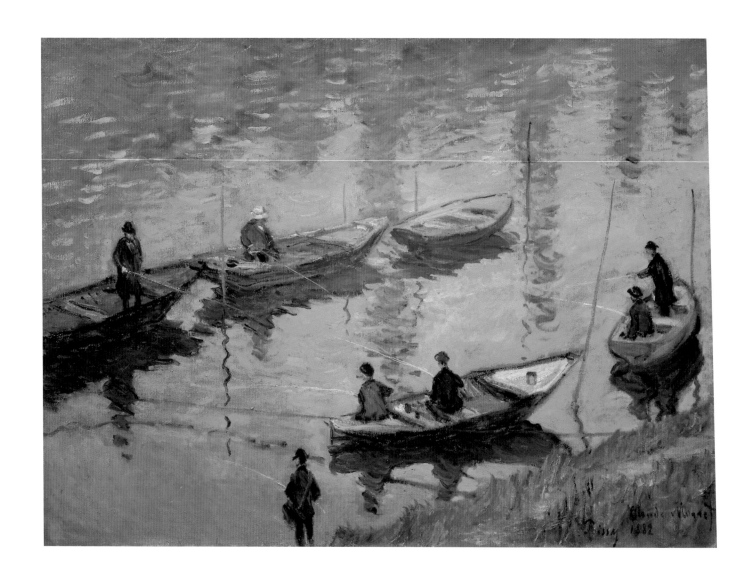

52. Monet, *Fishermen on the Seine at Poissy*, 1882, Österreichische Galerie, Belvedere, Vienna

53. Renoir, *The Railroad Bridge at Chatou*, 1881, Musée d'Orsay, Paris, Bequest of Gustave Caillebotte, 1894

54. Caillebotte, *The Argenteuil Bridge and the Seine*, 1880–85, private collection

55. Caillebotte, *The Argenteuil Basin*, 1882, private collection

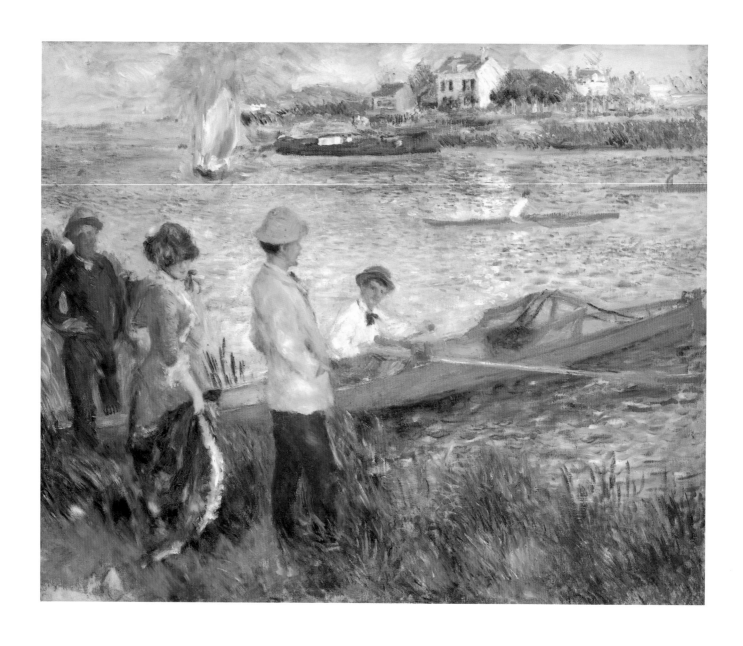

56. Renoir, *Oarsmen at Chatou*, 1879, National Gallery of Art, Washington, D.C., Gift of Sam A. Lewisohn

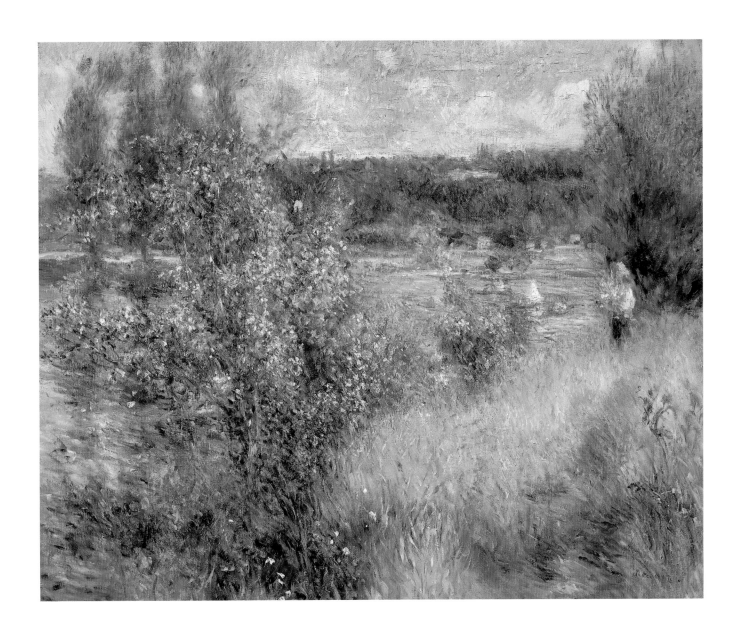

57. Renoir, *The Seine at Chatou*, c. 1881, Museum of Fine Arts, Boston. Gift of Arthur Brewster Emmons

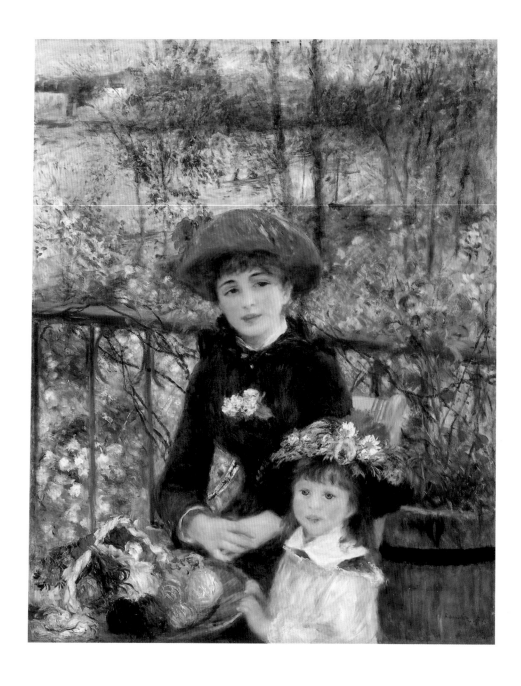

58. Renoir, *Two Sisters (On the Terrace)*, 1881, The Art Institute of Chicago,
Mr. and Mrs. L.L. Coburn Memorial Collection

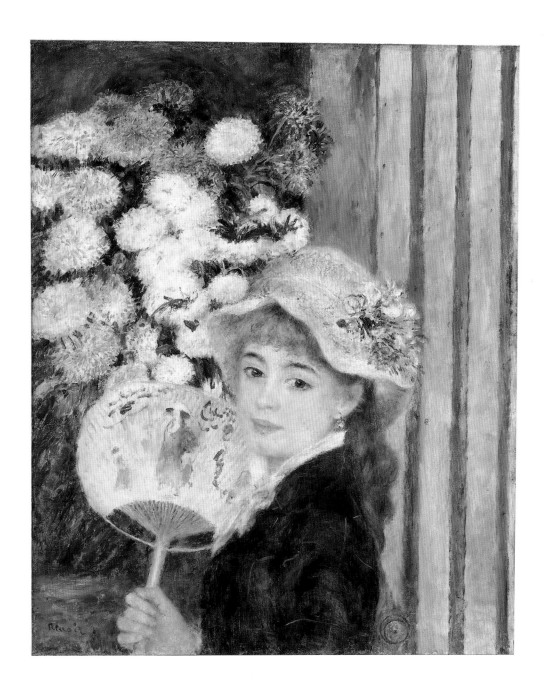

59. Renoir, *A Girl with a Fan*, c. 1881, Sterling and Francine Clark Art Institute, Williamstown, Massachusetts

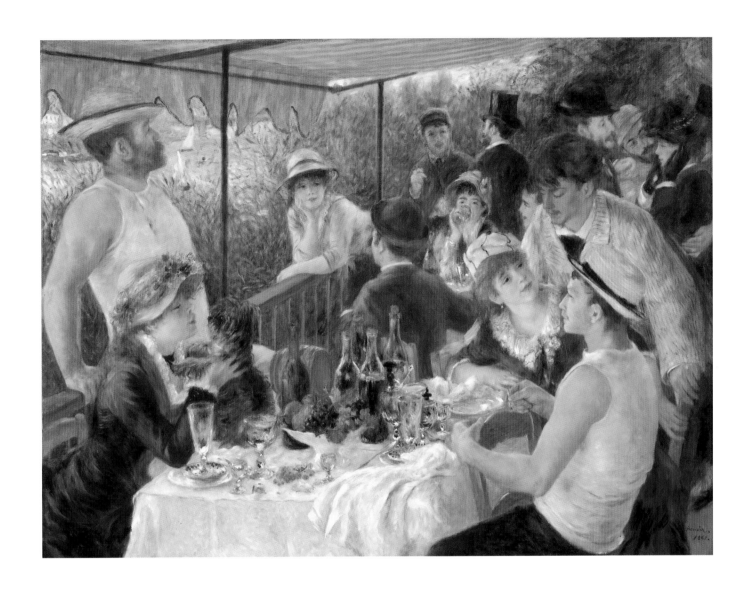

60. Renoir, *Luncheon of the Boating Party*, 1880–81, The Phillips Collection, Washington, D.C.

Achieving the Composition in *Luncheon of the Boating Party*

Elizabeth Steele

During 1995–96, in preparation for *Impressionists on the Seine*, The Phillips Collection undertook the first technical study that has ever been conducted on Renoir's masterpiece. In the conservation studio an in-depth visual examination of the paint surface indicated that the artist had made numerous changes to the composition. To elucidate these findings, the painting was examined using scientific tools such as x-radiography and infrared reflectography, imaging techniques that penetrate upper paint layers to reveal underdrawing and/or changes made to the composition. This examination resolved many unanswered questions and provided significant new information about Renoir's process in developing *Luncheon of the Boating Party*, one of his most ambitious works.

Much of the painting's success lies in the convincing interaction that Renoir creates among his sitters. Their arrangement in twos and threes leads the eye back and forth across the table and through the composition to the rear of the balcony. It is the complexity of the scene that makes the painting so intriguing, and it demonstrates the painter's mastery of strong compositional skills. According to a letter to his friend Paul Bérard in the autumn of

1880, Renoir was struggling to achieve the final grouping of figures, the table setting, and their surroundings. In recounting his progress, he complains of being behind schedule, of having to remove a figure, "and I no longer know where I am with it, except that it is annoying me more and more."[1] His frustration is corroborated by the technical examination of the painting. Study of the paint surface in raking light and under a stereo-binocular microscope indicates alterations in key passages throughout the picture. Dried brushstrokes from lower paint layers that bear no relationship to the corresponding image in the upper layers identify the locations of these changes. X-radiography and infrared reflectography[2] reveal the character of his modifications in many places. Since no preparatory studies are

83. (Left) Detail from the infrared reflectogram of *Luncheon of the Boating Party*. This reveals that the two men standing at the rear of the balcony were initially higher in the picture plane, and the man on the right originally looked out towards the viewer.

84. Detail of upper left edge in raking light. The thinly painted awning lies on top of ridges of dried paint (A, B, and C) from an earlier state of the composition when the landscape dominated the top edge.

85. X-radiograph of *Luncheon of the Boating Party*. (A) Brushstrokes are present that correspond to an earlier state when the landscape and sky dominated the top edge. (B) The awning pole clearly lies on top of a somewhat developed landscape. (C) The large, white shape identifies a different but indecipherable table setting. (D) The woman's hat was originally painted with more heavy atomic weight pigments than are found in most greens and browns.

known to have been made, and no underdrawing is seen using infrared reflectography, it is likely that Renoir developed his composition on the canvas, making changes as the work evolved.

Sweeping, textured brushstrokes that do not correspond to the striped awning are readily observable in the upper left. Examination reveals that the landscape and the sky initially dominated the top edge of the composition. The thinly painted awning lies on top of ridges of dried paint that correspond to this earlier

state of the picture (fig. 84). Under high magnification, yellow, blue, orange, and white paint—the same colors used in adjacent landscape passages—are visible beneath the striped fabric. Viewed through a microscope, blue paint is visible below the awning at the top center, and this presumably relates to a passage of open sky. Examination also indicates that the upper right corner was reworked in dark green. Under high magnification a lighter passage of blue, green, and white is visible, which was likely a continuation of

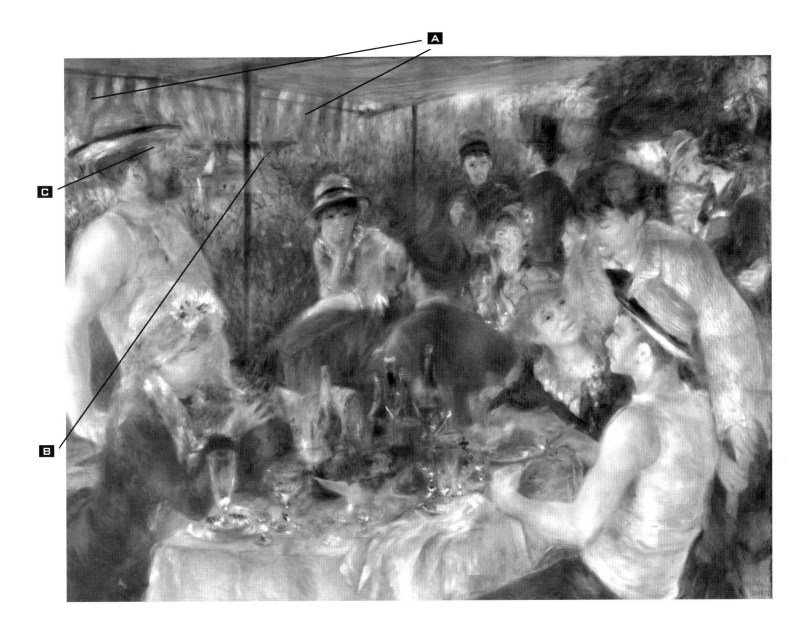

the adjacent trees and sky to the immediate left. In both the x-radiograph and the infrared reflectogram (figs. 85 and 86), brushwork in the lower paint layers that corresponds to the distant river banks and open sky is apparent along the top edge.

In the infrared reflectogram, the railroad bridge in the upper left appears to have been painted in its entirety below the awning. The awning poles seem to have been put sketchily in place before the fabric was painted, although they lie on top of a somewhat developed land-scape. In the x-radiograph the far left vertical pole is only barely perceptible and clearly lies on top of the landscape, while the rest of the metal frame is not record-ed at all. Under high magnification, how-ever, thinly painted blue lines indicate the presence of the metal frame in what must have been an early stage of the composi-tion. This framework was then rein-forced as the awning and background were more thoroughly developed.

Surviving nineteenth-century images of the Maison Fournaise depict the bal-

86. Infrared reflectogram of *Luncheon of the Boating Party.* (A) Visible brushstrokes indicate the presence of a developed landscape below the awning. (B) The entire span of the railroad bridge was visible in an ear-lier state. (C) Brushstrokes across his forehead indicate the hat was reposi-tioned several times.

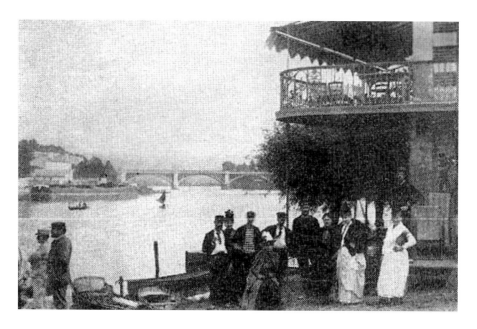

87. Maison Fournaise, late nine-teenth century, photograph. Courtesy of the Musée Fournaise, Chatou.

88. Detail from the x-radiograph of woman with dog in lower left. She originally faced towards the viewer. (A) Her dress initially had three-quarter-length sleeves. (B) Her arm was once positioned farther back, folded against her side. (C) She seems to hold a glass in her right hand. (D) Indistinct white brush-work and the density of the paint film in this area suggest Renoir reworked the figure several times.

cony with and without an awning, although the poles seem to have been fixed in place so the covering could be rolled in and out.[3] Photographs of the restaurant show it with a variety of awnings, some with borders, others with-out, some striped, and others solid (fig. 13). One surviving image does show a striped awning with a scalloped hanging border similar to the one depicted in the painting (fig. 87). It is not known what awning, if any, was present when Renoir was painting. It is entirely plausible that he began the painting with the awning rolled in and finished the work with it rolled out. In any event, its inclusion seems to have been a conscious decision made to strengthen the composition rather than merely to record the specific details of a setting. If an open sky and a distant landscape had been retained, the three-dimensional illusion would have been more difficult to achieve. By enclos-ing the top edge, the balcony's recession

into space is more convincingly estab-lished, and the sitters are better defined as a cohesive group. With the awning in place and the right side filled in with dense foliage, the luncheon assumes a more intimate feeling that would have been more difficult to achieve if the fig-ures had been arranged in a completely open-air setting.

Significant changes are also found in the sitters and in their relationship to one another and to the viewer. The figure of the woman holding a dog underwent dra-matic changes. The x-radiograph shows that in an earlier state she was turned in her chair and was looking out at the view-er rather than seen in profile facing her dog (fig. 88). The sleeve of her dress was initially three-quarter length, and her proper right arm was folded along her torso with her hand up to her shoulder. In this earlier state her hand appears to hold something, perhaps a glass. Pentimenti above and to the right of her head suggest

89. Detail from the infrared reflectogram of head of woman in white hat and woman drinking at rear of balcony. A second set of eyes (A) and the ghost image of the earlier position of the sitter's head (B) are visible.

90. Detail from the x-radiograph of head of woman in white hat on right. Facial features were repositioned; the placement of the eyes (A) and the change in the chin and neck (B) are apparent.

that Renoir altered this figure and her dog more than once. The indistinct, dense brushwork on the x-radiograph also records much reworking, but it is difficult to discern with precision what these changes may have been.

The position of the face and neck of the seated woman in a white hat on the right was also altered. Inspection with raking light locates changes in the texture of the paint film and indicates that she wore her hat more to the left side of her head in the first rendering. Close inspection of the paint film, together with the x-radiographic and infrared images, verifies that her head was in a different position, perhaps looking up at the man who rests his hand across the back of her chair rather than gazing across at the man

seated next to her. What appears to be an earlier pair of eyes above the final set is discernible in the x-radiograph. Her neck appears longer, and brushwork that possibly relates to a shadow below her upraised chin is present (fig. 90). This second pair of eyes is also evident in the infrared reflectogram (fig. 89).

The gaze of the woman who leans on the railing also seems to have been adjusted. Vigorous reworking of her hat and head are apparent in raking light. Subtle shifts in the placement of the hand that holds her chin are revealed in the paint surface and in the x-radiograph. In the infrared reflectogram, the chin and nose are noticeably distorted; they were initially positioned slightly to the left of their final placement (fig. 91). It seems likely that the model originally looked toward Renoir while he painted. Her face was later turned to the right, perhaps to engage the seated man whose back is turned toward the viewer.

91. Detail from the infrared reflectogram of head of woman leaning on railing. (A) and (B) indicate where her nose and chin were repositioned.

One of the most spectacular rearrangements occurred in the pair of gentlemen who stand at the rear of the balcony. Reworking of the figures is indicated by the textural disparities found in the paint surface in this passage. It becomes apparent in the infrared reflectogram that the two were initially placed higher in the scene and that the top-hatted figure faced toward the viewer (fig. 83). Lowering their position may have been necessary due to changes along the upper edge. In the earlier state their taller height presumably worked well in the

open air, but they must have appeared disproportionately large after the awning was integrated into the composition.

It may be hypothesized that Renoir altered the positions of his sitters to intensify their interaction with one another. Those that initially looked out at the viewer were turned inward to engage them more actively in the party. Possibly he repositioned the gaze of the woman in the white hat on the right in order to involve the man seated next to her or to create a unified grouping of three. Without this change, the man looking

across the table might seem estranged from the intimate gathering. Precise documentation of how Renoir assembled his models has not been found. Presumably he established an initial composition *in situ* with some of the sitters arranged on the balcony. As observed by John House, models may have sat on separate occasions when they visited Renoir in Chatou.[4] Repositioning his figures to heighten their interaction is understandable, given the importance of creating a convincing image of an authentic event.

The table setting is another passage that underwent radical changes. Strongly textured brushstrokes that lie below the upper paint layers bear no correspondence to the shapes of the bottles or to the wine cask (fig. 93). Other disparities in the paint film are found in the compote of fruit and in the back of the seated man in the brown hat. Moreover, the colors seen through the cracks in this passage differ from those that lie on the surface.

92. Detail from the infrared reflectogram of the table setting. Glasses from an earlier state (A, B, and C) were painted over by the artist. A stemmed glass (D) was transformed into a wine glass.

93. Detail of still life in raking light. (A) and (B) identify textural disparities in the paint film, which indicate radical changes occurred in this area.

Unfortunately, the large, indecipherable white image recorded in the x-radiograph where the wine cask and bottles are now located is too vague to reveal what initially dominated the table top (fig. 85). The amount of reworking, however, and the incongruous character of the brushwork in the lower paint levels suggest that the change was significant and that the wine cask and the bottles came during a second state. Some minor changes are discernible in the infrared reflectogram: a wine glass located in front of the cask was painted out; an aperitif glass was replaced with a small bunch of grapes lying at the front of the table; another wine glass in front of the compote of fruit was painted out; and one of the tall glasses on the right was originally a stemmed glass (fig. 92). Although it is conceivable that what was placed on the table changed as the painting progressed, the reworking of the table setting suggests that Renoir labored to perfect the details of his composition.

Other less dramatic changes indicate Renoir's constant reevaluation of *Luncheon of the Boating Party*. On the far right the woman's brown hat originally seems to have been a lighter color. Its white appearance in the x-radiograph indicates the use of heavy atomic weight pigments, such as those found in many whites, yel-

lows, and reds. Most greens and browns, the color of the hat, would appear dark in an x-radiograph (fig. 85). When studied under high magnification, red and yellow paint are visible through the cracks in the lower paint layers, which suggests that this figure initially wore a straw *canotier* similar to others in the painting. In repainting her hat, Renoir achieved a stronger visual balance between the lights and darks in this group of three people. On the left, a pentimento surrounding the straw hat of the man points to its reduction in size, which most likely occurred when the scalloped border of the awning was painted. Its final placement on his head seems to have caused Renoir some trouble. Brushstrokes across his forehead are visible in the infrared reflectogram and attest to the repositioning of the hat one or more times (fig. 86). The woman drinking at the rear of the balcony was shifted slightly to the right. Strongly textured brushwork surrounding her head that does not pertain to the final image attests to this move. Upon close inspection, a second arm to the left of her upraised one can be located in the paint film by the flesh tones that show through the thinly applied upper layers. A ghost image of her first position to the left of her final one is visible in the infrared reflectogram (fig. 89). This figure's subtle move to the right may have created a more pleasing compositional balance as it centers her between the two standing figures and not in front of the man on the left.

Renoir returned to the canvas to make major or minor alterations to numerous passages. Although documentation is scarce, he presumably executed some of the work on the balcony. It is not, however, the *plein-air* work of art that records a specific place during an exact moment in time. A technical study of *Luncheon of the Boating Party* revealed that decisions made regarding both the sitters and their setting led to changes in the composition and deviations from what Renoir may have initially seen. Reevaluation of the composition and subsequent reworking of many of the relationships most likely occurred in the studio. Although Renoir achieved his aim of capturing the immediacy of the scene, it is apparent that this was accomplished by continuously rearranging and revising the composition throughout the painting process.

This study was conducted with the generous assistance of Dare Hartwell, William Koberg, and Rocio Prieto. The strong interest of Marshall Cohen at Sensors Unlimited to conduct infrared reflectography of the painting added significant depth to the findings. I would like to thank the Conservation Division at the National Gallery of Art, particularly Elizabeth Freeman, Bonnie Wisniewski and Elizabeth Wamsley, for their assistance in processing the x-radiographs and compositing the infrared reflectogram. Catherine Metzger and Dan Kushel submitted valuable comments on the manuscript. Lastly, I am grateful to Eliza Rathbone for her enthusiasm and support.

1. John House et al., *Renoir*, exh. cat. (London, 1985), 222.
2. The infrared reflectogram was recorded using an indium gallium arsenide all solid state camera, the SU 128, from Sensors Unlimited, Inc. (Princeton, New Jersey). The SU 128 is sensitive to the wavelength range 0.9–1.7 microns. It features both conventional video output as well as a built-in frame grabber so digitized images can be transferred directly to a computer. An indium gallium arsenide camera can operate at room temperature, an advantage over other solid state sensors.
3. Unpublished correspondence between Eliza Rathbone and Henri Claudel and J. G. Bertauld, Association des Amis de la Maison Fournaise, 6 February 1996, confirms that the awning could be rolled up and down, "following the sunlight."
4. House, *Renoir*, 223.

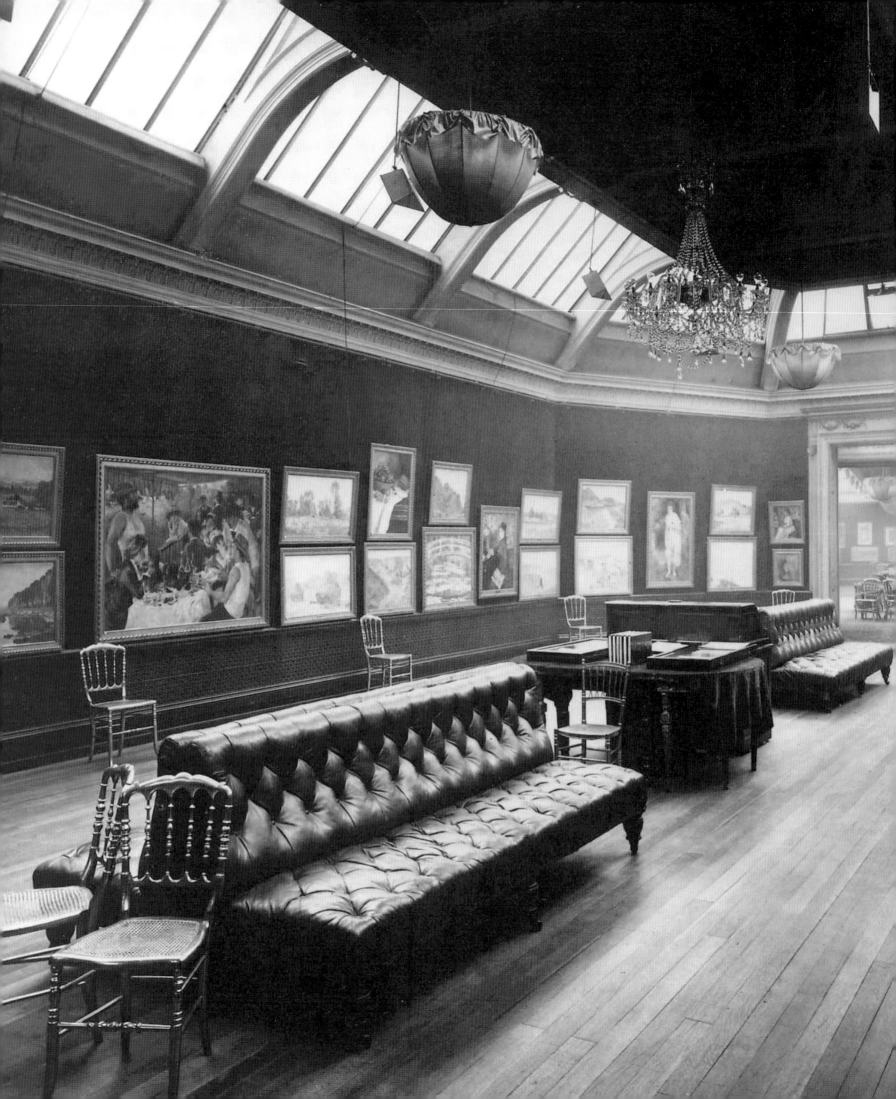

A History of Renoir's *Luncheon of the Boating Party*

Early Exhibitions and Acquisition by
The Phillips Memorial Gallery

The provenance of Renoir's *Luncheon of the Boating Party* is brief, its exhibition history substantial, and its bibliography voluminous.[1] This now-famous painting, whose presence in the literature on Impressionism is rivaled only by its reproduction in prints, postcards, jigsaw puzzles, and all manner of gift shop items, has had few owners since Renoir finished and signed it in 1881. It was purchased almost immediately by Paul Durand-Ruel on 14 February 1881, and although it passed briefly into the hands of the Parisian collector Ernest Balensi, Durand-Ruel reacquired it by early 1882, in time to show it in the seventh Impressionist exhibition in March. Durand-Ruel rented the room where the exhibition was held at 251, rue St. Honoré, and most of the works exhibited belonged to him. By then many artists, including Renoir, Monet, and Sisley, had ceased to exhibit with the Impressionists, or Independents as they were then called, but they were persuaded by their dealer and champion to participate this time.

The majority of the critics who reviewed the 1882 exhibition applauded *Luncheon of the Boating Party*, which "shared the honors of the exhibition" with Caillebotte's *The Bezique Game* (fig. 75).[2] The most unreservedly enthusiastic review came from Armand Silvestre, writing in *La Vie Moderne*. "It is one of the most beautiful pieces that this insurrectionist art by Independent artists has produced. For my part, I found it absolutely superb."[3] Already the painting was variously referred to as *Repas des canotiers*, *Déjeuner à Bougival*, and *Dîner des canotiers*. Following the seventh Impressionist exhibition, Durand-Ruel decided to present a series of one-man shows, and *Luncheon of the Boating Party* appeared again on public view in the exhibition devoted to Renoir in April 1883, which was held in the new premises of the gallery on the boulevard de la Madeleine in Paris.

In spite of the lack of success with the American public a few years earlier, Durand-Ruel began to plan exhibitions abroad. By September 1883, *Luncheon of the Boating Party* had made its first trip across the Atlantic to be included in a foreign exhibition in Boston, the first time a significant number of paintings by French Impressionists was shown in this country.[4] Only three years later, in 1886, the painting traveled again to the United States to be included in a major exhibition of French Impressionism that was organized by the American Art Association in New York. This exhibition of 289 works met with such success

94. *The Central Gallery, Impressionist Exhibition, Grafton Galleries, London,* 1905, photograph. Archives Durand-Ruel, Paris.

that after its first presentation it was shown again at the National Academy of Design. Thirty-eight works by Renoir were included in what must have been an outstanding exhibition of Impressionist painting by any standard. Luther Hamilton, writing for *Cosmopolitan*, "One of the most important artistic events that ever took place in this country, eminently the event of the season of '85-6, was the exhibition in New York, in April, under the auspices of the American Art Association, of a collection of works in oil and pastel by the Impressionists of Paris."[5]

In 1905 Durand-Ruel sent 315 works by French modern masters, from Boudin to Renoir, to be exhibited in London at the Grafton Galleries (figs. 94 and 95). Although no special mention was made of *Luncheon of the Boating Party* (exhibited as *A Lunch After Rowing*), the exhibition was undoubtedly one of the greatest ever held of Impressionist painting. The critic who reviewed the exhibition for *The Atheneum* deplored Renoir's recent work but extolled his painting of thirty years before as that of a "great master." He praised "the feeling for personality which makes each of his figures an inspired portrait, and of his marvellous talent for painting flesh so that it appears the living palpitating substance that it is, and not a painter's invention of one kind or another. In this respect, Renoir stands alone among artists." He went on to claim that Renoir surpasses Leonardo in the "quality of vibrant translucency which he attains."[6] After an appearance in Zurich in 1917, *Luncheon of the Boating Party* did not cross the Atlantic again until 1923,

when it arrived in New York to be exhibited in Durand-Ruel's New York gallery on Fifty-seventh Street (fig. 96).

On 27 November 1922 Paul Durand-Ruel's son Joseph took the initiative and gave Duncan Phillips advance notice of the impending exhibition in New York of a group of works by Renoir. "We have just brought to this country for a short while several of the most important paintings by Renoir from our private collection in Paris."[7] Phillips went to New York to see the paintings that Durand-Ruel had stated were for viewing only and were *pas a vendre*, not for sale. Presumably the paintings were brought to the United States to stimulate interest in Renoir and to show the high quality of those works owned by Durand-Ruel.

Phillips, who had opened his new museum, the Phillips Memorial Gallery, to the public late in 1921, had traveled to Europe in prior years, stopping at art galleries and museums wherever he went. The first time he saw *Luncheon of the Boating Party* may well have been as early as 1911, when he made a trip to Paris and, following a visit to Paul Durand-Ruel, recorded in his journal his enthusiasm for the work of Degas, Monet, and most of all, Renoir, of whom he wrote, "There is an infectious good humor about his work—a thrilling vitality in his vivacious raptures over modern life. Pretty girls in a box at the Opera or dining on a terrace . . . a group of Parisians lunching up the river on a hot holiday. . . ."[8] From this last description it can be deduced that it was probably then and there that Phillips first encountered *Luncheon of the Boating*

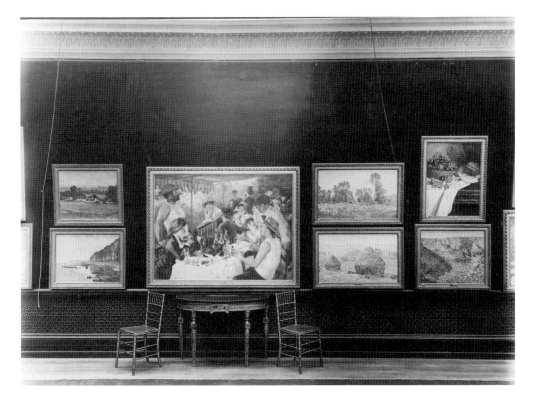

95. (Left) *The Impressionist Exhibition, Grafton Galleries, London*, 1905, photograph. Archives Durand-Ruel, Paris.

96. *The Durand-Ruel gallery, New York*, c. 1923, photograph. Archives Durand-Ruel, Paris.

Party. Phillips again visited Paris in July 1912, and at the Musée du Luxembourg he took special interest in the works of Monet and Renoir. He described *Ball at Le Moulin de la Galette* as "the sense of life's glamour felt even in watching a bourgeois crowd dancing out of doors in an amusement park—this is Renoir's shimmering richness."[9]

In 1923, when Phillips and his new wife Marjorie made a trip to Europe, they stopped in Paris, where they were invited to lunch with Joseph Durand-Ruel. The great painting was hanging in the dining room, where they could admire, as Marjorie put it, "that fabulous, incredibly entrancing, utterly alive and beguiling Renoir masterpiece."[10] Phillips made clear his desire to acquire the painting for his museum. On 9 July 1923 Durand-Ruel wrote to Phillips at the Trianon

Palace Hotel, Versailles: "As agreed between us we are selling you the painting by Renoir 'Le déjeuner des canotiers à Chatou' which is in our private collection for the amount of one hundred and twenty thousand plus interest at five percent. . . . We will ship the painting to our New York house and wait for your instructions before sending it to you."[11]

The very next day Phillips wrote a long letter to the museum's treasurer Dwight Clark, in which he conveyed the exciting news. "The big Renoir deal has gone through with Durand-Ruel and the Phillips Memorial Gallery is to be the possesor *[sic]* of *one of the greatest paintings in the world*. The *Dejeuner des Canotiers* is the masterpiece by Renoir and finer than any Rubens—as fine as any Titian or Giorgione. Its fame is tremendous and people will travel thousands of miles to

our house to see it. It will do more good in arousing interest and support for our project than all the rest of our collection put together. Such a picture creates a sensation wherever it goes. Durand Ruel has asked me not to breathe a word to any one over here, lest the news should reach some one able to start a newspaper campaign of protest against allowing so great a masterpiece of French painting to leave France. . . . The painting will be shipped in October" (fig. 97).[12]

The painting was shipped to New York on 13 September 1923, and on 18 October, Duncan Phillips wrote to Messrs. Holston and Durand-Ruel, "We have received the boxes containing the Renoir, [and other works] but as the house is not yet ready for them we have left them in the boxes."[13] On 27 November, Phillips wrote to Georges Durand-Ruel about publicity for the acquisition of

Luncheon of the Boating Party. Exceedingly proud of his recent purchase, he requested a statement about the importance of Renoir's masterpiece that would say, in effect, it was "the most important picture that you have sold."[14] Phillips noted that although he was glad to be known as the buyer of the work for the Phillips Memorial Gallery, he was in favor of "suggesting that a large price was paid without giving the actual figure."[15]

In spite of both parties' agreement to keep the price of the painting a secret, the press considered it part of the story and a figure of $150,000 was quoted in articles about the acquisition. On 1 December 1923 the *New York Herald* reported, in reference to a statement issued by the Durand-Ruel gallery, that the painting was bought for "the highest price paid for a painting by Renoir or for any other modern painting. . . . It is the

98. (Left) *"Luncheon of the Boating Party" in the Main Gallery of the Phillips Memorial Gallery,* c. 1927, photograph. The Phillips Collection, Washington, D.C.

99. *"Luncheon of the Boating Party" in the Music Room of The Phillips Gallery,* c. 1950s, photograph. The Phillips Collection, Washington, D.C.

opinion of art experts that the Phillips Gallery will attract art lovers from all over the country to see the picture, on which Renoir put all his mastery of line and color."[16] A week later, on 9 December 1923, the *New York Times Magazine* featured an article entitled "The Greatest of the Renoirs Acquired for America." According to the *Star* of Washington, D.C., on 30 December 1923, the painting was to be first presented to the general public on New Year's Day 1924. The *Star* described the museum's plans: "Announcement has been made that the Phillips Memorial Gallery, 1600 21st Street, will be open to visitors from 2 to 6 on New Year [sic] day and for a month thereafter on Tuesday, Saturday and Sunday afternoons from 2 to 6 o'clock. This little gallery . . . now gives to the public opportunity . . . to view for the first time the lately acquired masterpiece by

Renoir 'Le Déjeuner des Canotiers' acquired by Mr. Phillips for the gallery last summer while in Paris."[17]

Installation records of The Phillips Collection indicate that the painting was first hung in the main gallery of the house with paintings by Sisley on either side of it (fig. 98). Sisley's *Banks of the Seine* was later sold by Phillips, but to this day *Snow at Louveciennes* usually hangs in the same gallery as *Luncheon of the Boating Party*.

E. E. R.

Condition and Past Conservation

The state of preservation of *Luncheon of the Boating Party* is excellent. Apart from some abrasion to the edges from the frame rebate and a few small losses, it is in pristine condition. In Ambroise Vollard's recollection of Renoir, the painter is said to

have been afraid of painting "too thin" and that he wanted his medium to be "rich and fat."[18] The depth of color and vibrancy in the paint film that has been preserved attest to this practice. Renoir's love and mastery of the painting process is displayed in the virtuosity of his brushwork. The work is executed on a fine-weave canvas with a commercially prepared white ground. Much of the composition is subtly built up by working wet-into-wet. The soft brushiness of the modeled shapes were then sharply contrasted by the highlights on the glasses, bottles, hats, etc., which are daubed on the canvas in heavily impastoed strokes. Fluid red lines of vermilion and red lake bring definition to the edges of the awning, collars, sleeves, and hats as well as to some of the still life elements. Another contrast is found in the long, dry brushstrokes used to depict the foliage in the middle ground. This successful manipulation of the paint creates a strong sense of diffuse light.

The right edge of the painting seems to have been extended by one-half inch while still in the possession of Durand-Ruel. The tacking margin was folded out, and it was restretched onto a stretcher that was one-half inch larger than the original auxiliary support. The composition was extended along the entire right side, which is clearly a restoration and not an artist's revision. A possible explanation for this enlargement involves the original format, in which the signature and date may have been partially hidden or appeared too close to the edge of the frame. By expand-ing the canvas one-half inch, the risk of partially obscuring any of the artist's inscription was eliminated.

Charles Mopius carried out the first known restoration of the painting in Paris in 1920, judging by an inscription found on the inside edge of a stretcher bar that identifies him as a *rentoiler* (reliner). Mopius's inscription on this larger stretcher indicates that the half-inch extension must have existed by 1920 or was made at that time. Shipping records indicate that it was sent to Gaston Levi in New York in 1941 for relining, and two labels on the reverse of both the stretcher bar and the backing board verify his restoration. Later documents show that it was sent to the National Gallery of Art for "repairs" by Stephen Pichetto in 1945 and 1948, and to Mr. Sullivan for "restoration in same area" in 1950. Subsequent correspondence between Duncan Phillips and Sheldon Keck in 1953 identifies the problem of "blisters" in the paint as the past and present reason for restoration. In 1954 Sheldon and Caroline Keck of New York removed a linen and cheesecloth aqueous glue lining and relined the painting with linen and a wax-resin adhesive. They also removed a yellowed varnish and revarnished the surface using a poly (butyl methacrylate) resin. In 1981 Charles Olin of Washington, D.C., made some adjustments to the 1954 wax-resin lining, removed the varnish that had deteriorated, and revarnished the painting using an ethylacrylate-*co*-methylmethacrylate resin.

E. S.

1. A great deal of valuable research on *Luncheon of the Boating Party* was done by Grayson Harris Lane and Maura K. Parrott under the supervision of Erika Passantino of The Phillips Collection's Research Office.
2. Paul de Charry, *Le Pays*, 10 March 1882, quoted in Charles S. Moffett et al., *The New Painting: Impressionism, 1874–1886*, exh. cat. (San Francisco, 1986), 413.
3. Ibid.
4. Hans Huth, "Impressionism comes to America," *Gazette des Beaux-Arts* 29 (April 1946), 225–52.
5. Luther Hamilton, "The Work of the Paris Impressionists in New York," *Cosmopolitan* 1 (1886), 240–42.
6. "French Impressionists at the Grafton Gallery," *Atheneum* (London), no. 4033 (11 February 1905), 186.
7. Paul Durand-Ruel, letter to Duncan Phillips, 27 November 1922, Archives of American Art.
8. Duncan Phillips, journal entry, "Paris August 22nd, 1911," quoted in Marjorie Phillips, *Duncan Phillips and His Collection* (New York, 1970), 41.
9. Duncan Phillips, journal HH, entry for 11 July 1912, The Phillips Collection archives.
10. Phillips, *Phillips and His Collection*, 63.
11. Durand-Ruel to Duncan Phillips, 9 July 1923, The Phillips Collection archives.
12. Duncan Phillips to Dwight Clark, letter of 10 July 1923, The Phillips Collection archives.
13. Duncan Phillips to Holston and Durand-Ruel, 18 October 1923, Archives of American Art.
14. Duncan Phillips to Georges Durand-Ruel, letter of 27 November 1923, Archives of American Art.
15. Ibid.
16. *New York Herald*, 1 December 1923.
17. *Star* (Washington, D.C.), 30 December 1923.
18. Ambroise Vollard, *Renoir, An Intimate Record* (New York, 1925), 199.

Exhibitions

Paris, "Septième Exposition des Artistes Indépendants," 1–31 March 1882 (approx.), cat. 140, as *Un Déjeuner à Bougival*.

Paris, Durand-Ruel, "Exposition des oeuvres de P. A. Renoir," 1–25 April 1883, cat. 37, as *Dîner à Chatou*.

Boston, Institute Fair, Foreign Exhibition, "American Exhibition of Foreign Products, Arts and Manufactures," September 1883, cat. 26, as *Boatman's Breakfast—Bougival*.

New York, American Art Galleries, "Works in Oil and Pastel by the Impressionists of Paris," 1886, cat. 185, as *Le Déjeuner à Bougival*.

Paris, Durand-Ruel, "Exposition A. Renoir," May 1892, cat. 5, as *Déjeuner à Bougival*.

Paris, Durand-Ruel, "Exposition de tableaux de Monet, Pissarro, Renoir et Sisley," April 1899, cat. 83, as *Canotiers à Bougival*.

Paris, Petit Palais, "Salon d'Automne, 2e Exposition," 15 October–15 November 1904, cat. 11.

London, Grafton Galleries, "Pictures by Boudin, Cézanne, Degas, Manet, Monet, Morisot, Pissarro, Renoir, and Sisley," January–February 1905, cat. 244, as *A Lunch After Rowing*.

Zurich, Kunsthaus, "Französische Kunst des XIX und XX Jahrhunderts," 5 October–15 November 1917, cat. 167, illus., as *Le Déjeuner des canotiers*.

New York, Durand-Ruel, "Seven Paintings by Renoir," January 1923, unnumbered entry.

Chicago, Art Institute of Chicago, "A Century of Progress: Exhibitions of Paintings and Sculpture," 1 June–1 November 1933, cat. 345, illus.

New York, Century Association, "Exhibition of French Masterpieces of the 19th Century," 11 January–10 February 1936, cat. 1, illus. color.

Cleveland, Cleveland Museum of Art, "The Great Lakes Exposition," 26 June–4 October 1936, cat. 305, illus.

New York, The Metropolitan Museum of Art, "Renoir, A Special Exhibition of His Paintings," 18 May–12 September 1937, cat. 33, illus.

Philadelphia, Pennsylvania Museum of Art, "Problems of Portraiture," 16 October–28 November 1937; Washington, D.C.,

Phillips Memorial Gallery, 6 December 1937–3 January 1938.

New York, Museum of Modern Art, "Art in Our Time," 10 May–30 September 1939, cat. 50.

New York World's Fair, "Masterpieces of Art," 11 May–27 October 1940, cat. 332, illus.

New York, Duveen Galleries, "Centennial Loan Exhibition, 1841–1941: Renoir," 8 November–6 December 1941, cat. 36, illus.

Kansas City, William Rockhill Nelson Gallery of Art, "Renoir's *The Luncheon of the Boating Party*," 25 January–February 1942.

Paris, Orangerie, "De David à Toulouse-Lautrec," 20 April–5 July 1955, cat. 47, illus.

The Fine Arts Museums of San Francisco, "Master Paintings from The Phillips Collection," 4 July–1 November 1981; Dallas Museum of Fine Arts, 22 November 1981–16 February 1982; The Minneapolis Institute of Arts, 14 March–30 May 1982; Atlanta, The High Museum of Art, 24 June–16 September 1982, cat. 64, illus. color.

Tokyo, The Nihonbashi Takashimaya Art Galleries, "Impressionism and the Modern Vision: Master Paintings from The Phillips Collection," 25 August–4 October 1983; Nara Prefectural Museum of Art, 9 October–13 November 1983, cat. 35, illus. color.

New York, IBM Gallery of Science and Art, "Paintings and Drawings from The Phillips Collection," 9 December 1983–21 January 1984, cat. 85, illus. color.

"French Masterpieces from The Phillips Collection: Impressionism and Post-Impressionism," 19 February–8 April 1984.

Paris, Grand Palais, "Renoir," 14 May–2 September 1985, cat. 52, illus. color.

Washington, D.C., National Gallery of Art, "The New Painting: Impressionism, 1874–1886," 17 January–6 April 1986, cat. 130, illus. color, as *Un Déjeuner à Bougival (A Luncheon at Bougival)*.

Washington, D.C., The Phillips Collection, "Duncan Phillips: Centennial Exhibition," 14 June–31 August 1986.

Canberra, Australia National Gallery, "Old Masters—New Visions: El Greco to Rothko from The Phillips Collection," 3 October–6 December 1987; Perth, Art Gallery of Western Australia, 22 December 1987–21 February 1988; Art Gallery of South Australia, 4 March–1 May 1988, cat. 20, illus. color.

London, The Hayward Gallery, "Master Paintings from The Phillips Collection, Washington," 19 May–14 August 1988; Frankfurt, Schirn Kunsthalle, 27 August - 6 November 1988; Madrid, Centro de Arte Reina Sofia,30 November–16 February 1989, cat. 20, illlus. color.

From 1928 to 1951, ten interpretive exhibitions that included *Luncheon of the Boating Party* were mounted at The Phillips Collection. Some of them were augmented by loans. Although they were often accompanied by publications, in general these exhibitions did not travel. Complete information is in the archives of The Phillips Collection.

This exhibition history was compiled by the Research Office of The Phillips Collection, and specifically by former staff member Grayson Harris Lane, and prepared for publication by Eliza E. Rathbone.

The Artists

Gustave Caillebotte (1848–1894)

Gustave Caillebotte was born in Paris on 19 August 1848.[1] His father manufactured beds and blankets for the French army, and Caillebotte and his brothers inherited a considerable fortune upon their father's death in 1874. Caillebotte, himself an artist who exhibited with the Impressionists, utilized his financial resources to become one of their primary patrons, acquiring an extensive collection of his colleagues' works.

As a youth Caillebotte spent summers on his family's countryside property in Yerres, just southeast of Paris along the Yerres River, where he learned to row and sail.[2] In 1866 a new family residence was erected in Paris, near the Place de l'Europe. Both the Yerres and Paris homes figured prominently in Caillebotte's earliest Impressionist paintings.

In 1870 Caillebotte earned his law degree. During the Franco-Prussian War he served in the Garde Nationale Mobile de la Seine until March 1871. Soon thereafter he began to visit the studio of the established Salon painter Léon Bonnat, and his early paintings reflect the influence of Bonnat's naturalist approach and subject matter. In March 1873 Caillebotte entered the Ecole des Beaux-Arts under Bonnat's sponsorship. Two years later he submitted his

Gustave Caillebotte, c. 1878, photograph. Private collection. Courtesy of Galerie Brame et Lorenceau, Paris.

first painting to the Salon (*Floor Scrapers*, 1875, Musée d'Orsay, Paris)—it was promptly rejected. He left the Ecole the following year and accepted the invitation of Renoir and Henri Rouart to participate in the second Impressionist exhibition of 1876.

Caillebotte contributed five of his own paintings and loaned several others by his colleagues to the third Impressionist exhibition of 1877. Among the works he exhibited were *Paris Street;*

Rainy Day (1877, The Art Institute of Chicago) and *The Pont de l'Europe* (1876, Musée du Petit Palais, Geneva), which shared the Impressionists' concern for depicting contemporary urban life. His tightly rendered forms and subdued color schemes, however, contrasted markedly with the loose brushwork and heightened palettes preferred by his fellow artists.

His paintings in the fourth Impressionist exhibition of 1879 signaled an altered focus from the city streets to the river Yerres and revealed a closer affinity to the group's subject matter, loose brushwork, and bright colors. Of the nine canvases he exhibited, five portrayed boatsmen rowing on the Yerres.[3] In these paintings Caillebotte joined his contemporaries in representing the popular activity of boating. When the Yerres property was sold in 1879 following the death of his mother, Caillebotte increasingly shifted his focus from rowing to sailing. In 1882 he began designing his own sailboats and writing for the journal *Le Yachting*.

Along with Renoir, Monet, Sisley, and Paul Cézanne, Caillebotte refrained from participating in the sixth Impressionist exhibition in 1881. In May of that year he and his younger brother Martial acquired property on the banks of the Seine at Petit-Gennevilliers, across the river from Argenteuil, where Caillebotte indulged in his passion for boating and gardening.

He rejoined the Impressionists in 1882 and participated in their seventh exhibition, showing seventeen paintings that as a whole reflect his varied interests in the boulevard, bourgeois interiors, the *flaneur*, seaside scenes, and still lifes.[4] In the years that followed he painted less and less, and spent more time sailing and working in his garden. He was elected Conseiller Municipal of Petit-Gennevilliers in 1888. Six years later, at the age of forty-five, Caillebotte died from pulmonary congestion.[5] In his will he bequeathed his entire collection of Impressionist works (sixty-seven oils and pastels, one watercolor, and one drawing) to the French government on the condition that they first hang in the Musée du Luxembourg (then the museum of contemporary art) and eventually in the Louvre. Today forty works from Caillebotte's bequest belong to the Musée d'Orsay.

L. P. S.

Edouard Manet
(1832–1883)

Edouard Manet was born in Paris on 23 January 1832, the eldest son of Eugénie Désirée Fournier and Auguste Manet, a lawyer employed by the Ministry of Justice who hoped his son would pursue a similar career.[1] In 1848 Manet graduated from the Collège Rollin, where he befriended Antonin Proust, with whom he often visited the Louvre. Rather than pursuing a law degree, as his father planned, or studying painting, as he himself wished, Manet compromised by preparing for, and eventually failing, the entrance exam to the Ecole Navale. After spending a year on a training ship bound for Brazil and then returning to Le Havre, where he again failed the exam, Manet pursued his true ambition of becoming an artist. As a painter he would establish himself in the vanguard of French modernism, providing the link between realism and Impressionism.

In 1850 he entered the studio of Thomas Couture, where he continued to study until 1856. During that period he traveled throughout Austria, Germany, and Italy, copying works by old masters. His early works reflect both his master's characteristic use of sharp contrasts of light and dark, and the subjects Manet personally admired in paintings by Francisco de Goya and Diego Velásquez. During the next three decades Manet attempted to establish himself as a painter at the official Salon. His consistent preoccupation with depicting con-

temporary life in a modern style, an approach that would profoundly influence his young Impressionist colleagues, conflicted with the aesthetic tastes of the Salon jury, and the ensuing struggle between artist and establishment followed Manet throughout his career.

In 1861, after two failed attempts, his *Portrait of M. and Mme. Auguste Manet* (1860, Musée d'Orsay, Paris) and *The Spanish Singer* (1860, The Metropolitan Museum of Art, New York) were accepted

Félix Nadar, *Edouard Manet*, c. 1865, photograph. Caisse Nationale des Monuments Historiques et des Sites, Paris.

to the Salon, with the latter receiving an honorable mention. This marked the beginning of a turbulent, controversial decade for the painter. In 1863, after again being rejected by the Salon jury, Manet exhibited *Le déjeuner sur l'herbe* (1863, Musée d'Orsay, Paris) at the Salon des Refusés. The painting's bold style, illogical perspective, and the irrational presence of a nude woman offended nineteenth-century sensibilities, as did the realism and shamelessness of the nude in Manet's *Olympia* (Musée d'Orsay, Paris) of 1865. Frustrated with his unrequited attempts to gain official recognition, Manet organized his own one-person exhibition of fifty works in 1867. Although the exhibition failed to attract critical or financial success, he secured his position at the forefront of contemporary painting.

Manet exhibited in the next three Salons, each time receiving unfavorable reviews. During the Franco-Prussian War he remained in Paris and enlisted in the National Guard, where he served under artist/colonel Ernest Meissonier. Manet received his first enthusiastic critical and popular success with his painting *Le Bon Bock* (1873, Philadelphia Museum of Art), which he exhibited at the Salon of 1873, and sales of his paintings to dealers and private collectors increased. In 1874 the Salon jury accepted a watercolor and the painting *Gare Saint-Lazare* (fig. 25), one of Manet's first attempts to paint mostly out of doors under the influence of the *plein-air* methods of Renoir and Monet. During the summer of 1874 he joined Renoir and Monet in Argenteuil, where he painted Monet's family in their garden (1874, The Metropolitan Museum of Art, New York). He also painted *Boating* (pl. 27) and *Argenteuil* (fig. 9), both of which share similar concerns with the Impressionists in subject matter and use of a lightened palette.

The Salon jury's rejection of Manet's paintings in 1876 inspired him to organize a second one-person exhibition, which was well attended by both the public and the critics but still received largely contemptuous reviews.[2] The following year Manet submitted two canvases to the Salon, one of which was accepted, and in 1879 he exhibited two more paintings there—his earlier *Boating* and a new work, *In the Conservatory* (1879, Nationalgalerie, Staatliche Museen Preussischer Kulturbesitz, Berlin), both of which revealed his alliance with the Impressionists in their concern for portraying everyday subjects and the effects of light on form.

In 1880, with his health deteriorating, Manet exhibited works in Boston and New York, helped organize his one-person exhibition at La Vie Moderne in Paris, and exhibited two paintings in the Salon. The following year he was named Chevalier de la Légion d'honneur, and in 1882 he participated in his final Salon. On 30 April 1883, after years of suffering from syphilis, Manet died in Paris at the age of fifty-two.

L. P. S.

Claude Monet (1840–1926)

Claude Monet was born in Paris on 14 November 1840, and by about 1845 he and his family had moved to Le Havre.[1] He began his art career as a caricaturist, and several of his cartoons were displayed in an art supply store in Le Havre when he was a teenager. In the mid-1850s Monet met Eugène Boudin, a fellow artist who encouraged the young man to join him painting out of doors. Monet later recalled, "It was as if a veil suddenly lifted from my eyes and I knew that I could be a painter."[2]

In 1860, at the age of twenty, Monet enrolled in the Académie Suisse in Paris, and there he may have met Pissarro. Two years later he entered the atelier of Charles Gleyre, where he was introduced to Frédéric Bazille, Renoir, and Sisley. He met the Dutch artist Johan Barthold Jongkind the same year, and Monet later claimed that Jongkind had "completed the teaching I had already received from Boudin. From that time he was my real master; it was to him that I owe the final education of my eye."[3]

Monet's work was exhibited for the first time at the official Salon of 1865. Edouard Manet became aware of the younger artist when, due to the similarity of their last names, Monet's paintings in the Salon were mistaken for those by Manet. After his initial acceptance into the Salon, Monet submitted paintings to these annual exhibitions until 1870 (and once again in 1880), although he had less success as the years went by.

In 1866 Monet became acquainted

with Camille Doncieux, who first served as his model and later became his companion. During that same year a group of artists, including Monet, Renoir, and Sisley, began to gather occasionally at Bazille's studio.[4] In August 1867 Monet's first son Jean was born in Paris, and by the following spring Monet had relocated with Camille and Jean to the Gloton Inn in Bonnières-sur-Seine. This short-lived experience was the first time Monet lived in the suburbs west of Paris, a region that was to inspire him throughout the 1870s. By 20 June 1868 the Monets were evicted from the inn, and after finding a new place for his family to stay, Monet temporarily moved back to Le Havre.

Monet rented a small house in Saint-Michel, near Bougival, in the

spring of 1869. He and Renoir often painted together, and they both worked on sketches of La Grenouillère.[5] This collaboration marked their first experimentation with broken brushwork and a heightened palette, characteristics that remained part of their painting styles throughout the 1870s. Monet remained in Saint-Michel through the winter of 1869 and painted in Louveciennes near Pissarro's home. He married Camille on 28 June 1870, with Gustave Courbet serving as a witness.

The Franco-Prussian War began a few weeks later, on 19 July, and by that autumn the Monets had fled first to London and the following year to Holland. While in London, Charles Daubigny introduced Monet to Paul Durand-Ruel, who soon became his art dealer. After returning to France in November of 1871 Monet rented a house in Argenteuil that had a garden and a view of the Seine. Once established there, he bought a boat that he transformed into a floating studio in which to paint his riverscapes.

In the first Impressionist exhibition of 1874 Monet showed twelve works, including *Impression, Sunrise* (1873, Musée Marmottan, Paris), a painting that led critics to coin the term "Impressionist" to describe the group's collective style. During that same year Monet and his family moved to a larger house in Argenteuil, where the painter was often visited by his artist colleagues.[6] Sisley painted with him during the winter of 1872, and Renoir visited during the fall of 1873. Manet sometimes joined Monet and Renoir on their painting excursions in the summer of 1874.

Monet contributed works to the first four Impressionist exhibitions as well as on the occasion of the seventh one in 1882. He and his family moved to the small village of Vétheuil in the fall of 1878, and his wife Camille died the following autumn. During the 1880s Monet sought to expand his subject matter, traveling from the Mediterranean coast to Brittany, and during the following decade he consistently painted in series. One great source of inspiration was his ninety-six acre property in Giverny, to which he moved in April 1883. Its extensive gardens and ponds formed the basis of numerous paintings throughout the remainder of his career. Monet married Alice Hoschedé in July 1892, with whom he had lived since 1878. Three decades later, on 5 December 1926, the respected artist died in Giverny of pulmonary sclerosis at age eighty-six.

K. R.

Berthe Morisot
(1841–1895)

Berthe Morisot was born on 14 January 1841 in Bourges; she was the third daughter of four children of Marie Cornélie and Edme Tiburce Morisot. Her father's position as a high-ranking civil servant prompted the family to relocate several times during her youth, but around 1852 the Morisot family settled in the Passy section of Paris.[1] Five years later Madame Morisot arranged for her three daughters to take art lessons with Geoffroy-Alphonse Chocarne, an ardent supporter of Ingres and other Neoclassical artists.[2] The Morisots soon replaced Chocarne with Joseph Guichard, an advocate of Delacroix who proved a greater inspiration to the Morisot sisters. While it was typical for young bourgeois women to study art, it was certainly unusual for them to become professional painters.

On 19 March 1858 Morisot and her older sister Edma were granted permission to copy old master paintings at the Louvre,[3] and two years later they asked to receive informal training in *plein-air* painting from Camille Corot, who often dined at the Morisot home.[4] Corot's light palette, small-scale landscapes, and concern for capturing impressions of a scene seem to have immediately inspired Morisot, whose early works reflect the warm tonalities, classically clothed figures, and halcyon mood of Corot's paintings.[5] During the early 1860s Morisot also met Daubigny, whose habit of painting waterside scenes from a studio boat may have prompted her to paint river subjects.

Berthe Morisot, 1875, photograph. Private collection. Courtesy of Galerie Hopkins-Thomas, Paris.

In 1864 a studio was constructed for Morisot and Edma. That year both debuted at the Salon, where they continued to exhibit works throughout the

1860s. Morisot's Salon entries reveal her varied interests in landscape, still life, and figure painting. In a letter written to Edma in 1869, Morisot confided that "landscapes bore me," which suggests that by decade's end her interest in pure landscape painting was waning as she developed her skills as a figure painter. During this period Morisot also began attending Manet's Thursday soirées, where she met contemporary artists and writers such as Edgar Degas, Charles Baudelaire, and Emile Zola.

Morisot remained in Passy throughout the Franco-Prussian War, but following France's surrender she left for St. Germain-en-Laye, located slightly west of Paris, and soon thereafter joined Edma on the coast at Cherbourg. There she began painting harborside scenes from an elevated point of view, often fragmenting her subjects by suggesting an extension of their forms beyond the edge of the canvas.

Her works of the early 1870s reflect the influence of Manet, with whom she shared similar motifs and an analogous palette. In 1874 Morisot married Manet's younger brother Eugène. She also participated in the first Impressionist exhibition, thus making her the only female founding member of the group. The nine works she exhibited (four oils, two pastels, and three watercolors) reveal her virtuosity in various media and reflect her concerns in painting landscapes and the human figure, primarily the female members of her family, both indoors and out.

Morisot participated in the third Impressionist exhibition in 1877 but did not include work in the fourth one held in the spring of 1879. Her absence was perhaps due to her poor health, which partially resulted from her responsibilities as a new mother. Julie, her only child and soon her favorite model, was born on 14 November 1878.

She continued to participate with her colleagues in the Impressionist exhibitions of 1880, 1881, 1882, and 1886. During the early 1880s she spent her summers at Bougival, painting in the garden with Julie as her model. In 1882 she traveled to Genoa, Pisa, and Florence. During this period Morisot and her husband often entertained Renoir, Degas, Monet, Stéphane Mallarmé and Mary Cassatt in their home.

In February 1887 she sent work to the invitational exhibition of Les XX, a group of international avant-garde artists in Brussels.[6] By this time she had also begun working with drypoint and sculpture. Paul Durand-Ruel introduced Morisot's work to America in May of that year when he exhibited her paintings and other Impressionist works in his New York gallery. In the spring of 1892 a retrospective of forty of her oils, in addition to pastels, watercolors, and drawings, was held at the Boussod and Valadon gallery in Paris.[7] Morisot was stricken with pulmonary congestion in February 1895 and died shortly thereafter on 2 March at age fifty-four.

L. P. S.

Camille Pissarro
(1830–1903)

Camille Pissarro was born on 10 July 1830 in Charlotte Amalie, the capital of St. Thomas, Virgin Islands.[1] The son of a successful businessman, Pissarro began attending a boarding school in Passy, a section of Paris, in 1842, where he received drawing lessons. Five years later Pissarro returned to Charlotte Amalie, where he joined the family business and continued to draw. In 1852, in the company of the Danish painter Fritz Melbye, he journeyed to Venezuela, painting the landscape and the people there for two years before returning to St. Thomas, where he unwillingly resumed his position in the family business. Determined to pursue a career as a professional artist, Pissarro left for Paris in the fall of 1855, never again to see his native St. Thomas.

Pissarro's return to Paris coincided with the Exposition Universelle of 1855, where he encountered paintings by Corot and Courbet. In 1857 he met Monet when both were students at the Académie Suisse. Two years later Pissarro debuted at the Salon, and in 1863 his work was included in the Salon des Refusés. During this year Monet introduced him to Renoir, Bazille, and Sisley. In the years that followed, Pissarro regularly attended Zola's Thursday evening dinners, where other guests included Cézanne, Manet, and the landscape painter Antoine Guillemet.

In 1866 Pissarro settled in Pontoise

Camille Pissarro with his wife Julie, c. 1875, photograph. Courtesy of Musée Pissarro, Pontoise.

on the river Oise, in an area known as the Hermitage, with Julie Vellay, a servant in the Pissarro household who eventually became his wife and mother of their eight children.[2] For the next three years the Pissarros remained in the rural region of Pontoise, where the landscapes and rustic scenes suited the artist's yearning for a simpler life. Later he often returned there to paint. In 1869 Pissarro moved to Louveciennes, a suburb west of Paris, where he joined Renoir, Monet, and Sisley in painting the Seine between Bougival and Marly-le-Roi, and shared their interest in capturing the play of light on water and

their use of thick, broken brushwork. During this period Pissarro also frequently joined his younger colleagues Monet, Renoir, and Manet at the Café Guerbois in Paris.

With the outbreak of the Franco-Prussian War, Pissarro and his family fled to London,[3] a change that allowed him to study the work of English old masters and younger landscape painters. While in London, Pissarro met Paul Durand-Ruel, a fellow exile who later became his art dealer.

After the war Cézanne joined Pissarro in painting at Pontoise, and that same year, 1872, Pissarro and Monet began preparing for what was to become the first Impressionist exhibition in 1874. Despite the severe financial distress he experienced in the late 1870s due to the plummeting art market, Pissarro continued to exhibit with the Impressionists throughout that decade and the next. The early 1880s proved an experimental period in Pissarro's career. Moving to Osny in search of fresh subject matter, he strove to achieve more luminous colors and placed greater emphasis on surface pattern in his paintings.

In May 1882 Durand-Ruel sponsored Pissarro's first one-person exhibition. Two years later the painter settled in Eragny, on the banks of the Epte. Pissarro, always an encouraging mentor of young artists, invited Paul Gauguin to participate in the 1879 Impressionist exhibition, and Paul Signac and Georges Seurat to join the eighth Impressionist exhibition in 1886. While his interest in the theories of these younger painters eventually led to his own exploration of neo-Impressionist pointillism, it also caused Renoir, Monet, Sisley, and Caillebotte, all of whom considered the technique mechanical and rigid, to withdraw from the final Impressionist exhibition. Pissarro's own experiments in pointillism eventually waned, and he was soon painting in short, curved strokes once again.

In 1887 Pissarro began experiencing eye problems that would plague him for the rest of his life and prevent him from working outdoors on a regular basis. In January 1892 Durand-Ruel held a retrospective of Pissarro's work from 1870 to that time. Two years later, following the assassination of President Carnot of France by an Italian anarchist, Pissarro moved to Bruges, fearful of police arrest due to his own anarchist beliefs.

Pissarro had returned to France and was painting in Rouen by January 1896. He died in Paris on 12 November 1903 at the age of seventy-three,[4] having received official recognition of his achievements with the Louvre's purchase of two of his paintings earlier that year.

L. P. S.

Pierre-Auguste Renoir (1841–1919)

Pierre-Auguste Renoir, one of five sur-viving children of a tailor and a dress-maker, was born in Limoges on 25 February 1841. At the age of three he moved with his family to Paris, where he grew up.[1] His family's poor financial cir-cumstances required him to earn a liv-ing, and in 1854 he went to work for a porcelain decorator. During these same years he studied drawing with the sculp-tor Callouette, and in 1860 he received permission to paint copies in the Louvre, a practice he continued for the next four years. In 1860–61 he began formal art training in the studio of Charles Gleyre, and in 1862 he was admitted to the Ecole Imperiale et Speciale des Beaux-Arts.

At the Ecole des Beaux-Arts, Renoir formed friendships with Monet, Bazille, and Sisley that proved crucial to the future development of his work. From 1862 to 1864, while intermittently performing his military service, he experimented with painting outdoors, often in the Forest of Fontainebleau, in the company of Monet, Bazille, and Sisley. He exhib-ited at the Salon for the first time in 1864, but he later destroyed the painting. Two works were accepted by the Salon the following year, one of them being a portrait of Alfred Sisley's father William. That same year, through his friend Jules Le Coeur, Renoir met Lise Tréhot, who became his mistress and model.

Renoir and Bazille shared two stu-dios in Paris in 1867 and 1868. Unlike

Bazille, whose parents provided for him, both Monet and Renoir eked out a mea-ger existence, often turning to their friend for financial assistance. In the summer of 1869 Renoir stayed with his parents, who had recently moved to Voisins-Louveciennes. He frequently visited Monet and went with him on

Pierre-Auguste Renoir, 1870s, photo-graph. Collection of Claude Monet. Courtesy of Musée Marmottan, Paris.

painting expeditions in the immediate environs, including to La Grenouillère.

During the Franco-Prussian War, Renoir remained in France and served in the Tenth Cavalry Regiment. Although he successfully exhibited paintings at the Salons of 1868, 1869, and 1870, his work was rejected from the Salons of 1871 and 1872, and in response he joined many of his artist friends in participating in the Salon des Refusés of 1873. During that summer Renoir visited Monet in Argenteuil, and the two artists often painted together. The following year the first Impressionist exhibition of 165 works was held in the former studio of Félix Nadar.[2] Renoir was represented by three paintings, all figure subjects, including *La Loge* (1874, Courtauld Institute Galleries, London), a consummate example of the balance he achieved between a soft brushstroke and solidity of form. Although he contributed work to the next two Impressionist exhibitions (1876 and 1877), Renoir ceased participating in them until the seventh exhibition of 1882, which included twenty-five of his works, among them *Un Déjeuner à Bougival (Luncheon of the Boating Party)* (pl. 60).

Unlike Monet, Sisley, and Pissarro, Renoir continued to reside in Paris, taking occasional trips to Argenteuil and Gennevilliers. He made his first extended visit to the Maison Fournaise in the summer of 1875. Renoir frequently returned to Chatou, making a two-month sojourn there in August and September of 1880 when he did most of the work on *Luncheon of the Boating Party*.

Around this time he began to enjoy success with his portraits and received commissions from Victor Choquet in 1875 and from Georges Charpentier and Paul Bérard, among others, in the late 1870s. Although Paul Durand-Ruel came to appreciate Renoir's paintings later than he did the work of many Impressionists, he eventually became the artist's most dedicated champion and presented his first one-man exhibition in 1883.[3]

Having finally achieved some financial security, Renoir traveled to Venice, Padua, Florence, and Naples (1881), to Algeria (1882), and to Italy again (1883) with Monet, stopping on the way back to Paris to visit Cézanne in Aix-en-Provence. Renoir returned to Aix in 1888, 1889, and 1891, each time painting landscapes and occasional still lifes that reflect the influence of Cézanne. In 1885 Renoir's first son Pierre was born, followed by Jean in 1894 and Claude in 1901; in 1890 he married Aline Charigot.[4]

Renoir made his first visit to Essoyes, the childhood home of Charigot, in 1885. He eventually divided his time among Essoyes and Cagnes and Le Cannet in the south of France. In 1908 he moved into a house at Les Collettes, Cagnes, which remained his primary residence for the rest of his life. He was honored in 1904 when thirty-five of his works were shown in the Salon d'Automne. In 1912 his legs became paralyzed, and in 1919 he suffered from congestion of the lungs and died at his home in Cagnes at age seventy-eight.

E. E. R.

Alfred Sisley (1839–1899)

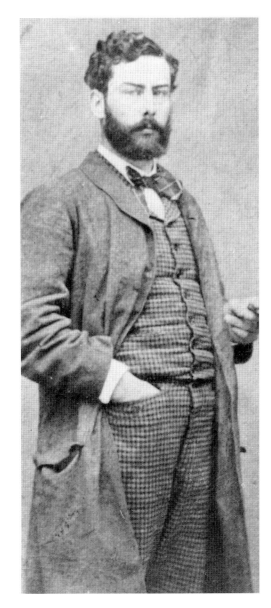

Alfred Sisley was born in Paris on 30 October 1839 to parents of English descent.[1] The success of his father, a prosperous businessman, allowed Sisley to live comfortably as a young artist without relying upon sales of his paintings for income. Sisley was sent to London at age seventeen to train for a business career, but he preferred studying the paintings of John Constable and J. M. W. Turner in museums and art galleries.[2] Soon after his return to Paris in 1860, he entered the studio of Charles Gleyre, where he met Monet and Renoir, and was encouraged by his master to paint out of doors and to express his individual style.

Sisley first exhibited at the Salon in 1866, showing two landscapes painted near the Forest of Fontainebleau, and another painting was accepted by the Salon jury two years later. The few works that remain from the 1860s reveal Sisley's enduring artistic concerns, such as the rural landscape occasionally punctuated with figures, a road receding into a distant village, and the influence of Corot in both subject matter and style.[3]

The acceptance of two of his paintings by the Salon in 1870 marked the final occasion on which Sisley exhibited there. After the Franco-Prussian War destroyed his father's business and caused the older gentleman's eventual death, Sisley was forced to depend upon sales of his canvases to support his family.[4] From his home in Louveciennes, where he moved in 1872, the artist traveled to nearby Argenteuil, Bougival, and Port-Marly, as evidenced by his paintings from this time. Also during the early 1870s he met Paul Durand-Ruel, who featured works by Sisley in an 1872 exhibition in his London gallery.

In 1874, as a founding member of the Société anonyme coopérative des artistes peintures, sculpteurs, graveurs, etc., Sisley contributed six paintings to the first Impressionist exhibition, including *The Ferry of the Ile de la Loge:*

Flood (1872) and *The Machine de Marly* (1873, both in the Ny Carlsberg Glyptotek, Copenhagen). That summer Sisley returned to England at the invitation of Jean-Baptiste Faure, a renowned singer and an early patron of the Impressionists. There he painted several views of Hampton Court and depicted everyday life in the nearby riverside village of East Molesey. Soon after his return to France, Sisley relocated to Marly-le-Roi, where he was again inspired to paint his immediate surroundings. One series of seven paintings captures the rising waters of the Seine as it flooded Port-Marly. At least two of the flood paintings were included in the second Impressionist exhibition of 1876.

Sisley contributed seventeen canvases, several of which again portrayed the environs of Louveciennes and Marly, to the third Impressionist exhibition the following year.[5] In 1879 Sisley abstained from participating in the fourth Impressionist exhibition and instead, along with Renoir and Monet, submitted works to the Salon (Sisley's were refused). One year later he moved to Moret-sur-Loing, which remained his home until his death two decades later.

In 1883 the Durand-Ruel gallery held Sisley's first one-person exhibition. By the middle of the decade, however, both critics and colleagues were growing dissatisfied with Sisley's paintings.[6] He continued to exhibit with the Impressionists, but like a number of the original members of the group, he did not participate in their final exhibition of 1886. Later in the decade, hoping to improve his financial situation as well as his reputation, Sisley began working in pastel, a medium popular with the public. Around this time he also focused on creating series of specific scenes with slight variations in time of day, light, weather, and season.

Toward the end of the 1880s Sisley began experiencing health problems. He traveled to Paris less often and produced fewer paintings. His *September Morning* (c. 1887, Musée des Beaux-Arts, Agen) was purchased by the French government in 1888, and later that year a one-person exhibition of his works was organized at the Galerie Georges Petit. In 1891 he exhibited with Les XX in Brussels, but a larger one-person exhibition organized by Galerie Georges Petit in February 1897 ended in both commercial and critical failure. Later that summer he traveled to England one last time. The following year he ceased painting and was diagnosed with throat cancer. Sisley died on 29 January 1899, never having attained the status, reputation, or financial success of his colleagues.

L. P. S.

GUSTAVE CAILLEBOTTE

1. Unless otherwise stated, biographical details are taken from Anne Distel et al., *Gustave Caillebotte, Urban Impressionist*, exh. cat. (Paris, 1994), and Kirk Varnedoe, *Gustave Caillebotte* (New Haven and London, 1987), 206 n. 3. His father was Martial Caillebotte, Sr. (1799–1874); his mother was Céleste Daufresne Caillebotte (1819–1878). Caillebotte's two brothers were René (1851–1876) and Martial (1853–1910). They had an older half-brother named Alfred (1834–1896) from their father's first marriage.

2. Marie Berhaut, *Gustave Caillebotte, sa vie et son oeuvre: catalogue raisonné des peintures et pastels* (Paris, 1978), 20 n. 12.

3. Among others, he exhibited *Oarsman in a Top Hat* (fig. 17); *Bathers (Baigneurs)*, 1878, private collection; *Périssoires* (pl. 49); *Oarsmen* (pl. 48); and *Périssoires*, 1877, Milwaukee Art Center.

4. Although he did exhibit works in other countries throughout the 1880s, such as Durand-Ruel's New York exhibition in 1886 and the Salon des XX in Brussels in 1888, the seventh Impressionist exhibition marked the last time he participated in an exhibition in Paris.

5. Kirk Varnedoe, with Hilarie Faberman, "Gustave Caillebotte: A Biography," in *Gustave Caillebotte: A Retrospective Exhibition*, exh. cat. (Houston, 1976), 41.

EDOUARD MANET

1. Unless otherwise stated, biographical details are taken from *Manet, 1832–1883*, exh. cat. (Paris and New York, 1983). Manet's two younger brothers were Eugène (1833–1892), who married Berthe Morisot, and Gustave (1835–1884). His mother, Eugénie-Désirée Fournier, was the godchild of Marshall Bernadotte, who later became the king of Sweden.

2. The exhibition was held in Manet's studio from 15 April to 1 May 1876, two weeks prior to the opening of the official Salon.

CLAUDE MONET

1. Unless otherwise stated, biographical details are taken from Charles S. Stuckey, *Claude Monet: 1840–1926*, exh. cat. (Chicago, 1995), which contains the most exhaustive chronology on Monet that is currently available (see pages 186–257 for text and pages 259–66 for notes to the text).

2. Ibid., 186.

3. François Thiébault-Sisson, "Claude Monet, An Interview," *Le Temps* (27 November 1900), quoted in John Rewald, *The History of Impressionism*, 4th rev. ed. (New York, 1973), 69–70.

4. MaryAnne Stevens, ed., *Alfred Sisley*, exh. cat. (London, 1992), 261, which cites *Pissarro*, exh. cat. (London, 1980), 59.

5. Gaston Poulain, *Bazille et ses amis* (Paris, 1932), 160–62, and Daniel Wildenstein, *Claude Monet: Biographie et catalogue raisonné*, vol. 1 (Lausanne and Paris, 1974), 427, no. 53, cited in Gary Tinterow and Henri Loyrette, *Origins of Impressionism*, exh. cat. (New York and Paris, 1994), 323.

6. Rudolphe Walter, "Les Maisons de Claude Monet à Argenteuil," *Gazette des Beaux-Arts* 67 (December 1966), 333–42, and Wildenstein, *Monet*, vol. 1, 429, cited in Paul Hayes Tucker, *Claude Monet: His Life and Art* (New Haven and London, 1995), 83, n. 38.

BERTHE MORISOT

1. Denis Rouart, ed., *Berthe Morisot: The Correspondence with her family and friends* (London, 1987), 18; this source says the date of the move to Passy was 1851. Armand Fourreau, in *Berthe Morisot*, trans. H. Wellington (New York, 1925), 8, states the family moved in 1852. Unless otherwise stated, biographical details are taken from Rouart, *Morisot*.

2. This date of 1857 is based on the recollections of Morisot's younger brother Tiburce (1848–after 1925).

3. Theodore Reff, "Copyists in the Louvre," *Art Bulletin* 46 (December 1964), 556.

4. Fourreau, *Morisot*, 19.

5. Morisot evidently destroyed the majority of her works created before 1871. See Charles F. Stuckey and William P. Scott, *Berthe Morisot: Impressionist*, exh. cat. (New York, 1987), 16.

6. Ibid., 124, n. 257.

7. Ibid., 158. The exhibition dates were 25 May to 18 June 1892.

CAMILLE PISSARRO

1. Unless otherwise stated, biographical details are taken from Ralph E. Shikes and Paula Harper, *Pissarro: His Life and Work* (New York, 1980), 21. See also Ludovic Rodo Pissarro and Lionello Venturi, *Camille Pissarro, son art, son oeuvre* (Paris, 1939), 16.

2. The couple married on 14 June 1871 in London, by which time they had two children together.

3. This marked Pissarro's second trip to England. On the death of his half-sister in 1868 he had stayed in London for just over a month.

4. John Rewald, ed., *Camille Pissarro: Letters to his Son Lucien*, trans. Lionel Abel (New York, 1943), 360.

PIERRE-AUGUSTE RENOIR

1. Unless otherwise stated, biographical details are taken from the extensive chronology of Renoir's life in John House et al., *Renoir*, exh. cat. (London, 1985), 294–314.

2. Charles S. Moffett et al., *The New Painting: Impressionism 1874–1886*, exh. cat. (San Francisco, 1986), 93, 123.

3. Lionello Venturi, *Les Archives de l'Impressionnisme*, vol. 1 (Paris and New York, 1939), 29.

4. Lhote and Lestringuez, who both appear in *Luncheon of the Boating Party*, were among the four witnesses at Renoir's wedding.

ALFRED SISLEY

1. His father William Sisley (1799–1870 or 1879) married his cousin Felicia Sell. Sisley had an older brother Henry (b. 1832) and two older sisters, Elizabeth-Emily (dates unknown) and Aline-Frances (1834–1904). See Richard Shone, *Sisley* (Oxford, England, 1979), 4, and Richard Shone, *Sisley* (New York, 1992), 14–18. Unless otherwise stated, biographical details on Sisley are taken from these two sources.

2. Gustave Geffroy, *Sisley* (Paris, 1923), 3.

3. Sisley probably met Corot in 1865 while working in the Forest of Fontainebleau. See Shone, *Sisley*, 1992, 203 n. 15.

4. Shone (ibid., 43) notes that William Sisley's death occurred in 1879, not in 1870, as had been previously believed. The date of 1879 is given by the Acte de Décès, Archives départmentales de Seine et Marne (quoted in ibid., 204). MaryAnne Stevens, for instance, cites 1870 as the year of William Sisley's death. See Stevens, ed., *Alfred Sisley* (London, 1992), 262. Eugénie Lescouezec (1834–1898) became Sisley's companion in the 1860s and his wife in 1897. Their son Pierre was born in 1867, and their daughter Jeanne was born in 1869.

5. For a list of the works exhibited see Moffett et al., *New Painting*, 206.

6. In his letters to his son, for instance, Pissarro wrote, "As for Sisley, he has not changed, he is adroit, delicate enough, but absolutely false. . . ." See Rewald, *Pissarro: Letters*.

Gustave Caillebotte

Oarsmen
(Canotiers ramant sur l'Yerres)
1877
Oil on canvas
31 7/8 × 45 5/8 in.
Private collection
Plate 48

Périssoires
(Périssoires sur l'Yerres)
1878
Oil on canvas
61 3/8 × 42 7/8 in.
Musée des Beaux-Arts de Rennes
Plate 49

The Argenteuil Bridge and the Seine
(Le pont d'Argenteuil et la Seine)
1880–85
Oil on canvas
25 5/8 × 32 1/4 in.
Private collection
Plate 54

The Argenteuil Basin
(Le bassin d'Argenteuil)
1882
Oil on canvas
25 5/8 × 31 7/8 in.
Private collection
Plate 55

Edouard Manet

Banks of the Seine at Argenteuil
(Bords de la Seine à Argenteuil)
1874
Oil on canvas
24 1/2 × 40 1/2 in.
Private collection, on extended loan to
the Courtauld Institute Galleries,
London
Plate 26

Boating
(En bateau)
1874
Oil on canvas
38 1/4 × 51 1/4 in.
The Metropolitan Museum of Art, New
York, H. O. Havemeyer Collection,
Bequest of Mrs. H. O. Havemeyer, 1929
(29.100.115)
Plate 27

Claude Monet

On the Bank of the Seine, Bennecourt
(Au bord de l'eau, Bennecourt)
1868
Oil on canvas
32 1/2 × 39 5/8 in.
The Art Institute of Chicago, Potter
Palmer Collection, 1922.427
Plate 1

La Grenouillère
1869
Oil on canvas
29 3/8 × 39 1/4 in.
The Metropolitan Museum of Art, New
York, H. O. Havemeyer Collection,
Bequest of Mrs. H. O. Havemeyer, 1929
(29.100.112)
Plate 2

The Seine at Bougival
(La Seine à Bougival, le soir)
1869–70
Oil on canvas
23 5/8 × 28 7/8 in.
Smith College Museum of Art,
Northampton, Massachusetts
Purchased, 1946.
Plate 4

Please note that whenever possible French titles are taken from the catalogue raisonné of the artist.

The Argenteuil Basin
(Le bassin d'Argenteuil)
c. 1872
Oil on canvas
23 ⅝ × 31 ¾ in.
Musée d'Orsay, Paris, Bequest of Comte
Isaac de Camondo, 1911
Plate 17

The Highway Bridge under Repair,
Argenteuil
(Le pont de bois)
1872
Oil on canvas
21 ¼ × 28 ¾ in.
Fondation Rau pour le Tiers-Monde,
Zurich
Plate 14

The Promenade along the Seine
(Les bords de la Seine à Argenteuil)
1872
Oil on canvas
21 ¾ × 29 in.
Private collection
Plate 15

The Regatta at Argenteuil
(Régates à Argenteuil)
c. 1872
Oil on canvas
18 ⅞ × 29 ½ in.
Musée d'Orsay, Paris, Bequest of
Gustave Caillebotte, 1894
Plate 12

Autumn on the Seine, Argenteuil
(Automne sur la Seine, Argenteuil)
1873
Oil on canvas
21 ¼ × 28 ¾ in.
Mrs. John Hay Whitney
Plate 20

The Railroad Bridge at Argenteuil
(Le pont du chemin de fer à Argenteuil)
1873
Oil on canvas
23 ⅝ × 39 in.
Private collection
Plate 23

Boats: Regatta at Argenteuil
(Les barques. Régates à Argenteuil)
c. 1874
Oil on canvas
23 ⅝ × 39 ⅜ in.
Musée d'Orsay, Paris, Bequest of Comte
Isaac de Camondo, 1911
Plate 30

Argenteuil Basin at Sunset
(Coucher de soleil sur la Seine)
1874
Oil on canvas
19 ½ × 25 ⅝ in.
Philadelphia Museum of Art: Purchased
with the W. P. Wilstach Fund
Plate 33

Petit-Gennevilliers
(Au Petit-Gennevilliers)
1874
Oil on canvas
21 ½ × 29 in.
Private collection
Plate 24

Railroad Bridge, Argenteuil
(Le pont du chemin de fer, Argenteuil)
1874
Oil on canvas
21 ⅜ × 28 ⅞ in.
The John G. Johnson Collection,
Philadelphia Museum of Art
Plate 34

Sailboat at Petit-Gennevilliers
(Voilier au Petit-Gennevilliers)
1874
Oil on canvas
22 × 29 ⅛ in.
Lucille Ellis Simon
Plate 32

Sailboats at Argenteuil
(Canotiers à Argenteuil)
1874
Oil on canvas
23 ⅝ × 31 ½ in.
Private collection
Plate 29

Sailboats on the Seine
(*Barques au repos, au Petit-Gennevilliers*)
1874
Oil on canvas
21 ¼ × 25 ¾ in.
The Fine Arts Museums of San
Francisco, Gift of Bruno and Sadie
Adriani, 1962.23
Plate 25

The Basin at Argenteuil
(*Le bassin d'Argenteuil*)
1874
Oil on canvas
21 ¾ × 29 ¼ in.
Museum of Art, Rhode Island School of
Design, Providence, Rhode Island; Gift
of Mrs. Murray S. Danforth
Plate 22

The Bridge at Argenteuil
(*Le pont routier, Argenteuil*)
1874
Oil on canvas
23 ⅝ × 31 ⅜ in.
National Gallery of Art, Washington,
D.C., Collection of Mr. and Mrs. Paul
Mellon
Plate 31

*The Promenade with the Railroad Bridge,
Argenteuil*
(*Au pont d'Argenteuil*)
1874
Oil on canvas
21 ⅜ × 28 ½ in.
The Saint Louis Art Museum, Gift of
Sydney M. Shoenberg, Sr.
Plate 21

The Studio Boat
(*Le bateau-atelier*)
1874
Oil on canvas
19 ⅝ × 25 ¼ in.
Kröller-Müller Museum, Otterlo,
The Netherlands
Plate 35

Red Boats, Argenteuil
(*Les bateaux rouges, Argenteuil*)
1875
Oil on canvas
22 × 26 ⅜ in.
Musée de l'Orangerie, Paris, Collection
of Jean Walter and Paul Guillaume
Plate 44

The Argenteuil Basin
(*Le bassin d'Argenteuil*)
1875
Oil on canvas
21 ¼ × 29 ⅛ in.
Private collection, London
Plate 39

Fishermen on the Seine at Poissy
(*Pêcheurs à la ligne sur la Seine, à Poissy*)
1882
Oil on canvas
23 ½ × 32 ⅛ in.
Österreichische Galerie, Belvedere,
Vienna
Plate 52

Berthe Morisot

View of Paris from the Trocadero
(*Vue de Paris des hauteurs du Trocadéro*)
c. 1871–72
Oil on canvas
18 1/16 × 32 1/16 in.
Santa Barbara Museum of Art, Gift of
Mrs. Hugh N. Kirkland
Plate 7

Boats on the Seine
(*Bateaux sur la Seine*)
c. 1880
Oil on canvas
10 ⅛ × 20 1/16 in.
Private collection
Plate 51

Camille Pissarro

The Lock on the Seine at Bougival
(Barrage sur la Seine à Bougival)
1871
Oil on canvas
13 × 18 1/8 in.
Marion & Henry Bloch
Plate 5

The Seine at Port-Marly
(La Seine à Port-Marly)
1872
Oil on canvas
18 1/8 × 22 in.
Staatsgalerie Stuttgart
Plate 11

The Wash House, Bougival
*(Le lavoir, Pontoise)**
1872
Oil on canvas
18 1/4 × 22 in.
Musée d'Orsay, Paris, Bequest of
Gustave Caillebotte, 1894
Plate 10

Pierre-Auguste Renoir

La Grenouillère
1869
Oil on canvas
26 1/8 × 31 7/8 in.
Nationalmuseum, SKM, Stockholm
Plate 3

La Grenouillère
c. 1871–72
Oil on canvas
17 3/4 × 21 5/8 in.
Private collection, U.S.A., courtesy of
the Artemis Group
Plate 6

The Seine at Argenteuil
(La Seine à Argenteuil)
1874
Oil on canvas
19 3/4 × 25 3/4 in.
Portland Art Museum, Oregon;
Bequest of Winslow B. Ayer
Plate 28

Boating on the Seine
(La Seine à Asnières, called *La Yole)*
c. 1875
Oil on canvas
28 × 36 1/4 in.
The Trustees of the National Gallery,
London
Plate 41

Self-portrait
(Autoportrait de Renoir)
c. 1875
Oil on canvas
15 3/8 × 12 1/2 in.
Sterling and Francine Clark Art
Institute, Williamstown, Massachusetts
Plate 43

The Rowers' Lunch
(Le déjeuner au bord de la rivière)
c. 1875
Oil on canvas
21 11/16 × 25 15/16 in.
The Art Institute of Chicago, Gift of
Honore and Potter Palmer. Potter
Palmer Collection, 1922.437
Plate 40

Monsieur Fournaise
*(Portrait de M. Fournaise, or L'homme
à la pipe)*
1875
Oil on canvas
22 × 18 1/2 in.
Sterling and Francine Clark Art
Institute, Williamstown, Massachusetts
Plate 42

* *The location cited in this French title is no
longer considered accurate.*

By the Water
(Près du lac) *
c. 1879
Oil on canvas
18 11/16 × 22 3/8 in.
The Art Institute of Chicago, Gift of
Honore and Potter Palmer. Potter
Palmer Collection, 1922.439
Plate 50

Oarsmen at Chatou
(Les canotiers à Chatou)
1879
Oil on linen
32 × 39 1/2 in.
National Gallery of Art, Washington,
D.C., Gift of Sam A. Lewisohn
Plate 56

Luncheon of the Boating Party
(Le déjeuner des canotiers)
1880–81
Oil on canvas
51 × 68 in.
The Phillips Collection, Washington,
D.C.
Plate 60

A Girl with a Fan
(Femme à l'eventail)
c. 1881
Oil on canvas
25 9/16 × 21 1/4 in.
Sterling and Francine Clark Art
Institute, Williamstown, Massachusetts
Plate 59

The Seine at Chatou
(La Seine à Chatou)
c. 1881
Oil on canvas
28 7/8 × 36 3/8 in.
Museum of Fine Arts, Boston. Gift of
Arthur Brewster Emmons
Plate 57

The Railroad Bridge at Chatou
(Le pont du chemin de fer à Chatou)
1881
Oil on canvas
21 1/4 × 25 3/4 in.
Musée d'Orsay, Paris, Bequest of
Gustave Caillebotte, 1894
Plate 53

Two Sisters (On the Terrace)
(Sur la terrasse)
1881
Oil on canvas
39 9/16 × 31 7/8 in.
The Art Institute of Chicago, Mr. and
Mrs. L. L. Coburn Memorial
Collection, 1933.455
Plate 58

Alfred Sisley

Banks of the Seine at Argenteuil
(Bords de la Seine à Argenteuil)
1872
Oil on canvas
14 5/8 × 22 in.
Private collection
Plate 18

Fishermen Drying Their Nets
(Pécheurs étendant leurs filets)
1872
Oil on canvas
16 1/2 × 25 5/8 in.
Kimbell Art Museum, Fort Worth,
Texas
Plate 9

The Bridge at Argenteuil
(Le pont d'Argenteuil)
1872
Oil on canvas
15 1/4 × 24 in.
Memphis Brooks Museum of Art,
Memphis, Tennessee; Gift of Mr. and
Mrs. Hugo N. Dixon, 54.64
Plate 13

The Bridge at Villeneuve-la-Garenne
(Le pont de Villeneuve-la-Garenne)
1872
Oil on canvas
19 1/2 × 25 3/4 in.
The Metropolitan Museum of Art, New
York, Gift of Mr. and Mrs. Henry
Ittleson Jr., 1964 (64.287)
Plate 16

The Seine at Bougival
(La Seine à Bougival)
1872
Oil on canvas
19 1/2 × 25 in.
Yale University Art Gallery, Gift of
Henry Johnson Fisher, B.A. 1896
Plate 8

Factory on the Banks of the Seine, Bougival
(La fabrique pendant l'inondation)
1873
Oil on canvas
19 5/8 × 25 3/4 in.
Ordrupgaard, Copenhagen
Plate 19

The Seine at Port-Marly
(Bords de la Seine à Port-Marly)
1875
Oil on canvas
21 1/4 × 25 5/8 in.
Private collection, Chicago
Plate 37

The Seine at Port-Marly, Piles of Sand
(La Seine à Port-Marly—tas de sable)
1875
Oil on canvas
21 7/16 × 29 in.
The Art Institute of Chicago, Mr. and
Mrs. Martin A. Ryerson Collection,
1933.1177
Plate 45

The Slopes of Bougival
(Les coteaux de Bougival)
1875
Oil on canvas
19 3/4 × 23 1/2 in.
National Gallery of Canada, Ottawa
Plate 38

The Terrace at Saint-Germain: Spring
(La terrasse de Saint-Germain—
printemps)
1875
Oil on canvas
29 × 39 1/4 in.
The Walters Art Gallery, Baltimore,
Maryland
Plate 36

Bougival
1876
Oil on canvas
24 1/2 × 29 in.
Cincinnati Art Museum: John J. Emery
Fund
Plate 47

Waterworks at Marly
(L'Inondation à Marly)
1876
Oil on canvas
18 1/4 × 24 3/8 in.
Museum of Fine Arts, Boston.
Gift of Miss Olive Simes
Plate 46

Index